Stories of Storeys

Thank you for choosing a SAGE product!
If you have any comment, observation or feedback,
I would like to personally hear from you.

Please write to me at **contactceo@sagepub.in**

Vivek Mehra, Managing Director and CEO, SAGE India.

Bulk Sales

SAGE India offers special discounts
for purchase of books in bulk.
We also make available special imprints
and excerpts from our books on demand.

For orders and enquiries, write to us at

Marketing Department
SAGE Publications India Pvt Ltd
B1/I-1, Mohan Cooperative Industrial Area
Mathura Road, Post Bag 7
New Delhi 110044, India

E-mail us at **marketing@sagepub.in**

Subscribe to our mailing list
Write to **marketing@sagepub.in**

This book is also available as an e-book.

Stories of Storeys

ART, ARCHITECTURE AND THE CITY

GAUTAM BHATIA

Photographs by Shivam Rastogi

YODAPRESS | **$SAGE** | **select**

Los Angeles | London | New Delhi
Singapore | Washington DC | Melbourne

First published in 2018 by

5 YODAPRESS | **$SAGE** | **select**

SAGE Publications India Pvt Ltd
B1/I-1 Mohan Cooperative Industrial Area
Mathura Road, New Delhi 110 044, India
www.sagepub.in

SAGE Publications Inc
2455 Teller Road
Thousand Oaks, California 91320, USA

SAGE Publications Ltd
1 Oliver's Yard, 55 City Road
London EC1Y 1SP, United Kingdom

SAGE Publications Asia-Pacific Pte Ltd
3 Church Street
#10-04 Samsung Hub
Singapore 049483

YODA Press
268 AC Vasant Kunj
New Delhi 110070
www.yodapress.co.in

Published by Vivek Mehra for SAGE Publications India Pvt Ltd, typeset in 11/14 pts Minion Pro by Zaza Eunice, Hosur, Tamil Nadu, India and printed at Chaman Enterprises, New Delhi.

Library of Congress Cataloging-in-Publication Data Available

ISBN: 978-93-532-8080-2 (PB)

SAGE Yoda Team: Amrita Dutta, Alekha Chandra Jena, Arpita Das and Ishita Gupta

Contents

Introduction

Let me explain at the outset that this is neither a scholastic thesis on architecture, nor a philosophical inquiry on buildings. I am a practising architect, and my primary connection with the profession is in the daily act of designing and constructing buildings. For all the formal burdens it carries, the definitions and themes and theories and all the needless self-inflicted wounds of anthropology and art and culture it professes to address, architecture is loaded with a host of conflicting intentions. For all its professed scholasticism, for all its remedies to social ills and national housing statistics, for all its reminders to itself of its worthiness, and its perennial harking to a better life, architecture is a failure. The impoverished Indian city is poorer for the contributions made to it by architecture.

The writing consequently has emerged from our continual misrepresentation of design in the city and landscape. The current decade of the 21st century, the period of supposed economic prosperity and growing social respectability, has been unfortunately mismatched by parallel architectural ideas. The Indian city has been painted with a shameful malevolence—with florid and irresponsible brush strokes, creating as a result a sad, opaque and loveless canvas. Glass office complexes, mega malls, imitation apartment towers, Italianate villages or modernist abstractions; the public audience—as unloved and uncaring participants in the work—is left to suffer urban life as an accidental misfit. What happens around, outside the home, in tedious, incomprehensible, dull, chaotic and disjointed assemblies requires infinite patience and tolerance to bear. More and more, the scenery, completely out of control, is getting harder to ignore.

The general levels of despair and squalor in the Indian city are proportionate to those in the profession of architecture. That is but expected in two entities that depend on each other for sustenance. Buildings that fall in the private domain, behind high boundary walls, or in private or institutional complexes make no visible impact on the city. Doubtless, high boundary walls influence the urbanity of places, but buildings that are neither visible nor part of public experience are, to my mind, not architecture. Though these often appear in discussions on design, I look instead at the ordinary, physical, visible and tactile involvement of our urban environment and the way it affects, communicates with, or influences us. The inclusion of buildings, landmarks, landscapes, art, etc., that defines the framework of daily life is the primary subject of the book, physical objects that loom large in daily perspective.

The book attempts to draw on the social life of some of architecture's role players, people whose peculiar demands on design have come to characterize the building environment of our times, this progressive isolation of architecture from the society of common people. Certainly, the rise of new money has given rise to a new scale of construction—public and private—but then do these mega projects spell new ways of living and thinking? Is there indeed a resurgent optimism, a change in the old attitude that India was always a serious problem waiting to be solved? Is there a glimmer of optimism, or is it just a glint in the steel and glass?

I have always felt that a profession that doesn't go by the book deserves a book that doesn't go by the book. My own work, whether building, art or drawing, has never qualified for those wide-angled double-spreads of photographs and plans that make architecture a perfect enticing picture. Most architectural books are a record of the logical sequence of events and ideas that lead to the eventual product of a finely finished and photographed building. For me such a single-minded approach is filled with professional falsehoods that distil architecture into a fine craft of production. More than ever, such a picture in India is elusive, and occurs only in the few short moments between the completion of a building and its occupancy. The real life of Indian architecture is the gut-wrenching reality of space contaminated by too many people with little money and too many ideas of their own—a type whose habits and lifestyles don't lend themselves to recording mediums like photography. This then is a book about improbable collisions and unlikely alliances.

Behind the seemingly ordinary life of an architect lie other less professional impulses that give shape to building ideas. Architecture has a social and anthropological aspect that takes it resolutely away from the drawing board and often lands you in the more familiar strata called life itself, life that winds itself around building and gives an altogether different reason for architecture. Unlike medicine or physics, architecture draws its inspirations from ordinary life and returns it with an equivalent maladjustment, an offering of one man's play with its day-to-day conditions. To practise architecture then as a profession, or as a dead beat logic of material assembled according to aesthetic formulae, is a form of suicide. Such practice merely keeps the professional feeling professional. In India the making of building is an agonizing medley that simply cannot be justified by theory.

The book is then an excavation, a digging up of the dirt that evokes unrelated states, the social, literate, personal, petty, lurid and other conditions of architectural undress that liberate ideas on building. I practise as an Indian living in a city, confounded by family, neighbourhood, urban blight and affluence, scarred by daily

assumptions and visual encounters, and forced into methods not of my choice or making. I am surrounded by a cast of characters who make and unmake my architecture everyday; they are not just builders and masons, but others hiding behind the bush. The bureaucrat, the beggar, the MP, the shopkeeper, whoever they are, their pervasive influence on my daily life and work is also condensed in the book as the virulent strain behind the architecture, the muddled and diseased voices that clamour and contaminate daily life. The book is not a distillation into the sterile preserve of design, but a further confounding; much like the Indian city and its architecture, a piece of visual and literary noise, a personal harangue of all the forces of delirium that go into the making of buildings in India. It is less a social history of architecture, than a social history of one architect, and his contentious reading of the profession, indeed his unsavoury maladjustment with the city, its art and buildings. The real value of the exercise lies in the deviant side tracks, the insignificant battles that erupt in the unformed stages of construction corrupting the mind and leading to often imaginary ventures. To me the value of architecture is what I have instinctively derived from that deviation. Prejudiced, dull, trivial, devious, despairing, crass, deceitful, blunt, arrogant, malicious, downright stupid, could describe life in India. I hope they also describe the book.

In recent times the most prolific adventures into architecture at a monumental scale have only been undertaken by two agents: private business and the state. In making an assessment of their endeavours, I have chosen to appraise architecture through five major scales of projects, each a type that expectedly signals a new direction in design, construction, lifestyle, technology and social attitude. At the scale of a city, a comparative measure between the private ideal and the public perception makes Lavasa in Pune and Naya Raipur, the new capital of Chhattisgarh as two distinct symbolic references to the new city. Six decades after Chandigarh, do any of these and other new towns reflect anything of the idealism say, of Nehru's time? Do these places consider the resurgent changes in India—the social upheavals, the burst of new money, the hopes of urbanization, the rise of consumerism, the serious divide between the rich and poor—and anything of the cultural clashes that today mark the Indian city?

The search for a big institutional building led me to the new Infosys campus in Mysore. Developed over several years and incorporating the work of a number of private architects, Infosys has become synonymous with an international pedigree in design, quality and execution of work related to the computer technology industry. A comparison with the Indian Institute of Management campus in Ahmedabad seemed natural, given the two were built in recognition of an emerging professional

life in the country. I lived on the IIM campus at a time when the initial impetus for business education was taking shape. In drawing parallels, I wondered if a company like Infosys could have extended ideas of innovation and planning to its own campus. Indeed, should the conception of places, guided by new and untested technological ideals themselves, not also be made new and experimental?

Amongst the high-brow and the monumental, the inclusion of a house is perhaps an anomaly. But the Ambani residence in Mumbai can hardly belong to the cosy and familiar domesticity of Indian homes. At 34 storeys, it consumes more space than many Mumbai office buildings; a serialized division of functions by floor and levels of privacy, it projects a Mughal palace scale to a city structure confined to a narrow highrise. Naturally, a home designed for a business tycoon cannot be assessed for conventional and familiar home ideals, but in my own practice I had encountered people with equally grandiose ideals: three brothers in a joint family of successful exporters, who wanted to construct Thomas Jefferson's Virginia home for themselves in a Delhi suburb. Domestic desire has a patchy history in India, but there are doubtless questions that address the 'iconic' character of places designated landmarks even before they are built, and then, only then, retrofitted with the burden of domestic routines.

Lastly, and possibly of paramount importance, the book redefines the role of politics in architecture. No single politician has made so significant a dent in the landscape of a state as Mayawati. Through a policy of land acquisition, large tracks of farmland have been transferred to private builders. The politics of such transactions aside, the architectural implications of the conversion of farms to apartments are a matter of serious social consequence. The growing nexus of builder-politician, buyer-seller is a dangerous urban portent when architecture becomes a speculative trade commodity. Doesn't such a scenario in regions of severe poverty demand that ideas on land acquisition and development be publicly operated? Moreover, in many monuments and landmarks, strewn over Uttar Pradesh, in Lucknow, NOIDA, etc., Mayawati's heroic presence cannot discount the serious role of the politician in the architectural life of places. Questions raised by the very size of her public works fall on economic, and moral, grounds, even though deification and memorializing may be the sole architectural intent of these projects. Mayawati's message is loud and clear: that public art can be effectively used for political purpose. Is this then a debasement of the public art form? Indeed, is there any distinction between political advertising and public art? Are art and architecture mere convenient mediums for political purposes?

I hope, the process of defining the examples in the narrative will also raise related architectural and social ideas about buildings, their backgrounds, and history, their connection to places and community, ideas too that define cultural notions of domesticity, of work and leisure and all the essential social ingredients that make architecture such a critical background to daily life.

If the practice of architecture is the clearest and most lucid method of communicating building ideas, then a defeat of the current models of building becomes essential to exploring and explaining alternatives. In a country where expectations are always low, there is of course all the more reason to initiate actions that may lead to some gratifying future result. Concerns for ecology and lowered carbon footprints are visible in a number of places and buildings, including traditional mountain houses and the work of Laurie Baker. I choose the more enduring examples of construction that does more than merely projecting themselves as 'green architecture'.

Certainly, the capacity to chart an entirely new future made possible by technology and design is a rewarding idea. However, the tactile and sensory qualities of architecture as essential to maintaining intellectual and emotional connections to people and places may one day act as a bridge between present conditions and abilities, and the more distant hope for an imaginative future.

<div align="right">

—**Gautam Bhatia**
New Delhi, March 2018

</div>

1. Reading the City

A few years ago, one evening, I found myself on the road that heads south out of Delhi in the city's fastest developing suburb, Gurgaon. The area along the road was one big construction site. Many new structures sat between piles of rubble and workers milled around concrete mixers, or brown hot ground, half dug half built. Pigs and stray dogs strolled and sniffed garbage around plate glass outlets for Pizza Hut and Benetton.

I was making a routine visit to the site of a house under construction nearby when I decided to take a look at the newly erected headquarters of a leading software company. This was one of the earliest so-called e-buildings in India—what its makers described as user-friendly intelligent architecture. In my own practice I have tried to conform to the ideals of hand-craft, low cost and no maintenance and having just examined the hand-applied mud plaster of the house I was working on, the idea of a peek into a high-tech extreme machine seemed all the more intriguing. I parked in the vast lot and made my way towards a composition of polished stone and bevelled glass. Built of Italian marble and erected with American and French technologies under South Korean supervision, it was truly global architecture. It was also perhaps six–eight times more expensive than the most expensive building in India. But a structure that has intelligence and the ability to interact with its users was one-of-a-kind among the dumb unfriendly buildings of old India.[1]

Nearing the entrance, a sensor alerted a mechanism in the base of the glass door that it might soon have to open. I stood under a concealed camera for a few seconds while my picture was beamed to an electronic control centre somewhere inside and it informed the circuit in the door that I be allowed to pass. Sure enough, the door opened. An expensive device had eliminated the need for a human Haryanvi guard at a small monthly salary.

Inside the lobby I stood in virtual darkness, looking for a light switch and hoping that the command centre would measure my distress and send down a light. For a long while, nothing happened. I stepped cautiously, hoping that the floor was real and not an e-floor. Once I had reached the elevators, light flooded in, as if all the switches had been flicked on at once. And I knew instantly how an ant might feel caught at Hoover Dam, if all the spillways were opened at once. Rubbing my eyes, I hoped again that the command centre would sense my distress and turn off a few lights; but that didn't happen. Still, this complicated light circuitry was worth it. It defrayed the cost of a 60-watt light bulb left on throughout the night and paid for

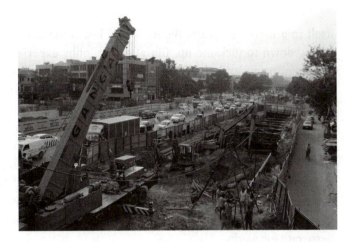

1. In a situation of overpopulation, and a future that the enlarging number puts in uncertainty, architecture's potential has to be judged in anticipation and unpredictability. Certainly, a construction that displays banality is often one that quickly solves a problem, but it can also be one of mesmerizing force and artistic resolve, an outcome informed by testing and experiment. Surely when the present is riddled with problems, without resolution in sight, the great infinity of possibilities is an open universe—the future, a piece of fiction, a hope that should allow the architect and the planner to construct altogether new, more lyrical stories. We do, because we have never done before, becomes a valid argument.

itself in a mere 120 years. Before long I heard the white noise of all six elevators racing down to pick me up. But after the lobby experience, I wasn't too keen on getting into a lift and opted to climb the nine floors by an old fashioned set of steps. Upstairs I was met by the building representative, who narrated the benefits of technology as if memorized from a brochure, explaining that the double glass wall had complex microlouvres and heat sensors inserted within the glass. 'On hot days,' he said, 'the entire south wall is protected without the expenditure of any human energy.' I wanted to tell him that in my parents' time they used reed mats that could just be rolled down when it got too hot. Instead I said, 'That's nice,' and looked through the glass at virtually all the free human energy around the road below: the thousands of underpaid labourers who had helped erect the building, and were now desperate for work.

But clearly the world had changed. In India like everywhere else, building had become a device to display forms of new abundance, and not just make them available to a growing market of consumers but move towards creating a new moneyed professional.[2] A client of mine, a farmer turned garment exporter, wanted me to recreate Thomas Jefferson's Monticello on a small suburban plot. Another, the owner of a Mumbai shipping company, asked me to design a house he saw in a film.

I often think back to my grandfather's house in Dehradun. Barely 25 years ago, it was a low brick structure set in a litchi orchard. Everything about it and its residents was local and Indian. As kids, we spent our summers there, perched on the trees during litchi season. The house was sold 20 years ago and divided into six plots with individual houses. Today the orchard is a set of 40 flats owned by a multinational company based in Canada.

Back outside, I began driving across a landscape of multiplex cinemas and shimmering plateglass walls. All around me, a younger breed of enthusiastic professionals were attacking projects with the impatience of lucrative business deals—seeking to align their work with the idea of India as an industrial power. I thought of the house I was working on, its mud walls and brick courtyard, the kind even Mahatma Gandhi would have approved of. And I realized I belonged to another age.

All around the big cities, a perfect world is being copied and erected from the latest American and European models, mostly by people who themselves have no home. Along the way, the roads are broken up, bits of stone piled up for road widening, concrete sewer pipes placed along mountains of earth, dug years earlier but still unlaid; tractors and earth movers and steam rollers chug along behind heaps of

2. With the sudden need for business schools, in some places the three-year global academic programme was condemned to a parochial village affair. The Lancashire Academy of Business Studies in Hapur, the Stanford International College of Business Administration in Moradabad, and hundreds of others similarly named, but poorly equipped schools in small towns all over India handed out degrees to keep employment lines moving. A system defeated by size could only cater to the lowest common denominator.

uncollected garbage. Cows sit in the fast lane; people urinate on the sidewalk; buildings shove, extend, encroach and usurp land. Wherever you are, burgeoning metropolis, mofussil city, or industrial town—the environment is in continuous flux: a new building is rising, an old one is being torn down, a house is acquiring a second floor, a barsati being refurbished, telephone lines dug, construction material lies on the road. Bazaars overflow onto arcades, wares spill on sidewalks; people jostle for space on the road. More children are being born, so more maternity homes and hospitals are appearing on the streetscape. Façades are perpetually erupting with blemishes of commerce:[3] Arora Electronics, Bansal Enterprises, Babbu Marriage and Tent House. Drive into a parking space in a residential area and the house owner pulls out his gun. The schizophrenic character of the new India is on permanent display.[4]

Every day is a crushing reminder of the expanding numbers. In banks, at bus stops, at metro stations,[5] at government office counters, every single queue is a bone-wrecking medley of too many people causing delay and despair. Drive into pristine countryside filled with corn, wheat or winter mustard. Stop in what you think is complete wilderness, and within seconds, an army of women will emerge with fodder on their heads. In the presumed quiet, a group of men play cards in the wheat field, boys graze cattle nearby. In mountain forests of deodar and pine, the sound of hacking is no forest mafia, just the daily desperation of too many local villagers in need of too little home fuel. In remote districts of Kumaon, enterprising builders have bought whole mountainsides, knowing full well that desperate increasing populations will one day demand housing. The loneliness of the country is a myth of overpopulation.

In every public act is an acceptance of the growing numbers of people. The sidewalk is for sleeping for the newly arrived, the railway line for defecation. Bungalows are broken to make apartments; the servant's quarter is rented to an IIT student, the garage to a doctor. Walls are closing in; the market encroaches on the sidewalk, the sidewalk on the street. Verandahs are enclosed, illegal rooms extend above into unreclaimed air space. The city dweller will possess all that is in the public realm, altering the public environment to suit his private purpose. The urban Indian will grab all there is to possess, altering his environment in a steady reclamation and making the city into a motion picture in perpetual slow fade. Indian urban conditions are on a perennial collision course with civic ideals.

On the highway, wads of notes change hands between builder and agent, the transaction taking place in full public view, on the bonnet of a car. Italian marble and

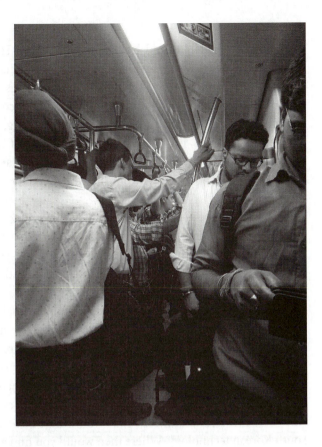

3. Decades after Sanjay Gandhi's despotic programme to reduce population, a new perspective was born: India's 1.3 billion people provide the 21st century economy with new skills and inexhaustible labour. Whatever the short-term benefits of that attitude, the country today averages 2.6 children per family, a figure much beyond the 2.1 required to stabilize the population, and one expected to cross two billion before the end of the century.

4. A graph of rising numbers invades hapless buildings. In 2017, a newly constructed building collapsed in Bengaluru killing 12 people. Approved as a three-storeyed structure, the builder had illegally added two more, knowing full well he would manage an easy sale of the extra floor space. Most structures are not designed to accept continual alterations and additions enacted daily. Places naturally buckle under the pressure of unplanned occupancy. Look at the early maps of Delhi, Mumbai and Calcutta; they reveal low spreading colonial subdivisions that grew around water and vegetation; recent cartographic surveys dismiss all details of land and physical features and express the growth only through land-use and statistics. Master Plan 2021, National Capital Region, Development Zones—the new city is described only by dimension. First a small town, then suburb, then megacity, it spreads outwards like water from a broken drain, swallowing all in its path—villages, roads, fields even small towns. Measured in mounting kilometres, on GPS maps, it stretches beyond visibility, housing people, places and incidents that often never intersect with each other. Its governance, despite the division into smaller districts, is not just impossible, but is not even expected.

5. Since it opened in 2002, the Delhi Metro, for instance, has had to make increases in the number of coaches, the frequency of trains, the size of stations, and the length of platforms. Yet despite all possible additions and supposed efficiencies, the Metro Corporation is faced with a life-long struggle to accommodate increasing numbers.

6

French glass panels are sold by drunk uneducated Haryanvi youth. Hundreds of mud shanties filled with migrant labour huddle under the high-tech reflections of steel and glass office structures. Pigs and stray dogs stroll in the dirt near Nike, Reebok, Benneton and Levi outlets, glassed and air-conditioned. Rajasthani labour and children mill around vast tracks of new housing, suburban malls and glistening office structures, each displaying the promise of its California original. Come to Lakewood City, Live Life King-size in Montego Park. For God's Sake Just Do It. Leave your past and get away from the wretched city.

As India progresses on the world stage with rising growth rates and impressive GDPs, it gets harder and harder to disprove Amartya Sen when he says that globalization is inevitable. In virtually everything around you, in products, places, even people, it is easy to see the crossing of national boundaries.

A mall was once American, a courtyard, Indian, a formal garden, French, pizza, Italian; simplistic notions of visual possessiveness, they have no connection to their origin anymore. Now great pizzas are available in Thailand, great Thai massage in California, the highest skyscraper in Dubai where traditionally single-storey houses were the norm, London Bridge is in Arizona, the samosa is a snack in New Jersey.[6] Now I use a Chinese ballpen to write, my television is Korean, my car Japanese. Nigerian students study at the IIMs, and down the road from where I live, a building is being built using South Korean technology. Where then would you find a traditional form of living?[7]

The purest form of Indian architecture is now seen in the Biennales and at Paris and London architectural shows. Indian architecture is now submerged under the burden of commerce. That architecture is on the fast track of change, is doubtless linked to land values and the rising demand for floor space. But more than that, it is being wilfully supported by people's perceptions of style.

Long back, I had written facetiously about Punjabi Baroque as an emerging style for Delhi's houses. At the time, in a childish thrill to elevate modern domestic building to the level of High Art, numerous other names and definitions were added to the style roster. Among them were Bania Gothic, Early Halwai, Marwari Mannerism and others. At the time, the names had emerged in my mind out of a sense of displacement, merely to indicate an excess of exterior decoration, and to make a gentle dig at people who needed architecture to make unequivocal statements about their affluence and their place in society. If not society, at least on the street. At the time I thought these styles were mere oddities in a place confident of its building traditions. And they would be quickly forgotten.

6. The new India is also on the road to trial and unabashed plagiarism. The perfect picture has already formed somewhere in the world and we are merely buyers on an indulgent shopping spree. Take an American highway and string it between Mumbai and Pune. Plant a New Jersey suburb in Bangalore. Copy a California condominium in Gurgaon, lift a Bus Rapid Transit system from Bogota for Ahmedabad. Help yourself to South Korean rail technology; buy yourself German carriages. Ask a Spanish designer to build a world-class airport. Do it because action must be seen to have been taken, whether it fits or not. The present will create its own future.

7. *Marooned in the heart of ancient India was a small village called Megdo. For centuries Megdo had subsisted on its more than adequate agricultural income. People lived in cool low-slung mud and thatch cottages, busy with their ceramic, wood and stone crafts by day, enacting dance, drama, music and other cultural diversions at night. It was a full life. Then the Enlightened Age dawned and things change rapidly. In the course of its development from rural hamlet to industrial township, Megdo was quickly overrun by packets of instant Maggi Noodles, freeze-dried Uncle Chipps, and plastic mineral water bottles. Bullock carts stacked with Kelvinator fridges, TV cartons and other symbols of economic progress could be seen rumbling in the streets. A state of wellbeing was suddenly visible throughout the village. And that was not all. Packages of economic reforms were handed out like malaria pills during an epidemic, employment schemes allowed even the poorest to set up small-scale industrial units for synthetic food, and to reuse nuclear waste in jams and achaars. The government distributed contaminated foreign wheat to the villagers, just so farmers could diversify into liquor-vending and gambling. Prostitutes also received government subsidies to set up operations in sexually deprived areas. In the evening everyone watched CNN live from Atlanta. No doubt about it. If there was one place with complete social, communal, political, economic and sexual harmony, Megdo was it.*

In the 20 years that it has taken Gurgaon to travel from a sleepy village of buffaloes and mud huts and old men on charpais, to a bloated hotbed of multinational tower blocks and apartments, the idea of Punjabi Baroque has acquired grand respectability, and at the monumental scale of a city. The builders of Gurgaon, now a formidable majority of urban practitioners, all seek to align their work with the idea of India as an industrial power. Even the quality of architecture has the adrenaline rush of instantaneous seduction and gratification: shopping malls, resort hotels, multiplex cinemas, computerized billboards—a lifelong materialist buffet that relies on technology to display newer forms of abundance, and make them available to a growing market of consumers. In the culture of malls, cineplexes and plate glass restaurants, is a new hunger for novelty and delight, and the thrill of being on the forefront of a new urban wave, regardless of what sort of urbanism it creates. After half a century of sustained denial, the thirst is endless. And architecture is at the centre stage, a happy participant in cross-cultural global exchanges, and hence subject to all the forces of the marketplace.

In the midst of these great construction sites I sensed how quickly my understanding of architecture as something heroic, interesting, relevant, informative, communicative, or even essential to wellbeing was being quietly eroded. I stopped there often enough if only to check on my own growing unease with the rising swathe of skyscrapers, each announcing its originality, with a twist of volume, a turn of material, a chrome pinnacle. And each time, the unease grew. Everyday that an anodized aluminium and bevelled glass façade broke across the sky, it caused neither psychic disturbance, nor joy. Nothing. I was quickly shrinking from buildings that were instantly interesting, ones that sparkled with appeal at the very first sight. I had no interest in such architecture. Beyond the idea of building as a valuable possession to be insured, bought and sold, or handed as inheritance, architecture had no scope beyond the boundary wall that enclosed it.

Yet the reading of this architecture grew out of a traditional perspective. Beyond history and fact, architecture is the record of an indigenous perception of place, the way people see a building, the way they occupy it. What makes the experience of a building memorable is the way architecture conveys a sense of enclosure or sequence, monumentality or intimacy, or suggests qualities of sheltering and harbouring. Architecture as sign, symbol or identity, architecture as duality of the public and the personal realms, architecture as perceived order, architecture as a reflection of the site's circumstance, architecture as movement through a sequence of space, architecture as a focus at the end of that sequence, architecture is all these. It is also a matter of structure, form and space and the intervening relationships that occur as a result of function, available materials and technology.

I am drawn to it for yet another, perhaps more personal reason. Architecture also occupies a personal position in the professional stage of an architect. Whatever the objective assessment of buildings and their performance in climatic, utilitarian and ecological terms, he is often intrigued by the spatial and sensory qualities of the buildings, assessing the kind of life that the architecture generates and the particular values its inhabitants attribute to it.

Still I noticed that what I designed and what I wrote and talked about were very different from what I eventually built. Part of the reason for this had to do with my own perception of the public places I encountered daily. Whenever I moved out of the home into the unmanageable pulls of the street, I was always filled with a sense of dread. I wondered, at times, why I was so often repulsed by the places we live in. It had nothing to do with poverty, disease and malnutrition. I was an Indian; they were a part of my heritage. The dread was related to the places of ordinary life, the known and unknown architecture of the city where I lived, the public building, the house and landmark. There was a feeling of elation, a sense of spatial purpose and humanist interest in the practice of architecture, which was difficult to experience in the reality of building. Architecture was that wonderful, thoughtful and imaginative wandering of the creative instinct, but building was a dreary mass of broken plaster and flagging spirit, that unavoidable site of daily exchanges and excursions, depressing, unsightly and blemished, overrun by goods and people.[8] I realized that I worked on a canvas so miniscule it could hardly affect the larger environment of the buildings around me.

The shops and offices I saw were like parasitic accretions that had slowly sucked out the simpler enthusiasms, the quieter life of earlier days, and like some uncontrollable disease, had spread over the earth. There was no getting away from it. In every architectural act of man was a depressing regularity, a meaningless clutter, a waste and weariness that appeared as you drove from an unmarked, and often beautiful, countryside into any area that hinted of man's presence.

For most people the experience of architecture requires no special training, no formal course on appreciation, no special invitations to exhibitions. Architecture doesn't hang in a gallery; it is on display 24 hours in the day, in blinding sun and monsoon rain. People move in and out of it; they crawl over it, they rub their hands against parapets, sit on stone stoops, piss against concrete walls, flick light switches, spit in dark corners, open windows to the winter light, draw curtains to withdraw, walk barefoot on cold summer floors, watch babies put fingers into electrical sockets, padlock doors at night. Every action is an action of architecture; building is the backdrop to life.

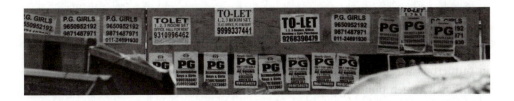

8. Naturally, one of the serious fears of an Indian architect whose practice seeks international recognition is the dilemma of overpopulation. Whatever you do, whatever you build, will eventually be overrun by people. People are, to the clean palette of the minimalist modern mind, the singular most brutal intruder in architecture. (A practice for which I worked years earlier, ensured that no raised flat stone areas were built in clear sight of people, who might use them as seats or benches. 'People spoil the pictures' was the clearly stated instruction to all us draughtsmen.) This is a singular flaw in Indian practice, and merely one of the many symbolic obsessions, that forges an approach that is 'more interested in the life of space as an expressive or technical "object" and in the pleasure of the solitary physiological experience.'

What they do to the environment and how people react to them are constant reminders of the importance of architecture in our midst. Architecture affects the public realm in numerous ways. It controls what we experience in the public life of a city, how we move between buildings, how indeed that movement is perceived in sights and sounds, how it may be altered or modulated by intervening things and landmarks—parks, buildings and hoardings. How these come together, whether in a consciously designed way or as accidental encounters, their physical appearance and their consequent perception, distance and proximity, are all part of the scenarios of city life.

Consequently, architecture in India is a messy, gut-wrenching, tiresome, demanding, enriching, contaminating experience. You merely have to step outside the gate of your house to feel as if you have been released into the monsoon current of the Ganga. Observe all you like, make theoretical and demographic assumptions about the city and shops and hoardings and unlaid drains and ineffective master plans, but eventually the physical side of the city will swallow you up completely. Certainly, there is no place for architecture in it. The city either consumes architecture like food left before a starving child or destroys it once and for all. To protect your creation, put up a high boundary wall and seal your turf.

Behind the high wall, an altogether different experience emerges. Across gravelled pathways, protected by dogs and electronic guards, are allusions to luxury so eccentric and exaggerated, it is hard to believe that the same high walls are also shared by some of the city's poorest. Leaning their broken plastic tenements against the side for support, people line up to scrub themselves, one by one, under a hand pump. While inside, a swimming pool is being drained to provide fresh blue water in case there is a sudden impulse for a dip.

The contrast is truly Roman. A family of six shares a meal on the sidewalk. A couple is served barbequed prawns in a Jaccuzi. One family occupies a 12-square-metre tenement, another a 12,000-square-metre country estate. Certainly, the physical structure of the city is much more engrossing because of such disparity, given the stratifications of the people who live in such close proximity. Against the backdrop of recent economic changes in the city, the rise of consumer culture in the midst of squalor, the divided city has become an unfortunate misfit of extremes.[9] It is often hard to understand the staggering range of human tolerance.

Cultural purists continue to dub the rapid changes of the last decades into convenient categories: post-industrial capitalism, consumer expressionism, constructive regionalism, globalization and certainly there is no denying that patterns

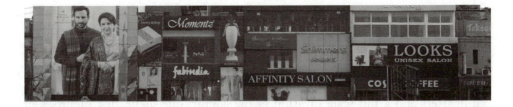

9. The increased numbers doubtless create greater levels of personal insecurity. The current 30% of slum dwellers will double; present traffic movement of a kilometre per hour will dwindle to the equivalent of a cyclist. And average family space will shrink from 200 sq ft, an ordinary room size, to 80 sq ft, average bathroom size. The close packing and congestion will consequently increase crime and violence and widening economic gap will doubtless spur the well-to-do to raise their boundary walls and protective armour against the clamouring onslaught around.

of consumption stand changed. The infusion of money, the transfer of technology, and indeed the complicity of design with business, has lent an unusual urgency to architecture that has changed the tenor of buildings altogether. In the recent past, place after place, all across India, has been witness to large-scale demolition of the old quarters and a full-scale invasion of the countryside. Repeating highrises of apartments have replaced old bungalows, and whole villages have been swallowed up in the rush to urbanize. Capitalizing on the obsessive Indian urge to own a family home, the builder sells the new domestic ideal as commodity—AC, valet parking, golf view, barbeque, etc., and calls it community. No longer the 'eternal' changeless landscape there appears now the singular sight of architecture as an event, a temporary stage-set on display for a short duration. Buildings may not be different but are made to look different. The visibility of the differences stated convincingly on the façade falsely promotes a sense of satisfaction that the building is a new, innovative ideal for the future. As adaptations from distant shores architecture is just like the new goods, smuggled across borders. Like shoes and computers.

In most projects individual traditions and local identities are forsaken for some abstract visual ideal. The sameness to buildings that occurs in places as varied as Singapore, London or Mumbai is also an admission that the architect's role is universal rather than a feature of local experience. An increasing industrialization of the building trades and the involvement of picture book designers in the development of every part and object of the building only reinforce the insecurity of the architect. And provides further proof that his mediating role is out of sync with the times.

Among the many accusations faced by architecture, the most virulent and damning is the profession's ease with illicit partnerships with an underground workforce. In a place where the worst of the present—rising corruption, inefficiency, lack of trust, poor quality of implementation and a singularly destructive apathy towards the surroundings—has rendered Indian places uninhabitable, architects and architecture have played a major role as enablers to the task. The plunder may originally have been of political origin, but the players who surround and confront the action are those with specific physical intent—the builders, the architects, the financiers, the plotting middle men—each in their own precise ways, putting the plan into effect. A significant part in the alliance has been played by the government. My own experience of the bureaucracy's perception of architecture highlights some of the difficulties of addressing and bridging the impossible gap between creation and regulation. The political agreement among the players, though unstated, leaves the incentive to plunder as the primary ambition of not just public work, but all private projects that must engage with the government for approvals.

2. City in Decline

If you stand on the upper parapets of the Humayun's Tomb in Delhi, you will get a clear picture of where the city came from, and where it is headed. First, look east. In the fading light of a winter evening, dung fires spread a darkening pall across the river. Amid the smoke, you can see whole neighbourhoods of tarpaulin houses—black plastic stretched over roofs of twigs and bicycle tyres. Around them, people tread through purple rivulets of sewage snaking at their feet. Down below, the screech of traffic, the insistent wail of a siren mixes with bird sounds in the evening air. And beyond the riverbank rise gray apartment blocks.

From this high vantage, the place has something of the character of war—a charged theatrical spectacle, perpetually smoking, smouldering and choking. A stage set of incomplete structures,[1] as if the day's battle is over, both sides have retreated to their make-shift encampments: a city on a perpetual move to the horizon. In such a setting, it is not easy to sense the heightened aspirations of the city and the quality of life that exists at ground level.[2]

Taking this high aerial view of any Indian town is the most obvious introduction to the civic sense of organization, the Indian sense of collective living. At first glance you mistakenly think the view is an introduction to some serious but temporary disturbance. Down below, there is an endless parasitical sprawl; it's hard to distinguish building from earth or landscape, home from street, public from private. People live in a sort of half baked semi-hard rubble that is more accidental than organic.[3] The image only gives off intimations of impermanence and erosion, as if the life that has arisen from the dust can only be makeshift and suspicious. For more than half a century this image has ground itself into the brain, forming a deeply embedded Indian anti-aesthetic from which, as architects, we wish to constantly escape. The picture makes no distinction between the new and the old, the living and the dying, growth and decay—a state of timelessness persists, a state that erases all the fearful and obsessive panic that architects desire from contrived newness, glitter, texture, reflections and North light. Instead it subsumes everything into a neutral brown haze, a human, animal, material composition of habitation, excrement, movement... there down below. The real practice of building is merely another extension of life's ordinary routines like eating, working, sleeping, defecating....[4]

Incompleteness and visual incomprehension are the very nature of this life, and architecture merely follows that pattern. For an architect, this living landscape therefore, has more in common with a maintenance yard than with say, the formal

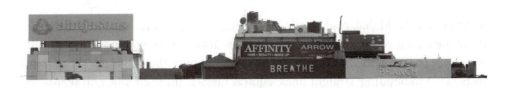

1. If ever there was an Indian symbol of incompleteness and disorder it would have to be the city. Unlaid drains, broken sidewalks, unfinished flyovers, construction material on public roads, telephone lines dug up, the transitory quality of the Indian city is in fact its most permanent attribute. In such a setting, the idea that a set of stadia, games villages and related infrastructure could be conceived, planned and built to international standards and within a specified time-frame was perhaps too much to ask. Even though between the award of the Commonwealth Games to Delhi, to the opening ceremony lay a lazy stretch of six years. Construction work on specific games projects began in earnest only two years before the opening ceremony. Two years within which to renovate, restore, refurbish, make new and test several high capacity venues for an international committee's approval. Given that the average construction time for a single house in Delhi is two years, this was a Herculean task. Who among the politicians and bureaucrats was ready to take on the responsibility, then the blame? Then why host the games at all? India would doubtless be a commendable host to the world conference on religions. The birthplace of the Buddha, home to Hinduism and Jainism, the second-largest Muslim population, a secular society, all the signals are of a society that practises its religious inclinations on a daily basis, but how does a country with no sporting ability, no genuine feel for sport and few training facilities host an event of international dimensions? Would a tropical country like Fiji play host to the winter ski races, or Sweden to the world Kabbadi Championships? Doesn't the host have an obligation to actively participate in the show?

2. *Near a newly dredged lake, there once thrived a large racially-balanced community of birds. Swans, cranes, cuckoos, nightingales, owls, peacocks, doves, parrots, partridges and other birds of genetically varied avian stock, all living together in mutual trust and harmony. Everyone knew their place in the pecking order, and there was an implicit respect for each other's wing span and air space. The main reason for this wellbeing was the complete absence of political life in the forest. There were no parties, no dogmas, no manifestos. Consequently, there were no ten-point plans, no fake promises, no worthless economic policies and income-generation schemes. Politics, it was known from the experience of mythological culture, eventually leads to the downfall of civilization. But after several centuries of harmony, things were about to change. It was but natural that one day the birds should tire of all their prosperity and happiness. And what better way to start on the path of decline than a seminar on 'The Quality of Life'.*

3. It is indeed unfortunate that the more formidable challenges of urban housing for the poor have so far been ignored by private builders. But in the absence of a more egalitarian public land policy, the parcelling of expensive prime land to private developers has led to a lopsided urban development related solely to middle-class aspirations. With builders expecting larger profitable returns from luxury housing—Belvedere Parks and Malibu Townes—it is but natural that the urban poor remain in slums or beyond the boundaries of large towns. The President's proposal for a slum-free India is certainly heroic, but given how previous governments have treated slums, its execution must be guarded and carefully monitored (Remember Hitler's Jewish problem). Reclaiming peoples' lives for the purpose of improving them is one thing but doing so for improving the city is entirely another. It would be interesting to see which of these is the motive for the President's call.

4. Indian architecture's connection with similar states makes for remarkable contrasts often within close locales. In the larger perspective Indian life is placed, misplaced and arranged

setting of the Taj Mahal. And it's all very different from the precise hard line geometry of the view if you were suspended over New York or Chicago. India's civic reality is a soft architecture, with missing edges; it often denies the very values that architects bring to building: straight lines, cubical masses, finite edging, and that wilful order of a formal plan created on the drawing board. Obviously when building materials vary from tarpaulin, and steel and bicycle tyres and plate glass and plastic sheets, walls that are half made, sometimes of reed thin partitions, and ground that is an unsteady bed of broken bricks, mud, urine and human waste, there has to be an altogether different view of city life.[5] It's a transformational understanding that cannot rely on brief visual or material markers. Things change all the time, but we as outsiders, remain entirely unaware of these.

At ground level a magnified reality takes over; it's still much the same story. Roads spit advertising. Between ancient monuments, excreta swims in garbage. Choked drains, traffic snarls, plastic bags tossed from fancy cars, drivers leaning out of Mercedes Benzes to spit *paan* venom, men on scooters stop to leave a trail of piss against boundary walls, Chinese Takeaway vans deposit eggshells and waste on the sidewalk, Rajasthani construction labour defecate in the park. Private brick piles lie on public sidewalks, garbage drifts around fancy coffee bars…. From the shamelessly affluent, to ordinary rickshaw drivers, to migrant workers, the city is a perennial dump of construction debris and bodily fluids. Every expulsion, every excretion, and discharge finds place in it; every form of private action is possible in the most public of places; without regret, without repercussion. The city is not just a place of waste, but a wasted place.[6]

Down the street, in ancient villages urbanized with illegal highrises, an imported life beckons: imitation western bars and French restaurants, granite halls and air-conditioned shopping arcades. Bitter German chocolate, coffee and warm croissants amid the odour of a market urinal. Move through the slime of an overflowing drain to lunch in a fake London pub. Or an evening romp at a brothel that covers itself as the respectable Hotel Delite. Contrasting moments of utter dereliction and exaggerated delight. Can the human spirit reconcile the two extremes?

The city's ugliness today, visible in dust-covered highrises of glass and steel, cannot be easily hidden. But the physical decline is only a minor problem when compared to the virulent undercurrent of sickness brought on by excessive privacy, the unhampered growth of private real estate, and the inability of the middle class to participate or promote public life in the city. In the savage rush to possess, public

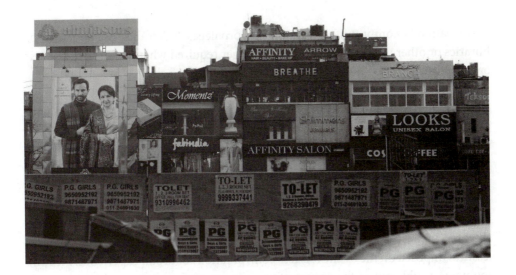

in a temporal contentment that has roots in smaller sustainable measures, far removed from the utopian ideal of freshly laid city plans with flowered avenues, manicured commercial and public plazas. Only conventional architecture's utopian tendencies hold the promise of myth and fable—the longing for some pictorial perfection where life is lived in an exaggerated nursery story. In India however, living happily ever after happens only in guarded vaults, behind the high boundary walls of country villas, gated communities and theme parks, places so socially isolated they hardly qualify as architecture. The unsettled view undermines the professional's language and lays bare its inadequacies in an 'anthropological' rather than a 'design' frame for living. Within the space of an ordinary rectangle of earth, local life and culture dissect simplistic architectural space and rearrange elements into their own social coherence. The discarded homogeneity is invaluable in reordering the identities of places into a multiplicity of fragmented regions, each with a life of its own.

5. In a city where gladiolas blooms are sold against the wall of a public urinal, where access to a French restaurant is across an alley of plastic bags and raw sewage, and grown men defecate at the protected tomb of a Mughal emperor, it is easy to dismiss these ironic contrasts between affluence and destitution as the growth pangs of a third world city trying to become first world.

6. A side lane near my home had been alternately dug up and resurfaced many times over for several years. At first, drains were installed, then fresh cables laid, then telephone lines removed, then a new gas line sunk, then internet cabling redone, finally, water mains repaired. So frequent were the disruptions, that after a while, a considerate junior engineer installed an Inconvenience Regretted sign smack in the centre of the road. For three years now, the road has not been dug, but the sign remains, permanently embedded in concrete. During the preparations for the Commonwealth Games, it was even lovingly repainted in bold letters along with other road signs. Today the bright yellow sign is the only inconvenience on the road. The Delhi Government has spent so much time and effort on it, that removing it would be a big burden on the Exchequer.

participation is compromised with private privilege.[7] Sidewalks, usable parks, or libraries or other public amenities are no longer required when the private home is everything all at once: home, movie hall, playground and club.

As a result, every daily act in the public realm is tinged with fear. Interaction with government departments for water, electricity, transport, municipal services, school or hospital admission, all leave you crushed.[8] You leave your home with a savage mistrust of people. When I move out of the house into the public squalor of the street, I am filled with dread, dread for the range of urban confrontations that will castigate and wilfully cut short my movement through the day. Throughout my progress—from home to market, home to office, office to restaurant, or home to shop or cinema—I am only aware of a monochromatic fatigue, a perennial sight-lessness imposed on me by the faceless confrontations of urban experience. Fleeting moments, visible out of the corner of my eye: acres of government housing, peeling and smudged. Parking lots so full that cars are packed in, as if at factory shipyards. At metro stops, a disgorging, as if a train vomiting people day in and day out in perennial indigestion. People, vehicles, places in constant encroachment of the other, all three tied to each other in a restless parasitic relationship. A traffic rage on the road; despondent sour faces peering over ledgers at bank counters, officials absent at the municipal office, building entrances closed for repair, malfunctioning lifts, drunk policemen in the Police Beat Box, drivers on the prowl, students on the make, people with grudges. The city unmakes you everyday. You don't want to leave home.[9]

Everything about it signals distress and failure. Distress in its perpetual state of incompleteness, as if it is a permanent construction site for some imaginary future that never comes. Failure in its inability to address adequately the needs of its citizens, failure too in its inability to enforce restrictive practices for the long-term benefit of its majority: the ordinary, the less affluent, those in need of public services. No sidewalks for its pedestrians. No restrictions on the sale of private cars, none on their movement. No penalties for encroachment.

Measured against world standards, Indian cities take a beating on the most rudimentary aspects of survival, and are often classified as unplanned spontaneous slums rather than functioning towns, with some of the highest recorded levels of toxic waste, and consequently, physical sickness.[10] Incidents of asthma and lung infection linked directly to pollution and almost a third of the population suffering some form of respiratory illness; annual health surveys give damning figures on

21

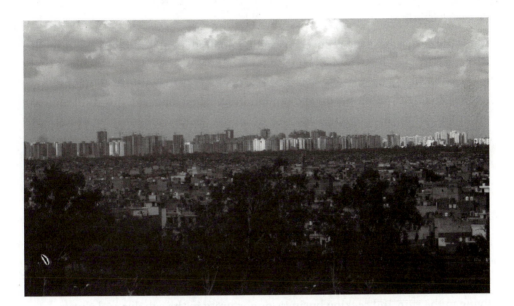

7. A minister once said, 'I ask you, is this country worth living in? If you were true to yourself, you would also say no. Chaos everywhere, traffic lights that don't work, petrol at such high prices, parking problems. Nursery schools without AC. Poor quality Chinese restaurants…. I mean it. Where are we heading? Is this the life we want for our children, hain, I ask you. Will you send your son and daughter to a school that has no basic amenities? No granite flooring, no glass squash court, hain, batao?' He gave a despairing nod and continued. 'There is such desperation everywhere. Whenever I go back to my village, people ask me what do we do for entertainment in our areas. Isn't there a multiplex or a shopping mall, I ask them, and they say no. And I have no answer. What do I tell them? That as a leader I've let them down. No. I can't do it anymore…' He looked downcast. 'Do you know in my village, you still can't get beer on tap?'

8. Everyday you encounter people in a daily war with the city: any dealing with urban water supply, roads, electricity, markets, banks, school admissions, or bureaucracy leaves you defeated and lost. As a result, people's movements are sluggish and shambling, expressions either sour or depraved. Because they are defeated even before they taste defeat, people behave older than they are.

9. In the 1970s, Harlem was like that, a weekend adventure, a sociological study of architecture gone bad. If you travelled up Manhattan then, the genteel surroundings of Uptown would quickly give way to war-torn Dresden during a particularly severe Allied air raid: bombed out tenements, mile upon mile of brick wilderness, windowless or boarded up buildings. Everyone was outdoors, because there was no indoors. Young men on stoops, women shouting down from high parapets, kids at a leaking fire hydrant, atrociously big cars, Pontiacs and Cadillacs parked on sidewalks, a place seething with makeshift urbanity, much like an Indian city. It was hard to believe that barely a few blocks away, rich white women scanned the windows at Tiffany's for a new diamond, while their poodles were being walked by Spanish maids in Central Park. Upwardly mobile white couples prettified their lives, buying apartments in old brownstone structures, upgrading, adding wooden floors and setting flower boxes in windows.

10. It was Gurcharan Singh Batra, the country's leading French existentialist philosopher, who once described India as a government steamroller, forever on the move, crushing

water-borne diseases, and reduced eyesight, impaired mental acuity and shorter life spans.[11]

In most countries public health and sanitation are taken for granted and fall squarely on urban administration. So basic are norms of healthy urban living around the world, they rarely ever make it as news items. Only in India do routine municipal issues assume national importance. Blocked drains during monsoons, road repair, malarial and Dengue outbreaks, children stuck in wells, open manholes, fallen trees and collapsing buildings are all signs of a disintegrating collective life. When municipal authorities fail to oversee ordinary maintenance and are incapable of undertaking decisions on day-to-day governance, the city becomes a nightmare of incompetence and failed ideas, regressing quickly into anarchy—a battleground so scarred that the rich can only isolate themselves into private compounds, creating their own insular lives unrelated to the city; the poor are left to their own devices, living in the ruin and seeking business opportunity in the squalor and clutter.

As the city divides and each group consolidates its private foothold, a palpable unease grows in public space. Because no rules exist, the city ensures that its residents remain entirely free of the norms of collective behaviour. The inevitable necessity to institutionalize behaviour, and even display it on boards shows scant regard for public life: Do not spit, Stay in queue, Silence please, and No urination allowed are the symptoms of an urbanity unused to the presence of others around it. Without pedestrian sidewalks, usable parks, public libraries, latrines or meeting places, private attitudes spill out onto the streets, consequently producing a species of human so self-engrossed and vain that it is incapable of surviving in a shared realm. Yet so dense and closely packed is city space that physical differentiation often occurs in uncomfortable proximity. The rich, the poor, the migrant and the older resident survive in touching nearness.

Many years earlier, I was invited to stay at the home of a shipping tycoon in Bombay (now Mumbai). A Delhi resident, at the time I had been amazed at the claustrophobic confinements of living in such crowded places and sensed how fearful rules of class and facility could be imposed even in dense urban situations. In what was the southern, fashionable section of the city, the tycoon's home was an Italianate villa, with all the refinements of a historic Renaissance façade, a portico for a sports car, a garden gazebo for breakfast; his was the only bit of planned real-estate in a complete slum. From my third-floor guest wing, I could see a private tennis court cut into a neat rectangle in the middle of crowded shanties behind his house. In the morning, while we served and volleyed in the uncomfortable silence of men washing

everything and everyone in its path, and moving so slowly that progress was imperceptible. Unfortunately, some years ago, Batra was himself run over by the steamroller in a hit-and-run accident. But the India he spoke of still survives. As the latest Marg-India Tomorrow Poll indicates, there is a great deal of apathy on the major issues of the day, though much of the apathy is divided along caste-class, and urban-rural lines. In a house-to-house poll conducted in the tribal belt in Orissa and Chhattisgarh, the survey found hardly any record of obesity. Other than in the state MP colonies, most people had low levels of transfats, cholesterol and triglycerides. Dr Satnam Singh of the National Institute of Tribal Health attributed this to daily exercise. Many of the people surveyed worked as manual labourers in bauxite mines, doing 12–14 hours per day. 'They often skipped meals', he added, 'and their only form of rest and relaxation was additional work.' Though AIDS was no longer considered a major health threat to society, survey findings still painted a grim picture. The highest recorded incidents of HIV-AIDS in India, a shocking 98%, were in fact found outside Ahmedabad at the 200-bed Kamlavati Sanatorium for Aids Patients. On the positive side it was also discovered that infant mortality was on the decline. A detailed assessment of families in Fortune 500 companies and households with an annual income above one crore were found to be virtually free of infant mortality. Death at childbirth was also only a minor factor amongst residents of Bhagwati Old Age Home. Even in the rural areas, it was found that infant mortality among unmarried adults was less than 5%. Oddly this result was on par with village households that had chosen to remain childless.

11. Obituary: The place was littered with effluents and decay, and the rising population of people and cars and aspirations, made the city suffocate in its own toxic breath. In its last days, it lay dying in its own waste, its demise compounded by water scarcity, electricity pilferage, road rage, personal insecurity, increasing slums, traffic snarls, housing shortages. Sadly, in 65 years of independence, these multiple crises had not found a solution in conventional wisdom, and every attempt to increase policing, widen roadways, build more houses, had only left a more beleaguered and distressed city, with yet more people facing a grim future. If an alternative urban life was possible, it should have taken an altogether different shape.

themselves from a hand pump barely twenty feet from the baseline, I was struck by this truly wilful act of urban irony. The immeasurable pleasure of un-built space in a dense, overwrought and ramshackle city was a singular perversity that defied, by contrast, the squalor that surrounded it. Un-built space in such conditions was itself a monumental form of elitism.

I wondered then how the desperation of daily life—families in unlit, ill-ventilated rooms, each the size of my host's gate cabin, all sharing a water pump, and relieving themselves in public—viewed the two men swatting balls across a net to no real purpose, neither to livelihood, nor to daily survival. From whichever side of the fence you looked, the closeness of the encounter was as disturbing as it was outrageous and ironic and has produced a litany of unusual professions for urban India. The city had created such agonizing social divisions, the real question was merely related to the monetary value of urban space and its zoning allocation. Still, the fact that the two Bombays have existed peacefully and with such rigid boundaries for so long attest to peoples' extraordinary acceptance of the city's dual nature; part, I suppose, of the unspoken belief that both, the inheritance of riches and the condemnation to poverty are in India at least, birth conditions.

Yet most civic divisions only have bureaucratic reasoning. Urban forms of commerce, residence, work and recreation are marked all over the city as isolated actions enclosed by boundaries. Because of their invisibility, and the private nature of most pursuits, there is an informal understanding between people occupying the same space: park sites acquired for hotels, migrant families in sewer pipes, guard dogs and high boundary walls, security services and BMWs.[12] Housing in industrial swamps, office façades blemished by commerce: D.K. Video Library, P.K. Enterprises, G.K. Housing Pvt. Ltd. Farmhouses with no suggestion of farm or connection to land, Baroque villas with no links to Rome, makeshift factory making pirated tools behind a shop front, private businesses that operate from home basements.

How do you begin to ascribe physical order to such a place? To my mind, there are today only two ways of understanding Indian architecture: one as an episode, a private encounter, a mere incident in a city of many incidents, like a *paan* shop, a road accident, a case of assault. Architecture as just another jaywalker comfortably crossing the road at his own pace, entirely unaware and oblivious to the consequence of his actions or his presence. Just a fleeting disturbance in the life of the road. In the larger culture of the city such architecture is entirely insignificant. Merely a private moment petrified. Usually such architecture exists with a distinct well-defined

12. When ₹20,000 is the average value of one square foot of apartment space in Mumbai, and ₹1 lakh, the cost of the same square foot of land in South Delhi, how do such figures apply to migrant construction labourers, now permanent residents in each of these places? That slums make up over 70% of buildings is hardly a surprise. If the present trend continues then the informal, read slum, component of Delhi and Mumbai is expected to be 90% by 2020. And with increasing scarcities of water, electricity, living space and land the urban divide will make people more miserly and more protective.

boundary within which there is a building, an object of gratification, surrounded by garden and landscape. It's meant only for private viewing, a jewel in a glass case. Other than pleasing its occupant, its owner, its architect, it has no social dimension. It raises no questions about urbanity, or visual import, nothing about the values inherent in its materials, structure and construction, neither does it communicate methods of occupying space, or indeed its place in the community. In the cultural milieu of its surroundings, enclosed by boundary walls, it is entirely irrelevant. An end in itself.

It does however ask one pertinent question: If it is not for public consumption, is it even architecture? Or art? If it qualifies as architecture is it worthy of discussion outside the subjective strain of beauty, design or aesthetics.

The other is an architecture culled from the despairing mess, the gut-wrenching, palpitating putrification of the daily wounds and fissures of survival that make up urban Indian reality.[13] The soiled streetscape, the loosely strung wires across markets, the peeling monsoon stained walls of government housing, the sidewalk-less streets, the overflowing garbage dumps, the plastic bags blowing in the wind, the defecating mass of immigrant life in ancient monuments, French restaurants on Lal Dora land,[14] glass mall lobbies baking in the noonday sun, the broken roads, and sewer pipe houses—the tiresome, demanding, life-sapping, life-enriching, continually unfolding contaminating experience that makes architecture a deeply heartfelt social and cultural call. A call that effectively replaces the professional with homegrown beliefs.

When I was growing up, the city was a different place. I lived in a bungalow spread low along the ground, set back from the road in a private compound. Its garden, faded patches of dry earth, was tended by a slight man on his haunches, forever arranging and rearranging the clods of earth within borders of inclined whitewashed bricks. The house was an inseparable though innocuous presence within the scheme of the garden he tended.[15] Its structure, the yellowing pastel shade of plaster stained by monsoon rain, was shielded by a jaffrey of creepers. In the shadows stood a cream-coloured Ambassador car.

Behind the car porch, there was another green painted jaffrey, fluffed white with jasmine; you could hear the quiet hiss of a summer lawn on a hot day. There was a sameness to things, a kind of colourless homogeneity which made you aware of

13. Three rules of entropy apply to all Indian cities. First, any and every planning model is overturned by an excess of population—housing and public transport, for example, cannot keep up with rising numbers. Second, space is often not legally used for the intention for which it is made—markets become warehouses, houses are used as makeshift factories, sidewalks as temporary homes, parks as toilets. Third, everything decays and falls apart faster than the Mughal monument down the road, an indicator as much of weathering, as of poor construction quality. These unwritten rules make every act of construction redundant before its time; moreover, it helps developers and architects to either build expensive private structures behind high walls, as villas and apartments, or make the kind of buildings that are a temporary defacement of the land, such as government housing, markets and slums.

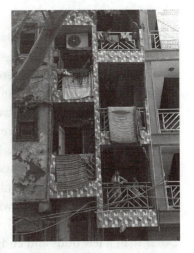

14. Without rule or regulation, Lal Dora is attractive both for landlord and tenant. Balram runs a halwai shop in Khirkee; the four floors above are occupied by a mix of office and home tenants: a graphic design office, a small print workshop, an Afghan refugee family home. The mix and match nature of Lal Dora life is an attractive antidote to a city so painfully regulated and confined to a dismal geometry. In the shadowy lanes of Hauz Khas village, every corner and alleyway is a visually demanding amalgam of a disjointed endless puzzle. A curving line meticulously landscaped with roses as an old Roman alley ends in a smelly urinal, another takes a sharp turn and past an embroidery shop, a hand pump and an Italian restaurant ends abruptly against a blank wall. No explanation, no signboard to indicate how you may proceed. The bewildering array of movement up narrow stairs, through dark passages, under precarious cantilevers makes any transaction in Lal Dora a three-dimensional computer game. Once visiting the third-floor office of an animation company in Shahpur Jat, I was given the following directions: Park your car and take the lane nearest to the garbage dump. Go all the way till you see a left turn into an alley behind the Mother Diary booth, after 100 yards there will be a blind fruit vendor. Stop there, look up and shout my name, someone will come and get you. While much of agricultural land that made up over 75 villages in South Delhi and Gurgaon has been sold to the wealthy for weekend farmhouses, Lal Dora is a bastion now of downmarket and upscale commerce: electrical plumbing fixtures spill out of shops more like godowns, scooter repair happens across from all-glass Adidas and Benetton outlets. While the regulated city is a mess of broken rules, precarious encroachments and a canvas of daily drudgery, the Lal Dora promises a life made of no rules at all. A simplified structure that innovates places for living, work and recreation through a negotiation of organic private space and public facility. There are no controlling regulations, dimensions or set back; no demands on utilities, no proposals for parking, no forced message of neighbourliness, no call for social place or courtyard. Without rules there are no fights for parking, no road rage, no high boundary walls, no grounds, no…. When there are no rules, people make up their own. Perhaps in time the regulated city will learn a thing or two from the Lal Dora life.

15. The story of the bungalow began in colonial India. Muriel Tapworth's life lived in the understated affluence of country estate said all that was dear to the English heart: bone china, sheffied cutlery, gothic windows, baroque furniture, chrysanthemums and peonies in the garden. The tasteful accumulations reflected all the qualities of refinement, taste consequently rank, class, and social position. Within the upper-class walls of her country houses, Muriel had spent her entire life entertaining other Muriels, admiring the design of the tea services and discussing the spacing of the rose bushes. For most of the memsahibs of Devonshire and Surrey, York and Stratford, white ladies of delicate skin and constitution, India was a rude shock. In the flat, dusty plains of Jubbulpore, with its strange brown natives, featureless skies and stifling heat, entertainment of the kind Muriel had practised with Lady Wentworth could hardly be imagined. Pansies would not grow and butlers had no uniforms. Such a hostile environment threatened the very essence of country etiquette, the very

ordinary things and private places.[16] If my sight held a tree in wonder, it was only because the neutrality of things left the senses free to roam and to focus on natural surroundings. Where the differences appeared was in the trees that lined the road, in the perception of patterns in a monsoon sky. The grass, when it was green, was really green, when yellow, it was as good as dead. Sometimes, when I walked on the road after the rain, I saw the grey-blue light reflecting in puddles so shiny they were like broken sheets of plate glass left there on the ground, so that people could notice all the special tints and colours of the sky by just looking at their feet. When old men in dressing gowns came into the park early in the morning to rub their soles in the dewy grass, I knew it was winter.[17]

Other than a few odds and ends, nostalgic reminders of the past are but few these days. Certainly, there is a gratification in the gloom of a Mughal tomb, and pleasure still in the sequence of gardens that surround it. But now the experience tantalizes by contrast. The urban fabric that surrounds the old garden is like a parasitic concrete growth, suffused in its own failures and incapable of providing similar experiences. When the irony strikes, as it does so often now, the Mughal presence becomes a caricature. A whiff of greatness in a choked, doomed place. The past, the history of earlier Delhis, is now enacted not on a living stage but in a frame of stagnation, as an aspect of tourism. Effectively distanced by the people who preserve it into walled enclosures, remembrances of the old architecture are like the scent of a forgotten time still lingering in bed—the caricature of a Mughal time.[18] The cartoon of citizens that now races through the old tomb gardens and abandoned madrassas know all too well the shortening time-frame of their experience. And the ground that may soon disappear from beneath their feet.

The new city is a place of momentary temptation, not of lingering pleasures. There is space in it for the fast food restaurant, but not the scented Mughal garden. The enclosed cinema, the hermetically sealed restaurant, the basement bowling alley, the fluorescent commercial centre, the air-conditioned flat. Quietly, almost without fuss, they have replaced the bungalow, the open arcade of shops, the sunlit sidewalk and the tree-lined avenue, the courtyard and the winter roof terrace.[19]

Delhi's transformation from a pastoral colonial community to a suburban American town has seen many physical changes. Changes that have once and for all transformed a pleasant rural backwater into a pungent, hostile and petrified backwater.[20] The city's provincial attitude and absence of community often strike the visitor as cold-hearted and mongrel. As if in the urge to establish their foothold, the Delhi

Britishness of the British life. But there was no retreat from it. The only answer lay in creating little Englands, where all the aspects of the finer culture could be preserved, protected and practised. And so came the bungalows—English country houses indigenized to suit the local climate, low oblong buildings that hugged the ground and spread their wings and galleries and loggias into an extensive lawn. They stood apart, away from the street, in walled compounds marked by pompous gate posts, and wrapping extensive verandahs around the periphery. Spacious airy rooms, shaded windows, and skylights under high roofs. The bungalow spoke only the quiet language of western classicism.

16. For me the significant qualifiers of places are personal associations. The longstanding reminders of childhood, the old houses, landmarks, the unchanging features of a city landscape. Without these, every city is no-man's land. A drive-in cinema, enthralling for a while but giving nothing of itself in a sustained way. The Hanging Gardens and the Towers of Silence in Mumbai, India Gate and Lodi Gardens in Delhi, the Lucknow Residency, are the unchanging public landmarks that only provide history and orientation to the places; but private lives are sustained by private places; a tomb in a Delhi colony, familiar church steps off a Kolkata street, a Parsi garden within a dense cluster of Bombay highrises. There, amongst the old fallen stones, a collapsed arch or a forlorn scent, the city becomes real. Against the backdrop of these places, even its daily indignities and hardships are forgotten.

17. The old ways of Delhi emerge in winter, among an older set who have made the city their domain over many generations, the urban sophisticate, that specially chosen breed of landed gents and ladies who set the tone and manner of life for others. They move about in quiet harmony and elegance through carefully tended patches of pansies and gladiolus, sipping Campari or carrot juice, thinking of autumn fashions and delicate handlooms, attending book launches, and trying hard to enjoy a monsoon Qawwali concert, sweating away on the lawns of Humayun's Tomb yelling Wah Wah. They live on Prithviraj Road and Jor Bagh and Sundar Nagar and think that the city boundary ends at Lodi Road. Theirs is a lifestyle of infinite charm, almost a classical sobriety. When life began for them, they realized they had to go to the right school and college, appreciate the right kind of flower shows, join the right clubs, get the right jobs. Life is for form's sake. Appreciation and taste are the two things that mattered. You were meant to like Pandit Jasraj but not Lata Mangeshkar; you were more inclined to play golf than listen to the cricket commentary; your intuitive knowledge of handwoven fabrics had to overcome your longing for synthetics. But these are small things, and with money having been already successfully earned and invested by forgotten generations, there is all the time in the world to enrich your tastes.

18. When I was growing up, Mughal Delhi was always a discovery. The pathways to Humayun's Tomb and Mehrauli and Tughlaqabad were littered with thick forest, the kind now found only in Borneo. You risked your life and limb to cut through the scrub and snake pits to discover, after hours of hacking and cuts and bruises, that you were face to face with the tomb of a Mughal Emperor called Humayun, feeling like a true explorer that you were the first to discover his existence… only to find a group of American hippies sitting around the grave, smoking.

19. The city lived in a perennial wonder of uncontestable discoveries. Its eternally quiet character, peaceful and provincial was the mark of a place too shy to come out into the open. It hid behind shrubbery of Neem and Amaltas; it lay low in the green grass, never raising his head; it stuck to a monochromatic vision of itself. And it slept through most of the day.

resident's only interest is self-perpetuation. With a view to demarcation of social status and territory, his first and foremost urban act is land acquisition and building. So uneasy is the owner in a situation of shared living, the first instinct is always protectionist: electrified fence, high boundary walls, German shepherds, Haryanvi guards and threatening signs: Private Parking. Tyres will be deflated. A shotgun lies in the study drawer, just in case. To the outsider the city of inequities has the look of warring tribes of disgruntled people in private encampments: rich vs. poor, poor vs. even poorer.[21]

The transitory quality of the Indian city ensures that private ideals remain entirely hidden behind walls while its public attitude displays only incompleteness and incoherence.[22] One time perhaps, there was a city structure assembled on the ground. It was based on a germinated plan, and the belief that people had come to live together for a reason. Whatever that reason, their presence required a framework, a geometric cohesion that set a comprehensive structure to their lives. A plan that influenced their work, their play, their very movement in the city.[23] But the history of that cohesion has now sunk below the surface and though there remains a lingering sense of its once complete picture, newer, more seductive smells are floating across the old submerged foundations.

The new city quickly enveloped the old with its fancier forms. The green disappeared under the concrete car park, the house erupted into apartments, the city's familiar stone archaeology submerged under the restless march of commerce: the Digjam ad, the black Contessa, the gold-bordered Kleenex box on the dashboard, towelled seats, J and B whisky, CD players, double door frost-free Kelvinators, Reebok running shoes, microwave ovens, Astroturf, 30+ stress tablets, Reliance shares, Aquaguard water filters, Times Square bars, time-share resorts, solar panels and judicial panels, AC plants and rubber plants. Malibu Towne and Beverly Park, Renaissance villas and mud hovels, data banks and Swiss banks…. These were the tangible background to my new existence.

The place changed beyond recognition. Much of what existed around, much of what constituted the places I inhabited was new. Every place was marked by sudden and bewildering hyperactivity; over the telephone, on television, in the newspaper, on the movie billboard, was the urgency of a paranoiac expression. The pink made-up face radiating the sexual energy of a new skin cream, mobile phones that interrupted your golf game, houses that spoke the language of Spain and California, airports on

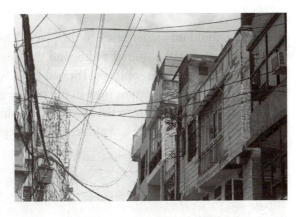

If you cycled through Connaught Place in the 1960s, it was a journey through a ghost town. The encircling colonnades were starkly shaded and R K Stationers, with a half-open shutter would let you know that if you had the money they would transact a deal for a pencil. But rarely did a car whisk by. You could stop your cycle in the middle of the road and without dismounting, have a quiet pee, knowing full well you were in the midst of the city's most solitary and remote place. If anyone was around they too were probably having a pee against a Connaught Place column.

20. In the natural human urge for misery, the Indian city provides enough sustenance. It is ugly when compared to London; poorer when compared with Dhaka; unhealthier than Lahore; more crowded than Lagos, more miserly, polluted, selfish and uncouth than crime-infested Bogota. Amongst its sister cities in South Asia, Delhi, Gurgaon and Mumbai, are often used in case studies for what not to do in governance, urban policy and public health. A few years ago, an American filmmaker, looking for footage of war-torn Iraq, shot scenes in Kanpur to get a similar atmosphere.

21. An examination of civic infrastructure will reveal that a mere 28% of the city population uses almost 80% of the public facilities in the city. Roads, subways, housing, malls, markets, offices, parks, museums, virtually every aspect of the city has a sizeable middle-class component. Consequently, the middle class also contributes the larger quantum of waste: home garbage, raw sewage, air pollution, commercial and industrial waste.

22. Some years back, an uncle of mine on a visit from Canada fell into an open manhole in South Delhi. He had merely stepped out of the house for a walk before dinner but returned eleven hours later in the morning when a passerby heard his shouts, and he was rescued. Had the incident happened in his hometown of Toronto, he would have sued the city authorities for a million dollars. Or so he said. Despite the tragic accident, he was lucky to have escaped with only minor injuries, and luckier still that someone else hadn't fallen in on top of him. The next day's newspaper carried stories of three separate manhole accidents. It need hardly be said that the Indian city is a minefield of disasters waiting to happen. The collapse of buildings in Mumbai, flooded streets in Kolkata, garbage explosions in Delhi are all part of a hidden gameplan of civic tragedies that occur with such regularity that they no longer surprise the long-time resident.

23. When Sir Edwin Lutyens drew the radial lines on his drawing board for that residential enclave to be lovingly called Lutyens Delhi, little did he think that the bungalow would become the most sought-after stereotype in Indian domestic architecture. However, the new residents of 'Lutyens Zone' do not find the bungalow an easy adaptation. Armed with numerous black commandoes and a retinue of hangers-on most houses have had a make-over. Anterooms and side wings added verandahs enclosed, to allow the old houses to retain little of the original. Changing attitudes to privacy and the public nature of Indian political life made the alterations necessary. And yet, the real value has remained in the real estate itself. Four acres of open space when land cost is one of the highest in the world, the urgency of appropriating public land for a private trust is still the most lucrative—a legitimate form of real estate speculation. And every minister worth his politics will stake a claim with duly nationalistic declarations: my father was a freedom fighter, my father was killed at Jallianwala Bagh.

steroids.[24] I could no longer relate to the places I lived in, to the people and signals around. The road had acquired width, and the sidewalk, a fresh coat of whitewash, a new row of eucalyptus saplings. The old trees were no longer noticeable in the park, but the chrysanthemums were in full bloom on the farm. The sacred river was an industrial drain, sucking in the effluents, washing away the sins of its polluters. I was merely propelled easily and aimlessly into its gentle stream of decay.

24. The new Terminal 3 in Delhi is cited as the eighth largest in the world and comes loaded with enthralling statistics: a floor area of over six million square feet, the equivalent of twenty malls, 92 automatic walkways, 78 aerobridges, and 168 check-in counters. In every respect the building recalls all the high-tech skills of construction and automation, and customer satisfying conveniences that say that the building belongs to the new century. Certainly, the successful completion of a large and complex structure like an airport is to be commended. Just the feasibility of a functioning airport at such a monumental scale is no easy task. And in a country where efficiency is a prized and rare commodity the terminal doubtless makes a significant contribution. But is the satisfaction of statistical demands the only way to go? If the prime minister were proud of the airport as the gateway to a new global India, as he said at its inauguration, he is only crediting the many international companies now working in the country for making India appear more efficient, more competent, more capable... more, well, like everyone else. That Indian ideas have an equally useful place in the globalized world, may perhaps find due recognition outside India in the near future.

3. Public Architecture

When questioned about the cultural and technological stagnation that came with socialism, a bureaucrat in Nehru's time once remarked that all the best work had already been done in the West, and we merely had to pick ideas for our own use. At a time when Indian inventiveness and productivity were state controlled and highly suspect, borrowing made a lot of sense.

Sadly, even in today's era of open economic borders, we still remain unconvinced that the Indian mind is capable of producing anything of real value.[1] Foreign technology and inventiveness on Indian soil is certainly revolutionary, especially in a country that has had a long history of direct imitation and mimicry. In the 1950s when the British discarded the Morris Minor and Landmaster models, we bought the dyes and began producing the Ambassador, India's wholly indigenous car. Later in the 1970s it became a matter of Punjabi pride that the world's most successful innovations could be copied in Ludhiana. Grimy workshops filled with labour were kept busy producing German machine parts, American denim, and other sundry items picked up in European markets. Indian businessmen travelled abroad to European industrial fairs and American specialty stores, merely to buy items that could be duplicated in India at a fifth of the cost. Anything the world could do we could do, if a little worse. Today things remain much the same, only the scale of the borrowing has changed; as an open society we need no longer secretly copy and produce but invite the original inventors to participate in a global bid.

While many of the new projects, airports, stadiums and metro stations, provide a sparkle and glitter to the dusty ramshackle grime of the Indian city, they remain foreign implants, silent spaceships sent by self-absorbed cultures. Faced with situations and conditions that are uniquely Indian, new formulas were quickly adopted. Though none among the new buildings seek Indian resolutions or make any concessions to the way Indians treat their buildings. Designed neither for the unforgiving landscape, nor the general misuse of public facilities expected in India, their long-term usefulness is suspect.

Above the rough woolly green of Delhi, Bangalore and Hyderabad, amongst the numerous commercial highrises that stick out of the shrubbery, are the more recent additions to the cityscape, the glass malls, stadiums and office towers. They stand

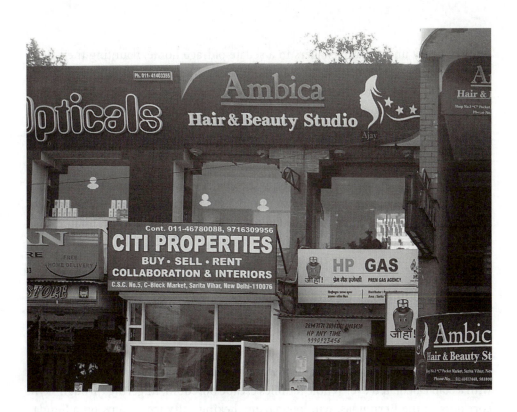

1. The Indian city is unfortunately a sad and mismatched combination of a rural culture trying hard to mimic a foreign cosmopolitan culture. The possibility of the two coming together just doesn't exist and shouldn't even be tried.

out like pesky underclad teenagers in a sedate old-age home, flaunting their new-ness in a profane exhibitionist sort of way. With a glint of steel, and shine on reflec-tive glass, they throw out their seductive glances at a public too long used to brown, mud-spattered walls, and so induce a new sense of pride and ownership. We are, as politicians remind their subjects regularly, as good as them even if our lives are ingrained in old habits.

The Indian city's shamelessly brazen quest to be considered on par with London, New York and Shanghai is not just an immodest hallucination but has been effec-tively thwarted by administrative bungling, and the mistaken belief that a city's international stature is created by a few glittering sights.[2] In the shift from the rooted colonial bungalow set firmly in a garden landscape to a steel and glass building set equally firmly in a black top parking lot, the city's agrarian roots are convulsing and choking. As if in the absence of an urban storyline the city can thrive if it adopts the light-hearted theme of the amusement park, a magical world of glitter, with the make-believe vision of belonging nowhere and everywhere, to London, Rio or New York. Yet the despair of Indian street life, turns every building inward into skylight atriums, fortified and air-conditioned with the belief that the wretched are shut out with a cold calculated eye. Whole families escape boredom, lingering through skylit corridors in the Bermudas, window-gazing, licking softy ice-creams on a Sunday afternoon. Time pass, the critical measure of the life of people with no public life or private interests. Within the mesmerizing gaze of new products, architecture hardly matters.

Designed by foreign architects, using foreign materials and foreign design ideas, any architecture is acceptable. New airports, refurbished railway stations, stadiums and barrel-roofed metro stations have cut an improbable swathe through the old neighbourhoods with new approaches and signage.[3] If once architecture was a log-ical pattern of space and organization, it now manifests in a kind of contradictory chaos that relies solely on international technique. In malls, and airports and office towers, it has to provide answers to the millions of its differently evolving users, and indicate a quick route to changing potential realities. The push towards greater levels of grandeur, more daring structural forms, and yet more devious combinations of material and colour, leave the visitor staring up in disbelief and wonder. And with a new-found smugness: Yes, we are after all better than animals. And even though our buildings change quickly they are still the true measure of our great civilization.

Hard-pressed though we are to find symbols of the new India, the new terminal, its import of foreign designs, foreign materials, construction technology, and foreign

भारत सरकार

GOVT. OF INDIA
DL 3C V 8841

2. Yet despite their brazen newness, they are barely adequate for current needs. Beijing air-port by contrast, has more floor space than Heathrow. Even though presently, Chinese air travel demand is low, it has been designed for the next quarter of a century of air travel. By increasing speeds over 400 kmph, Chinese trains deliver more passengers in shorter time spans over greater distances. Two thousand kilometres of track were laid to connect Tibet with the mainland, something that required construction at 15,000 feet-high mountain terrain. By contrast, our Kalka-Shimla line built over a century ago is considered both an engineering marvel as well as a heritage masterpiece. Certainly, it is both, but by denying the great possibilities of invention and ideas to its many transport problems, India remains an unfortunate bystander.

3. On the road to the airport is a sign for the Indira Gandhi International Airport Domestic Terminal (sic). Should there then also be an Inter-State Bus Terminal for local buses? The city is filled with meaningless signage that conveys little but looks self-important enough to suggest that Delhi is a world-class city.

supervisory work force, does little to promote India and Indian ideas. Does then the environment of India endorse the identity of a young nation, and an old culture? Does architecture have a place in the collective identity of a people? Do buildings have a stake in fortifying our self-worth?[4]

In an age of mimic styles, of instant acceptance, boredom and rejection, little effort is spent in making public structures memorable—places characteristic of local situations and resources. If a particular bridge design has worked successfully once, it will be repeated across every culvert, every ravine and riverbed in the country, regardless of size or location, till everything looks the same. If anything comes to mind as an icon for the Indian city, it is the acres of housing projects, self-financing schemes, decaying, peeling, chipped and stained, yellow citadels that stretch indefinitely on undeveloped wasteland to the far horizon. With the diversity of urban life they generate, it is they that define the new public face of India. And it is they that will remain in memory.

In part, the perception stems from the disjointed nature of the cityscape, built into its unfortunate development as a plotted town. Each site demonstrates its own frills and thrills, surrounded by boundary walls, and forming no links with its neighbour or the street. In such a scheme, the diversity of individual expressions when seen collectively in the cityscape produce only a monotonous incoherence, a tiring jaded ugliness. Private colonies with personal ideals of space and style, public housing with endless repeat of numbers, and a desperation to personalize the repetition.

Some years ago, I attempted to capture something of this perennially changing cityscape by photographing one building, from one spot, at monthly intervals for a period of three years. I figured that if that transitory urban state reveals itself, it will do so best in the steady and structured sequences of time lapse still photography: 36 frames that record the birth, growth, decline, death and rebirth of a single piece of the cityscape.

The building was a set of government flats near my own house. With the clinical detachment of a scientist, I found the same spot on the sidewalk on the 1st of every month and directed the camera to precisely the same angle for the photograph. When viewed as a sequence after three years, the building rose out of the ground, then its brickness was plastered, it was painted, people moved in, flower pots appeared on the balconies, and blouses and underwear dried on terraces. Later, cracks appeared on the walls, monsoon stained them black, and a Peepul began to grow in the crevices. I knew nothing of the people behind the façade, but the act of

4. *Dear Madam Prime Minister: I am writing to you from my small illegally constructed office in Gurgaon, on the first floor directly above a noisy printing press. I have to keep my window closed because of the stench from the garbage dump below and urinal near the back stairs. As you may have guessed, the letter is about the sheer desperate ugliness of the cities we inhabit. And how our urban population is in a daily war with civic problems, water supply, electricity, school admissions, crime dealing with government departments, missing sidewalks, broken roads, deteriorating air, the downhill spiral is visible in all aspects of the city. Unfortunately, when you drive in your motorcade and see the wide expanse of open landscaped road, I am sure you wonder why people complain. But madam, the truth is that my motorcade of one car gets stuck in traffic and gives me a lot of time to look, and wonder why we must live with overflowing garbage, poor drainage, road rage, water wars, and shrinking space and a life filled with daily uncertainty. Do you wonder then madam why people in our cities are so sluggish, shambling, defeated and generally unhappy and dissatisfied? Surely it must be something to do with the implicit mistrust and the need to fight daily for water and parking. Is it a wonder then that people shoot their neighbour for a parking space, or you must drive twenty miles to get to work? The sheer ugliness of urban life demands a change. Obviously your sudden elevation to national public life will doubtless involve you in more serious political matters, and this late stage of India's urban crisis, you would be hardly in a position to take on the serious challenges of resurrecting Delhi, Mumbai, Bangalore and other established cities from the blight and chaos that engulfs them. They have all seen their glory days and it would be the best. You direct your energies to the many new cities planned for the future, the satellite towns, the industrial corridors, and the infrastructure of public buildings, schools, bridges, hospital etc.... I need hardly remind you Madam Prime Minister of our apocalyptic urban demographics and the daily population surge from the countryside, the unquenchable demands for energy, power, the search for new solutions for urban life. Home, electricity, transport, fuel will obviously be a priority with your government. However I think it is already abundantly clear that conventional methods of tackling these have resulted in failures. The people are too numerous, their demands too exacting, the only answer lies in writing fresh guidelines for yet unmade places, ideas that move away from the current conventions altogether. First and foremost the new city offers no form of private ownership. No home to be bought, only places on lease, built in a public-private partnership, where lower income housing is more public, the higher end, more private. The new city allows no attachment to home, or the idea of family ownership to be handed down to succeeding generations. Temporary biodegradable or dismantlable housing, may also be considered. Secondly, without roads and cars the city gains almost a third of urban area, which allows for healthier greener neighborhoods where home, office, recreation, commerce are easily accessible through pedestrian lanes. Thirdly, the design of buildings must take into account both the unexplored underground and the great arc of sky. We have for too long been a cautiously terrestrial people, clinging to the ground surface like insects. The natural insulation below ground and the unhindered vertical heights, if constructively used, can free up enormous space for homes, vertical gardens, institutes and industry. I ask you, Madam Prime Minister, to please trash building codes, zoning laws and floor area ratios, and begin again. Fourthly, in matters of building we live within a stranglehold of conservatism; unable to believe that*

40

recording an occupied structure with a continually changing public face gave me a brief insight into collective living. The building was like the private car in a public parking lot. It revealed the furry dashboard, the miniature Ganesh above the speed dials, the yellow plastic seat covers and the aluminium hubcaps. I saw the changes that came over individual balconies; some were made into utilitarian spaces, some, tiny gardens hanging in mid block, some enclosed entirely. But the compositional alteration affected the whole façade; and I saw the changing environment of people's lives 11 in frames when viewed as a rush of playing cards. A 10-second film.

The public reading of cities is in fact most visible in private townscape. Once, on a trip to Rishikesh when I looked across the river bank, two views of the place were firmly etched in the skyline. On one side, I could glimpse Hinduism's benign skyline—a line of ghats lapping the river edge: mouldy temple silhouettes and repeating ashram windows set in whitewashed walls lining the streets. A simple life of religion expressed simply.[5] But on the side where I stood, the city gave a more distressing contemporary view. Along the main highway lay the standard North Indian town: pink and yellow plastered buildings, incomplete pastel-shaded structures stained by monsoon, and *paan* and urine stains at the base with signs of commerce at the top.

Like so much of the new architecture, jewels of thrift and austere beauty they were not. Pepsi signs, AC shopping arcades and hotels of Rajasthani sandstone, each with tinted windows curled at the edges giving that desperate design twist to its façade, that mild turn of architectural phrase, just to let people know that this was the Mughal Ganga Hotel, more beautiful than the Krishna Palace Lodge down the road. Each came with bar and open-air restaurant. Each with the special river view. Each trying to outdo the other in design, colour, detail and advertising gimmickry. A monetized world of amenity. Meanwhile, on the opposite bank, the old stood, a mute and saddened observer of the shifting architectural tide.

Should architecture, like other aspects of popular culture, reflect something of the taste and conditions of the present? If there was a professed spatial, humanist or aesthetic purpose to architecture it was difficult to experience it in the reality of the city. On paper, architecture is that wonderful making of spaces, that sculptural massing of forms brought together in light. But the city displays nothing of that. What is noticeable is but a dreary mass of broken and smudged plaster. There is no remembrance of landmarks, no encounter with history, no care for monuments.[6] No cause for celebration.

As a student in America years ago, I lived in a low-rise of row houses lining a narrow Philadelphia street. Along the street were two small restaurants, a pharmacy, a

anything that has not been built and tested elsewhere isn't worth doing. In a booming construction market and a future surge of infrastructure projects, the prescription calls for a broad unhindered imagination and an embrace of new technology. In the long run this would open up the building profession to new ideas rather than the present invitation of Western imaginary. Finally, and of paramount importance, is the psychological life of the resident. Beyond the essentials of the physical infrastructure and the necessity of schools and bridges etc., the shameful lack of public life in the Indian city calls for a serious realignment of public expenditure. I draw your attention, madam, to the minor public colonial gesture in Nainital where a pedestrian boardwalk was built at the edge of the lake along which were situated a library, a meeting hall, a boat club—all considered inessentials to city life. But I ask you, Madam, aren't these too critical to human development? Wouldn't the placement of libraries, meeting grounds, shaded water gardens, or courtyards be an asset to any city? Madam Prime Minister, India is at the crossroads of a major decision, to enter the world market as a shameless imitator of China and the world; competing on expanding highways, ports, and making highrises out of cities, like Shanghai and Dubai. Or it closes a path of serious local discovery and directs its energies to a more imaginative development inclusive, absorbing technology and forging an altogether new future. Yours sincerely, Mohan Lal

5. Close to a tourist taxi stand in suburban Saharanpur, there lived a man of the cloth, a sanyasi called David Yadav. David had chosen this particular profession out of ancestral duty rather than any internal drive to promote religious wellbeing. He was not, shall we say, big on commitment. Sure, he liked preaching, but only theoretically. If he'd had his way, he would have found some more lucrative method to perpetuate life's ideals. And he did. One day, sensing that the ceremonial side of Hindu life, things like birth, marriage and death, could yield quick monetary rewards, he discarded his export-surplus clothes and donned some white homespun; then he tied a black string around his waist, smeared some ash across his forehead, and changed his name to Dev Sharma. With his new name, he also acquired the natural flair of the pundit, the uncanny ability to take ordinary ideas and place them in a completely incoherent religious perspective. In a country where children were being produced at an alarming rate (people got married in childhood and died young), this was an important skill. So, he placed an ad in the Saharanpur Tribune, outlining the list of religious services offered at throwaway prices. Then he got some visiting cards printed. And waited. They came. Slowly at first, but they came. Harbouring notions of their own inferiority and social worthlessness, they came right up to Dev Sharma's threshold, and emptied their purses before the smug priest. Some presented him with finely woven garments; some gave him small automobiles with power steering; some brought titles to small land holdings. Very soon he realized he was amassing wealth at an alarming rate. So, he invested in a small stone shrine at the edge of a municipal park. Then when money and influence grew, he had the park paved into a parking lot for his wealthier car-owning followers, and hastily erected a brick temple, an elegant marble structure with a full basement and additional underground car parking. As a normal middle-of-the-road guy with few wants, he

provisions store, a coffee shop and a bar. I lived upstairs from one of the restaurants. On summer days on my way to college I walked through a neighbourhood park. In the evening the restaurant often became my living room. In a regular exchange with its stores, bars, restaurants and parks, I derived a direct benefit from the neighbour-hood. The pleasures of this personal urban landscape—in which divergent occupa-tions, residence and leisure occurred side by side—made the neighbourhood truly mixed-use in character.[7]

Sadly, the application of an urban graciousness to daily actions is the hallmark of cultures that seek sensory appeal in ordinary life. Planter boxes along a Dutch street are maintained by private homes and are often not even visible to the owners, but are appreciated by people on the street. In Bologna, houses along busy streets build arcades for pedestrians, an idea that wasn't dictated by ordinance, but merely grew out of a desire to provide shade.

As a culture we remain entirely oblivious to any such form of spontaneous visual action. A Delhi flower-seller provides an array of colors—tulips from Holland, purple gladioli from the Himachal, white hibiscus from Bangalore, all seeded and grafted from the worlds' most delicate hybrids. But the sale occurs against the stench-filled wall of a suburban market's urinal. Aspects of beauty mingle freely with waste and decay. It strikes neither the middle-class housewife buying flowers for the *puja* room, nor the shop owner using the urinal, that the proximity of their actions 'contaminates' the other. The refusal to acknowledge the difference between conflicting scenes is a form of cultural myopia hard to comprehend.

For all its large-scale projects and grandiose plans, the Indian city offers no selfless acts of generosity or gifts to the spirit. No surprise gardens hidden behind walls, no water courses or arcades built for no reason at all. No maze where citizens can lose themselves. No urban recognition of seasonal variations, no monsoon greens or summer gardens. Conferring a sense of positive identification with a place is a difficult burden left to the old architecture: the ashrams of Rishikesh, the ghats of Vrindavan, the mosques of Delhi—buildings that not only make up our imagined world, but create the placeness necessary, the history we need for ourselves.

wished only to convey to his followers the simple truth of his austere existence. So, he had the temple floor redone in maroon granite, and the area centrally air-conditioned (a fan coil unit was cleverly concealed inside the Shivling). The old stone benches in the mandapam were replaced by multicoloured plastic furniture, and a made-to-order American shag rug carpeted the adjoining yoga and meditation complex. On the gate outside he put up a board: Vishva Dharma Ashram (Non-profit Voluntary Organization). Having become a sucker for utopian ideals, Dev even had a Macintosh set up in the rear of the sanctum sanctorum, just so he could catch the religious vibes on the Internet. Then, one day, out of the temple's renovation fund he bought some new software, and put his sermons on CD Rom. That way, instead of personally dispensing the divine word he could simply plug in the Spiritual Software Kit, and head out for a game of squash. But the money still wouldn't stop. And Dev was forced to look beyond the temple complex. He invested in a locker at the local nationalized bank. When that little compartment got filled, he got himself a Savings Account and a range of credit cards. Later, unable to stem the tide of increasing resources, he set up a trust fund with himself as the chairperson and prime beneficiary. Just to be on the safe side he kept a purse with all his paper holdings under his armpit, removing it only for the early morning deodorant spray. But the money just wouldn't stop. So, he bought shares in Defiance Petrochemical Company. Finally, he bought the company and its extremely irritated managing director. He was now, according to Fortuner *magazine, one of the 10 richest swamis in Saharanpur.*

6. In the 1980s, a proposal to refurbish the much-revered statue of William Penn in downtown Philadelphia was put forth by the Philadelphia Arts Commission. The city government accepted the proposal, and soon enough, Penn's stone figure was surrounded by scaffolding and woodwork. A few years later, when no work had been done, and the scaffolding itself had begun to fall apart, someone suggested that funds be allocated for the refurbishment of the scaffolding. That is the way of most public monuments in India.

7. There are no real cities in India, where people genuinely share urban values and culture. Most of our cities are dense villages that come together only to partake of municipal services like water, electricity and roads. The binding factor is still the family, caste and community—these don't make a city.

4. Architecture Definitions

'A cowshed is building,' said Nicholas Pevsner, 'Lincoln cathedral is architecture.' It was a statement that encapsulated one of the most important arguments in the profession. In the twentieth century when more architecture was made by builders, it became important for architects to make this distinction. A new breed of boorish, fast-talking men in shiny business suits had appeared on the architectural scene and had cast a spell of gloom on the lives of those finely dressed professional gentlemen by talking of the glass box instead of the Elizabethan and Georgian periods without the slightest prompting.[1] To say that a cowshed is a building and Lincoln Cathedral, architecture, was all very well for those involved in the making of Lincoln Cathedral, but for most people in the construction trade it was tantamount to admitting that architecture was a trade and not an art. When the professional could willingly admit that he was no longer responsible for the environment of buildings it was time to restate the specialized intellectually invigorating nature of the art. Architecture was for the big buildings, said the architect, those not burdened by utility or life's niggling necessities. And even though he sounded much like a doctor forsaking medical responsibility during a particularly fearful plague epidemic, the architect and his historian were perfectly happy to retreat. Moreover, in an age of unemployment when cowsheds were being made by people who were conditioned to making only cathedrals, the statement too, seemed to have lost some of its previous artistic edge. But except for builders, the difference between architecture and building is a distinction the world has slowly come to appreciate, even in India.

A house that doesn't leak, where the plaster doesn't chip, or the structure collapse, is a building; a house with French windows opening into the North Indian sun, with a central air conditioning plant and wall-to-wall parquet flooring that is replaced every year, is architecture. A slum colony is a building; a housing colony is architecture. An office complex with cross-ventilation and shaded walls with an elevator that works is a building; an office complex with imitation Egyptian columns and repeating square windows sealed to the outside is architecture. And the list goes on. A mud house in Rajasthan is a building; a marble house in Greater Kailash architecture. A set of barracks built by the Central Public Works Department (CPWD) is a building; a set of barracks designed by them is architecture. A flat in Lokhandwala Estates in Mumbai is a building; Lokhandwala Estates is architecture. Only the architect knows the difference. And it is best he keeps it that way.

Firmness, commodiousness and delight may have at one time been the valid determinants of architecture, but in an age of rapid change and planned obsolescence,

1. The concept of the glass box was as unique as the concept of the box, four walls joined together in a rectangular configuration sitting on a rectangular base and supporting a rectangular lid. The difference between the two was mere visibility. The utter simplicity and monastic frugality of the idea was enough to make it the very essence of all the world's greatest architecture. Ludwig called it 'rectilinear space'. Le Corbusier called it 'the sculptural massing of pre forms'. Years later Robert Venturi used terms like 'decorated shed' while referring to it. And Philip Johnson was hardly one to dismiss its 'in'significance. The box was here to stay, like it or not. He shed its opaque skin altogether and revealed the explicit nothingness of architecture.

instant acceptance, instant boredom and instant rejection, it is difficult to say if the same holds true any more. If the spirit has gone out of architecture, it is because the architect is no longer responsible for the shape of his buildings. That is determined by the petty businessman who has sunk a lifetime's savings into his dream house, by hoarders and racketeers whose black money finds an architectural outlet in expensive materials put together in outlandish ways. Architecture is to be seen in the awesome edifices of public sector buildings, in the design of capital complexes and private apartment complexes, and in the visible simplification of structures called 'modern'.[2] In the rest, which constitutes almost 90% of building, architecture is nowhere to be seen. For you and me and a billion Indians living in mean, cramped self-financing schemes, in squatter settlements or in rural huts, shopping in grim municipal marketplaces, strolling in desolate parks, and sending children to cardboard box public schools, architecture can go hang.

What really is the purpose of architecture in such a place? Architects will perhaps disagree, but to my mind, architecture exists only to provide meaningful occupation to architects. While most people are busy threshing wheat, administering medicine or building bridges, architects earn a more meaningful life so they can raise a family in a decent neighbourhood of the city, to watch satellite television, eat out occasionally in non-vegetarian restaurants and go on a yearly vacation to the hills. This is the real god-given purpose of architecture.[3] Architecture has nothing to do with providing solutions to the shelter needs of the country or making the city a better place to live in. Nothing whatsoever to do with making buildings suitable for habitation, nothing to do with light, air, sun, and texture, or worrying about depleting resources. Contrary to what architects think, architecture has no moral purpose, no sense of public responsibility. It is merely a hot water bottle, serving to keep the bed warm at night. It has no use in the morning.

In India, architecture has become a simple, almost subconscious process. It begins with a simple plot of land. If it has any local features like extrusions or rocky outcrops that give it a uniqueness, they are removed; old, life-giving trees are cut and eucalyptus saplings planted in neat rows, boundaries are drawn and an enclosing wall built. The architect, whether private practitioner or government employee, pulls out old drawings, erases the titles and reissues them for a new housing project. The local building authority approves the blueprints for a small sanction fee above the table, a large one under it. Tenders are floated. The building contractor promises the architect a 6% kickback if he is given the job, an additional 10% commission if he is also given a free hand in controlling its quality. The architect, of course, has been hired by the client because he has agreed to do the work free.

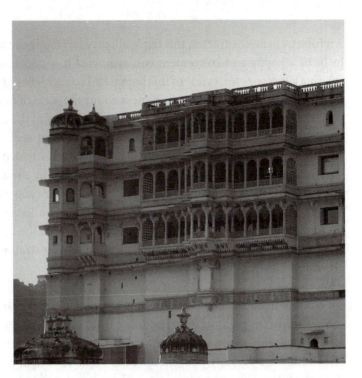

2. The story of Modern Architecture began in the house of a Swiss watchmaker in 1887. When a son was born to him that year, little did the proud father imagine that the young tyke was headed for greatness. Naturally, like any father, he thought his son could join him in his family's successful watchmaking business. But that was not to be. And 35 years later, the younger Jeanneret not only moved out of the house, but even out of the country, to which he was born. Just to get away from a family business he despised. In a small studio in Paris he began to paint furiously. Not intricately tedious watch dials with Roman numerals, but the larger canvases of an artist. But for an up and coming painter, Jeanneret was a name that gave away his provincial beginnings. He was now an artist in Paris. He need a name with a certain charismatic flair, so he opted for the more urbane Le Corbusier, and had it registered at the local Patents office. Some decades ago, on 27 August 1965, this slight man swam out into the sea off Cap Martin in Southern France, never to return again. He carried with him the consciousness of a modern generation of architects, based on an ideology of his own making; he carried with him the blueprint of numerous unbuilt projects, ideas for cities, paintings and sculpture which were to remain in his head. It was a death that was said to have occurred by drowning, but nobody was convinced of this. The simple and decisive manner in which he swam out, the circumstances of a morning dip in the ocean turning tragic made his departure all the more dramatic. Out of such a mind the Chandigarh plan had emerged. It was the work of an artist, and it was as inflexible, authoritative and perfect as the man who decided to swim out with a smile on his face, never to return again.

3. A building's depiction of natural law, as visible sensation is in fact the unwritten requirement of architecture. The architect can be forgiven for leaks in the roof or cracks in the wall, but never for denying its residents and visitors the expectation of physical phenomena. Stand in the colonnaded cloister of a medieval stone abbey in Southern France and watch the columns absorb the sunlight in such a way that the time of day can be read in shadow. When there is no discernible divide between light, twilight and darkness, the gradual diminishing of one into the other causes a visual reverberation in all it touches. Inside and out, surfaces change, floor patterns come alive, then fade and die, day disappears into

Architect, client, contractor, this triple alliance has made the practice of architecture in India a happy and convenient compromise.[4] It is necessary to look beyond the existing cityscapes for a view of this happy and convenient partnership. Architecture all around speaks with direct frankness about the state of building and the profession, the workmanship of the contractor, the integrity of the client, even the creative energy of the architect. But the conventional view of such enterprise is one that alters the physical environment in such radical ways that places lose their genial familiarity and recognition. Progress is implemented by a man who is a developer, a private individual or organization supported by the local government in matters of procuring land and services. For him the idea is to build at a pace in keeping with the statistical goals of national policy. And to bring to the building art, the efficacy of a business model, along with all the accompanying strains of cost over-runs and profit margins.

All around, there is a slow demographic explosion in progress, an unknown, anonymous mass of people is shifting residence from village to town. A more easily identifiable type is moving from town to suburb. Twenty million need to be housed while one million are actually housed. Space is required. There is little need to preserve the city centre or the historic quarter. There is no need to be sentimental about history, no need to save monuments to dead Mughals when urban land is so precious, so rare, so valuable. Change is necessary, change is desirable, change is profitable. The old is demolished to make place for bigger, more efficient, more marketable ventures. The motor car and the highrise flat disrupt the established patterns of the city, cutting open chasms into traditional cores and neighbourhoods, opening up sites for development and widening roadways. Luxury apartments are built in the central neighbourhoods of the town. In place of the bungalow, the owners must make do with a small parcel of air space on the fourteenth floor. Housing for lower income families appears beyond the suburbs, in places where land is cheaper, the commute longer. But the trains are equipped with card tables. Personal food packets will follow them on the same line, whatever the distance. Vast residential tracts can be made with greater profits and newer marketing strategies.

The architect, both participant and victim, moves hesitantly, happy to share in the money-making, moving at times to the sidelines, unable to reconcile to an urban destitution of his own making. In the new reality of destructive production, he acknowledges architecture as a marginal activity. The sounds of industry and progress and its accompanying qualification of life leaves him confused. There is a feeling of historic loss; there is a loss of culture, a degradation of personal identity and he senses within him the strident conflict between a self-taught humanism and the

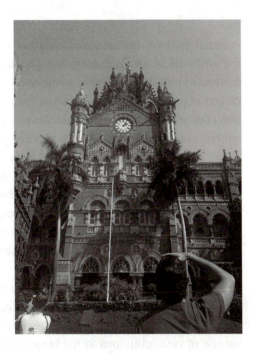

dusk, the outer profile turns from shadow to silhouette to black. The prolific variation of light, itself becomes a reading of the day. In fact, architecture assumes an altogether new dimension when building connects with celestial phenomena. At the Temple of Ramses in Upper Egypt, the temple interior was specifically constructed with studied depth, such that it allowed a single ray of light to enter only on the winter solstice and illuminate the statuary. All other days the temple lay in darkness. The extraordinary willingness of architecture to submit to such rigour was a test of a universal truth; it drew the architect away into other-worldly dimensions and asked the all-important question: can architecture be read as a place of mythic and timeless experience, even if that experience lasts barely a minute? When does building lose its formal description as a physical object and become a phenomenon itself? What would a forest lodge be without a forest? Without the ray of light as anchor, the Temple of Ramses could well be a warehouse.

4. Architecture is in fact formed out of defenceless and multiple surrogacies—the many mothers, fathers, donors in the form of clients, builders, contractors and municipal engineers who eventually influence the birth of a building. Too reluctant to take credit for its final form, they attribute it squarely to the architect. The philosophy that flows out of the production gathers force in some obscure, but acceptable design rhetoric of the time. Ideas of style, conservation, technology and environment are pressed into a convincing defence of the public presentation, and effectively weighed in professional journals, websites, art and design forums. At interviews the words flow in a generous cascade of critical phrases that few outsiders can understand. The building's altruistic nature forces a multivalent use of public space, so the imbalance of community and intimacy is shared by the inflow of residual functions within the design performance. If the client himself makes an innocent inquiry as to why his house looks like a concrete barn, the architect merely turns his head in a baleful glare, and in a voice coated with cynicism says, you must understand the building's duality is inherent in the fundamental linkages that draw their reference from a vernacular ambiguity. With such a ready monologue sliding off the tongue, the architect learns to protect himself not just from clients but other architects.

external forces of production. He does not know where he belongs.[5] Meanwhile the city rises in an unmanageable dimension. There is still talk of a human scale. Instead of man being located at the social of society, he becomes a universally perceived object. He is avoided in the frame of city life; instead he is drafted as an object of architectural veneration only in the drawings. Seated cross-legged within squares, or standing tall within receding circles, his arms stretched in an earthy desire to take possession of a world he is slowly losing, he becomes a caricature, a universal modular man whose power, as depicted on paper, radiates from his own bodily centre. The perfection is only a humorous paradox, for the sights and sounds of buildings around him grow into an impenetrable accretion, like some gigantic out-of-control switchboard of lights and noises that appear on television, in film, on cellphones, in literature.[6] He is the inheritor of the new world.

In a place where urban reality is unquantifiable, its functions known, and structures and mechanisms still unstandardized, the architect learns to adjust his practice; he builds only in the controlling shadow of a client's private demand, on small parcels of land, oblivious to the larger, more difficult demands of the city. Despite the constant, and often uneasy overlaps of India, he happily denies the multiplicity and variety in the engulfing environment. He has learned to separate the exclusive world of design from the all-inclusive reality around him. When he sits at his drawing board he sees only concrete forms, Euclidean shapes empty and expressionless. He has only been taught academic theory, that idealized and hackneyed view of architectural perfection which allows even the untrained eye to build house, housing or highrise, all from the same kit of stylistic spare parts. The ordinary landscape of cows and pigs, *paan* shops and sewer pipes, squatters and pavement dwellers, never appeals to the architectural psyche; it only presents an image of uncontrollable chaos, and architecture's struggle with rampant poverty. Better then, that the building remains geometrically pure, architecturally pristine. But in the end, when reality takes over, as it always does in India, it is easy to shrug and dismiss it as just an unfortunate encroachment.

It happens every day in every city in India. Leave any building on the ground, free to be inhabited—Taj Mahal, Connaught Place, Victoria Memorial, anything. Stand back and watch. Watch for a week, a month, a year. People set up *paan* shops on window ledges, xerox centres in niches intended for firefighting equipment, restaurants in windowless basements, kitchens under staircases. The architect knows that the abundant and ambiguous use of public space defies borders and makes his task difficult. Laundry dries on road dividers, people sleep on sidewalks. Offices enclose balconies as their own. The urban Indian reclaims as his own all that is in the public

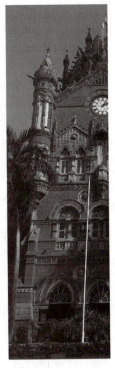

5. 'The old codes have been overturned,' Corbusier said. 'Buildings are man-made,' he shouted. 'Our towns have narrow streets walled in by seven-storey buildings, enclosing unhealthy airless courtyards. Who wants them? Our new towns will show great blocks of houses with successive set-backs, stretching along arterial roads. No more courtyards, but flats opening on all sides to air and light and views of other great blocks, and arterial roads and factories and…', Corbusier was merciless. Just as Art Nouveau some years earlier had produced little of artistic merit, yet as a movement had proved eminently successful, modernism was happily promoted by Corbusier in the hope that architects could carry on a philosophical dialogue amongst themselves without the facility to design for human purposes. In the remote villages of Nepal, in the bistros of Rio de Janeiro and in the lost mud hamlets of coastal African settlements, architects withdrew from the traditions of local wisdom and became engaged in creating architecture in the international style. They tore down their damp rat-infested earthen houses, their wooden mansions with leaking roofs and rough stone constructions with dark unlit hallways and replaced them with the ideals of the new age. With damp rat-infested, unlit and leaking buildings of concrete. Even though the builders of these places had never met, they were making buildings that were surprisingly similar. Modern architecture had that special adaptive quality that transcended language and all cultural barriers. A flat, concrete rooftop sat on a set of concrete columns, to make space that was then enclosed by white walls or glass, what was termed 'curtain wall'. In the new world order, form followed function diligently. There was no other truth. A new spirit had dawned. A great epoch had begun.

6. In the age of the cell phone, the SMS is the finest, most lucid form of literature. A line from Karen Wu's new online publication *Craz-E*: Pick up sm beer. C u later. Lol, may be a cryptic message, but it is filled with literary ambiguity. The *Times* literary critic John Sudland, speaking at the London Writers Festival said, 'The writer is obviously socially very close to the sender. And the writing', he continued, 'has both a sense of contemplative authority and suggestive tenderness. The c u later is in fact written with hope and genuine affection.' Such tenderness was completely missing in the earlier works of Jane Austen. Even though an exact similar sentiment was attempted by Lucy in *Sense and Sensibility* when she said 'I am rather of a jealous temper too by nature, and from different situations in life, from his being so much in the world than me, and our continual separation, I was enough inclined for suspicion to have found out the truth in an instant, if there had been the slightest alteration in his behavior to me when we met, or any lowness of spirit that I couldn't account for, or if he had talked more of one lady than another, or seemed less happy at Longdale than he used to be.' Lucy wrote this line with reference to her relationship with Edward. Had she been writing in the 21st century she could just as well have said 'Ed, pick up sm beer, c u later, Lol.' The literary merits of phone messaging can hardly be undervalued, because the screen in the palm of your hand also enlarges multinodal four-dimensional space that intrudes across transmedia air-waves. Though why such a personal message should be beamed across the world's satellite dishes calls for serious sociological review. Pick up sm beer. C u later, lol. The sentence indicates a complex inner landscape that vies for space with a personal truth: a belief in each other. That belief is constantly tested by the professing of love (not laugh out loud), the call for refreshments, and a face to face meeting expected in the not too distant future. The final note of warmth only guarantees the transport of the beverage, without ambivalence, without ambiguity. The story couldn't be more personal, more universal, in its simple message.

realm. That public space belongs to no one is a strangely western belief; that it must be preserved and paid for by everyone is an entirely alien idea.

Is our loss of identity then linked to the physical loss of identifiable and familiar places and landmarks, he asks? Perhaps. Part of the sense of loss has to do with the heroic nature of architecture itself. There is in him an irrepressible urge to be 'original', to develop an individual style of his own. It is a tendency often difficult to curb.

In fact, much of the story of architecture is the story of conflicting aspirations—where personal, national, regional and international identities clash with each other. Chandni Chowk Chippendale, Tamil Tiffany, Early Halwai, Akali Folly, Marwari Mannerism, Punjabi Baroque, Bania Gothic and Anglo-Indian Rococo among others, are all part of the permanent collection of architectural canvases on public display. Unconcerned with the environment from which they have sprung, such houses spread out across the expanding suburbs, devouring valuable land, lending a certain self-conscious charm, and appearing with remarkable regularity in places as diverse as Delhi, Madras, Bangalore and Lucknow.

Fearful of the surrounding poverty and insecurity, the architect must make appropriate separations, between them and us, between abject poverty and unaccountable wealth, between their imagined misery and our apparent comfort, between 80 men at a hand pump and one on an 80-acre golf course. If, for some reason, the sanctity of this exclusiveness is infringed upon, the architect merely accommodates. If security is threatened, the boundary walls rise; if status is questioned, newer, fancier symbols appear on the façade? The good life is insular, and the architect must help to keep it that way.

And then it is time to move on to another project, or to attend the longstanding demand for seminars. Conceptual ideas and tools need to be written about and discussed in order to avert any future crisis of reality, the growth of the population, the spread of the city.

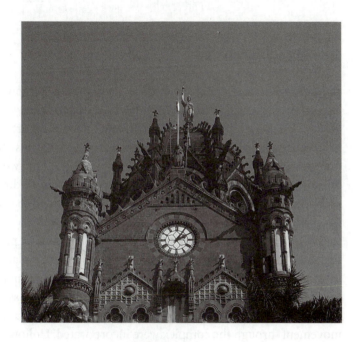

5. The Architect

As one of the many thousands of Indians practising some of these self-created deceptions and contradictions of India, I needed the safety of a profession to earn a living. I had very little imagination, I knew I was not an artist. I had neither a range of unique personal ideas which I was yearning to express to an admiring public, nor the capacity to turn inwards for an inspiration for my work. I was happy to look outside to the daily stimulation of the physical world to direct my life. So, I chose architecture; I also had very little integrity, so I decided to practise in Delhi.[1]

In the 1980s when I started a practice, one of the earliest projects was a School for the Blind. During the course of its design exercise the plan attempted to not only meet the difficult conditions of the handicap but try and make them a positive feature of the scheme. When the provision of auditory and sensory responses had to be given greater priority than mere visual enhancement, a number of ideas to ease movement through the complex were incorporated. Hollow floor tiles to exaggerate sound while walking; different shaped hand-rails to guide touch, and landscaped courts with herbal and fragrant plants to give even an olfactory element to architecture. While much of the added expense for making the building functional for the unsighted was approved by the committee, it was resoundly rejected by the contractor. In response to tenders floated for the work, the bidding contractors came to the office with large sums of cash to have us alter the expensive finishes. As the clients were blind, the reasoning went, they wouldn't notice the change. At the time, newly married, penniless, and living off my mother's savings and in her house, it was tempting to place the cash in the cupboard… but then. For the architect, these are the hazards of a profession that is perpetually selling itself.

Architecture today offers some of the neatest and untraceable forms of large-scale corruption. With a little money in the right pocket anything can be sold. As an architect, I have lived with corruption most of my working life. Day in and day out, the sanctuary of large-scale projects, the exchange of finance between builder and buyer, the expense of building material and the awkward link between the contractor and architect make the corrupt way not just possible, but when the amounts are large, almost pleasurable.[2] It is hard today to talk of constructing a home and not be at once intimidated by costs. Or to buy a flat without also paying for a pool, valet parking, tennis court, clubhouse, marriage hall and other facilities that come built into the package. In any architectural transaction every agent is in close touch with large quantities of unaccounted cash. Shall we say, 60% black and 40% white.

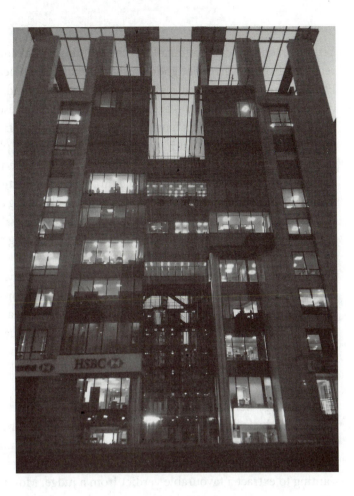

1. Architecture is one of the odd professions that lives by a continuous urge to make a statement. Dentists, surgeons, lawyers, all accomplish their work with ease and efficiency, ensuring that their client is satisfied commensurate with the professional fees being charged. Architects instead use clients merely as props, much like a tailor uses a sewing machine, to launch their own ideas into a project. Sure, the design expressed in the finished building resolves functional requirements, but for the architect, it become a professional poster for future work. As every architect will grudgingly admit, the final building is the much-needed performance enhancing drug.

2. For a project in Uttar Pradesh I was provided a full listing of the government officials who would indirectly benefit from the work, with the precise amounts that would go to the Development Commissioner, the Director of the Housing Board, the Chief Engineer, the Junior Engineer, the site staff. At 4,000 units there was enough money to go around, even though it would all come out of the 'official' budget, leaving in the end, just enough to make buildings that don't collapse before the inauguration. Unable to stomach such blatant mis-appropriation, I wrote an article in the local paper giving complete details of the 'unofficial' budget. It took barely two days for the government department to issue a notice blacklisting me for 'unusual delays and inappropriate expenses'. The notice ensured that we never got any work with the UP government ever again.

Yet the practice of corruption afflicts the building profession in many ways. Steel is removed from government godowns at the scale of whole bridges, storage sheds. Flyovers are constructed at eight times their safety standards—a strange institutionalization of corruption—because the government presumes that material will be stolen. At times, tenders have been issued for the repair of a major bridge, only to lead to the discovery that it was never built in the first place. At a resort project in Himachal we had proposed local pine for much of the woodwork. Our plea to stick with this ordinary wood available through forest auctions was summarily dismissed by the owner, who scoffed that the cost of chopping a pine was the same as a Deodar. It was just a matter of finding the right forest official. Stone quarries, shown as closed on paper, continue to supply material to building sites.

The taint of big money corrupts, and corrupts completely. Its sinewy claws penetrate deep in all aspects of administration, finance and construction, producing in the end work of such regrettably poor quality, it sets a measurably declined quality of life.[3] I am always hard pressed to find a building of quality in the last 50 years when asked to find one example of architectural pride. The search invariably leads to Lutyens or the Mughals.

Such readings were perfectly in sync with the public's perception of the architect as an individual who merely eased the process of a building's realization. He knew which permits were required from which government organization; he knew whom to bribe to speed the process, and he could do it with the same ease as that of a lawyer wanting to extract a favourable verdict from a judge. Moreover, he knew when the system required a monetary kickback and when only a bottle of Scotch was needed to move the file to the right officer's desk. The professional was an important individual because he knew the quieter methods of operating in a bureaucratic system that functioned on discretion and innuendo, and the surreptitious movement of goods and services behind closed doors.

New to the profession, I was, however, quickly given a methodical indoctrination into the subtler tactics of architecture. It was all very well to design beautiful buildings, I was told, but unless the plans had sanction from the local development authority, they would remain nothing but paper ideas. I had done enough paper architecture; there were several schemes for unbuilt houses and unrealized institutions in the portfolio; it was time to build. So armed with the blueprint, smug in my own innocent self-righteousness, I approached the office of the engineer. The design for a large farmhouse had to be passed. The application forms had been filled in duplicate, the drawings signed in quadruplicate, the unofficial sanction fee was tucked in my breast pocket. Everything was in order.[4]

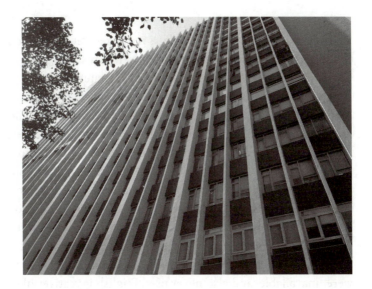

3. It is hard to understand the Indian tolerance for the sub-standard life—a life marred daily by broken roads, poorly finished buildings, sidewalks without edging, buses with cracked windows, train compartments with misaligned doors—all of which have been compromised in quality by kickback. So much money has changed hands there is none left for the purpose for which it was originally allocated. Part of the decline stems from the daily dose of political rot meted out by the media, the incessant air waves and sound bytes of mediocre men who control and charge the atmosphere with daily venom. And they are everywhere. Replacing genuine heroes like Gandhi, Tagore and Einstein, they rush in and out of the television frame, people with 10 minutes of fame, casting aspersions on each other, men and women with rasping opinions but no vision, spewing volumes of self-righteous indignation. The daily face of the politician, the cricketer, the bureaucrat, the journalist, the film hero and the Godman, those interchangeable personalities of India. The movie star's opinion on trade, the minister's opinion on art, the journalist's view of nuclear energy, the cricketer on corruption, the bureaucrat's participation in the Literary Festival, all contaminates daily life to a point of distraction and diversion. A minister for agriculture controls a private cricketing body; a cricketer joins the Rajya Sabha; a Communist party leader writes a regular newspaper column; a film actress wins elections in Rajasthan, a convict in Uttar Pradesh. Substitutions can be made between politics, sport, religion, film, smuggling....

4. Try getting a building plan sanctioned in any of the northern states, and you will immediately know the value of lost time. For the uninitiated, the system has produced a finite web of relationships that only needs the easy intervention of the liaison man. He is at your office to pick up the plans and the pay packet for distribution: ₹30,000 to the Chief Engineer; 20,000 to the Junior Engineer; 10,000 to the Area Engineer; 5,000 to the Sanctioning Architect, 2,000 to the File Clerk: 200 to the Peon. Not to be left out, 10,000 for himself. Later he will come for the local police, the electricity and water departments. The system works, if you know how, and how much.

58

I also had a copy of the land title, a notarized set of the land transfer documents, the receipts of the sale, the ownership certificate, the possession certificate, a copy of the land revenue records, the latest tax statement from the owner, including a copy of his ration card to prove that he was a local resident. Except for his marriage certificate, I had everything in my hand to prove that my client was a God-fearing man, who paid his dues to the government on time, stood erect when the national anthem was played in the cinema hall, drank only occasionally, prayed regularly, never touched his wife or those of his office colleagues in public, never dabbled in the share market, contributed to the National Defence Fund, smoked only in the bathroom, that too, only Indian cigarettes, avoided meat on Tuesdays, fasted on religious holidays, gazed lustily only at loose foreign women holidaying in India, never interfered with his children's upbringing, beat his wife only on weekends, the children only on Tuesdays, his meatless days, the servant when family members were unavailable, and also never used English invectives like bastard and bitch but relied only on regional languages to convey his anger.

For an applicant of such honour and personal integrity there could hardly be any complications. But there were. I didn't realize that public organizations had a way of functioning that lay outside the bounds of public service. I was turned away by the peon just outside the office. Sahib was not on his seat.

I returned dejected. Only to learn from a colleague that the way to get Sahib quickly back on the seat was to wave a fresh note before the peon.[5] This would get me entry into the junior engineer's office. Once inside, I was to utilize one of two tactics to extract the relevant file from the godown. Either I could let some loose notes of high value hang limply from my breast pocket; if the engineer was particularly shameless, he would simply learn across and withdraw what he felt was the correct amount for himself; or, if he was a highly moral man with deep-seated religious inclinations, you would be expected to let your wallet drop—accidentally of course—on the floor, with a loud enough thud to have him know that you were permitting him to leaf through your tenuous financial state. Being a man of personal integrity and honour, and also a junior engineer with a wife and kids to feed, with a house under construction in an outlying suburb for his retirement, he would quickly remove the crisper notes. Then with an expression of genuine alarm he would hand over the wallet and say, 'Bhatiaji, you better be careful, don't go around dropping your wallet.'

Once the file had been procured, you were ready to move to the office of the engineer-in-charge, the man overseeing the area in which the building was to be

5. At the time I had been shocked, but over the years I realized I had become like the build-ers I worked for. Once I realized that in India intention superseded action I was no longer discouraged by people who spoke about 6 crores and 7 women with rum breath. Real action was behind closed doors, in seminars on communal harmony, not on the burnt streets of Gujarat or UP. It was more important to show that you cared than to actually care; it was more important to lay the foundation stone for a building than to complete its construction. A conference on national integration was always more popular than actual integration. The symbolic act has always been of greater importance than any real accomplishment. Growing up in Delhi in the 1960s, the singing of the national anthem was part of public obligation. We stood to it at the school assembly in the mornings, and we stood to it again at Odeon or Regal in the evening, after a John Wayne movie. Both times you mouthed the words in a meaningless mumble that was more forced nationalism than genuine celebration. You were told to believe in the wonder of India. So, you believed.

located. He would be a senior man, and deals with him would have to be transacted with greater subtlety and finesse. You merely follow an established code.[6] The initial foray into his room is made with the singular intention of making contact, to show your face, to bow humbly to his greater worth, and exchange visiting cards.

The first meetings must also involve liquor bottles, I was told, or small perfumes for the wife. An established code of conduct existed in the dark offices carpeted with jute matting, the dim corridors ending in the toilets. Rum, Scotch and Charlie were the explicit mediums to ease the official message. The idea was to use them to establish a level of friendliness after which the real, the darker deals could be struck. And if any work was required from a government department, the only possibility lay in establishing trust. But such contrived friendships were always distressing for me. I had enough difficulty making friends with genuinely friendly people, people from whom no favours were desired; official friendships were near impossible. So, I wondered what I was expected to do. I could hardy let bottles of Johnny Walker Red Label drop on the engineer's office floor, and expect him to reach down and take a few grateful swigs before saying 'Ah… here you go…. You better be careful. Don't go around dropping expensive whisky bottles.'

But there was a subtler way. And it was carried out first as genial banter across the engineer's table, with Mahatma Gandhi observing the moral status of the transaction.

'Helloji. Sorry for disturbance.'

'No, no. No mention. Please sit.' He pointed to a chair with a missing leg.

He then read my visiting card, I read his. I memorized his qualifications, he asked me about mine.

'Ah Pennsylvania, beautiful city,' he said. I could not tell him that Pennsylvania was neither a city, nor beautiful. He was the engineer; I wanted my plans passed.

'I was there once,' he continued misty-eyed, 'Gormant duty, you know.'

What kind of work could the Government of India have in Pennsylvania? Or was he referring to the American government? I didn't ask. He was the engineer. I was there to have my plans passed.

6. Like other professions architecture has created its own conventions. Play the role expected of you as a professional, ask the right questions, design and build accordingly. As a profession architecture is now profoundly deadening. If there's to be any future, it has to be practised in two diverse ways: either as an art form, or as an instrument of sociology. One is in complete isolation, the other as an involved team player. Risk and pleasure have to be brought into the picture. When that happens, architecture suddenly becomes relevant, both for the architect and the people whose life the building has affected. You then begin to build for people at two ends of the spectrum. Either for those too desperate to require the services of an architect, or those too affluent to take any interest in the work.

'Manchester is beautiful too.' I said, feigning interest in his background. His card had announced Roorkee and Manchester as the two places where he had obtained his engineering degrees. I knew Roorkee to be far prettier than Manchester. But when you are visiting a senior government engineer to have your plans passed, you make sure you make the correct references, even if it is to a grimy North England industrial town.

'Beautiful place,' I repeated. 'I flew over it once.' Nobody would fly over Manchester unless they were on their way to some icy destinations on the North Pole. But the engineer was not interested. He had moved on to other more personal details.

By now, we both knew each other's educational qualifications, we had firmly established our foreign credentials, the beauty of the two places we had inhabited during the sojourn; we were now on common ground. It was time to resume a discussion on each other's personal and professional goals.

'But, why India?' he asked. 'After all these years, why come back to India?'[7]

Why India? What a question, I thought. Because I was born here, had lived here, had Indian parents, Indian citizenship, a ration card, Tata shares, monthly interest from a fixed deposit, an Indira Vikas Patrika. Because I had a grandmother who had promised to leave me her hill property in her will; because I liked Indian Kentucky Fried Chicken more than American Kentucky Fried Chicken; because I had seen *Gandhi*, the movie, and had been touched by the humility of the man.[8] Because I had seen Rekha and Mandakini and wanted to be close to them. Because I remembered Nehru and I liked what he had said about allowing the winds of change to blow through the house; because I believed in Ayurveda and Ayodhya, the Vedanta, the Bombay Gymkhana, the Rig Veda and Kwality Ice Cream... and most of all because I had no work permit for Japan and no entry visa for Germany or England. I was completely rudderless. The only country that would have me was India.

'Bhai sahib, home is home, you know,' I said, allowing a tear to roll down my face. 'Home is India, India is home.'

'But you had green card, didn't you?' he asked, wondering if my patriotism was natural or the result of a US Immigration Service denial.

'*Haan, haan!* Yes, of course,' I said. 'But you know, after a while you get tired of America....'

7. The average Indian practises an edgy and uncertain form of patriotism. Removed by half a century from the heady days of Independence, patriotism now takes the form of prayer, a ritualistic form of cleansing. Like the businessman who turns to the family *puja* room after a successful sale of a defective product. You bellow out the strains of Vindhya, Himachal, Jamuna, Ganga while your company trucks remove Deodar from Himachal. You fall in line at the Gandhi Museum under the gaze of the Mahatma knowing that your chemical company has poisoned whole villages in Punjab, Sindh, Gujarat and Maratha. But the tear still rolls down in nationalist pride, that one like him, our Gandhi, in flesh and blood walked this earth.

8. In the 1980s after the successful release of Attenborough's film Gandhi, an American beer manufacturer decided to use the Mahatma in a promotion of his brand. In a smoky American bar, the ad situated a dhoti-clad Gandhi look-alike on a bar stool across from a mug of beer. As the camera rolled, Gandhi turned to his television audience, picked up the mug, gulped the foamy brew and said with a resounding burp, 'Nothing like Swiller beer to break a fast.' Soon enough the company stock rose, and the ad came to be viewed as comic relief as well as commercial brilliance. But a visiting Indian was so incensed by the mockery of the father of the nation, he sent a complaint to an MP in India. Before long there were questions in Parliament, and, through deft diplomacy, the offending ad was withdrawn. India 1 – America 0.

'Tired of America? USA?' The engineer had never heard such a blasphemous statement on the new world. 'But the land of the free....'

'And the home of the brave, I know, I know,' I said, dismissing his weak defence. 'But I couldn't take the change.'

'Change? What change?'

'You know, changing cars. Changing girlfriends. Fed up trying to decide whether to buy an American Oldsmobile or a Korean Hyundai; whether to kiss on the first date or save that for later. You know, after the sex,' I said. 'You get fed up of commuting from the suburbs everyday, and driving to the beach on weekends.'

'You do?'

'Oh yes! If every Friday you must decide on whether to go to a beach resort or a mountain resort, whether Poconos or Hyannis Port.... If every evening you have to decide which bar to go to, what to drink; whether you want French food or Greek, then try and figure out how you'd like to pay for it; with cash, or credit, if credit, then which card—American Express or Visa or Master Card; then whether to go for a late evening coffee or liqueur, then how to pay for that. You know, you would also be fed up.'

'I see what you mean.'

'Not only that,' I continued, having caught him in a cultural crossfire, 'sometimes when you want friends over for dinner you have to decide whether to invite Madge and Bill, or just Madge, knowing that the two have a troubled marriage, or if you decide on Stan then you don't know whether to call his new girlfriend whom you've met only once, or the earlier one, the one you are more comfortable with.'

The engineer sighed, thinking of all the good things he had heard of America.

'Once the people arrive,' I said without letting up, 'you have to decide whether to have an all-beef barbecue outdoors, for which you must check the weather forecast on the FM radio, or grille the meat directly in the oven with A-1 steak sauce or chilli sauce, or soya sauce or just plain old tomato sauce. Then if you are indoors other difficulties arise.'

'Difficulties? What sort of difficulties?' The engineer looked distracted and confused. This was not what he had heard of America. Even Manchester was better than this, he thought.

'Well there is the whole question of home entertainment.'

'Home entertainment?'

'Yes! How do you keep your guests entertained at home? Do you just flick on the colour console and hope there is a baseball play-off game on, so you can hand them each a can of Miller Lite that you bought at a liquor shop sale; you yourself can then retreat into the bedroom with a can of Heineken to read a good book; or do you think up some fun party games like Russian roulette and wife swapping….'

'Wife swapping?'

'Yes, wife swapping.'

'What's that,' the engineer raised his voice in innocent inquiry.

'You know, where you exchange your wife for somebody else's, or for a colour TV. Or, if she's old and haggard, then just a black and white TV.'

'By God! Really… exchange. Just like that?' The engineer was aghast. 'Just like old clothes?'

'Just like old clothes,' I said, enjoying the measurable shock that an inexperienced architect could introduce into the life of a government engineer.

The engineer sat back pensively wiping the sweat off his forehead with a bath towel hanging on the back rest. The bath towel was one of the perquisites of life as senior engineer, along with all the other furnishings that formed part of the office inventory: two desks, wooden, with lockable drawer, one swivel chair with bath towel, two visitors chairs with cane backs, one photo of Gandhi, one paper weight, one peon, one file marked ST/Approval/Proj./Const./32…. All senior engineers were entitled to a bath towel; while their juniors had to contend with private handkerchiefs.

'Wife swapping, haan?' Suddenly his faith in the new world had been restored.

'Yes… very common suburban pastime… just like lawn-mowing and supermarket shopping.'

'Really?' He said, a sudden glint in his eye. 'Just like buying vegetables.'

'Of course, you have to be married to play the game.' I added a touch of caution to his sudden and growing enthusiasm for America.

'Of course, of course,' he said, eyes radiating the happiness of some imaginary erotica.

The way the whole discussion was progressing, the easy geniality of the exchange had clouded the original intention of our meeting. We were no longer talking of American suburban life with the idea that the informality of the content would introduce a familiarity within which a set of blueprints could be signed and approved. American suburban life had itself become the sole purpose of a government engineer's life. Lite beer, barbecues and wife swapping had given new meaning to an existence that had so far been confined to bootlegged whisky, omelettes and the unhappy permanence of an Indian middle-class marriage. The government job too was permanent—the engineer, however inept, however corrupt, was secure in the knowledge. Marriage to a woman with a temporary moustache was always permanent. Three daughters were permanent to the point where adequate dowry could be collected to release them into their own situations of permanence; the flat came with the permanent job. So did the staff car and the driver. Whether you worked or not, permanence was the very hallmark of life in India.

What appealed was the fleeting transience of the American way; if you didn't like Miller Lite beer, you could always buy Budweiser Lite; if barbecued meat was unpalatable there was the option to bake or grille; if your Buick Skylark was beginning to look dated, it could be junked for a Buick Riviera; if your wife had a moustache, you needn't bother with hair removing creams; you just removed the wife. America was a wonderful place.

But the discussion was not getting us anywhere. While the engineer's thoughts were somewhere across the Atlantic watching a soap opera with his new blonde, moustache-free wife, the plans lay untouched on the table. While images of champagne being sipped alongside pools drifted through the open window, striking the joyous face of the engineer, my client's architectural status remained unchanged.

This hardly seemed the time to return the official to his more tiresome position in India as senior government engineer, with reams of blueprints to scrutinize, varieties of official document to stamp and sign and three strapping daughters to marry off.

But I had to. We had strayed too far out of the dust-spattered windows of his corner office, too far beyond the stained *durry* and the irritating flicker of the neon tube above his desk. His fantasy had to be interrupted. 'Tea? *Haan, haan...* yes of course,' he replied, before losing himself in the arms of a luscious suburban housewife, freshly swapped. I reached for the button dangling along the side of his metal desk, and summoned the peon. 'Two teas, *do chai* extra strong, no sugar,' I said.

The peon looked confusedly at me, and then at the man who normally issued such commands.

'*Haan, haan...* What are you staring at,' snapped the engineer, suddenly assuming the power bestowed on him. '*Jao jaldi, chai lao!*' Before the peon exited he handed him all my plans and documents and said. 'Tell Bansal that I want these drawings cleared immediately. VIP job.' The engineer sat back on his plastic swivel chair, the towel forming a striped halo around his receding hairline; he twirled a sandalwood paper-knife in his hands and returned to his new life in America.

I was back on my plastic visitor's chair and read Mahatma Gandhi's words hung on the stained wall. 'If you do what is good for your fellow man, you will have done what is good for you.' The toothless face smiled downwards. I smiled back. Little needed to be said. I had done what was good for me. My fellow man who sat opposite also seemed satisfied. The plans had been approved with no passing of money, no exchange of Scotch, just the imaginary promise of a new life. A state of architecture had been achieved.

Was this a betrayal of India or just a temporary suspension of conscience? Whatever it was, I learnt to live life the way it was meant to be lived. Survival was possible only in the extremes of piety and pragmatism. There was place in the country for the saint and the sinner—Vivekananda, Agnivesh and Muktananda could exist alongside Phoolan Devi, Charles Sobraj and the UP politician. Each at his own extremity of existence had found a way to trespass through the debris, because each had managed to transcend the ordinary conditions of survival. The politician and the criminal could survive because their strong-arm tactics could subvert the system to their own advantage. The artist and the saint could endure because their subsistence

was not contaminated by India; they were the seers and observers whose search carried them beyond the tainted bounds of surrounding politics and violence. But the middle ground was untradable. There seemed to be little room for the committed school teacher in an Uttar Pradesh town; there was no support for the doctor practising his trade in a government hospital in Bihar. Ordinary life was a malignant condition that had begun to suck out the spirit in a controlled parasitic way. Whether inside an office or an open city site, it was the same story.[9]

I had sensed the poison in the air; the slime and murky shroud of daily indignities. The plan had to be passed, but its passage demanded a bribe; the electricity had been cut, its restoration required the gift of a watch; the computer had made a mistake with the phone bill, its correction needed more gifts, more fiscal reassurances. City living had introduced a discordance in my life that was now palpable. I felt the pollution slowly invade the skin, the poison enter the bloodstream. I finally came to the realization that what I desired in my work life had nothing to do with what I achieved in my work life. The obsessive and calculating manner with which I pursued the right to exist on my own terms was severely countered by the reality against which I was constantly buffeted. But it was not entirely an external effect. I felt like a haemophiliac; every time the surrounding blight of people and situations intruded I sensed an invasion of my red blood corpuscles; with every transaction, every daytime encounter, I sensed a bit of myself drain away. I saw the attacker standing on firm ground, scoffing at my fallibility, ridiculing my inacceptance of the new situation, the changed face of India.

9. Just stand on the 20th floor of any building and look down. It is hard to imagine a place so self-consciously made and yet so destitute. A whole city without landscape, without a coherent road network, without utilities. But already occupied. A vast canvas of cranes and scaffolding and concrete and brick piles and Rajasthani migrant labour. Builders, architects and developers mingle among them, smiling, exchanging drawings and packets of notes, a new team in the game of architecture, finding a language as they speak.

6. Architecture in the City

But the real change was in the state of architecture itself. In fact, in the 1990s, architecture became increasingly visible. It began to depend not so much on its need to shelter and protect, but, by its very presence, to communicate. No longer merely a smudge on the horizon, it felt the urge to be heroic, interesting, spacious, relevant, meaningful, and informative, all at once.[1] In the suburbs of Delhi, Mumbai or Bangalore, the eye was always in a state of unrest. Against a hot white sky, buildings arose in steel and glass and brushed aluminium, glinting, reflecting and mirroring futuristic foreign expressions set in Indian wilderness.[2] They displayed newer, shinier forms of materials—materials whose very juxtaposition in the third dimension was meant to create a frisson of delight among the viewers.[3]

The mega mall, the gated housing complex, the corporate headquarters have all been conceived as heroic statements. As if the architect struck a sudden note of inspiration, and in one fell swoop, conceived of his structure as a complete individual image.[4] Yet despite the supposed personal nature of the inspiration, the mega mall looks strangely similar to the gated housing, the gated housing surprisingly akin to the corporation headquarters, which is just like the picture on the cover of the Architectural Record.... On close analysis, all submit to a single formula: a wide arching cantilevered portico curves and stretches towards the parking lot to indicate the entrance. Inside, acres of plate glass reveal a skylit atrium, and a series of elevators noiselessly moving up and down; to add theatre to architecture, polished steel surfaces throw unlikely reflections across hallways. In one instant, the structure stands revealed. No surprises, no discovery of hidden space, no value to shadow and darkness—the building is deliberately simplified to create a single moment of revelation, a sudden amplification of the senses. Within seconds, the building reveals its full amplitude and history. Within seconds, the building is forgotten.

This application of blunt commerce to every architectural endeavour makes the structure into a restless theatre of surfaces. Notions of neighbourliness and the daily connections between people were altering into a homogenous static monochrome. The difference between office, home, and recreation realized earlier in the struggle to enact their distinctions through architecture were blended into a singular mass of building. An architectural type that was enclosed in glass, soundproofed, air-conditioned, looked onto a garden landscape, had underground parking, and all facilities and services. Even the names gave no clues to its central function. Malibu Gardens, could be an apartment complex or an office, or a club, or a mall. Malibu Gardens could be in Malibu California or Bangalore, India. Malibu Gardens could

1. When I lived in Ahmedabad, I often cycled to work, and along the way, always noticed a high five-storied wall, standing forlorn in a dusty dry field. The wall, I learned, was India's first ever Drive-In movie theatre. I had no access to a car, but decided to spend an evening there, in the hope of getting a taste of the historic moment. Oddly, the absence of a car did not hinder my entry to the place. Several others—groups of families, office colleagues, students—had all come without a vehicle, but were allowed to sit in the open far back on the field; a couple of Fiats and Ambassadors had parked between us and the screen. The movie began. Blurred by distance, in the swirling dusty field—between the blaring of car horns and an audience regularly relieving themselves in the open—the film remained, from title to finish, in soft focus. It could have been a Russian melodrama, a science fiction thriller, or a Bollywood romance; it didn't matter. The Drive-In as a new architectural experience was enough.

2. They are exactly the objects in space: like giant iPods, monumental Ray Bans, pieces of 21st-century chrome technology planted in black parking lots. They have no life of their own, other than that given to them artificially through electronics, air conditioning, lighting. And like any other new object you acquire, you derive a sort of momentary pleasure from them and then they are forgotten. People tire of riding up glass elevators in chrome atriums and return to the local municipal market after a while.

3. I used to think that expressing your identity in design was but a childish impulse. Most buildings that are architect-centric are usually colossal failures. If you look at some of the great examples of architecture—the Velodrome in Oslo, the Stockholm Public Library, the Woodland Crematorium and Chapel—they are merely background to life. They create an assemblage in the landscape that has deeply memorial concerns. There is none of the sensory and visual obsession for material and texture and elevation and proportion, the tools that merely create the architectural picture.

4. Just the way Walter Gropius had. The Bauhaus building opened amid great pomp and ceremony. The Dessau Herald Tribune hailed it as a momentous stage in architecture, a new beginning, calling it the ultimate in decorative frugality and comparing it to the new campuses that were opening in Treblinka and Babiyar, and Auschwitz. The absence of complexity was one of the main attributes of the plan. The building could be viewed from within its glass shell or from a vantage of two miles away; but both viewers had equal command of its details. They both knew immediately what the building was made of, how many floors it had, and who was working late behind the curtain wall. Gropius was a complex and articulate architect. He needed to understand the reasons behind his work. So, he explained to the reporters, 'The typical building of the Renaissance and the Baroque has a symmetrical façade with an entrance along the central axis. In my building, the view offered to the visitor is flat and two-dimensional. Since everything looks the same, the person just

be a tandoori restaurant in Lucknow, or a club in Karachi. In the glow of the neon, the professional too is transported into a heightened state of self-absorption and pretension. He is left with the belief that his work has changed the quality of people's lives.[5]

The transformations also spawned a whole new range of personalities. The old maharajas lived a country life given to aggrandizement and sensory pleasure. The newer rajas, the grandsons, deprived of their privy purses, are often willing brokers in the sale of their ancestral places and rare artefacts. All the old labels are now somewhat askew: the minister as a political guardian is now also seen as a harbinger of good fortune for members of his own family, the image of a swami, a man of the saffron cloth, who renounced materialism for an ascetic life in the Himalayas, is now blurred by the fashions of a new lifestyle—the fleet of BMW cars, the annual audit of the ashram accounts, the relationship with a foreign disciple. In a similar vein, the non-resident Indian returning home flaunts the signs of his monetary success. When such people crossed the moral realms of ordinary architecture by building jacuzzis in meditation chambers and therapeutic flotation tanks in ancestral palaces, it is time again to embark on a narrative adventure which goes far and beyond architecture. And ask the nagging question: is architecture mere building or something more?

The force of individual expectations, and the cast of idiosyncratic characters begins to influence the shape of the new architecture. If, in the past, Mughal emperors like Shahjahan and Akbar made decisions that have today determined our perception of the good life, a newer breed of emperors is creating forms that will become the architectural benchmarks for future historians. Yet for the new patterns, many of these forms fall outside the realm of their own daily lives. Unfettered by local economies and traditions, sitting around corporate boardroom tables, their faces reflected in the bevelled glass, they take their decisions on design and architecture in a way that takes building and ornament to a personal quest. The ideas of the industrialist, the minister, the tycoon and trader on matters of architecture have begun to define a social terrain that gives immediate clues to a changed life. The talk has shifted from political alliance and God to economic freedom and free trade, from the freedom struggle and salt marches to most-favoured-nation status and export quotas.[6] Constraints have eroded: there is a greater profusion of words, a new meaning in the context of money, earned and often untaxable; a greater imagination is required for its expenditure. And architecture is as good an outlet as any.

keeps walking around the curtain wall, till Maholy-Nagy or Kandinsky or someone else lets them in.' Earlier when discussing the project Walter Gropius had said, 'We should build the entire structure under one roof.' There was general unanimity that this was far better than building it under one floor. Then, Wassily suggested, 'There would be a set of workshops, where everyone can work on some modernist notion related to their own field.' Federal seconded the idea and said, 'These should be large expressionless spaces, uniformly lit but with no hint of personality or character.' Everyone liked that. Then Maholy-Nagy spoke up. He said, 'These workshops should just be called workshops for the sake of expression.' Everyone admired him for his honesty. 'The architecture department,' Gropius decided, 'should be in a separate architecture block, so that architects don't get involved with inferior arts like graphics, interiors or product design.'

5. To fall into the terrible trap of architectural seduction is one of the many risks of building without ideals. What looks good in Canada is bound to look good here is a mistaken belief. But who's listening. While architects like Sir Norman Foster and American firms like SOM wait their turn at the bigger legislative building commissions, under consideration for the master plan are design firms from Singapore. Does the picture-perfect vision of buildings with acres of reflective glass offer the only real answer to India's urban future? For a country always looking westward for solutions, perhaps.

6. In matters of economics, the present prime minister of India knew all along, that what had sustained India for centuries was the permanent divide between the rich and poor. His supporters remained steadfast in their appreciation of his drive to improve life, and formulated an unusual slogan called Make in India, a catchy way to expand their operations. They rallied from their boardrooms and golf courses when they learned that his idea was to lift them out of affluence and raise their profit graphs. To make India a free market for investors, roadblocks like poor people, land acquisition, tribals, tax regulations, labour laws and environmental considerations were removed, and foreign companies like Union Carbide, DuPont, and GM Foods invited to India. To show that this was not a one-way form of economic colonialism, the government's decision to open Kirana Shops throughout Europe and the US swayed public opinion and showed the PM to be pro-poor. That much of that public opinion was gauged by NRIs in Madison Square Garden was another matter. India, after all, was a rich country; the poor had given it a bad name. Most ordinary citizens affected by continuing high inflation and unable to afford vegetables were provided tax relief when the government reduced the import duty on German sports cars and private jets. The important thing, the PM felt, was to appear people friendly. And if for some reason things got out of hand with the land bill or Swiss bank accounts or 2G scams, he could always change suits and rush off to China.

But, if the making of money is a speculative demand, its application to objects, its transference to architecture, is equally a speculative matter. The house, the apartment block, the corporate headquarters become the easy instruments of a personal preference—historical or contemporary, borrowed or invented—sometimes comic variations on a yet unrealized theme. Building follows no rules, no simple instruction manuals. Rules can be created as you go along. Economic or technological change has absolutely no influence on architecture. It can't alter the course of memory and history. It has as much effect as the addition of new model car into the stream of traffic in a city. Architecture, like everything else, falls outside accepted norms of convention.

Born to traditional patterns, having lived out their early years in the confinement of havelis and brick-paved courtyards, the new patron's curiosity about architecture veers happily into these unconventional domains. Take the minister who derives tax benefits from a charitable trust set up in his deceased father's name. With funds tucked away in the safety deposit box or the *puja* room, he develops a consummate ambivalence towards the legacy of his ancestral architecture. His hereditary social status is a rank that he wilfully alters with every new acquisition. He learns to mouth the rhetoric of egalitarianism, to preach a docile servility. His speech has the infinite power to unify humanity, however degraded its condition, but the public view is at variance with private hankerings; the visible signs of his private life are inconsistent with its cadences. The new German car has nothing to do with the simple need for transportation, the new house in the suburbs has hardly any links with the ancestral home in the Orissa village.

The industrialist is similarly horrified as he looks from behind the curtained Porsche at the miles of tarpaulin hovels of indentured labourers working in his steel forging plant. He is disturbed by the growing divide, the despair he must witness daily. There is talk of supporting a project on industrial housing, of transferring a part of the company profits to alleviate the poverty that exists along the factory wall; there is sadness in the boardroom at the condition of wasted humanity stirring the dirt just outside. But it is the end of the fiscal year. The despair dissipates quickly. A hefty dividend is declared. The talk shifts rapidly to reinvestment, and the profits expected in the next fiscal year. The message is only that of evident self-adulation, an immense self-absorption.[7] And architecture is the new image provider, a necessary foil to the surrounding despair.

Contradiction becomes the inherent quality of urban life. Double-think takes over: the industrialist learns to smile at the factory hand with a new sincerity. There is

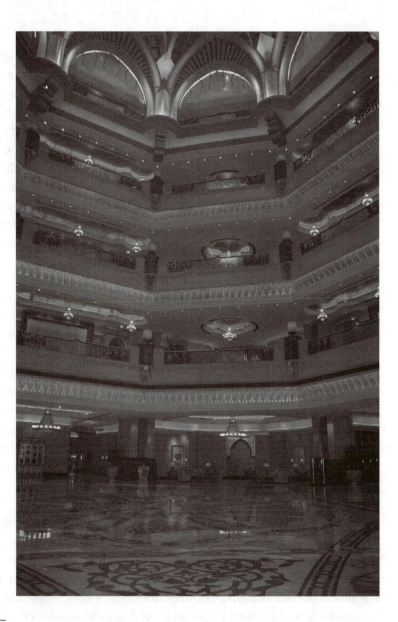

7. Hi, I am a Mumbai-based industrialist running a successful software company listed on the NY Stock Exchange. Last year I was voted Businessman of the Year in Fortune magazine. My wife is an actress of exceptional beauty. We live with our two sons in a 16-bedroom estate at Nariman Point. We are a close-knit family and like to spend time together flying to the Maldives for lunch or getting together at the Kentucky Derby. Two months ago, I tried to commit suicide by jumping from the Taj Hotel. Of course, I didn't realize it was the ground floor, so I just lay there thinking they will scrape my mutilated body up, but a policeman came and gave me a ticket. My wife also tried to do the same. Her body was found on the beach; they got all the seaweed and water out of her lungs and revived her. Only my horse Kohinoor was successful. He committed suicide by hanging from the stable fan. But I am still hoping to get the Confederation of Indian Businessmen Gold Medal for this year.

renewed faith in the system; local law can be invented to suit fiscal compulsions. Everything can be understood, everything manipulated. Like the conflicting charges of a magnetic current, he becomes the moving force of any new enterprise. Waving decisions aside in quick and easy restitution, he learns to balance his life in an atmosphere of mutual but happy suspicion. People walk in and out of his field of vision, waving documents, making requests, raising issues, treading the vast social stretch between humble servility and utter contempt. Pulled in different directions by monetary and social exchanges, he traverses an uncomfortable terrain. Strung out between the opposites of family and officialdom, labour and capital, the material and the spiritual, between personal beliefs and professed religion, he is like a bridge suspended across a ravine, but with no moorings on either side. In this he recognizes the imbalance so essential to his existence.

Newly rich, his half-literate status is now ignored, for he belongs to a minority whose influence comes from the manipulation of the GDP. With his daily doze of self-aggrandizement, he believes that the flash of earning exemplifies the truth, the truth above all truths, above all values of art, entertainment, joy and thought. Deprived in early life, he now learns to possess, to own, to rent, lease, mortgage and loan all the appendages that ensure the perpetuation of his new lifestyle. The despairing frame of surrounding life, the strife and fear on the streets, only increases the show of magnificence, as he pursues his goals even more rigorously. As a representative of the new world his home has symbolic status. Even if unfamiliar to his traditional background, its reading as iconic compensates for its physical discomfort, its awkward newness.

Like him, others too thrived on marking their differences. The politician was similarly used to an architecture of such girth and spread, that he was unlikely to have known that domestic architecture could be anything but a sixteen-room bungalow on a four-acre lawn. Perhaps his constituents, who lived in mean, two-room flats, saw this as the line that divided them from him, a man whose life they had learnt to emulate, if not in power, at least in dress. Distinct boundaries set up from the life around them, boundaries of economics and class, social boundaries between themselves and ordinary people—people with large families, with several generations of parents and unemployed brothers-in-law, and children running about. The difference between visible ownership of building and outright poverty was what made life worth living; visible disparity provided the notion of power.

Throughout history, architecture has only been an instrument to promote disparity. As the most tangible form of physical expression, building made the difference

noticeable in the most direct way. An emigrant returning to India could best project his foreignness in a building that had no Indian precedent. A condominium was an American idea realized with all the accoutrements that made it American, the Jacuzzi, Astroturf on the lawns, mini golf course, valet parking, and wall-to-wall carpeting, and other inessentials from the foreign product line.[8] Piped music and a surveillance system were as essential to the design as cross-ventilation. The Jacuzzi and Astroturf suggested a remoteness from indigenous facility that was essential to the architectural baggage of any successful emigrant, a man returning home to make a statement after years of economic exile. As he made his way through the airport terminal, under the admiring gaze of customs officials, the Marlboro bag with duty free liquor, and the video recorder tucked under his armpit, he knew them as the smaller instruments of his new assertiveness, the passport to his new middle-class life.

Obviously, architecture could lend a degree of stability and solidity that no bottle of whisky could, however long it had stood on the mantelpiece. The whisky, moreover, was not visible from the street. Architecture was. It played a larger role in project-ing personal patterns into the public domain; the condominium was a collective projection of the emigrant's success. Its presence in the city, its civic visibility, were crucial to its value as architecture. But when access to wealth was recent it was not held in guarded lockers; for the home-bound emigrant it became a matter of public celebration. After many years, the ship had come home. And while the receiving relatives stood at the dock looking up at its monumental hull, teary-eyed and joyful with the emotion of an expected reunion, the older brother, the New American on the upper deck only waved diligently, acknowledging the cheers, knowing full well they were not meant for him, but his phenomenal success.

However, when wealth did not require display to give it value, its presence acquired a greater expressiveness between confining bounds. In the case of the landed tycoon the public was given neither visual access nor even fragmentary knowledge of its origin. Who had the money, how it was earned and how it was spent, was a private concern. On the surface the lustre is rubbed daily, lovingly polished and restored, skin bleached whiter than white, business reviewed on the Nasdaq, gold bought and sold in private parlours, the Sunday marathon raised to a fitting social cause. The poor, the silent, the dispossessed, the needy, the unkempt, the threatened, the different, the ordinary, are all swept away in a wave of contempt. City lights focus brightly, and only, on the newest member of the Billionaire's club, and the daily upswing of personal graphs. The dwelling was approached through a guarded gate made impenetrable by dogs and distanced by foliage; it spread in confinement so

8. A recent index of wellbeing gloated over the sudden infusion of 'international' facilities in India's biggest metros. It even picked Bangalore and Delhi as cities with the best quality of urban life in India. The poll only measured facilities for shopping, health, education, housing and transport. Does such a record of infrastructure provide a true picture of people's wellbeing? Are numbers of hospital beds a better statement of a city's health than a citizen's own fitness? Is the opportunity to buy 16 models of the latest cars an indication of a quality of life, or fresh vegetables at the local market?

84

lonely that it made the few privileged enough to enter it more aware of their own special status. But the guard dogs and the alarm systems, the long drives through uninhabited woods were only buffers that delayed the reception into the secret realm and kept out prying eyes and income tax officials. The separation and the planned delay made the eventual experience of the guarded realm even more desirable, more startling.

Architecture then was not an act of public proclamation, but of private exclamation. Its expression consequently bypassed the accepted bounds of aesthetic morality into an inner world whose standards were as exceptional as the objects in possession. Ancient bedsteads, Chippendable grandfather clocks, Shekhawati chairs and modular steel furniture were the acquisitions of an ordinary life. These were conspicuously missing. For the true inheritors of old world grace, objects acquired greater value by their custom manufacture, or by the exclusiveness of their antiquity. A hand-made Swiss mirror, Brazilian terracotta tiles lining the pool, and a gem-inlaid ceiling worked on by Kashmiri craftsmen, formed the more arresting display. Only the reticent industrialist knew that there were four such Swiss mirrors made; only he knew that there were gems in the ceiling; in any case, only those who could appreciate and sense the presence of precious stones around them would ever make it beyond the gates of the mansion. Only a visiting coal baron sipping water from the crystal in daily use could have a real sense of oneness with these surroundings; only a Bolivian oil man would feel comforted by the architectural treatment of infinite, but guarded, space. For the ordinary visitor, the unwritten code of artistic gratification was just not in evidence. The office chartered accountant could only gaze upwards to get a fiscal perspective on a ceiling studded with expensive stars.

For a people who use architecture to convey a personal message, building can hardly be viewed as part of historical tradition. If older buildings reflected the ideals of a collective, the newer ones stand out now only as fragmentary representations, testaments to some imaginative bravado in private enclaves.[9] Whether the home of a labourer returning to India from the Gulf, or a businessman in a designer home, there is little difference. If in style and substance the designer home detaches from the cultural fabric of the city, it reduces itself to a theatrical device which merely duplicates the condition of a stage set. Devoid of stability, reflecting in its newness only the disquieting transparency of its occupant, there is only the acknowledgement of his alienation from the surrounding collective.

Architecture's real value then lies in its elimination of geographical distance and combining the wants of a new moneyed citizenry into isolated expressions away

9. Such architecture has no sociological depth or political reach; its inherent value lies only in design, that too behind the boundary wall. Making buildings is now an insular monochromatic exercise that no longer reveals anything of the culture and setting. It's a safe bet to do design for a private unconcerned client. But if you practise architecture as a daily visible outdoor profession then it's a different story—you've essentially imprisoned yourself in an ill-tempered bureaucracy of regulation and rules from which there is no escape. The necessity to falsify, alter and appease to get anywhere in the building process is a compromise architects make all the time, all in the hope of construction. Sadly, little of value actually emerges on the public building site. The quality of housing, markets, schools, railway stations, legislative buildings, government offices—all betray the essential despair of compromise: gray, peeling, unfinished cracked structures, that blemish and smudge the horizon of most towns.

from the mass of ordinary people leading ordinary lives into places and ideas that never existed before.[10] But in doing so, it was also eliminating itself. Just the way excessive tourism was destroying the temporal aspect of places, architecture too was becoming interchangeable and dispensable. Commerce, marketing and advertising had created the logical development of architectural space into similar saleable packages.[11] When everything was different, collectively it was all the same. The interior decorator had to be brought in to indicate the differences.

10. The urgency to be original made the owner of a riverbed eatery in Ahmedabad resolve to turn it into a revolving restaurant. It did not matter that the view from high up was of the city's largest slum on an empty Sabarmati riverbed; the 360-degree rotation ensured that the customers paying for overpriced Dhokla not only got a panoramic viewing of the mud tenements, but also the rivulet of slime, the defecators lining up along the embankment. The draw was in the very act of revolving; in a profession that relied wholly on position and a settled view, movement made it unique. Architecture could make the humblest of intentions grandiose and monumental, and entirely out of sync with the function.

11. In the 1980s with VCRs and home movies, cinema halls like Odeon and Satyam realized that audiences of 2,000 were beyond the expectations of the management. The Multiplex was born. A building that cut, sliced and chopped the giant volume of a cinema and produced smaller, more financially palatable numbers of internal subdivisions. Like dividing the cake among a larger group of hungry. Having outlived their purpose, a physical and cultural change was needed that would keep them useful and usable. The Multiplex was an entertainment idea whose time had come.

7. Practice

Armed with reference to technology and tradition, I too began to approach every project as a new form of personal fulfilment. Brushed steel columns if it was an office, a skylight above an atrium for a mall and acres of plate glass if a house.[1] Accordingly, the nomenclature changed, and phrases assumed their rightful professional tone. 'I'm trying to recreate the duality of urban enclosure as both physical confinement and symbolic representation.' In designing an elaborate farmhouse, I was always careful to select the right words to convey the importance of architecture. If I added a colonial mirror-cum-hat stand to the entrance hall it was called an 'Arrival Loggia'. The drawing room, however cramped, was christened 'Entertainment Galleria'. In discussing the bedroom on the drawings, I made sure we marked it as 'Sleeping Chamber'. The thing to remember was not what a building was, but how it would be perceived. If people had made a financial success of their life, my job was merely to make them enjoy it all the more, despite all the lies I told them and myself.[2]

In the profession however, the worth of a man was measured by quantity, not by the thoughtful exercise of his faculties and practices. At first when I'd be asked if I had designed any schools, I would honestly say no, I hadn't. My inexperience, I thought, would become a positive attribute in a profession where replication of well-seasoned ideas had become the norm. But that was not so. A promoter of a new school was as interested in innovative school design as he was in innovative educational ideas. In a country where a child was born every 1.2 seconds, school was a matter of business, not education. Schools put up quickly constructed class-rooms in easy repeatable progression along a corridor; rooms meant students, students meant money, more students, more money. Architecture was for those with time to discuss, experiment, implement. It engaged a series of testing minds in the uncertain area of education. Architecture was a waste of time.

Since school projects never came my way, nor new museums, new laboratories, new houses, new commercial centres, not even new architecture schools, a different approach had to be adopted. I realized that till I made deception the central theme of my career I would not be successful, I would not be true to the profession the way it had come to be practised. So I learned to lie, to cheat like a true professional. I redid my resumé giving myself a few false degrees from notable foreign universi-ties: LAF (Hons.) UC Berkeley, MCP (also Hons.) from Sorbonne. It was import-ant to demonstrate a well-rounded international background in a variety of fields related to architecture. In case a new industrial township was required in Bihar, the MCP from Sorbonne would help me secure the contract, if the Airports Authority

2. In reality though, after building some small mud projects in the villages around Delhi, I realized how utterly alien the material was to me. Apart from its structural potential, I didn't possess any connection to it. I had no sensory feel for the place it created, nor any real affinity with people who had absorbed it into their daily life. No real idea of rural lifestyles. The same way, when we were working on a luxury hotel, I was again out of my depths. My idea of luxury was very different from that of a business executive who lived in and out of hotel rooms. I was as much an outsider to village ways as to hotel etiquette. In both places I was an outsider. And the only way I could be an architect was if I was asked to build for people who were like me, those who shared my own cultural background and my own memories of architecture.

needed designs for new terminals, the LAF (Berkeley) should do the trick. Then I gave myself a number of important fellowships that nobody could really trace: the 1984 Fulham Fellowship for Design Relevance, 1991 Ernest Vanguard Trust Scholarship for Housing in the Developing World. Both helped to state that despite stints abroad, my heart was in the right place; that even while at a student rally in Berkeley, my mind was actually grappling with deeply relevant concerns afflicting my home situation in India. There could be no better individual where national commitment was concerned. Such ideological concern was also reflected in a listing of international awards that followed: the 1986 Arnold Borinsky Award for Global Understanding through Design, the 1978 Pan American Medal of Honour, and the 1996 CIBA Brooch for Excellence in Historic Conservation.[3] And of course the International Competition for the new Apple Headquarters in New York.[4] It was important for the prospective client to feel that he was going to be dealing with an idealist-cum-humanist-cum-activist-cum-realist with a deep sense of historical continuity. He had read *Fountainhead*.[5]

But for the prospective client, leafing through a catalogue of personal achievement was not enough. A man who wanted a building on a difficult land acquisition wanted to see architecture in colour photographs, wide-angled and in double-spread. He wanted to run his eyes over glossy 8 × 10's and 10 × 12's of architecture. No awards for international understanding could substitute for the real thing.

The colour pictures would then make an appearance. If I sensed that the man was a traditionalist with a deep and abiding love for the way houses were made in the past, I would bring out the photos of stone houses in a mountain village or a cluster of handcrafted and decorated desert homes from Jaisalmer. 'These were done during my student days,' I would say with practised nonchalance, 'when we were doing a project on vernacular forms.' Nothing like a picture of latticed stone screens and courtyards from a haveli to convey an architect's commitment to tradition.

'You are very committed to tradition, I can see,' the client would invariably say, while his eyes admired the stone dwellings.

'Only for its value as an instrument of continuity,' I would invariably add, while my hands groped in the drawer for the contract. The client would cast an affectionate glance at me, a look that would clearly say that he had found his architect.

Then there would be others who thought of architecture not as a means of providing space, but a method of making their building different from anything anyone

3. Some time back, the office received a mail for an annual architecture award. The sponsoring company called for us to nominate as many buildings from a variety of categories: hotel, housing, office, industrial, interior, whatever. As long as we accompanied every project with a ₹40,000 entry fee, the award was guaranteed. Nominations happen in the summer so that you can wear a suit to the winter award ceremony, held at the Taj Land's End in Mumbai. If for some reason we don't get this award there are 12 TV channels that give similar annual awards, 8 Indian Design magazines, 6 newspapers, and numerous interior and toilet fitting and cement manufacturers. Last year, we paid for, and received a gold-plated replica of an outdoor shower from a bathroom fixture company, in the 'Spa of the Year' category. Accompanied by a lavish dinner, and a speech on the Future of Indian Architecture by the CMD of the Toilet Fixture Company. Twenty-five years ago, awards were rare, and given for achievement assessed by a serious jury of peers. But in a culture of narcissism, the badge of merit or achievement is both unnecessary and difficult to assess. What could be better then, than giving yourself the award you deserve. In sports, advertising, news media, design, engineering, politics, wherever you look, everyone of any public standing is being conferred a prize.

4. Architects registered with the Institute of Architecture, a defunct professional body, are asked to submit entries for a design competition for a New Town Centre for Metropolitan Madras to be called New Madras. Although the choice of the architect has already been narrowed down to two: Pradeep Kotla of Pradeep Kotla & Associates, nephew of the present mayor, and Subhash Grewal, architect and son of the Deputy Chief Engineer of the Madras Municipal Corporation, our politics of nepotism coupled with a sense of fair play compel us to advertise for a third candidate and break this deadlock. A panel of internationally acclaimed architects from the Public Works Department and retired and partially senile teachers from the local engineering college will judge all projects with complete impartiality before selecting the Mayor's son for the job. Forms asking for useless details may be obtained from the run-down office of the Institute of Architecture in New Delhi upon payment of ₹5,000. Bribery of judges with cash payment under the Code of Ethics of the Institute of Architecture is strictly prohibited but bundles of cash and bottles of rum will be accepted after working hours in homes of the selection committee members.

5. I think, as architects we all start our professional life as Peter Keating, succumbing easily to the mediocrity around, and as we grow, we slowly age into very private Howard Roarks. Ironically, as our influence and quantum of work declines, we become brave and ready to be more experimental.

had ever seen. For them I would bring out a poster-size print of the Sydney Opera House. 'This is a small competition project we completed some years ago,' I would say with as much indifference as I could muster. And add. 'Sorry, but you know, I just haven't had the time to get some of the other bigger buildings photographed.'

'Bigger buildings?' he would ask amazed, sighing with deep satisfaction as he studied the poster, the massive concrete sails of the Opera House, the glistening concrete fantasy floating effortlessly in the light of dusk in Sydney harbour. 'Bigger than this?'

'Well you know the Hongkong and Shanghai Bank, the extension to the Louvre,' I would enumerate with bored apathy. 'The Gerkin Building in London… Fallingwater….'

'No, no, that's all right,' he would say, still mesmerized by the back-lit sails on the poster.

'I know, but I was very keen to take you through one of my old favourites.'

'Old favourites?'

'It's a laboratory building I had done some years ago for Salk….'

'Jonas Salk, the Nobel laureate?'

'Yes Jonas, It's in California. Nice site…. Just above the Pacific. Anyway, the next time you are in La Jolla, I'd love to take you there. I did it with the help of a local architect called Kahn.'[6]

There would be little need to bring in the Seagram building or the Eiffel Tower into the discussion. The client by now would be fumbling with the pages of the contract, furiously searching out the dotted line.

Besides the monumentality of his buildings, the architect's concern for landscaping invariably created a favourable impression with the client. He would see in the carefully tended garden around the building that there was more to architecture than mere form and concrete. 'See here. We had this client, a Frenchman, he wanted a very formal layout.' I would say handing him another photograph depicting the garden design in a long shot, an aerial view of Versailles.

6. Whatever the nature of the project, Kahn always wanted to get to the very source of architecture. 'I want to discover the nature of the building,' he said, when designing the Bangladesh Assembly in Dhaka. He looked relaxed and tanned in the Bengal sun.

'It's an assembly building, Lou,' said his engineer Nick reasonably. 'Where people assemble.'

'I don't just mean assembly,' said Kahn, 'I mean assembly, as in the nature of assembly.'

Everyone started dispersing. Le Recolais looked up at the cloudless sky; Nick looked at the mossy ground. Norman Rice slowly meandered away.

'The assembly is a place of transcendence for political people,' Lou continued. 'In a house of legislation, you are dealing with circumstantial conditions. The assembly establishes or modifies the institutions of man.'

'What you mean is that if a country like Bangladesh begins to have institutions, the rest of the world is in trouble,' someone added helpfully.

'What I mean is that prayer is central to the wellbeing of the Bangladeshi. It is an immeasurable realization that I have only just realized.'

So, Kahn made the entrance to the whole complex through a mosque. And gave the bewildered ministers, alighting from their Toyotas to discuss the country's foreign policy, 30,000 square feet of fully carpeted floor space, oriented towards Mecca. It was the only official place, where they could officially fall to their knees before proceeding to discuss rebel insurgency in their home towns inside the great central hall. Into the dark depths of this religious sanctum they were propelled by the centrifugal force of Kahn's building plan. And while they ranted and raved in some indecipherable provincial Bengali dialect about flood protection for the masses, or newer food subsidies to the drought-prone areas, Louis Kahn's heavenly light fell from the great beams and arcs of the roof structure above, animating their faces, and casting the final shadows of Western influence on the architecture of an old, tradition-bound, irrepressible subcontinent. 'Just so ordinary people don't mistake my building for an ordinary institution,' Lou said, 'I've decided to call the building the Citadel of the Assembly.' And as soon as people around him also started calling it the Citadel of the Assembly he quickly changed it to the Citadel of the Institutions of Man. There was no way anyone, let alone a learned Bangladeshi, was going to say that he was just going over to his office in the Citadel of the Institutions of Man without having a brick hurled at him.

'What a large estate,' the client would add, thoroughly impressed.

'Well, not really,' I would say with the apathy beginning to build. 'It's seven hundred acres; but only two hundred are landscaped.'

'Two hundred!' The client, aghast at a size which could normally accommodate a small township, would scrutinize the manicured grass, the manicured hedges and topiaries and the manicured peopleless walks, the grand symmetries of water bodies, the marble statuary, the great flanks and approaches, and then comment. 'It's very beautiful, but I'm sure maintenance cost is very high… do you have something more cost effective, more intimate maybe?'

'Yes, yes, of course,' I would say, and pull out photographs of the Katsura palace and gardens in Kyoto.

I thought I had outwitted the situation till I learnt of an architect given to greater deviousness than me. Apparently, he had realized, in the course of his numerous dealings, that the client was ignorant of the ways of architecture. And capitalizing on the advantages of his ignorance, he had decided to run his practice like a doctor's clinic. The waiting room was larger than his own private office; there, enthusiastic couples came and waited, bringing their dreams, their hopes, their copies of the site plans, sitting under the lethargic blades of an Usha fan, thumbing through back issues of *Sports Illustrated* and *Inside Outside*, recapitulating in their silence, each other's threshold of architectural desire, exchanging looks that conveyed the size of the living rooms, furtive glances that indicated the position of the bathrooms—an imaginary plan, all rehearsed and re-rehearsed in a multitude of shared dreams. The bell would ring; their hearts would ache with a mixture of longing and fear. The wife would reach into her bag for her own copy of *Inside Outside*, the one with the fancy Himalayan-style house in Kerala.[7] The husband would reach into his breast pocket to brush his fingers against the cheque book. They would glance at each other again, unsure of the difficult road that lay ahead; the journey through which they were now eternally bound.

Inside, Mr Chawla sat at a small table with one large blueprint before him, and a thousand coloured photographs of the city's choicest houses—photos of cornices and balustrades of marble, photos across lawns and along carving driveways, pictures of austere single-storey dwellings and self-stylized three-storey bungalows; pictures for which the proprietor of Sharma Studio in the market had been paid a small professional fee that covered the cost of two rolls of Kodachrome and an

7. Milestone Home Delivery Company set up 1982 under National Home Rule Act, with branches in all major cities and villages. We manufacture some of the finest homes at our factory in Meerut and ship them to any part of the country. Custom designed homes made of the finest materials and assembled by our team of internationally renowned architects. Choose from ever popular range of styles—from the simple Punjabi Baroque to the more elaborate Bania Gothic. If you are a Marwari or a Sindhi, choose a Hacienda style or an Italian Revival. We have some of the finest Kitsch styles for our Nouveau Riche clients. Or select a simple Modern. Just place an order on our toll-free number 816-3192 and within 48 hours your house will be on its way. Our engineers will come and plant it for you on the ground. So hurry call now. Order within 7 days and get a 20% discount on our Early Halwai Model.

afternoon's scooter fare. The couple would gaze lovingly at the portraiture and be filled with the agonized longing that afflicts people at the edge of an emotional chasm; the architect would look at his watch. An impatient man, a temperamental artist, he had work to do, his own dreams to realize. He had no time for petty sentimentality. There were other couples waiting their turn outside.

'Now how can I help you?' he would ask.

'Well, you know,' the husband would begin, 'we have a plot….'

'Yes, yes! I know you have a plot.' The architect has no time for frivolous chit-chat.

'Our neighbours have a Renaissance façade,' the wife would add helpfully.

'All granite.' The husband would chip in.

'I don't care what your neighbours have; you are not here to redesign their house now, are you?' The temperamental artist in the architect would surface. 'Think of your house as an object in space….'[8]

'Of course, of course!' the husband would say, restraining his wife with a sideways glance. 'We want number 17.' He would point to the numbered photograph behind the architect, the house with the painted Rajasthani entrance and the Venetian windows under a front porch of Egyptian columns.

The architect would swivel in his chair and confirm. 'That one, the Rajasthani Gothic.'

'Yes,' the wife would say in reconfirmation, 'but could we have stained glass in the window?' Just to state her own independent mind, her own architectural options.

The architect would nod, swivel back to his desk and start writing a prescription. One Rajasthani Gothic with stained glass, at 75 Mayur Vihar. 'Any other preferences?' he would ask, like a doctor inquiring about a patient's symptoms.

'Yes, we want Vaastu,' the wife would say.[9]

'I want a skylight in the study.' It was the husband's turn to state his architectural options. 'Plexiglass skylight. Blue, to reflect the colour of the sky.'

8. Architecture as an object in space—a rudderless, free-floating idea that has no real meaning, and no reason to exist other than the simplistic defined need of commerce, or residence, or trade. What makes it architecture are the people and places: people meaning culture, and places meaning history and terrain. Where the building sits, why, who uses it, what for, are concerns of sociology and history, without which the building is only 'an object in space'.

9. Some years ago, a friend and his family fell into an unfortunate decline as soon as they moved into a new house. Rahul was an accountant, with an office in the garage, his wife, Radha, a beautician. Their son Adarsh was doing philosophy honours from St. Stephens, while Kavita, the youngest, volunteered at a charitable clinic. The family often ate together but was acutely aware that some celestial miscalculation was responsible for their unambitious lives. A few months into their sad existence, Radha asked if she could get the house realigned according to Vaastu principles. 'But Rahul must not know' she said, 'he doesn't believe in it.' So, when Rahul left for two weeks to cremate his mother in Bhopal, a flurry of activity ensued. A host of silver pyramids, bronze plates, etc., were hurriedly inserted into floors at a considerable cost, and before Rahul's return, the carpets pulled across to cover up the signs of reconstruction. Within weeks there was palpable change in the family fortune. Rahul got a job with a machine parts factory in Meerut and Radha won an Amway contract selling door to door in nearby Punjab, leaving little time for the family. Which was just as well, because the kids suddenly came into their own; Adarsh became a bouncer with an upscale Gurgaon bar; Kavita joined a call centre, even acting in local porn films. In every way, thanks to Vaastu, the family tasted the success of the new urban India.

The architectural physician would look up from his notepad, sigh the sad sigh of an artist exposed to an insufferable patron, and rewrite the prescription: One Rajasthani Gothic with stained glass, Vaastu-aligned, and plexiglass skylight in study area.[10] Blue colour. He would then tear out the carbon copy and hand it to the couple. 'Make an appointment for next week and I'll show you the plans.'

Then as the grateful duo shuffled out towards the door, their smiles indicating a couple leaving an adoption agency with a baby of their choice, the architect would add, 'Blue, *haan*! When was the last time you noticed the colour of the sky?' Sarcasm is always the final outburst of the temperamental artist.

The couple would ease their way out of the door satisfied but wondering if hostility and ridicule were the standard sentiments of a client-professional relationship; while Mr Chawla, Architect, AIIA, ARIBA (USA) would ring the bell for the next couple.

The following week a shorter brisker scenario would be played out. The couple would return with high expectations, ease their middle-class frames into the straight-back chairs, and wait for a decision on their architectural fate.

The architect would look up. 'We have been working very hard,' he would say.

The confused couple would look around and wonder who this 'we' was. All they could see was a half-asleep receptionist and a half-awake architect sitting in a garage full of dust-covered photographs. The architect would notice the confused look and briskly add. 'You see, the main office is in Hong Kong.' He would throw his hands in the general direction of the city's most prestigious commercial centre. 'I like to separate the creative process from the production.'

The happy couple would be left with the image of an artistic genius, reclusive in his creativity, but supported by acres of draftsmen and engineers in a distant building, all drawing away furiously, bringing the master's imaginative notions to realization. India's very own Frank Lloyd Wright.[11]

'Yes, we have all been working very hard,' he would repeat; then he would reach into his desk drawer and withdraw a rolled blueprint, the only blueprint in the drawer, a drawing that duplicated the colour of his client's skylight; then he would spread it across the table. Leaning back on his swivel chair, he would flick the gold lighter at the dangling cigarette, blow a trail of smoke into the airless cubicle and ask, 'How do you like it? Good, *haan*?'

10. The rise of the middleclass is now part of the larger urge to possess all that had been impossible earlier—architecture, art and design has entered the realm of gold and jewellery at one end, and the daily haggle at the vegetable market at the other. As a culture flaw, it is impossible to have a collective agreement on architecture, or any form of overriding belief or precise method in a way of judging it, or practising it. We are thus duly condemned to relive the past, repeat mistakes, and hope for redemption in some future invasion from other cultures.

11. Frank Lloyd Wright died in 1959, but like Lenin they made sure that death would not dilute his ideology. If Wright's reputation did not suffer in the turmoil of 20th-century architectural thought, it is only because he clearly established himself as the leader of the pack. At least among architects who were looking for a leader. When a five-feet high portrait of the man who was the greatest architect of all time appeared on the rough stone walls of Taleisen, architects from all over the world came to touch its gilded frame and gaze into the deep-set mid-western eyes, to see if they might extract something of the man's greatness. His presence in a larger than life portrait commanded a respect and awe and fear that could hardly be expected of oversized Kodak paper dipped in photographer's solution. But it did. 'I am not only the greatest architect in America, I am the greatest architect of the century,' Wright glared modestly under the auditorium lights. It was a statement that carried a surprisingly authentic ring to it; it was modest, it was true, it was American. Moreover, since Wright's career spanned the 19th and 20th centuries, it was uncertain which century the claim was being made for. Warm, humble and intensely humane. Frank Lloyd Wright's image of himself as an architect was always at variance with people's image of him as a person. If the Chicago audience clapped a little too loudly, it is only because they thought that Frank was kidding. 'Ha! What a kidder,' they said, 'what a clown, what a guy,' Luckily Frank Lloyd Wright was blessed with a sense of personal superiority that transcended his modesty. He didn't smile.

The couple would strain their eyes in the gloom of the place and scan the undecipherable blue sheet before them for some clue to their professed architectural desires: the skylight and the stained glass, the barbecue pit, the sunken conversation pit, the raised jacuzzi. Amidst the faded blueness they would notice instead, numbers and dimension lines and triangular symbols, and words like floor levels, rear elevation and window schedules. And they would feel eminently satisfied.

'The dining ensemble is the focal piece of the composition.'[12]

'Any questions,' the architect would ask.

'No, no! No questions,' the husband would say, restraining his wife with a quick side glance, and pulling out the cheque book. The artist should not be troubled with minor details.

The cheque would be placed in the breast pocket, the blueprint in the drawer. The bell would be rung again. Another couple would enter; the one wanting a Palladian staircase in a Gujarati haveli, with the Spanish tile Japanese roof. They would sit before the master, who would retract the same blueprint, and architecture would begin all over again.

12. In a dead-pan memorable scene from the Fellini Film *The Discreet Charm of the Bourgeoisie*, people are seated around a formal dining table. Chatting as the well-to-do do when in close proximity with others like themselves. There is however no food on the table. Not unusual since all of them are bare-bottomed and seated on WCs performing the task of give-out rather than in-take. The servant passes around rolls of toilet paper. In the midst of this convivial banter over a community excretion, one man suddenly gets up, excuses himself, pulls up his pants and rushes into a little cubicle, where he furiously eats at a small table, even shouting a harried 'occupied' when someone knocks. There is no better illustration of the social interchangeability of the ingestion of food and its outflow. Both are, as Fellini said, controlled bodily functions, performed quietly and without fuss. Why then is so much public attention and enterprise lavished on one, while the other languishes in private squalor in dark cells. The bathroom and the dining room are merely two spatial allotments of the body's daily pressing needs.

8. Architecture and the Bureaucrat

If the architect had reduced his profession to a game of bluff, the government only promoted greater transparency in its daily practices.[1] As I have said earlier, so much money changes hands there is little left for the purpose for which it was originally allocated.

But there are always exceptions. In 1986 I met an unusual IAS man. Scrupulously honest, a thoroughbred scholar of Indian texts and with a keen interest in literature and science, he was moreover filled with an achingly sincere inquiry about every little aspect of daily life. He sold me a piece of land at the rate at which he had acquired it 15 years earlier, dismissing his right to its new market value with a shrug, 'If I had wanted to make money I wouldn't be in the IAS.' A few years later when the government posted hefty back pay packages for itself, he distributed his windfall to all those lesser individuals who had served him, meticulously locating each one in distant UP villages and towns. So ideally suited to the IAS life, and the professional call to resolving daily battles of Indian administration he was a natural for the UP cadre. After five years of service he retired with as much enthusiasm for the premature exit as for his original enlisting. Someone had tried to bribe him.[2]

At the time the travails of an IAS association in UP had left me with an altogether different experience. The building was a small dance and theatre complex in Varanasi fielded by the Department of Culture.[3] Indeed, in Uttar Pradesh, in the hands of government officials, architecture was one thing, but its realization into building was entirely another. After five and a half kilograms of needless paperwork that accumulated over seven years, the project progressed, or rather limped, towards construction.[4] Intricate site plans, working drawings in quadruplicate, perspectives in spectra colour, detailed specifications, building estimates, parking diagrams and seating capacity charts were submitted, with copies to the client, copies to the Culture Secretary, copies to the building organization and to the co-ordinating agency. In an effort to keep the peace with a burgeoning state machinery, letters full of bureaucratic parlance were exchanged in a weekly banter of official jargon. They always ran: *We wish to hereby inform you with reference to your letter DO/SC/10/319/File 612/AC9-7 52, dated 10-8-91, received 13.8.91, and filed 18.8.91 under 'Misc. Culture Corres.'—that the hereinunder concrete floor slab, hereafter called concrete floor slab of the first part, was cast yesterday dated 7.9.1991*

1. Once considered the bane of Indian society, corruption surprisingly is no longer a contentious issue. A growing transparency in bribery, and an annual audit of bribes by the Vigilance Department, had made life easier. Everyone was corrupt; the idea that a government doctor could supplement his income by accepting money from a patient in hospital for a difficult neurosurgery was the logical evolution of a just and democratic system in which the patient had himself taken the money from someone for granting an illegal licence. Both had gained in the transaction, even if the doctor's bribing of the medical examination board now put the same patient at a minor risk.

2. At a train ticket counter once, I was approached by a tout who promised me a substantial discount on my ticket, if only I agreed to walk with a limp when in the ticket checker's sightline. Thirty percent, he said, and proceeded to demonstrate how I must drag my right foot to give the appearance of a handicapped person. But, I don't have a problem, I protested. He assured me that he was a man of conscience, and my secret would be safe with him. I merely had to act out the falsehood and claim my discount. Ever since the government had introduced the scheme, he justified, he had done it for hundreds of people. The idea that India's biggest enemy is India itself has been around as far back as I can remember. Nobody has ever raised a grateful eyebrow at a government idea or largesse that may in fact offer some benefit. The first and primary feeling is suspicion, as if every act of the government or any large institution is a form of betrayal. Why are they doing this, and how can I outwit them with a scheme of my own?

3. The project was acquired just the way projects are normally acquired in India—through a friend of a relative.

Are you busy these days, he had asked, as we sat sipping Kingfisher at the Gymkhana. It was 11 am on a weekday, a working day. But I put up a brave professional front.

'Busy? Of course, we are busy. I just completed the plan for an industrial township. You know, Greater NOIDA Part II, Phase 3, Big project. This is just a short respite,' I yearned to let him know I hadn't slept all night.

'Really?' He seemed surprised.

'Yes! Really. The office boys are drawing it up.' I said this knowing full well that the office boys were doing no such thing. In fact, the office boy, namely me, was sipping Kingfisher with a friend in the Gymkhana.

'You know,' my friend said, 'I am the Director of the Hindu Natya Akademi.'

'Oh! I had no idea! I thought you were in the IAS.'

'I am,' he said.

'But how can you hold two jobs. I know the IAS isn't much work, but still… you probably don't get much time with the family.'

by the appointed contractor, hereinafter called appointed contractor, without appropriate reinforcement. Kindly forward post haste six copies per each in quadruplicate of revised slab drawings as per attached and attested addendum of secondary specification. Hereinafter and aforesaid, yours truly R.P. Vadhera, Assistant to the Deputy Chief Secretary, Dept. of Communications for....[5]

The letters were always touching manifestoes of verbal thrift and forthright communication. I wondered if this innately bureaucratic necessity to complicate matters in the writing was part of a larger game plan—one in which confusion was introduced with a specific purpose of delaying or subverting a given task that disappears in the labyrinthine structure of record-keeping.[6] Perhaps not; perhaps this was the way R.P. Vadhera, assistant to the Deputy Chief Secretary always communicated, maybe even in more personal situations. Imagine him calling his wife late one evening and whispering into the phone: *Darling, I am hereby just making this telephonic communication to hereinunder inform you of the possibility of an aforesaid delay in my personal impending departure from my before-mentioned official premises to my appropriate residential quarters, hereinafter called appropriate residential quarters of the first part. I beg to inform you of this above-mentioned information and seek your pardon for the same.*

Sometimes there would be no communication for several months. And we would begin to think that maybe they had gotten hold of a local architect, a man who could use aforesaids and hereinunder without cringing. Then a government directive would be issued to all departments—Railways, Agriculture, Labour, Petroleum, Mines and Minerals, Food and Alcohol, Electricity, Water, Conventional Energy, Non-conventional Energy, Human Resources, Animal Resources, Environment, even Architecture—that all official dealings were to be conducted in the national language, Hindi. It was an official directive, and so could not be questioned.

Slowly, the replies from the deep recesses of the government would start coming to us in Hindi. They would be full of words that no ordinary Hindi-speaking person had used in the 40 years of his Hindi-speaking life, nor was likely to use in the rest of his Hindi-speaking life. Words like ascharyajanak or vyavastha and samajik—words that only Hindi newsreaders could understand—added another confusing dimension to the growing litany of hereinafters, aforesaids and thereinunders. The new director, however, was a staunch supporter of national unity that could be achieved only through strict adherence to a common language. In my meetings with him we both became acutely aware of our shortcomings. I knew he couldn't speak

'The directorship is an IAS position,' he said, sounding like an IAS official.

'Really!' Now it was my turn to act surprised.

'Yes, really,' he said. 'Well anyway, the reason I asked is that they—I mean we—are looking for an architect.' He raised his administrative eyes up from the frothing glass, to check if the statement had sparked any change in my expression.

It hadn't. I continued to yawn and to look vacantly about me. But the vacant look was an act of conscious deception. I had long ago learnt that the professional way of firmly securing a job was to feign utter disinterest. Never let a client know that you are eager and willing to take on his project. The minute he senses that you are interested, actually enthusiastic, he will take his work elsewhere, So I acted intensely bored, looked at the peeling plaster ceiling, surveying the retired brigadiers slouching on the bar stools. I also whistled for the waiter. 'There is a friend,' I said after ordering another beer, 'he's an architect. I could ask him if you like.' I bent down to tie my already tied shoelace; such was the extent of my boredom.

'I was thinking of you,' he said.

'Me?' I said acting surprised.

'Yes, you.'

'Well! I don't know,' I said finally. It was best to demonstrate disinterest, but within certain limitations. I began to mumble something about having two museums to complete, then that sketch for the National University that had to go to the University Grants Commission; of course, there was also the housing project. 'Well ok,' I finally said grudgingly, 'but it will have to wait till after we finish the Planetarium and Astronomy Complex for the Tatas.'

'I'll wait,' he said, and knowing full well that I was out of work, he signed for the beers and dropped me home in his government car.

The site for the academy lay on a parched and sandy lowland on the undeveloped side of the Gomti, an unmemorable tributary of the Ganga. The sandy stretch that I was shown by the administrative officer as the valuable and expensive urban land newly acquired by the academy was itself memorable for its dryness. The sand swirled around us in summer gusts; there was not a blade of grass in sight, no building nearby, and except for the beige Ambassador car and a driver slumped against the steering wheel, no signs of any human presence. Even the nearest tree was about five miles down the road in the old city.

'This is the most sought after land in the city,' the administrative officer said, 'Most popular.' 'Yes, I can see that,' I scanned the sandy horizon to see if I could spot anything of the old city. 'Right there,' he gestured impatiently again. This time the sweep of his hand also took in the general direction of Lucknow. 'It's quite a nice site,' I said, looking at the sky and trying to muster up some enthusiasm for the emptiness. But I knew the emptiness would not last for long. Given the trend of the city's rapid development the project would, in all

English, he knew I couldn't communicate in Hindi. But since he was the director and a government official, Hindi prevailed. The few times that we met, I would keep watching his lips to decipher what he was saying. But I could do nothing but nod back foolishly in English.

How, I wondered, were we to discuss architecture, when the language barrier had put such a deep rift between us. I noticed that he even started publicly acknowledging my ignorance of Hindi by starting a sentence facing me but completing it in someone else's direction—someone who could speak, cringe and prostrate himself in a suitable national language. This was also his way of suggesting that I was not a good Hindu, that I was a traitor, maybe even a Pakistani. Over the course of several close encounters which employed unofficial translators sitting innocuously with us and whispering some incomprehensible syllables in the right language into appropriate ears, we slowly began to develop a passionate dislike for each other. It was an intense hatred that could not be contained by the boundaries of language. And it certainly didn't need translators. The kind of spiritless disgust he conveyed to me as his initial greeting, or the despondent leer that began to naturally form on my face could hardly be conveyed by intermediaries. He despised me, my guts, my drawings, my Ludhiana jeans and my fake Lacoste shirt. I could see it in the way he winced when I entered his room without knocking or bowing. I could sense it in the planned manner by which he would proceed to busy himself with his files just when I had come to meet him. For my part, I hated his surly manner, his thin manicured moustache which looked as if it belonged on the face of a mindless thug in a B-grade movie, that twitched each time he moved his stained mouth.

I hated the soiled towel that hung on the backrest of his office swivel chair to absorb the afternoon sweat off his meaty neck. I hated the piles of frayed files in which he furiously signed and countersigned a whole range of moth-eaten papers, which he then tied with a shoelace before ringing the fulltime peon.[7] I hated the peon. I hated the bell under his desk which he used to call the ragged man from outside. I hated the way he asked him to hand him a paper clip from the corner of his own desk, an item which he was too lazy to reach for himself. I loathed the large yellowing map of India behind his towel-clad chair, a standard wall-hanging in which he probably had difficulty locating Uttar Pradesh, the state of which he was the Culture Secretary, two broken filing cabinets and a framed mountain scene that could be Kashmir or Uzbekistan—a clutter within which the bureaucrat was a malignant presence.[8] I even began to hate his wife and children, who were permanently looking up and smiling at him from their picture under the desk glass. Altogether it was not a wholesome relationship.

likelihood, very rapidly become part of a dense urban area. In the city, life beyond the boundary wall just cannot be controlled, and may, years later, even reveal situations of rampant encroachment, illegal building and roadside settlement. It is a particularly Indian condition where the street offers to the new migrant from the village the most obvious and immediate form of city employment. Paradoxically the planned city, the string of undistinguished institutions of a neighbourhood, all housing dissimilar, often discordant activities, can no longer confer any sense of belonging to its residents. High walls come up between places that have no common ideology, share no concerns. With neighbours such as the Institute of Statistical Planners, the government's Water Control Board, a hospital and on the opposite edge a major roadway. Such an orientation, not surprisingly, occurs in a number of the newer institution complexes and reflects, in part, the growing uncertainty of life in the city.

4. No country pursues the twin ideals of procrastination and ineptness with such unrestrained enthusiasm. At the core of Indian administration lies the belief that the start of new work is an electoral responsibility. Its rightful conclusion is neither in the statute books nor, after decades of practice, even public expectation. The list is extensive. State and national road projects including the grand quadrilateral, 7–9 years behind schedule; airport and infrastructure projects sanctioned, but incomplete; state education and health projects, foundation stones laid, *pujas* done, work delayed; expansion of the central rail network, 13 years behind schedule; rural irrigation and water schemes, 16-year average delay, and so on. In a system where bureaucratic norms provide a shifting responsibility, the urge to delay and incompletion has official sanction. In charge of surface transport in one posting, culture in the next, sugar control board in another, the Indian bureaucrat is licensed to remain a floater, skimming the surfaces of different departments, studying proposals, starting up projects, and just as the first brick is laid, moving on.

5. A news story a few years ago had a sentence: PMO and UPA including Delhi CM likely to be indicted by CAG in CWG. Such lazy writing presumes the reader is entirely clued into Indian politics. But a foreigner reading it may understand that a pre-menstrual obstruction and a uterine pituitary ambulatory are the cause of a constriction of the aortic globulin. If you drive along the hills in Himachal, you will come across other sets of government signs whose language seems to have been fashioned by a frustrated, but highly moral poet. Marry Safety Divorce Speed. Then an almost Wordsworth-like We love you enough, About Safety We Never Bluff. Or the more risqué, If you love porn, at curves sound horn. In an important government department in Dehradun, the Bureau of Road and Infrastructure Poetry, grown men sit around a table to discuss their inspirations. 'Aare Prakash, how's this: If Your Bus falls in Khud, Life is Nipped in the Bud?' 'Yaar, you are almost Tagore.'

He was an IAS man, self-absorbed and hungry to project his powerful hold over the dispossessed and wretched of the state, which he doubtless did in his private time. He was a person who probably had a long family history of bureaucracy, just the way normal families have histories of heart disease, gout and arthritis. It was possible to discern from his permanent petulance that his schooling had probably been at some exclusive place like Mayo or Doon, his college probably St. Stephen's, or IIT. With such a desirable past, he spoke from a position of unquestionable authority. I, on the other hand, was only a private citizen—free-floating, rooted to no past, no future, whatever that was worth, in not having followed the rightful path of family, education and career, I spoke from the unsure tentative standpoint of an unknown family and dubious schooling. But language, family, education, profession, caste, status and personal hatred were only minor barriers between us. For some odd reason the man was full of frustrated rage, a rage that went much beyond the inability to communicate in a foreigner's tongue to another human being, on equal terms with a certain human cordiality. Much beyond the endless social measures he promoted as a conscientious bureaucrat. Only when he started raising objections to the openness of the plan and resenting the wideopen plaza across which you entered the building and finding fault with the languid stretches of tiers in the open-air amphitheatre, did I learn the real reason for his bitterness.

The man had had a chequered career; he had been hit by a difficult downswing in the prime of his short bureaucratic life. His arrival in his present seat in the Department of Culture was the most unbearable let-down of all. Although he had been officially promoted from Deputy Secretary in the Department of Prisons to Secretary in the Department of Culture, in his mind, it had been a demotion. There was no doubt about it. Understandable, in a state where there was little difference between criminals and politicians, where election rallies were difficult to tell apart from inner-city gang warfare, where criminals dictated to politicians, most of whom had campaigned for their second term from prison itself.[9] Even though large sums of money had been made and stashed in unlikely places, such a job transfer could only be viewed as a demotion or forced retirement.

He had moved from an important position which involved implementing official policy on crime and politics to one of deciding which painter or mime artist to invite to a forthcoming cultural festival. How could the IAS do such a thing? Everyone knew that his personal interest in criminal politics and political crimes far superseded his inclination for evening ragas and tribal art. Something was terribly wrong with the system, and this despite all his public gestures of austerity and social upliftment.[10] He, as its prime sufferer, was naturally peeved. He directed his

6. The right to information on public works can no longer be merely an access to records but needs direct and shrill public display. A highly visible exhibit of the work with the precise details of its contents—recipes, name and address of its maker—is the only way to shame private misdemeanours for large-scale public actions. Let everyone know in bold type that the broken road between Okhla and Ghaziabad was made by ManiLal contractor. C 3/7 Munirka Avenue, Sector 49, Greater NOIDA. Let everyone know that the new government office for the Department of Agriculture with faulty wiring, broken lifts and ceiling cracks was constructed by the Engineering Section of the DMC, and that the Himalaya View resort was built with a government loan for which a seven-acre forest of Deodars in Kinnaur was sold to a builder by Rajesh Kumar, Indian Forest Services, for forty lakhs delivered in two separate bundles to his relative Kamlesh Singh's home in the outskirts of Shimla.

7. In my office is a full-time government officer of the horticulture department, who is also a full-time peon in my small architecture practice. He gets two salaries, with health and insurance benefits, TA, DA. A diligent worker, I have never once seen him head to his government job. Earlier he used to mark attendance and return, but now a colleague takes care of that minor inconvenience, even delivering his paycheck. Jagan (name changed from Jagat) takes great pride in the fact that he has outwitted the system. By making himself anonymous in a system that favours anonymity he will doubtless go far, a bonus next year, perhaps even a certification of his diligence. Without doubt, he will draw a hefty pension till death, perhaps even after. But it has never struck Jagan that he might be defrauding the government. In his mind he has merely found a way to derive the real benefits of government service.

8. In the 1980s the then prime minister Rajiv Gandhi insisted on physically cleaning up government offices before attempting to create a clean government. However, his proposal for a new aesthetic in the official workplace made everyone uncomfortable. With the introduction of efficient furnishings, no longer could bureaucrats sit on padded leather chairs with towels draped on headrests. A chattai on the floor would not allow them to remove their shoes to rub their soles on nylon carpets. And the most difficult of all, the removal of the old wooden filing cabinet did away with all the prerequisites of the bar hidden behind the files for the afternoon break and siesta. The lockable personal drawer was abandoned for a no storage flat top desk, thereby doing away with space for the brown currency packets. So damaging were these changes to bureaucratic morale, that for many years applicants for the services chose to enlist in the Police and Income Tax. Till of course Rajiv was killed and people could return to their old ways.

peevishness at those unable to retaliate, namely his subordinates, his wife, his archi-tect, his children, his servant. Whenever we disagreed on the seating capacity of the auditorium or on the choice of flooring for the theatrical movement classroom, he would give me a venomous stare, the kind he had earlier reserved for political inmates of the Lucknow prison isolation cell. Whenever I asked him for his choice of stone for the street façade, he would begin to pace up and down the room, in the manner of his earlier days as a glorified prison warden. And I could tell he was incapable of any action.

Just when he had a complete and professional grip of the state's cultural situation, the IAS code struck him down; he was transferred to the Wasteland Development Board in Tamil Nadu. It was a move that came just six months into the job but coin-cided with the laying of the culture centre's foundation stone. Material had been procured on the site, a contractor appointed, engineers, clerks of works, masons, and foremen were busy preparing the groundwork for the construction. A model programme had been set for initiating all the steps towards a fruitful cultural goal.

Another order was issued. The New Culture Secretary had arrived to assert her position; she was a violent upholder of the norms of the civil service (Violence apparently was the only way to uphold civil values). She asked for a halt to all work on the site. It was an official directive. And it was in Hindi. She had just returned from a trip to Canada on a government sponsorship to study district policy plan-ning as part of her former posting as Sub-Magistrate in the Kumaon hills. It had been an important research trip that had given her, and her other IAS colleagues, a good feel for how the Canadian government implemented rural programmes in its backward French-speaking provinces. And it had cost the exchequer only a quarter of a million dollars in foreign exchange. She was looking for a new way to dispense government funds. But, while staying with her sister in Montreal, before returning to her new assignment as an official spokeswoman of culture, she had come across a theatre complex in the city. She had liked it. Some important ideas had formed in her mind. She needed to talk to the architect.

9. *It was found that many of the senior bureaucrats in Madhya Pradesh and Haryana did not follow the government guidelines for extortion, normally released every fiscal quarter. When questioned on this discrepancy, Rajesh Khandelpati, a senior spokesperson spoke to the survey team on condition of anonymity. 'You must understand,' he said in a hushed tone, 'there are great economic disparities in a developing country. Our extortion rates are graded for different strata. What we get from an industrialist is different from what we charge a shoeshine boy. Graded scales are necessary in any democratic set up.'*

10. *Austerity Drive: In view of the budget deficit for the current fiscal year, the Government of Orissa has put into immediate effect stringent austerity measures for all ministries and departments. 'We'll have to tighten our belts and cut out all needless expenditure,' said state finance minister, David Patnaik, at a press briefing at the Oberoi Beach Resort. Dipping into his prawn cocktail, the minister singled out three departments, Primary Health Care, Rural Education, and Women's Welfare, which would be permanently closed, to meet the shortfall. 'We must live like Gandhiji,' he added, and left by helicopter for Delhi, to discuss the grave situation.*

9. Architecture as Style

If homeowners in India take great interest in the exterior of their homes, it is only because they wish to exhibit their idea of architectural style to the street. And not merely to give the public an opportunity to laugh, scoff, or admire, as one might think.

The interior of their home is of course another matter.[1] Local taste, personal prejudices and fears of visual deprivation make them do things that could make for innumerable interesting psychological studies on behaviour. That a flat screen television is placed prominently on the main wall of the living room has less to do with the quality of programmes aired, than the need to display the diagonal width of the screen. Ten years ago, no one could have imagined a chair so unsuited to the human posture as the Shekhawati chair. Now everyone knows. Just because the neighbours have installed a large poster of Niagara Falls in their dining room is reason enough to paste an equally large picture of a New England autumn in yours. It matters little that your home is opposite the municipal bus terminal and is approached through a public urinal. If the basic requirements of a home were not of much importance to Louis XIV, why then should they be to yours? All that matters is style.

In fact, one of the more persistent legacies of modernism is the instilling of a fear among the general public that the architect they employ may not have a sense of style of his own. Before any contract is signed, 'What is your style?' is an inquiry that comes with shrill demand.

I often wonder how best to answer such a query. With honesty, or with the flippancy it deserves. If the question comes from a farmer-turned-garment exporter, I generally say, 'Why, Punjabi Baroque of course', and in a tone that suggests, 'could there be anything else?'. If however, it is a well-travelled executive with a laptop and several foreign postings, the reply is usually centred on the need to be historically correct within a modern perspective. 'We respect history,' I say, and follow it up with, 'but we work with straight lines.'

The house however offers only a partial view of personal style. Among the various implements of daily convenience, the car sets even greater demands on personal status, whether Jaguar or Nano.[2] Colour, size, make, upholstery, gadgets, and extras are the outward manifestation of that status.[3] But the true status-seeker will also convey to you that the car is an EXL 5 Luxury model with a 3.2 L Overhead Cam and a 4x4 Front Wheel Drive with Power Disc Sonic Vibrator and a 260 RP

1. Remember, not so long ago, if you opened the door to your Aunt's Lajpat Nagar residence what you saw—an interior laid out in a quiet simplicity. As quiet and simple as things were in the 60s. Whatever she possessed was on display. Knick-knacks she had bought, or Uncle had swiped from different offices where he had worked. Ugly shells from Marina beach in Madras, ashtrays stolen from the Air India office, a chipped Madonna imitation from somewhere, a couple of pieces of multicoloured porcelain, and of course, something in sandalwood, something in brass, something in driftwood. In other words, the sort of stuff that kabariwallas buy by the kilo. Checkered table cloths were everywhere— behind chairs, even on top of the steel almirah that stood prominently behind the sofa, even there the triangular cloth came as cladding down. A couple of copies of the *Illustrated Weekly of India* and *Femina*, again swiped from the barber shop, lay on the tables. From one corner of the room a Murphy transistor radio was issuing KL Saigal lyrics amid static so shrill, it sounded as if old KL was singing in a thunderstorm. Walls rose up around you in a PWD blue so vivid that the peacock feather fan that hung near the Ganesh calendar appeared almost colourless. But that didn't matter, for on the main wall opposite the entrance, a painting displayed the full colour spectrum from Jenson and Nicholson (When you see colour, think of Aunty).

2. As Beethoven's symphony resounded in the dark hall, suggesting the first sounds of human creation, the strobe lights picked up the bubble of the Nano, and yet another conventional, but cheap, car rolled off the assembly line. At rupees one lakh, the cost of a holiday to Bhutan, the car however generated an excitement that has reverberated much beyond automotive circles. Its export potential, its compact design, its gleaming chrome and dynamic shape, all naturally garnered moments of pride for a nation steeped in a perpetual state of unfinishedness. Incomplete roads, open drains, broken sidewalks, projects delayed, how could something so complete and good looking as the Nano be produced in India by Indian hands? Beyond the allure of a beautiful product, the car addresses none of the larger concerns implicit in its release. It says nothing about the state of the roads on which it will be driven, nothing about the future of fossil fuels, nothing indeed about technology or emissions or the environment. By all counts it is a conventional car. The reasons for such omissions have less to do with the Indian capacity for innovation, than with the psychology of a culture that sees Indian situations as problems to be solved. The mere act of completing the Nano project is itself a matter of great satisfaction. Working within the limits of convention, the Tata approach can hardly be termed a bold initiative. It is, as Ratan Tata himself admitted, merely the promise of a one lakh rupee car, delivered. No one will argue that the central premise behind the Nano is aspirational. Like a house or a watch, people will buy it less to enact a physical change in their life, than as a symbolic improvement of their condition. (Our first family car, an Ambassador, bought by my father, was driven out of the garage everyday, washed and polished, then returned to the garage.) Yet when it is driven, the mere action of its introduction onto the road makes the Nano a public act, to which both, the car owner and manufacturer owe a civic responsibility. Is the one-time payment of road tax enough compensation for the 10 years of congestion and pollution the car will cause?

Automatic Flash Cruise Control. The simple fact of the car's ability to get you from one place to the next is forgotten in a maze of useless ads and notations that make clear differences between used car, second-hand car, and previously owned car.[4]

Oddly, however literate and proud the person is about the statistics of his car, it is unlikely he will give you the same details of say, his fridge, or his air-conditioner. 'You know, ours is a 300 BTU with a 2.8 CFG of Freon and a separate eight cubic foot vegetable compartment.' The car moves on the road, visible to neighbours, and people in a hotel lobby; the fridge sits in the dining room, exposing its 300 BTU status to the domestic help.

As with the house, excessive expenditure on the development of expensive status objects has of course been the hallmark of every successful industry. Tag Heuer watches, Gucci bags, Nike shoes and Ray Bans—each company banks on people's desire for social conformity to ensure that its large investment in untested waters is safe. Instead of reflecting each person's unique personality, new objects are given a mass-produced image of individuality at the factory itself. Such institutionalization of middle-class dreams guarantees the success of the luxury product. To have what you don't need, to buy that which you can't afford, to display that which everyone has, is after all the ultimate test of successful marketing.[5]

There are enough psychological studies damning the supposed inventiveness of new objects. A watch that provides prevailing wind speeds, heart rate, blood pressure, humidity and temperature levels can no longer be called a watch (Should it be available at the watch shop or the chemist?). Just the way a mobile phone with a camera, a calculator, and a microwave oven—the day isn't far—is no longer a phone. When attachments overtake the original function, the implement loses its purpose. Too much convenience becomes an inconvenience.[6]

While the expansion of uses in gadgetry is a form of contrived convenience, its introduction into architecture produces more insidious dangers of social atrophy and isolation. When the home expands its operation with cable TVs, pool and barbeques, beyond sheltering and becomes workplace, entertainment centre, sporting arena, it becomes independent from its neighbourhood—a world unto itself.[7] The successful Indian protects himself with new forms of material entitlements behind encircling shields of privacy. What then is the purpose of living among others, when every domestic action states that you'd rather live alone.

However in a country like India, where aesthetic values have for years been considered a sentimental and unnecessary luxury, a different measure also applies. The

3. The more consumers there are, the easier it is for advertisers and manufactures to make and promote products of greater and greater uselessness. For years, people survived without posturepedic mattress and ergonomic car seat design, but now it is difficult to do so, without getting a backache. And how many of us have just sent ₹8,999 for the Vegomatic Express machine to Vegomatic Services in Hong Kong. Just so our kitchen, that had functioned so far on just a set of knives and a hot plate, can remain up to date.

4. When used cars are sold it's best to give the ad a prefix of Lady Doctor Driven, Maruti 800. If there is no lady doctor in the family, then the next best is 'Army officer used Maruti 800'. Presumably the officer is on border duty and doesn't get a chance to drive. The mere act of possession by a lady doctor or an army officer implies that the car has high pedigree, from a good home. Follow this up with, 'owner going abroad', and you have a legitimate reason to sell the car. Most of our lies are small and white. Some cultural inhibition stops us from simply stating that 'a 12-year-old Maruti 800 that chokes and splutters could be picked up cheap'.

5. My son uses a Gillette Mach III Turbo Triple Edged Razor with Tungsten edge, recently upgraded from the Double Edged Gillette Sensor Series 2. In the half hour it takes him to shave, he also uses a range of beard softeners, gels, aerosol cans of foam and aftershaves, finally emerging with a mild reduction of facial hair. By contrast, my father used an old Bharat blade, which he carefully saved for the next day's shave. The transformation from Bharat blades to Gillette Mach III in a mere 30 years, spells a generational shift from an era of useful functional objects to one of mindless consumer frivolity. But then, the dissociation between function and appearance is a phenomenon of our time, and one of the primary contradictions of the many new objects flooding the market. The shoe store is now a Foot Accessory Studio. Hundreds of sport shoes back lit on a wall of plexiglass. Shoes for tennis, football, running, walking shoes, trekking shoes, strollers, hikers—all displayed with worryingly scientific tags: Triple Density All-purpose Fibre reinforced Base with CVA Heel Support and Gel-pad Shock Absorbers. If you stand in front of the aerodynamic Apollo series with a guiding light in the heel, the salesman will tell you, 'Notice it's got a narrow footprint to cut back on ground friction and air resistance.' The all-purpose PT shoe is a museum relic.

6. I listen to about eight songs on my iPod. Which is a real shame since it has a capacity to store 40,000, plus several full-length films, office accounts and property tax data, and who knows what else. The Apple iPhone 3G has video recording, voice control, GPS, maps, a compass, email, camera and many other non-phone features. Is this the new form of convenience living, to carry all your gadgets in a single object? When such multipurpose-ness overwhelms the original purpose, doesn't the implement in fact become less handy? Similarly, a wrist watch with multiple dials that provide the weather forecast, wind speeds, altitude, heart rate, blood pressure, skin temperature and humidity levels, can hardly be called a watch. That it is sold at watch and jewellery stores and not at a chemist is another matter. But its wearer, proud of its link to Roger Federer and Tiger Woods, is hardly concerned with telling time. Nautilus, a watch that can take water pressure up to a hundred metres below the ocean is usually worn by teenagers who barely go near a swimming pool. Is this plain stupidity or just good marketing?

true determinants of form and function have always been economics and politics. If a concrete box can be built cheaply it will be built to house a family who lost their home in a cyclone, regardless of its suitability. If a government building is acceptable as a district office in Barmer, Rajasthan, there is no reason to change its design for the district office in Nainital. When people are unwilling, indeed unable, to question architectural wisdom, the acceptance of second-rate ideas becomes the norm.[8]

Look at products For many years the only car on the Indian roads was the cream-coloured Ambassador. Luxury meant owning an Ambassador with a sun visor. For decades, HMT produced the only watch for India. It not only told time but could be strapped to the wrist for ease of transportation. Luxury meant getting one with a seconds' hand, and a washable strap. You asked for a watch, you didn't get a camera. The dissociation between function and appearance is an altogether new phenomenon.[9] Moreover, it is one of the primary contradictions of the many new objects flooding the market. Does the HEAD Titanium TX500 racquet allow you a better game of tennis than the Wilson TZ4000? Does the new shopping mall have an external identity different from the new airport? Is the form's technical abstraction an introduction of a new technology or just an intentional distraction?

If you examine the suburban farmhouse in Delhi, Mumbai and Bangalore, you will doubtless notice that outwardly the architecture makes all the right references to the ideal village home: mud walls, rustic wooden doors, local terracotta, sometimes even a thatch roof. But the inner space is of vast proportions, built with the firmness of concrete, air-conditioned, and lighting straight out of an Italian catalogue. A pool in the backyard, behind the barbeque. The lifestyle of Rio clothed in the weary hues of poor India, a contemporary ideal developed out of a self-conscious imitation of country life. The unsuitability of the village to middle class patterns reduces the adaptation to mere imagery but keeps people believing in the value of private choice.[10]

Image-making is a critical aspect of middle-class self-preservation. In an urban village in Delhi, a chef stands by the side of the table, explaining in a French accent, 'Today I prepared a chiaroscuro of contemporary greens, garnished with a traditional base of Dijon mustard in a combination of shredded Brussels sprouts and African melon sprayed lightly, as a cheeky French topping.' You nod and eat quietly. The atmosphere could well be like any country-eating in Provence. Wooden tables, checked table cloths, lit candles, a wine rack, and baskets of bread and cheese. A wicker container at the counter overflowing with fresh baguettes, and white waiters

7. When such specialization and attachments overwhelm the original purpose, the implement becomes less handy. Why is the new Apple iPhone 3G even called a phone? It has video recording, voice control, GPS, maps, a compass, email, camera and so many other features that, short of providing sexual gratification, it does everything. Is this the new form of convenience living, to carry all your gadgets in a single object? Or is too much convenience actually an inconvenience? In a product culture everything gets designed, redesigned and over-designed to fit the changing demands of the era. In the 1950s furniture had spindly legs that splayed outwards. The 60s and 70s returned to the straight line requirements of the age of chrome and steel. After the 1980s objects began to bloat. CD players became fat and rounded with numerous dials and knobs; Cielo cars bulged as if they had consumed a few Marutis. Of late, the Mahindra Scorpio baring its chromium teeth grille is looking threatening enough to make its own road. Big and ugly and powerful is the design dictum of our times. And big and ugly will remain, till some Italian or Scandinavian designer says it's time to move on.

8. Some years ago The Duke of Edinburgh encountered a loose wire hanging off one of the walls of Buckingham Palace; he inquired if an Indian had done the electrical job. His innocent enquiry caused quite a stir among the Indians in the UK, many of whom were not electricians. But the Duke's words hurt, not because they were slanderous, but they succinctly summed up the truth about a cultural trait. Half-baked, incomplete, inconvenience regretted are phrases that have been sunk into Indian urban consciousness. And left us with a deep sense of ineptness, failure, and a growing belief that the Indian is neither capable of attempting ordinary tasks nor completing them satisfactorily. The Duke need only visit an Indian airport to know that his inquiry was not misplaced. That Indian quality, workmanship and incompetence were known around the world was reason enough to buy 'foreign' and know full well that the foreign item would be of long-lasting and of better quality than its Indian counterpart. Part of the mistrust was doubtlessly related to the Indian ability to adapt and copy and reproduce visibly coherent clones of foreign ideas. Part was however related to the belief that people of culture and religion were not expected to be materially advanced or technically progressive. It is a belief that has percolated to all levels of Indian physical and visible landscape. From flyovers that are over designed, to trains that are antiquated, to airports that are inefficient, road systems that breed chaos, and hospital signs that mislead, it takes a mere glance out of a car window to reinforce the idea of India as an incomplete and visibly incoherent man-made landscape.

9. Some newer inventions do away with the original object altogether. Kindle, the electronic reader has dispensed with the book. You hold an electronic page barely a quarter inch thick and pretend that there is a whole book in your hand. Can a 10" long light-weight wireless screen ever be a substitute for a heavy 300-page hardback, with curry stains and a torn book jacket. Will technology ever be a substitute for the sensory pleasure of a book's weight? Amazon, the promoters of Kindle, even promise 'we want to have every book ever printed in any language available within 60 seconds on Kindle'. By employing seduction, pictorial imagery, sci-fi aesthetics and other inessentials of design, marketing companies evoke a sense of newness with the product and ensure that you feel hopelessly outdated if you don't confirm and buy. Consequently, design changes in objects are mostly cosmetic and pointless. Products like car accessories are downright useless: wipers on headlights, indicator lights on side mirrors, sun roofs in the June heat, dimming light switches for dashboards, cup holders,

milling about in the self-possessed arrogance of supporting a French cultural institution. For a short while as you break bread and dip into the smelly cheese, you bask in the sensation that you are sitting in a country house overlooking a vineyard, while the owner's family is crushing grapes for the old favourite, the Pinot Noir with the delicate rustic sweetness you associate with grapes crushed by a Parisian ballerina with unshaven legs; a beautiful image of sensuality, longing and loss; but then as you gaze out of the window, the resident buffalo of the Haryanvi family living across the road, chewing on the garbage outside, lets out a moan, and slops out a large quantity of fresh dung behind its tail. Suddenly the high-priced French cheese acquires a not-so-delightful smell, and you awaken from your Mediterranean dream, and realize the dashed hopes of a quiet meal in rural France, the incompleteness of an urban deception that should have taken into account Indian urban reality.[11]

However hard you try, pretentions of class and aristocracy can never overcome the more lurid popular undercurrent of ordinary life. The deception invariably shows up as an awkward and incompetent idea. If you ever boarded an Air India flight in the 1970s you would know. The flying Maharajah was a fully loaded aircraft bought from Boeing. It had a body, an engine, seats, armrests, seat covers, luggage storage bins, lights. All Air India had to do was add a logo on the wing, fill some fuel and fly. But they had other ideas. The plane was too international looking. So, the inside was redone in red and maroon upholstery, part khadi, part silk; dal-coloured yellow was used on seat covers, and a textured orange rug on the floor. The air hostesses wore matching saris, blending so perfectly into the background, you had to look twice to see her scowling above you. Window flaps were additionally painted with Mughal arches, a scheme that was repeated along the full outer length of the plane. When the jumbo lifted off the runway, it looked as if the entire stone citadel of Fatehpur Sikri was airborne. Complete, with Jodhabai, Miriam and Emperor Akbar's entire entourage. The need to make the plane look Indian required a makeover so overbearing and pretentious, that the machine from the supersonic age was reduced to an Indian decorative stereotype commonly used in restaurants, hotels and homes.

Why do Indian businesses and enterprises feel compelled to make such inherently false statements of style? Even 50 years after Air India began its heroic mission, the need to restate some artificial reminder of India remains a tiring Indian obsession. At Delhi's new airport, a building designed with all the necessary conveniences of air travel, and with the latest technology to move people and planes in the most efficient manner, it is hard to control that nagging fixation that the arriving foreigner must be slapped with some resounding imagery of India. So, in the midst of modern efficiency, inessential artworks and reams of stylized and textured carpeting are

foot lights, lights in boot, foot level AC, spoilers… uselessness upon uselessness, fripperies to astound the most excitable consumer. What are these extras for? Obviously, they didn't appear spontaneously. There is probably a full Research and Development division where grown men sit around a table bouncing off ideas. 'Hey Prakash, why don't we carpet the boot so the luggage is comfortable.' 'Great idea. I was thinking the same for the poor engine doing all the work up front.' 'Let's carpet the road so the tyres can take it easy.'

10. An interesting philosophical debate on the nature of possessions was posed by Amartya Sen in his book Development and Freedom. Beyond the function an object performs in our lives, said Dr Sen, it needs to be examined for its potentials and hazards: Does it nourish or deprive us, does it increase one's accessibility to the community, and does it in fact enhance freedom? While the initial seduction of cell phones, cars, and yachts may spell a new form of personal nourishment, the eventual burden of such things is that they impair freedom, take away too much time and energy that could be devoted to other matters. Though human wellbeing has always been linked to multiple choices. Go to a supermarket anywhere in the US and the choice is enough to get you running back to India to the small neighbourhood grocery store.

11. The desperate bid to make reality better than it is, is the unfortunate trademark of a film industry that refuses to believe that ordinary life can be recorded without trumping up and fictionalizing. Films must use exaggeration and extravagance as legitimate props to make a point. The promotional ads for the film *Bhag Milkha Bhag* show a rather muscular and excessively gym-conscious Milkha Singh, racing across the track in slow motion, a figure of rippling biceps and contoured abs. Had this been the real Milkha, India would doubtless have secured a silver or bronze medal at the 1960 Rome Olympics. But as far as I remember the real athlete was lean and skeletal, closer in physique to African runners rather than the brawn depicted in the film by Farhan Akhtar. Milkha Singh was, and still is, one of India's legendary sporting inspirations, a man of great integrity and immense modesty. In times when heroes were not made by Pepsi endorsements, the Flying Sikh's fourth place was truly commendable. Omprakesh Mehra, the director of *Bhag Milkha Bhag*, has done the legendary Sikh a disservice by making him into a hero of the present Pepsi generation—a lacklustre iron-pumping fleshy nameless poster boy, the kind that hang around gyms, or make deodorant ads.

introduced. After 12 hours of flying, their primary function—to attract by design—is submerged in visual distraction and fatigue. The most rudimentary ideas of efficiency, movement and making distances appear visually shorter, are compromised. By introducing what many may feel is a happy diversion in the airport scheme; the airport's original clarity is reduced to a new form of ugliness.[12]

Over the years, excess and clutter has become one of the few ways of identifying India and Indian places. Its very origin in the Indian home has had a long and tested history.[13] Only in the nature of an acquisitive society could increasing levels of clutter become a class thing. Compare for instance a tribal home in rural Orissa, with a middle-class home in Lucknow or Jaipur. In one, a mud floor and walls freshly hand trowelled, a stove built into the ground, a few gleaming utensils on a shelf, a handmade wooden chest; the place is a picture of thrift and efficiency.[14] In the other, whatever is possessed is displayed. Knick-knacks picked up from a sale. A piece of porcelain from the Frankfurt Duty Free. A Godrej Almirah in one corner, an angled TV with a plastic mat supporting a brass vase of marigolds, a velvet sofa set with flowery head cloths to absorb hair oil. A Ganesh calendar from a machine tools factory. Lamps with silk shades and tassels. On the floor, an imitation Bukhara design. Stackable plastic chairs strewn about in an informal disorder, as if at a family engagement. When the singular purpose was acquisition—more furniture, more degrees, more children, more servants, more cars—the resulting disharmony of the home could be easily overlooked. Clutter was a cultural thing, a uniquely Indian thing of beauty.

Older, more settled households practised an odd material austerity, but learned to extend the idea of selective clutter into daily routine.[15] In the 1960s, the ultimate form of extravagance was a morning silver tea service served in a verandah overlooking a winter lawn glistening with dew drops. Couples sat on wicker chairs like some British landed gentry sipping Lopchu and nibbling on biscuits, gazing unfocussed into the shimmering early winter light. Inactivity in the slovenly splendour of dressing gowns and Kohlapuri chappals was the height of good living. Under the neem tree, a chair, table and hot water had been set up for an hour-long shave. And in the evening the same verandah became a haven for a quiet whisky soda with friends—all gazing happily into the semi-darkness. It was a form of luxury by absence and indolence and an interior steeped in hopeless history.[16]

In the 1980s and 1990s the welter of Indian middle-class possessions pushed the envelope of shared enjoyment indoors into conditioned air and threadbare interiors where minimalism forced families into utter discomfort. Bereft of furniture,

12. If you travel regularly on Indian trains you would be hard-pressed to figure out what makes First Class travel first class. Is it the red nylon carpet that smells of urine, or is it the frilly curtains that smell of sweat and are invariably out of alignment. Could it be the gold-plated curtain rod that falls each time you pull the curtains across, or the cloth pouch near the armrest meant for your valuables, but invariably filled with a banana peel or egg shells. Maybe it's the mirror encased in imitation wood, or the plastic waste bin. Or the tinted windows with moisture between the glass to cut out the view. Maybe it is all these, all the tacky appendages that add clutter to the compartment in the hope of contributing to passenger well-being. Even though all they really do is make the compartment similar to a cheap hotel room in Paharganj. In the arena of public design, the Railways have left their mark.

13. German architect Ludwig Mies van der Rohe was the antithesis of clutter. He had a profound and growing interest in all things related to architecture, like furniture, or fixtures, or textiles, or kitchen gadgets. It was the hallmark of good business to do it all, so you not only got a hefty percentage of design fees, but you also managed the strictest control over the buildings you created. Ludwig's German background made strict control a lot easier. He insisted on designing every visible element in a room, including curtain wall, curtain rods, curtain rail, curtain fabric, the heating pipes, the cooling vents, the glass walls, the onyx walls, the marble walls. If a piece of sculpture was to be included Ludwig made certain he had a chat with the sculptor. 'What type of stone do you plan to use?'

'What particular pose will your figure adapt?'

'How will it be finished?'

'I'll let you know under which track light it is to be located.'

There was nothing that would escape the steely hawk eye of the Bauhaus director. But designing was only a minor facet of his remarkably artistic personality. Mies also insisted on integrating furniture and furnishing as he saw fit and was never swayed by the ill-formed ideas of clients. The chairs were always face to face, always parallel to each other, separated by a rectangular glass table, which was always perpendicular to a lone side board. This was the unique Miesian set-up—a parallel, rectangular or perpendicular. No other composition was possible. It mattered little whether the client was Germany's largest manufacturer of heavy brocaded oak furniture. There was only one way. And if he so much as shifted an ashtray, it was enough to kill the whole scheme.

14. At one extreme, the village mud house, still visible in the 21st century, was the physical manifestation of a primitive building tradition. Its survival was intrinsically linked to the life of its owner, the man who had designed it, built it, and maintained it over the period of his life. If the house returned to the earth after his passing, it was not a physical loss, but like other aspects of village life, a transition to some other stage. The growth of the house, or its demise, even its seasonally applied decoration, recognized the decay and erosions that made building as mortally transient and changeable as its inhabitants.

15. *Within easy reach of a suburban commuter rail line, there once lived a weaver called Mantharaka. Mantharaka was an able male as men go. During the day, he worked the looms,*

the living room was a stone floor with chrome chairs and a corner flower pot, the dining, a geometry of such precise tubular steel, no guest had the courage to venture in to its use. People stood around uncomfortably in the emptiness, acutely aware that they were party to a deeply moving artistic achievement. Thankfully because of minimalism's discomfort, guests left early and the host could retire to the private bedroom, filled with all the politically incorrect knick-knacks that could not be displayed publicly. This period promised the luxury of space and lasted a mere 20 years.

In the search for architectural relevance, the 21st century found another human frailty to practise its newer forms of interior aesthetics. The luxury of experience opened the doors of architecture to the builder and the product manufacturer. Building was no longer a mindless enclosure of minimalist emptiness, but came garnished with all the fripperies that said, I am a consumer, so give me all there is to taste. After years of sensory deprivation, the new owner was ready to live dangerously.

So you put a jacuzzi in the living room, a sofa in the bath room. A kitchenette beside your bed. A pool in the basement. Architecture vaulted to new untested forms of silliness. The multi-tasking of the new age required that every experience have at least a dual nature. If you sat in the jacuzzi it was as much to give yourself a relaxing soak, as it was a social event. In the whirlpool were close friends slurping Mojitos while waters swirled around their legs. And the cricket match between the Punjab Royals and the Pune Warriors was blazing on the 30-feet screen on the opposite wall. This was the good life in America; so it was the good life in India. Occasionally the servant bent down to offer prawn kebabs to the guests in the pool.

If life's primary gifts were related to products, what then was the role of the architect in society? Was he merely a placemaker, or an inventor? Was the architect only an evil necessity, a conduit towards a grand masonry realization, a man whose own ideas, if contrary to the wishes of the builder, could become a preposterous inconvenience.

If the relation between the client and the architect is today one of master and slave, it has a long and unhappy precedence. In the past the builders of villas and palaces, estates and towns, temples and cathedrals, thought of the buildings as their own creations, to be made to their own exacting desires. The purpose of architecture was merely to project a socially powerful image of the maker.

The primary purpose of much Indian historic architecture had likewise been to express power. Islamic rulers asserted their greatness through their palace citadels,

overseeing the warp and the weft under the despotic gaze of the Chairwoman and CEO of the firm. When he returned home, he did the laundry and mopped the floors, before heading out to the community centre to watch the latest video episode of The Male Eunuch with other beasts of burden. There were few other diversions of Mantharaka's life. In the matriarchial society of which he was an unwilling product, his sister had inherited the land, the jewellery and the beach house. He was left with the family stamp collection and his father's old Moulinex mixie. Still, by the existing standards of male wretchedness and exploitation, life was not too bad. One day, while Mantharaka was weaving hard and fast so that he could afford the down payment on a new, fully automatic idli maker, the wooden supports of his loom broke. Splitting clear down the middle, they sent Mantharaka into a fit of economic desperation. Aware that the spare-parts market for used and second-hand looms was somewhat limited in his neck of the woods, he decided to rely on his own innate resourcefulness to get the thing fixed. 'Darling,' he yelled out to his wife

who sprawled on the Lazee-Boy chair, drinking a Heineken and leafing through The Gender Question. 'I'm just heading out to get some wood from the jungle,' Then after a pause he added, 'Don't worry! I'll be back in time to cook your dinner. And make your bed.' Darling was the standard middle-class wife—a heavy-set woman with a vast wardrobe of gabardine pants—whose expectations from a marriage to a middle-aged, downwardly mobile weaver were naturally imperialist. She looked up from the section on Male Menopause that she was reading and cast a derisive glance at her marital unequal. Why does he want to go to the jungle, she wondered. Doesn't he know that most natural forests have already been converted into monoculture timber fields? 'Dalal and Sons—Timber Merchants' down the road had more lumber stashed in their godown than all the forests of North India put together. She considered her husband in an accusatory, non-negotiable manner. Her jaw dropped in a leering smirk, but she didn't say a word. It's his life, I guess, she thought, and sipped the lager peacefully.

16. My own Chachaji collected antique furniture from Chor Bazar—credenzas, chiffonniers, tables, stuff like that. Antique furniture was not like stamps. You couldn't stick it in an album; it needed space. Chachaji had the largest collection of colonial hat stands, all with bevelled mirrors and umbrella racks. He had no hats, but lots of hat stands. If you sat in his drawing room sometimes he'd come and sit next to you, put his arm around your neck and pull you towards his face looking all slimy and devious in his fancy English suit, like he wanted to give you the low down on some deep dark secret about Chachiji. Instead he'd get this twitch at the corner of his mouth, eyes twinkling like mad as he pointed into the room saying something like 'Beta, you know, that over there is a 19th-century French Provincial credenza. With gold leaf decoration, see.' Or he'd wag his pudgy finger towards some dainty little desk with curved legs and add 'I'll let you in on a secret. You, young man, are looking at the very table that Sir Stadford Cripps used when he wrote to Maulana Azad....' Chachaji was an incredible liar. And one of those real pukka sahibs he was, always sitting down to a proper tea in the afternoon, with lace napkins, and silver-rimmed cups and matching saucers, stuff people stored in glass cupboards to show off their old-world status.

burial places and gateways; architectural megalomania was the most convenient ploy for a monarch to keep a permanent and tangible record of his career, a record that outlasted him as well as the succeeding dynasties of despotic grandchildren. Napoleon's admiration for Rome made him seek out architects who would alter Paris into Rome, only with more classical details, more marble on the buildings, more vacuous statuary strewn about the city than anywhere else. For the fascists, Rome wasn't good enough as a capital city. It was a place too deeply enmeshed in history, its architecture clouded by inessential religious ideology; so, they built their own New Rome, ten miles outside Old Rome. For Nehru, Indian architecture wasn't modern enough. It smacked of age, history, tradition and centuries-old common sense, so he built himself Chandigarh.

Those unable to wield political power through prominent public displays of architecture have invariably managed to use the house as an instrument of their expression, if not in the design of large estates then even in miniscule interiors.[17] When American millionaire heiress Alice Vanderbilt hired an architect for her new house it was not to seek his ideas on window details or to ask his advice on the market rates of stone veneer. No, she had grander ambitions. She needed him to make an exact three-dimensional xerox of a French chateau, a type of house she felt was the closest approximation to her own lifestyle. Architect George Post's job was to advise Alice on the selection of which chateau was to be copied, since there seemed to be so many of them floating about the French countryside. After several intense deliberations, Chateau de Blois was eventually chosen for its eternal qualities of grace, its traceries, steep roofs and helicoidal staircases. Moreover, to Alice's millionaire eyes it seemed the most impressive of all the different stone castles she saw in the catalogue. It seemed so archaic, so grand, so steeped in tradition, something she so utterly lacked in her own background. She had to have it. And did.[18]

The building was a fine tasteful selection. Of course, it made much more aesthetic sense in the manicured openness of its original location, along stretches of low hedges, lawns and moats and rusticated stone walkways where old men in berets carried wicker baskets of long, tasteless bread. But Alice had it moved to the corner of Fifty-Seventh Street and Fifth Avenue in midtown Manhattan, where it seemed for some unknown reason suddenly misplaced. All around were high buildings of steel and glass tall structures that had nothing to do with an old country with grand homes of gables and Mansard roofs. Yet, misplacement is in the eyes of the beholder, and since most of the beholders in New York were not French aristocrats, but merely Algerian refugees or Greek hot dog vendors, derelicts and bums, or

Once when the police had called to say Bunty, that's his son, had had an accident, Chachaji happened to be hosting a fancy dinner for some old English guy. He merely excused himself with a smile making it look like he had to use the loo or something then rushing out of the back entrance, had old Bunty admitted to Willingdon Hospital, before sauntering back to the dinner table, all in time to catch the final serving of Lamb Au Gratin or some other fancy dish, and to laugh insanely at the English guy's jokes, just the way Indians did when they wanted something. Chachaji pretended he had real class. Even if the house was burning down you could expect him to act in the typical Chachaji way. He'd probably first wipe the edges of his mouth, fold the napkin carefully and say 'Forgive me, Sir John, I'll be with you in a moment,' before rushing off upstairs to make sure that all his chiffonniers and credenzas and Louis IV chairs were safe, then sliding calmly back into his chair with a 'Ah, now where were we, Sir John,' while Chachiji and the kids were being reduced to ashes in their bedrooms.

17. The new elite has an extraordinary sense of just what, how much and where. Every morning when he breezes downstairs in his crumpled kurta pyjama, he stoops in front of the life size portrait of Sai Baba and sighs, happily readjusting the garland of four-day-old marigolds. With his head bowed he issues a silent, heartfelt prayer. Then he goes to call his stockbroker on his cordless, touch-tone telephone he bought from the smugglers' market. Religion is one thing, real life entirely another. In the drawing room steel highback chairs with angled head rests are arranged around a centre table of tubular steel and bamboo. A nylon bath rug lies under it, covering only a small square portion of the marble floor. When guests arrive in a whole range of safari suits and chiffon sarees, they sit comfortably in a circle drinking Johnny Walker and conversing easily. A purple sofa of raw silk with an eloquent baroque head-piece sits dangerously close to a green, velvet divan, alongside little cane tables with ashtrays from Air India. One entire wall papered with a gigantic poster brings to the Bania home an experience of a New England autumn. But tucked away somewhere in the profuse red and yellow foliage is also a reproduction of a delicate drawing by Michelangelo. The Bania believes in abundance balanced by a quiet understated elegance.

18. It was a glorious century, and everyone, including Frank Lloyd Wright, was enjoying the heady affluence of the time. People were riding about in Chryslers and Cadillacs with chrome and fins, smiling in open air seats, hair flying along Route One, stopping at Dairy Queens or returning home to shoot a few baskets into the net against a suburban garage. Baskin Robbins had just set up a range of ice cream parlours across the country; McDonald's had already sold its one millionth hamburger. A colonel in Kentucky was frying a batch of chicken drumsticks with a secret recipe. Rock groups were beginning to band together in Liverpool. Pop artists like Roy Liechtenstein were becoming intrigued by the aesthetic power of comic books. Working in the advertising department for the Campbell Soup Company, Andy Warhol was learning to make photographic reproductions of Marilyn Monroe and Coca Cola and still be able to make a living. Claes Oldenberg was happy making four-storey high golf balls and clothes pins and calling them art. City officials and administrators were happy buying four-storey high golf balls and clothes pins, installing them at important civic squares, and calling them art. Tax-conscious citizens were happy paying for four-storey high golf balls and clothes pins and calling them art. Everyone was happy. They had to be; they were living the American dream.

uninspired suburban executives on a short lunch break, it hardly mattered. George and Alice were happy with what they had found. They were not about to issue public statements on their building's inappropriateness. They were smug in their newfound history. A few decades later another American millionaire decided that he liked the old London Bridge. It too had history, it had charm, it had all the qualities lacking in the dusty desert trail of Arizona where he lived. So, he bought it and moved it to a spot where he could see it everyday while driving to the supermarket to shop for the evening barbecue.

When whole buildings could be copied or moved across continents, deception became a natural part of the language of architectural communication. Through select words and overworked drawings the architect learns to present an imaginary pictorial and graphic view of the client's dream house.[19] The man may be an officer in the public facilities cell of the Department of Transport. But when he comes to the architect for a two-bedroom low-cost house, all he can afford in an outlying suburban plot on which there are no roads, he has in mind his own version of Fatehpur Sikri as seen in situ, his own rendition of Chateau du Blois as seen on a poster in the French Cultural Centre. Merely for an eclectic selection of history he needs an architect.

Drawings called front elevations and bird's eye perspectives are prepared for him in a bid to explain the architectural idea. The architect shows him a four-bedroom, three-storey mansion, with Gothic windows and a monumental arched entrance. He notes the smile on the client's face. A great deal of colour and shading and fine lines are added to the drawing. Easy chairs are depicted in an extensive front lawn under a grove of sweet-smelling Champa trees. The transport officer likes what he sees. Two cars of recent European vintage and American girth are shown parked in a drive; a man in white uniform is opening the door of the one under the portico. Large panes of bevelled glass are etched into the drawing so as to link the living room with its subsidiary seating den and the garden. The architect acknowledges the client's nods of approval. In a particularly generous gesture, he even throws in a bar near the dining room, for free. There is general satisfaction all around. Hands are shaken, heads nod in pleasure. In the motions are all the signs of a fruitful professional collaboration.

But the architect also learns to protect himself. A new language of architecture has to be learned to express simple ideas of building to people who fall outside the profession. The outsider is a fool and must be made to appear so. If he wants to know why the place for the fridge was made in the kitchen and not in the dining room, he is to be told that it would be out of context, and the architect as an interior designer

19. 'All we really want is a small intimate house with a fireplace for those sub freezing semi-Russian winters,' said Mr Tungendhat. One of Mies van der Rohe's earliest clients, the Tugendhats came from a simple working class background, the only background possible in the Czechoslovakia of the 1930s. 'And a drawing room,' added Mrs. Tungendhat, 'where we could meet other working class couples like ourselves.' With a design brief of such utter simplicity it was unusual for them to seek out an architect of such utter perfection as Mies; but they had heard that he was a simple man and did simple buildings. He let the Tungendhats get a feel of what they were getting via the manifesto of new modernism. 'Architecture's sole duty is the satisfaction of function,' he said. 'Before beginning the project I want to make it amply clear to you, that I never allow function to get in the way of my pursuit of beauty. Let me tell you that the practice of art is far more critical to me then worrying about trivial details of privacy for the bedroom or the provision of some cover between the garage and the house so you don't get soaked. It is more important to keep the chrome columns in a polished state for the photographers, than spend time designing a much needed storeroom, something, which is never likely to make it to the history books. 'I vant to give you an impression of endless free flowing space,' Ludwig said when he presented the model to the bewildered Tugendhats. The outer walls of the house were designed completely in glass; they could be opened by lowering the wall into the floor, so there were virtually no barriers within and around the house at all. Mr Tugendhat could walk between the living room and library and garden dining room, through the garage and back to the living room without realizing he had moved from one place to the next, without even realizing that he had left the house during the short period he had been in the garden. Besides, the Tungendhats couldn't just get away by having Mies do the house only. The architect insisted on making a type of chair which could only fit the universal space but would also conform to the universal arrangement around a centre table which he loved so much. So that when the photographers came from the major journals they not only pictured the Tugendhat house but also the Tugendhat chair; not just the Barcelona pavilion but also the Barcelona chair, not only the Wissenhof housing, but the Wissenhof chair and the Wissenhof armchair. Even though most of the clients for whom these furniture masterpieces were created had long since retreated to physiotherapy centers with intense back problems.

is rightfully exercising his spatial prerogative to determine the positive constraints of the existing site conditions to layout advantage. Moreover, it is all part of the attitudinal difference between members of the same family, and the placement of a household gadget is only a reflection of their underdeveloped sociological instincts which, if improperly placated, could ultimately lead to programmatic misunderstanding, and hence spatial and visual embarrassment. Not to mention psychological disorientation. It is best for the architect to make clever statements to which no one could possibly react, no logical or reasonable person that is. If a client makes an innocent inquiry into why his new house was beginning to look like an oversized cowshed, the architect merely has to turn his head in baleful reproach and explain that the meaning of a building is the inherent nuance and tertiary reference to a vernacular ambiguity. And it is in fact a client's short-sightedness in viewing his home merely as a physical thing in space. If that doesn't work, it is easier to say that the deeper structure of architecture professes a set of fundamental linkages to the complexity and contradictions of a traditional approach to functionalism. If that doesn't shut him up, nothing will.

Whenever a client makes an awkward inquiry like why there are no windows in the living room, or why the study ceiling is three storeys high, the practised professional need only yawn and repeat a sentence from a litany of useful phrases like spatial flexibility, or functional adaptability, or adaptable functionality or aesthetic composition, or harmonic proportion, or proportional harmony, or multifunctional planning or classical purity. With a little bit of experience these can be assembled into effective rejoinders for difficult situations. You see, he repeats, we are only trying to retain the adaptive purity of the multifunctional plan within the aesthetic constraints of the given spatial context. And then watch the client cringe in his own ignorance. Of course, if for some reason the client is not taking enough interest in a design on which you have spent several sleepless nights you could merely rephrase the same statement into a question: You know, Mr Khosla, with due deference to your ideas, I was wondering whether you would like us to retain the adaptive purity and harmonic proportion of the multifunctional plan, given the aesthetic constraints of the spatial context, or would you rather we conserve the spatial dilemma that is so clearly implicit in its anti-classical composition. The inquiry which besides sparking renewed interest and bringing in a quick 'Yes, I think so' answer, would also ease the release of any architectural fee that may be long overdue. No client wants to start losing polemical debate when all he wants is that his dining room get a bit of the morning sun, or a vent be provided in the bathroom. To feel foolish in front of his architect is the last thing on a client's mind. But the architect has strung together a new set of visual ideas.[20]

20. 'Less is almost there, less is much, less is more… less is more.' Less is More. The core of Ludwig Mies van de Rohe's being lay in that statement. Mies sought less of everything, less architecture, fewer architects, fewer columns, fewer people, fewer products, less hassle. The search into this very heart of nothingness led him to examine the art of building with a blindingly zen-like consciousness. 'By reducing architecture to its essential elements,' Ludwig believed, 'the architect can heighten the awareness of space. There is little need to look beyond the rectangular cube; if you accept its universal shape as the final solution to the architectural problem, whether a house or an airplane hanger, exhibition pavilion or university auditorium all will be sell. But if you don't and start looking at a structure for its exceptional quality or its humanist intentions, then you are compromising the universality of architecture, and you would be up shit creek, die Scheisse creek.' What Ludwig meant was that the open expressionless, peopleless, furnitureless, treeless and lifeless plan was to be prized above all else, no matter who you were working for. This was an unwritten code of all good architecture. Nothingness had to be worked at to be achieved.

In the end the client will often just nod in complete and utter distaste, but he is happy all the same, knowing that he is dealing with a true professional. After a while when architects actually begin to converse with each other in a language nobody is meant to understand, it becomes a confusing linguistic liaison. A small room is a spatial incongruity. A house which is sometimes referred to as a three-dimensional composition of volumetric elements has a traditional vocabulary and structural devices. A house in a neighbourhood is a thread which has woven the fabric of a city. A simple brick wall is a plane of visual reference. A building doesn't have walls, but envelopes. Windows are replaced by fenestration, and glass by curtain wall. By relying on words rather than on brick and mortar, the intellectually inclined builder begins to see architecture as a metaphor for the larger meaning of life. The simplest and the most ordinary bits of a building can be qualified with a string of meaningful words, captivating and indecipherable phrases that can impart deep and insightful meaning to even a broken shed. But such meaningfulness and indecipherability is essential if an ordinary building is to enter the sacred realm of architecture and remain there for a while. It is not enough to say that the windows can be opened; it is better to say that the Northern cantilevered façade has operable fenestration. You feel foolish suggesting that the room opens into the garden; a more appropriate statement would be that the architecture integrates a dynamic spatial flow between the external and internal realms. We all know that the architect deals with space, and through the course of a career, must develop appropriate signs that state that, Yes, here is a man who understands space. Space flows; a room is called space; a large room is called monumental space, a small one intimate space; material and texture are called mediums of spatial tonality. For the practised professional even the most mundane can be so easily vaulted into a spirit of deep philosophical inquiry.

For the architect to have a wider social appeal, he must also structure his sentences with the rapidly expanding vocabulary of the global age: the economic variables between the orders of consumerist expression must be delinked from regional cultural mannerist tendencies and transmutations. The brittle austerity and extreme functionality of the Early Modernist Movement does little justice to the cultural inheritance of the national heritage of monuments, which actually means that a new building looks odd next to an old one. Architecture is the masterful massing of forms brought together in light, something which Le Corbusier said in defence of his early work, only means, I'll do what I have to, whether you like it or not. When German architect Mies van der Rohe uttered the sacred words 'Less is more' it was not so much a statement on the state of the architectural polemic of the time, than on his own professional abilities. Mies did less than most architects.

There are, of course, some things that are indisputable truths of architecture. North light is good, West light is bad; West light from the north, though a virtual impossibility, is amazing. In designing a house, it is not a good idea to keep the entrance to the prayer room through the bathroom, especially if your client is a religious fanatic. Muslim shrines and Hindu temples should not be built one above the other, or in any way that requires them to share a foundation. In a housing colony the house of a Sharma should not share a courtyard with that of a Yadav, two names whose proximity could start a prolonged caste war. In a commercial-cum-residential complex the placement of a swimming pool above a computer software office may cause problems. In an important national architectural competition the placement of an uncle on the judging panel is not likely to cause problems. When designing a house for a minister the architect must ensure an adequate waiting area where groups of gun-wielding guards can drink cheap liquor and lie about, abusing each other in a friendly local language. Government architects must conform additionally to other unwritten rules of architecture. For large housing projects the architect must leave enough stretches of open ground, where construction debris may be allowed to accumulate, even years after the flats are occupied. Private builders in metropolitan cities must always attach small balconies to apartment blocks, which, once the plans are sanctioned, can be enclosed and sold to unsuspecting buyers as additional bedrooms. For effect it is also important to refer to ordinary things in extraordinary ways. The use of foreign words helps: columns are pilotis (French), a hanging bamboo curtain shading the windows is a bre-soliere (French); a garage is a porte-cochere (French), a room, a salon or chamber (French); a court is an atrium (Greek), a forecourt a piazza (Italian).

If all these can be effectively combined to convey an idea, the architect is understood to have progressed beyond the ordinary needs of a construction science into a more metaphysical realm.[21] The bre-soliere extended to encompass the pilotis such that the ceremony of arrival in the porte cochere could form an effective axial sequence from the airy piazza, across the atrium into the privacy of the salon. In his ability to construct such sentences is the tacit recognition that the architect is now ready to leave the building site and give lectures at the university. He can now talk to younger architects who know nothing about axial sequences and porte cocheres and encompassing pilotis. But when they do, they too will one day leave the school to work at a building site, a place which they will eventually forego to lecture at the university, which will finally turn into a writing career and end in the publication of a gentle reprimanding manifesto on the beleagured state of architecture. Having spent a lifetime complicating the simplest of matters, the architect heaves under the excess weight of self-inflicted baggage.[22] But before retirement the beleaguered

21. A consumate professional learns to complicate the simplest matters. 'The dominant and consistent rhythms which contribute to the validity and vitality of circumstantial complexities,' architect Robert Venturi said, 'are invariably at variance with a manifestation that employs architectural contradiction in an uncontradictory way.' What a fine sentence to begin a seminar with. And that too at Harvard. The front line of academic octogenarians fidgeted with newfound satisfaction in their dark suits and issued the silent smirks of a fulfilling intellectual life.

'What the hell does he mean?' one asked.

'It means that, if you put an Egyptian capital in a modern building it was alright.'

'But if you placed it directly on top of a Doric column it was almost alright.' It was ironic juxtaposition.

'Break the order,' Venturi said. 'The essential meaning of a building can be understood only if you break the order.

"If you are drawing a row of two hundred square windows on a façade, just ensure that you make one that suddenly, for no reason at all, becomes a circle.'

'But shouldn't order first exist before it can be broken?'

Venturi didn't bat an eyelid. 'If spontaneity is accepted as a valid notion introduced to highlight the limitations of an existing order,' he said, 'then should we not create an external manifestation of order by acknowledging the limits of the system within which the building is created?'

'Are you trying to tell him he doesn't know his stuff. Just because he's an Italian from Philadelphia?'

'… a more ambiguously hierarchical relationship of uninflected parts creates a more difficult perceptual whole,' Bob continued.

'… but the whole does not depend on inflection alone. Equal combinations of building parts achieve a whole through superimposition and symmetry rather than through dominance and hierarchy.' But ironic juxtaposition was only one facet of his multilingual architectural personality. Bob spoke eloquently of 'independent wholes' and their 'dependent parts'. He spoke of 'motivational consistencies' and 'fragmentary exclusion'. He knew his architects, and he made no secret of his knowledge. He talked of the works of Kahn, both Albert and Louis, as if he had been a partner in their offices. When he talked of Saarinen, it was invariably about the lesser known Eliel, the father who was unfortunately eclipsed by the greater success of his son, Earo. He muttered revelations about the temple at Luxor and the Vatican

134

artist, stung by a life of academic and construction aggravations will also turn on the computer to record his experiences in a personal story of love and hate and bitterness, a diligent but tragic saga of a working life stilled early by the engulfing architectural blight and professional unrest.

The architect has, after all, a cool exterior, a studied manner; he is part teacher, part practitioner, part writer, a kind of new-age Leonardo dabbling in disciplines for which he has neither training nor skill. When there is no work in the office there is time to write a manifesto or two; when there is nothing to write there are always students willing to listen to a lecture on some obscure but promising new theory of design. Failing which, there is always an informal discussion with local ladies' groups on the irreparable harm private builders are causing to neighbour-hood monuments. Of course, failing that, there is always time for a more formal discussion with local builders on the irreparable harm ladies' conservation groups are causing to a neighbourhood which could replace decrepit old monuments with wonderful new housing.

And the architect's credentials are always impeccable: a diploma from a five-year programme from a recognized school, a specialist degree in some sort of related architectural field like urban design, city planning, backed by another specialist course in Third World development patterns, from Princeton, Sorbonne or Harvard. Low key, cool, gently urbane with just the right doses of reticence and cynicism, he is a man anxious for the great leap forward. Beard speckled white, with glasses shielding eyes in a perpetual state of bewildered anxiety, the expression always a little aloof—an artist, architect, intellectual, urbanist, and professed humanist, the face always displaying a palpable concern at any discussion on rural poverty. Soft-spoken, prone to mumbling when dealing with statistics and statisticians, but able to debate freely in private forums of other architects, mixing historical references from obscure periods with contemporary design dictums.

The blueprint is the most effective product of his architectural endeavours. Its instant association is with the image of the professional as hero; the portrait of the artist as a young man, a man who holds a long roll of bluish paper with a dense marking of lines and dots and figures that clearly mark him as a technical man. The shoulder laptop filled with 3-D translations of his humanist vision. But on the construction site his eyes are shadowed by the hard hat; he raises his arm towards an exposed steel bar on the twentieth floor. Obviously, a man with an eye for detail. A man who turns to the lift foreman next to him to suggest that the contractor recheck the concrete pour joints in the lift diagram before proceeding further. He

in the same breath. He was as familiar with the Byzantine mosaics inside the chapel of Galla Placida as the academic crowd was with the cobbled pathways of Harvard yard.

22. It reminded me of the New Yorker cartoon showing a surgeon standing over the bed of his patient, holding up a complete human skeleton, and saying. 'Mr Brown, look what else we found inside your body—this old structure of bones. It's prone to breakage, calcium deficiencies, back problems, fracture, arthritis… so we took it out.' In a small office I worked for, years earlier in America, the front desk was (wo)manned by a young receptionist named Sophie. Every couple of months Sophie would disappear for a few days, only to return with her smiling cheerful front desk face, happy as ever. Each time she left it was to get some body part removed that had become either mildly unhealthy, infected, or a physical hindrance to her routine. In the four years I worked there Sophie had her thyroid removed, had a kidney hacked, intestine shortened, gall bladder taken out. Those were just the items known to the other office members through standard lunch time conversations. Someone would bite into a roast beef sandwich and proclaim, 'Hey, did you hear about Sophie's ulcer, it burst in her rectum the other day.' When some months later Sophie had her breast removed because of a cancerous nodule, everyone thought this was the end, and soon she would disappear from our lives forever. But she returned, smiles and all. At a time when breast reconstruction was a rarity, Sophie looked happily asymmetrical in her stance. She stuck out her job for many years, getting lighter and lighter by the day, continuing to treat her body with an almost Buddhist-like detachment. For her the body was like an erratic ambassador car, without frills or thrills. When a part failed, she took no time in disposing of it to the side of the road. After that, the car ran better.

stands there, the sun glinting against his Rolex watch, or playing reflections against the tie clip, the only man in a position to make sense of the lines and dots and figures on the blueprint; eyes scanning the print then rising to check its translation into building—a hero, testing his paper imagination on the difficult terrain of a construction site. He has been written about as an arrogant creator, a fountainhead, whose creative powers are also destructive; he has been extolled in movies for his flamboyant lifestyle, the uniqueness of his workplace and home. Surrounded by beautiful women who draft the blueprints for him, carry his coffee, and always keep him in touch with the latest development in the office.

'Sir, Mrs Mathew was here; she wanted to show you the fabric she has selected for the Park View lobby upholstery, you know the muted pinstripe silk that you like.'

'Suresh, Defiance Textiles is setting up a petrochemical unit to manufacture synthetic food for the drought prone regions of Orissa. They want to set up a factory in Bangalore, but they want to know if you can visit their head office in Dubai on Thursday afternoon.'

'Sir, there was a call from the IBD office in London confirming your participation in next week's symposium on "Developing the Underdeveloped World". Would you care to read the paper Sheila has prepared for you?'

'By the way, sir, your wife also called yesterday, just to remind you to keep yourself free for your son's wedding tomorrow. You know the one who's just graduated from architecture school.' And who will despite his poor record be guaranteed a senior partnership in the firm.

The schedule is tight; but for the architect anything is possible. Including nine holes of golf before the Dubai flight.

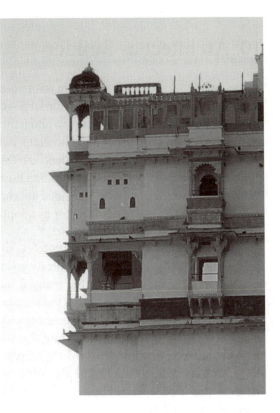

10. Architect as Builder

Through the course of the 1990s when an open economy enlarged the coffers of Indian business and industry, the demand for large-scale construction projects pushed the architect away from the studio into an altogether different inspiration and work ethic and an expression formed out of commerce.[1] Nehru's insistent belief that independent India must have an independently identifiable architecture was abandoned for something entirely new, entirely original. Indian business hopes lay in a Western-oriented futuristic outlook, a singularly one-sided approach that had arguably no architectural merit, but was seen as far-reaching for its adoption of new structure and technology.

The architect, therefore, handily accepted a simplified expression of technology. A three-dimensional graphic of space, merely giving expression to the chaos of the economy and its new shiny symbols. For many, it was a revolution of sorts, much the way building changed in Europe after the industrial revolution. This was India's revolution, India's century. And it was meant to generate a style-less building whose identity lay not in architecture, but in space and structure. The rooted, static and measurable qualities of old buildings were discarded in the dung heap, and in its place grew an intangible uninhibited and classless landscape. The glass office complex, the glass residential tower and the glass mall were separated by a tenuous means of internal organization. The interior designer sanctified the distinctions, the management firm built the structure; the architect was demoted to an intermediary, a distant outsider. The balancing act of building and culture was beyond the scope of architecture. It belonged now to the builder.[2]

The builder's hold on the money and the project manager's on its disbursement had tarnished the traditional aura of the architect. Without reliance on art, politics, history or tradition, the architect had no leg to stand on. Nothing that gave it meaning in an economically vibrant world. Or said that the architect was even required for building. While architecture was a measurable entity, architectural experience was in doubt. The building absence of traditional qualities of familiarity, containment, enclosure or exposure, were being constantly defied by structures that sought other definitions of habitation and a visibly altered appearance.[3]

The dissolution of difference was visible in a classless world, where reflections in plate glass or distortions in stainless steel were the only reminders that you were around buildings. In the international scheme of things, buildings became architecture only when they lent that assertion of visibility to the user. There were external agents always angling their way into architecture's space, the changing shadow in the evening light in atriums. The constant hum of air-conditioning, the sound of Musak, and the staggering collisions of people in restless space. Without the crowd, architecture lost relevance, and became a cow-shed. Sometimes the sheer emptiness

1. If the decline of architectural expression is the outcome of the nexus between politics and business, its relevance to the new Indian city is a question open to debate. Beyond public political symbols is there a larger cultural relevance to civic space? Is it a loss of cultural innocence that every city today has begun to look like the other, so to say become another New York, all at the expense of complex cultural histories and architectural ideas? Perhaps it is inevitable that advanced states of urbanity—highrises, air conditioning, skyscrapers, high density living—invariably produce the same logic of construction wherever it occurs. Beijing, Dubai, Abu Dhabi and many African capitals have been submerged under an uncontrolled commercialism and business order. Even Singapore, so often the source of all architectural planning in India, is merely an urban expression of private commerce.

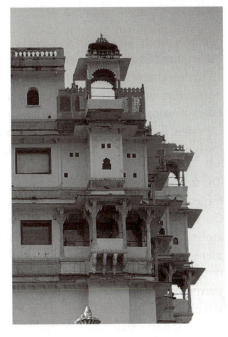

2. Only the rare individual could break away from the pack. In a career that spanned six decades and a firm commitment to Kerala, his adopted home, Laurie Baker built over 2,000 houses, numerous fishing villages, institutional complexes and low-cost cathedrals. It is hard to discount the remarkably varied spectrum of projects that came out of his solitary practice. (Baker employed no draughtsmen, had no office staff, and worked directly with teams of masons and carpenters.) And yet for someone with such a large and varied body of work, Baker had virtually no following in India. His ability to give 'a better building at half the cost' found few takers in a profession that relies on hefty fees and kickbacks; his insistence on discarding coloured tiles, fake veneers and the other useless fripperies of design, left him friendless in the building trade, a trade intent on promoting expensive products. Moreover, his method of practising as architect, builder and contractor all at once defied the antiquated norms of professional practice where each role is specified according to a code of ethics. Baker lived and worked by his own rules. He needed no blueprints or unnecessary architectural details. An idea drawn on the back of an envelope became a building; a coconut palm on a site acquired a courtyard for its future growth. By letting his clients design the house during construction, he even flouted standard municipal approvals. And, in doing so, created his own architectural types, innovated building details, formulated methods of cost reduction, suggested improvements in vernacular technology, and even found new ways of practising the profession. In virtually every building he designed, Baker asserted the appropriateness of traditional methods of construction to local conditions, adopting available materials to newer forms. The single-mindedness with which he pursued his vision of building, the devotion to his craft, and the unwillingness to compromise on quality, was the outcome of the way he himself lived. Simply and without fuss. There was no formal living or dining room in his house. If a visitor were present, he or she merely ate with the family in the kitchen under a ceiling of utensils. A recognition of Baker's contribution to architecture has a singular timeliness today.

3. Part of the desperation to stand out of the crowd has lead design to forms of distension that have moved away from conventional definitions altogether. In Egypt a nursery school building is designed with the children's height in mind; adult teachers crouch in classrooms barely five feet high; in Sweden, like it or not, a building with glass pipes forces residents to see all their bodily expulsions travel to the municipal drainage system. In Dubai, an apartment complex set on a computerized rotation, allows floors to rotate at selected speeds. Some flats are timed to follow the sun, some move around to avoid sunlight, some choose not to revolve. The result is a building profile that is always changing and dynamic, like an enormous mechanical desert reptile on the prowl.

of places meant for crowds was itself an assertion of the formlessness of architectural experience.[4] Every person entering the sight-line, every cloud covering the sun, and all the mechanics required to please the numbers condition architecture. There are no realities of time and distance, no need for the physical markers of dimensions, no expressions of beauty or ugliness, only a constantly passing memory of private experience. Hermetically sealed in comfort, people will walk aimlessly and endlessly, so they will never recall anything of that experience.

The flighty intentions of commerce blend the building mass into a singularly prosaic forgetfulness, from which even the architect cannot escape. Structures even exude that air of mock superiority. And all the trivial details of their differences from others around them bear witness to that effect. The display of wealth is not shared but is mere extravagance. An end in itself. The singular wish is to startle by its presence, not provoke, not attract. A sunless glare, restricting the shine to itself. Architecture's power of possession and ownership that creates visual squalor. So violently detached is some work from its surroundings, so deprived is it from the sustaining power of a common understanding of buildings and the landscape that its ramshackle state is mistaken for human complexity.[5] But since architectural experience had changed, so had the implements of its daily encounters. Buildings had no front and backs; their designing took place 'in the round' which required no side or rear or entrance elevation. The entrance was no longer an oak panelled door, but merely part of a glass wall that moved; preference for opaque surfaces had changed to transparent or reflective. Light from movable windows was earlier a manual operation, allowing people to balance their comfort level inside against the possibilities of the climate outside. Centralized air systems, humidifiers and chilling plants removed the choices to a control room. The building was on its way to becoming Le Corbusier's machine for living in. A mechanical device, much like a power plant. The architect too was on his way to becoming a mechanical engineer, a manipulator of space parts. In many cases he had handed over responsibility altogether to the space doctor.[6]

All the experience of ordinary day-to-day living was slowly disappearing from architecture. Since the choices had been made for you, you no longer opened windows, banged doors, looked for the light switch, changed a bulb, felt enclosed by walls, drew curtains, closed the blinds, repainted ceilings, washed floors, got lost in corridors, got stung by a hive under the eves, smelled the thick air of a summer cooler, felt the heat of a coal fire in the fireplace, watched the monsoon rain seep in through the glass, rubbed your nose in the frosted fog of a winter mirror, lay on a water-cooled stone terrace on a summer night, no. Architecture required no exertion, no effort. You were no longer the cause of the transformation you enacted to space. Merely a cautious recipient. Like a monkey in the closed environment of the zoo. Architecture had changed. And there was no looking back.

4. In such cases it is easy to see that architecture is a genuinely useless activity, one of those rare professions that needs no depth of inquiry, investigation or writing to convey ideas. Instead pictures can be used to tell a story. Important structures make statements about 'skin' and 'shadow', transparency and opacity, materiality and temporality. While these may be valid designer concerns, rarely do their architects talk about human beings and habitation, culture and social norms, or the old dictum that 'real architecture is mere background of life'. Why do people ask so little of their buildings? How does architecture even survive with such low expectations?

5. The psychological dilemma of a spreading city unfortunately fuels both, private aspiration and public apathy. In a city where people are privately demanding and publicly indifferent, it is impossible to create cohesive communities. They want more electricity, more water, more entertainment, more shopping options, more and bigger cars, better schools, better medical care, more servants, house pets, security guards. All life is built on material expectations and promise of their quick delivery. In contrast, public life is steeped in abject squalor. The inability to share urban resources equitably makes for lowering standards of city life. More pollution, uncollected garbage, encroachments, stolen electricity, water wars, road rage, crime and sexual assault. It is well known that high density living makes for corresponding reductions in pollution and energy consumption. People travel shorter distances, save time, and generally live healthier lives. Standard of living surveys set highrise places like New York and Hong Kong above more spread out cities like Paris and Los Angeles. In any multi-use multi-storied scheme there would be obvious questions about infrastructure, parking, utilities, etc. But if thoughtfully conceived, and with ideas that combine both, an Indian sensibility and the new technology, chances are the great middle-class skyscraper will be a success. The daily life of a town—home, work, recreation, commerce, pleasure—occupying the space of a Greater Kailash in one structure, with no driving, no unnecessary commutes, more modest homes, no private land ownership, and a citizenry that engages with each other. The current imagery of the luxury highrise is only a squalid reminder of urban India's architectural class distinctions. And despite the neon wasteland that immodestly claims itself to be Shining India, the country's architecture can be truly heroic if it claims a place in the minds of ordinary people, where the unworkable model of perpetual prosperity and growth is replaced by one of contentment and neighbourliness.

6. Dear Dr Vaastu: I am a successful Brahmin priest with a net income that crossed ₹1crore last year. I operate out of a rented temple premises on the first floor. My landlord is a Muslim who runs a Halal meat shop on the ground floor. Of late I find I am losing some of my regular clientele, specially on days when he is slaughtering cows. Do you think it could be due to a blockage of the north western energy?—Yours, Distressed. Dear Distressed: I don't think I could help you with this one. You see I am a Roman Catholic Christian and I don't understand what you Muslims and Hindus go on about. Have you thought of converting to Christianity? It's a nice religion, it doesn't have too many holidays nor can you make the big bucks, but it lets you eat anything, and every Christmas you get presents. And you can be sure it's not a packet of condoms from the Pope. Dear Vaastu: I have a garage in the north-east corner of the plot, but I have a lot of difficulty parking the car. Do you think the negative energy flow from the east where there is a sewage treatment plant is hampering my driving?—Yours, Desperate. Dear Desperate: Let me first ask, do you have a driving licence? If you do, then where exactly is the garage located? A garage built on the second floor can cause a lot of inconvenience.

11. The Home Owner

Amid the changes, I had a visit from some close friends:

There they came, slowly down the asphalt drive, three grown men driven from their ancestral home, into the sacred fold of architecture. Joginder, Mohinder, and Harminder belonged to the garment industry, and I always thought of them as three overgrown caricatures of their own work life. To me, they were Suiting, Shirting, and Panting. Dressed with the immaculate grace of a fashion magazine advertisement, theirs was a shifting, easy and confident gait, of men indulging in their new affluence.[1]

But they had come to architecture nursing the wounds of a larger religious grudge. The state to which they traced their ancestry was the cauldron of a continuing strife. It was no longer the melting pot of two religions. Brotherly love had become a phrase that found meaning only between the members of a single family. As three earnest individuals seeking little beyond material prosperity, they had been drawn willy-nilly into the religious crossfire—innocent victims, they had become the unhappy bystanders of a national epidemic.

When I first met them, they had appeared restless and agitated under their designer suits. Manufacturers and exporters of garments, they reflected in their manner, the unease of their situation. Jalandhar in Punjab where they lived was torn by religious unrest. And as members of the underdog community, their personal and professional lives had been wilfully unsettled. Perhaps their agitation had something to do with the strife in Punjab; perhaps it had something to do with their being members of a Punjabi joint family; but more likely, something to do with their wearing suits in the warm Delhi sunshine. It was, however, not till much later that I was to discover the real source of their uneasiness.

They had come to me, not out of appreciation of any particular building I had done, but only because we shared the same last name: Bhatia. For much of their own undistinguished past, they had lived only to perpetuate the heady banner of this family name. Protected by ties of kinship, it was as important to their togetherness as an earned title. The importance of a Bhatia could be gauged only in the presence of other Bhatias. And their coming to an architect with the same name was meant to be a revival of the trust lost in the chaos of their present situation in Punjab. Bhatia to Bhatia, this was to be a long-lasting, meaningful,

1. *Zealous as any religious fanatic, there once lived four young men in a damp basement in downtown Moradabad. As second sons of local priests, they were born without the security of a solid business inheritance, and so had to rely on the natural graces of their position in the social hierarchy for peace and mental wellbeing. But in a largely Muslim town, with the job market low for priestly Hindu employment, the four could do little but sit around the local chai shop, swatting flies and shooting bull. So they gave up their rental basement, the too-secular-for-their-liking neighbourhood, their niggling Hindu-undivided-family relatives, their extensive libraries of religious books and parchments, their waterbeds filled with Ganga jal—and started off on their travels into the Himalayas. After a short halt for lunch in the denuded foothills, they headed deeper into the world's youngest mountain range. Into areas, where—except for the occasional yogi government official, timber merchant or Greenpeace volunteer—no ordinary human had been. For many days they continued their uphill climb, persistent and uncomplaining in their arduous task, stopping only for the occasional pee. Then, somewhere near a wayside juice bar, one of them dropped his stick. Digging at the spot, he uncovered—sure enough—a treasure of stone. 'Hey guys, look,' he pointed to the thick juicy slabs emerging in neat cellophane packets, all marked with current prices, ready for sale. But the others were already beyond hearing range. So he collected the stone and returned home to invest in a Building Materials Supply Store. A few days later, the second Brahmin—while struggling to keep his balance on a rocky cliff near a branch of the State Bank of India—dropped his stick. He pulled a shovel out of his knapsack and striking violently at the ground uncovered another vast treasure: an underground source of water—viscous, limpid, pure water, unlike anything he had ever seen. He started 'Himalayan Mineral Water Private Limited,' right there, on one of the flatter terraces. The other two continued upwards with their sticks, each hoping for its immediate accidental detachment. And sure enough, it happened. Just as the younger of the two was admiring the sun setting over the stumps of dead trees, the stick flew out of his rucksack and fell into a dry river bed far below. The excited Brahmin ran down the slope. With a few digs of the ground he unearthed another valuable find: a sizable quantity of fine clayey silt. The Brahmin went mad with joy. His mind raced with images of profitable brick kilns and terracotta factories.*

client to architect, brother to brother relationship. Because of a common ancestry, the joy of sharing ideas on the design of an evolving family home would become even more significant and personally fulfilling. And if things didn't work out, as they often didn't in family matters, we could always lapse into mild anecdotes about our forefathers.

Now with the firm resolve to make their home in a new place, the clan had acquired family real estate in Delhi's Qutab Enclave, and on this quarter acre of newfound family property, Joginder, Mohinder and Harminder rested their hopes of a renewed family prosperity, and the perpetuation of their ageless Punjabi name.[2]

If life had to be recreated for the Bhatia family, it needed, so they mentioned, a return to the easy geniality of the village—a place where the larger community had always lived, protected and cloistered in an amorphous mass of relatives. Being a Bhatia, they said, I would understand. Brothers, uncles, wives, aunts, grandparents, nieces and nephews, were to live in one dense and happy clutter, and I, as their architect, I, as a fellow Bhatia, would help them recreate the memories of that distant rural harmony.

The idea of the house as a village, and the village as a home had instantly appealed to Joginder, especially since he had thought of it in the first place. In excited, but halting tones he described to me the ideal situation of his home. There were to be no walls, he said, motioning their immediate removal with a flick of his hand, he would be free to move as he wished, spending time in his brother's bedroom, having his morning tea in the front garden, shaving in the family courtyard, moving about with an aimlessness that was an intrinsic family trait. Life was one continuous, overlapping situation. With no distinction between the nuclear and the joint family, you moved about at will, from your own bedroom to the brother's drawing room, from kitchen to verandah, giving orders to the servants, your own or your brother's; sipping tea, your own or your brother's; discussing business with other male members of the family, or calling the factory on the cordless phone. Around you a host of sons and daughters, nieces and nephews, servants and sisters-in-law gravitated in their own states of inherited aimlessness, playing their assigned roles with equal lethargy, performing the messy chores of multiple households under a single roof, but with no guiding patriarch. Everything was there, the use of each other's hospitality, the shared responsibility of servants, the common family business, its income doled out in the running of a large house. Nuclear privacy was anathema, so discarded in

2. Delhi's new urban elite—the upwardly mobile businessman represents with all his symbols of wealth and prosperity—the microwave ovens and Audis, the self-defrosting fridges, the iPhones and flashy houses—a new culture of over-indulgence. Although his sudden affluence is not a step towards a more equitable distribution of wealth, it hurts to see his progress, his fancy shoes, his Rolex watch, and the Android phone he flashes from time to time. And it hurts most when he speeds past your old Ambassador on his way to '5-star hotel'. Actually, on the outside he looks like any normal human being. He can be tall or squat, fiery, or mild-mannered but his over-indulgent lifestyle and Bania ancestry is given away by a middle-age bulge difficult to conceal, even among the pleats and ruffles of his rayon safari suit, its wide lapels and over-sized buttons. But he doesn't care. When he stalks confidently into his favourite 5-star lobby with his usual air of cultivated indifference, people gaze at him in wonder. Who is this debonair man right out of a Digjam ad, with his gold watch and silver bracelet? Why is he wearing white suede shoes and dark Polaroid glasses? He is the New Indian, full of fresh ideas and a delightfully monetary approach to life and a lifestyle free from the encumbrances of taste and common sense. His architecture, like the rest of his life, seeks to balance modernity with tradition. He is a master artist. He believes that building is one thing, architecture entirely another. A building is a collection of rooms—large and small dark and airless and follows no particular plan—and its worth is measured by the quantity of space it encloses, never by the quality of life it generates.

favour of overlapping, infringing lives. It was the village once again. Only the cows and the wheat fields were missing, banished by the conveniences of modern life. The bedrooms, Joginder hoped, would be air-conditioned, even if they overlooked the family yard; the kitchen would incorporate freezer and microwave, even though kerosene was still the main cooking medium. The family washerman would continue to make his weekly rounds, despite the electrical washer and dryer. The multiplication of useless appendages inside and out was part of the essential autocratic ruling of a Punjabi client, whose life had created a style of its own.[3]

The changes in lifestyle inflicted by the move from village to city had been too rapid, and Joginder was keen to recapture something of the old ways. There was great solace in receiving the winter morning rays in the courtyard, and slowly lathering up for the shave. There was comfort and grace in the tedious mannerisms of sitting down to a full tea service in a shaded verandah, overlooking a lawn. To him it was the little things that mattered. And architecture had to be brought in to highlight life's finer details, to make them happen.

His images were always romantic, but always inconsistent with the fashionable corduroy suit that Joginder wore. And realizing the incongruity he would add, 'Of course, there would be one common family house, but within it, there would be three independent nuclear households. You know, for the children. When they grow up.'

Later, after the plans had been prepared, and the blueprints for this ageless, rural philosophy and lifestyle had been made, there came the standard fire between architect and client.

Give me a courtyard where the buffaloes can roam.

Could I have a small prayer room?

Could I have a small verandah next to the bathroom? I like to read the paper while shaving.

I want a roll-out barbeque.

With an automatic ice maker.

3. Punjabi Baroque was the middle-class break from the past, away from the colourless homogeneity of colonialism: peeling bungalows, monsoon stained walls, and beige Ambassadors. It spelt the coming of age of people who had no ideas of their own but had the brazen confidence to attempt some serious imitation and mimicry. To take other people's history as their own—Bavarian castles, French chateaus, Italian villas that sprawled in European country estates—and compress these into small family plots in Greater Kailash and claim them as their own. Many resorted to combinations of ethnic havelis and English Tudor houses, a sort of East meets West concert of architecture, assembling spaces that had so many incongruous elements that it could only be called Punjabi Baroque, a stylistic aberration. In the larger scope and spread of a house it had no influence. Space, room, lighting, ventilation, all things that matter to architecture remained unaffected. Punjabi Baroque was mere application to the building façade, a way in which the residents felt good about themselves, and kept visitors amused. Internally the house remained the same: dark, drab, lifeless, much like a family warehouse of memorabilia. So messy was Punjabi Baroque that a turn of the century reaction was but expected. Tired of wall hangings, Rajasthani doors, Italian moldings, Greek pediments and gilded furniture, the new client dropped everything. And created places of such extreme Gandhian austerity and material absence, that another style was created: a Punjabi Baroque of such utter minimalism. If you entered a room, you couldn't find the light switch, let alone the furniture. The chair was a twisted rod of polished steel, only to be admired. For sitting some folding chairs were brought out of storage and quickly re-stored when not required. A well-to-do Gurgaon couple who recently built such a home, tried placing their wedding photo on their bedside but were quickly shamed by the architect into removing it. There are standing instructions with the guard outside to delay the architect's entry so as to gain enough time to remove all such traces of comfort, family history and familiarity before he enters. Today Punjabi Baroque has changed from a style to an attitude. But its basic theme, as a method to keep the viewer in a state of visual enthrall, remains unchanged. No longer just confined to the façade, Punjabi Baroque is now a complete experience: a complete design record of a house, from landscape, to architecture, to interiors, to even the cuisine; a designer's visible hand must be there. The idea is to keep the visitor in such a state of unfamiliar and alien suspension, that he is forced to ask 'who is the architect'. And when given the name, only to keep it at the back of his mind, to never use his services.

I want a roll-out bed.

With an electric blanket.

Give me a jacuzzi. And a sauna.

Could I have those new, non-slip tiles in the kitchen?

I want space for a washer dryer.

There were minor changes to be made on the drawings, walls had to be repositioned and the dimensions of rooms reduced or increased to fit an appliance or a peculiar habit. Throughout the discussions the plans slowly altered. Tensions between needs and desires, wishes and affordabilities, architectural ideas and conformist tastes came to the fore. Mohinder and Joginder participated in the rounds with an intense eagerness. It was their house, and they had a right to know the building set backs, the room heights, and the interior finishes.

Only Harminder sat quietly. Unaffected by the vociferous rumblings of his brothers, he either chewed at the end of a ball point or gazed listlessly out at the traffic on the road. Sometimes he did both, chewing and gazing, but he never paid attention to the details of the house's slow evolution. His interest was not in allowable set backs and building codes; it didn't seem to matter to him that his bedroom was next to the servant's quarter, or that the only view out of it was into the driveway. These were matters of practicality best left to shallower people, his two younger brothers. He was the elder statesman of the family and needed to maintain an independent direction.

His was a metaphysical interest in architecture. After the mundane and pragmatic rumblings had died down, after Mohinder's bedroom window had been shifted to accommodate a Godrej almirah, after a prayer room had been installed next to Joginder's lavatory, the practically-minded brotherhood would retreat, and the meeting would focus its attention in Harminder's direction. And he for his part would dutifully perform the rituals of a man carrying the heavy burden of culture into the ordinary domesticity of a home. He would slowly reach into his designer jackets and retract a frayed magazine *Historic American Homes* and offer it to us as tangible proof of his more important household requirements. His hands, knotted by the count of rupee notes in the factory, would quiver and rustle the creased sheets of the magazine to page 76, to what appeared to us as a massive alabaster

colonial portico, the kind attached to historical buildings; pristine white against a red brick backdrop; the portico seemed doubly impressive for its glossy spread on two pages. Harminder's stubby finger lovingly traced the outline of Monticello, Thomas Jefferson's house in Virginia.

What a Punjabi garment exporter who had lived his childhood in village courtyards patted with cow dung had to do with the 18th-century American, I couldn't understand. But the relationship was thrust into the professional scene with the bluntness of a secret passion, suddenly revealed, like the desire for some unfaithful lover. Harminder needed Monticello, his very own Monticello, and he wanted it badly, complete with front portico, entablature, the brickwork façade, the classical mouldings of the 'y' frames, the heavy mullions of the windows, even the fireplace in the bedroom.

As he explained, his eyes welled up with the mist of a distant yearing, the pain of architectural longing. And I slowly began to sense what he meant. He had been on a trip to Virginia, part of a group of Chinese, Korean and Indian tourists. It was there that he had come across Jefferson's home. He had bought the magazine in the gift shop, and carried it home to India, so that one day he could recreate that magical experience for his own home. That time had come. Handing the open magazine to me, he raised his watery eyes to see if the image had affected me with the same pangs he had felt while trudging about the Virginia countryside. It was a difficult moment, this handing over of the sacred journal especially to someone who was incapable of demonstrating such emotion for an old American façade. Still, I felt much like a doctor, a cancer specialist receiving a stricken one year old from the trembling arms of the mother.

In fact, it was not altogether odd for Bhatia to seek inspiration outside the comfortable context of his village past. The Punjabis are after all a rootless people. During Partition, they left their homes in Pakistan and made new ones in India. And since independence they have settled in as far-off places as Birmingham, Toronto and Nairobi, with as much ease as their brothers in Hoshiarpur, Ludhiana and Jalandhar. For most though, the difference between Hoshiarpur and Toronto is only superficial; it is only a difference of language and culture, and a rootless people have no culture. Their architecture, inspired perhaps by this rootlessness, is a hybrid, a mixture of many influences and contradictions put together in a curious variety of shapes to create a style of its own, a Punjabi style.

The Punjabi is a born architect. He is a strict believer in the dictum, 'Form follows function', and yet he never lets function get in the way of his design. As a result, much of his architecture also includes elements that express function without actually performing it. For instance, a balcony on the second floor of a house is presumably designed to allow people to sit outside and enjoy the view. Yet in a Punjabi house there is no door leading onto it. At the edge of this balcony, a classical balustrade is provided to protect people from falling off. It is a balustrade designed to protect people from falling off a balcony that cannot be used anyway.

Modern architects believe that 'less is more' but the Punjabi believes just the opposite. Less is no longer more. Less is just less. In fact, less is too little and more is just not enough; the Punjabi sees, assimilates and accumulates. His method of building is unique: he begins to design his house long before he acquires a plot of land. His search for architectural excellence always turns to places that are for him culturally the least accessible. Italy, France and England are greater storehouses of historical spare parts than the familiar places at home such as Ahmedabad, Varanasi and others, those with a long tradition of domestic building. So he tunes to them willingly. He sees an arcade in Rome and he remembers it. He sees a stained glass window in a church and stores it in his memory. He likes a haveli door in Jaipur and he buys it. Little by little, piece by piece, a house is forming in his mind, so that eventually the real building becomes a simple exercise in recall and assembly.[4] And it is for this that he needs an architect to probe his mind, a mind very much like a storage bin, at times even like a sewage pit, but always full of architectural memories.

As a design psychiatrist, the architect acts to uncover the client's hidden past, his deepest, darkest memories, and to give them physical shape. Out of this cesspool of uncoordinated ideas, he will pull out the Roman arcade and the church window and put it together with the haveli door which is lying in the garage. The house that emerges as a result, if you can call it that, has elements from ancient Greece, Papal Rome and Mohenjo Daro, all assembled in a style that also borrows heavily from Early Bhatinda architecture. The house is a montage, a pastiche, in other words, a real mess. For true to the grand sweep of history, the Punjabi uses the entire vocabulary of classical forms available to civilized man, but unfortunately, he uses them in a spirit that is totally alien to them. His houses are like Neanderthal caves. A huge arch, cavernous and tomb like, rises out of the ground and reaches up to the top storey. There it turns, not knowing quite what to do, it goes around the corner and then comes back down again. In its simple elemental shape, the Punjabi has created a new aesthetic. He has taken ugly and ordinary forms—forms that history

4. Such domestic assembly describes a peculiar middle-class condition that reduces building to an unusually vagabond form of visual ambiguity. In the search for a relevant expression, the private house in the 1980s sought to smear the façade with the new and the dysfunctional, the irrelevant and the unintentional, the despairing and the devious, all in the hope that it would present a lively discourse to the cityscape. It did. It was the result of a middle-class vanity that explored the new architectural frontier of excess money, foreign travel, plagiarized design journals, and personal recollections of architecture into an entirely new and untested medium. It described four types of domestic demands prevalent: first, the most rudimentary: to encase the interior in a blindingly obvious, if perverse texture of richness, something that included velvet, rabbit fur, gold, brass, coloured glass, nylon and plastic laminates. Second, the concern for an equivalent outer expression of history so far removed from the life of the owner that it would instantly elevate the architecture to misplaced artefact. Third, the premise relied on the more abstract expression of architectural girth and spread, and the idea that affluence of the finer kind had slipped two notches above the rest and had retrofitted the home with a new form of abundance, space. And finally, there lay the approach of the 1990s egalitarian, a new type of radical, whose feet though firmly planted in the new materialism, had his hopes set in a post-Gandhian reality, a reality that still awaited definition. The half-baked mud walls of his new air-conditioned home would signal something of the guilt of over-consumption, and so give him solace. The private home was, as described by artist Claes Oldenburg, an art that takes its lines from the lines of life itself, that drips and spits, and fluffs and extends, and is coarse and blunt and sweet and stupid as life itself. The house therefore was an intimate autobiography.

154

has repeatedly acknowledged as being ugly and ordinary—and by sheer gigantism, made them uglier and more ordinary.

But this should not be misunderstood. The Punjabi believes in the high values of architecture, in structural harmony and noble proportions. And in that perfect mathematical relationship of parts which is the source of all beauty. He seeks to emulate in his architecture the laws of nature: laws according to which divine reason constructed the universe. His is a thinking, that goes beyond all convention, all established rules, into the realm of the sublime and even further, into places where materialism and desire meet to shake hands.[5]

What had drawn Harminder to Monticello had perhaps less to do with the man's active passion for the American presidency, and more to do with the heavier discount on the tourist itinerary promised by the travel agent. But whatever the reason, it was easy to discern the striking parallels in the character of a garment exporter and an American statesman. For a man who had skilfully guided the financial pursuits of a joint family into the empire of garments, it was, in fact, not unusual to be drawn to the home of a man who had drafted the American Declaration of Independence. Both were trailblazing reminders of the time they were set in. There was a fire burning in both sets of eyes. And walking about the hillsides of Virginia, Bhatia instantaneously understood historian Hugh Morrison's reference to Jefferson when he wrote that 'in politics he sought a freedom that was not yet born; in architecture he revered an authority that was not yet dead.' Morrison's words were Bhatia's thoughts.

House was a physical entity, but home was in the mind. In the rural setting of Monticello, as the tour group trudged uphill towards the white portico, Bhatia was moved by a distant reminder. He thought of the name Monticello, which meant little mountain in Italian, and even though he was not entirely familiar with Palladio's four books on architecture, he could appreciate the idea of little mountain. To his mind it suggested expansive origins, a vastness that he instantly identified with the American pioneer. Walking down from the steep terrace where the house was sited, he observed the surroundings with a kind of casual introspection: the distant forests, the rolling plains speckled with farmhouses. The objects and the landscape were entirely alien to him, yet that strangeness struck a personal chord in the Punjabi, a chord that the other, more reticent viewers from Taiwan and Tokyo could not apprehend. Bhatia saw the flattened plain that became the impressive foreground to the brick mansion, the gentle rolling ascent for the horse drawn carriages; then he thought of the rocky plot in Qutab Enclave where he would have his own concrete driveway, his own red Maruti. His imagination took in the sight

5. Ancient wisdom had precise rules for such encounters. Four walls using bricks, with cement as binding agent, must be used to describe the extreme perimeter of the house. The exact proportions should be determined only by the Sthapati, the architect, and direct descendent of Brahma, or an intelligent passer-by. The physical powers employed in the rationalization of solid to void and the exactitude of opening placement requires intimate knowledge of the Vedas, whose study can be further used to determine placement of windows for any room that may occur behind the wall. The correct application of the Sthapati's skilled powers can attempt a fusion of the mundane and the sublime to behold the majesty of the work and the emotions of piety and frankness that will eventually confront the viewer. The height of each window must be three-quarters the breadth of the portion of the wall betwixt each opening, but no more than one-third the height of each floor measured between natural ground level and ceiling, the measurement taken from top to bottom only. The central door is apportioned to Maheshwara and its alignment to cardinal East is beholden to the householder's primary position and for the worship of the household deity, placed at right angles on a high base without pedestal, till such time that an appropriate pedestal is obtained from a licensed quarry or a pedestal dealer. A Sutragrahi may assist the Sthapati in the heroic task, but for the purpose he must be of cheerful temperament and a sound mathematician.

of Thomas, good old Thomasji sitting by the Palladian window watching the slaves mowing the six acre front lawn; then Harminder thought of his own slaves, his servants, his driver, his wife....

The two-storey house, explained the guide, was the result of Jefferson's extensive preoccupations as an amateur architect. And Bhatia was quick to appreciate its conception. Jefferson's original idea indicated the cruciform formation, whereby the projecting axes gained prominence by their resolution into classical porticos. The internal octagons that manifested themselves in the Monticello plan were derived as an expedient device to disperse the rooms with greater geometric variation than would be possible in a more compact orthogonal arrangement. What a skilful plan coming from a part-time architect, Bhatia thought. Different angles were calculated to constantly conceal or reveal vistas of the surrounding countryside. How cleverly Tom had used geometry. The house was a free-standing structure, the only man-made element in a setting controlled by nature. Something only Le Corbusier could do so effortlessly.[6] In its finite control of geometry, the Jefferson building sought the intimate closure of the fireplace and the contrasting openness of its broad outdoor terraces. I too must have intimately closed fireplaces and broad outdoor terraces, Bhatia decided. The reordering of the building's envelope became critical in view of the extensive agricultural horizons to which the house related. There was little that was manmade in the immediate vicinity to offer any axial or visual links, only the dim background of trees, the fading pastoral panorama of the Virginia countryside. What a thoughtful building. What a great man.

Jefferson's interest in Palladian villas became clear in the numerous sketches he developed for the porches, of which only one was realized in its totality. To Bhatia, the great number of these possibilities only suggested the many design traumas of a man obsessed, seeking just the right proportions for the entrance, the right height for the colonnade. The rightness Jefferson felt could only be measured by the most logical interpretation of already realized historical ideas. For no contemporary situation could ever outwit a historical one. No new building had even come close to the greatness of a recognized monument.

The freedom to claim an alien liberty as your own, and the architectural right of other cultures as your own, showed the durability of the Jeffersonian message. There was nothing larger than truth stretched to encompass new boundaries. That an antiquated declaration could hold meaning centuries later in a different setting was a test of its durability, its ability to prevail through changing situations.

6. Corbusier sat with a yard-long piece of white paper, black pencil in hand. He picked the easel and removed all the paints and canvas and bowls of fruit to the other side of the studio. In the soft glow of the North light at the rue de Sevres the master waited for inspiration. Before long, he had placed a row of vertical lines on the paper. He reached for the bottle of wine, and with his right hand threw in a couple of horizontal lines as well. Horizontals and verticals. To the lay person the poorly drawn set of lines suggested the work of a child, but to the makers of the modern movement in architecture, the smudged bit of paper was the most critical manifesto of the 20th century. Corbusier converted the misshapen lines into a working drawing, wrote out a specification stating that the building be composed of vertical columns supporting a horizontal floor and intersected by ramps and stairs with pipe railing and long bands of windows. The whole building must be painted white. The architecture that emerged from his minimalist drafting pattern was itself so minimal that most thought it was still unfinished.

'There are no rooms,' people said.

'Rooms are old fashioned,' Corbusier said.

'But where do you sleep?'

'I deal with space,' Corbusier repeated.

'… what about intimacy, and fireplaces with stone floors.'

The people of Poissey had asked for it; the house was unlike any villa they had seen before. To the ordinary person the sight projected a view of the utmost severity, its receding austere planes spoke of a unilateral barrenness of texture, colour, and complexity—all aspects that the architect considered deplorable and utterly useless to the building's final form. Its extreme whiteness set in the contrasting green of the French countryside was typical of a man who said he dressed in black suits and bow tie to conform to the dress code of the ordinary Frenchman. In a setting known for the organic blending of its architecture, a place of rusticated stone farmhouses, where slate and tile roofs scoured by rain had over the years settled within the bucolic background of natural dense vegetation, the Villa Savoye stood out in a perplexing brilliance. Made of concrete and glass and painted with synthetic glass, it was as alien and incongruous a presence as the perplexing brilliance and incongruous presence of its creator. Through the Villa Savoye, Corbusier conveyed to his confused admirers the realization that architecture was no longer a decorated stage set for family activity, but an opportunity for spatially free sculptural compositions. Enclosure of space into conventional, four-walled rooms could be replaced by a whimsical arrangement of rising and falling planes. The columns served to support the floor, without the limits of heavy masonry construction. The building was a composition of planes and cavities, colonnades and taut skins of white plaster, of cubes and cylinders, to which life could submit itself once the artist had finished with it. The Villa Savoye became to the architect what the Taj Mahal by moonlight was to a newly wedded couple. In its whiteness, architects wallowed in states of uncontrolled ecstasy. People, grown up people, lovingly pressed their palms on the smooth

For Harminder though, the hero worship of the American statesman was not merely a question of equality. He may be more equal than Mohinder and Joginder in matters of selecting fabric for the winter shipment to New York, but that was where the equation ended. He realized that the two brothers exercised an interest in architecture that was merely a means of extracting comfortable living accommodation for themselves; at the same time, he could hardly claim to be the equal of a man who had given him a direction for the pursuit of architectural happiness.

As an innocent bystander to the historical task, I wondered to what extent I should be involved in the negotiations. In the possible meeting ground between a Virginia plantation and a Delhi plot, an American statesman and an Indian exporter, was my role that of a United Nations peacekeeper patrolling the tenuous border between genuine imitation and pure mockery, or was I more like the army seeking to subdue any resurgence of historic trivia with ruthless bombardment. Did Harminder's obsessive allegiance to history make me a partner in the crime?[7]

One day when Harminder looked to me particularly dejected, I mentioned in passing that Jefferson had harboured a glowing admiration for the works of Palladio. I thought this facet of Thomas's life would bring some cheer into a group whose discussions were beginning to stagnate in a distant historical backwater. But the revelation had little effect.

After a while, my mind began to drift from architecture to the personalities around. I began to notice that Harminder had begun to wear his hair long, even allowing it to curl at the nape of his neck. He would wear what appeared to be a starched period suit, expressly stiff. With his hooked nose and glazed eyes he would sit on the high wooden stool which I normally kept for myself. Harminder would occupy it with the naturalness of a man oblivious to professional etiquette, a man who had gotten off a Punjab tractor after seven generations of wheat-threshing to seek a more metaphysical dream in an air-conditioned office. Given such a background of upheaval and transition, there was little to do but relent. And merely watch from the sidelines. On those winter mornings when the sunlight streamed through the dusty glass and split Harminder's pensive face into alternating profiles of light and shadow, I thought he looked remarkably like the still life marble bust of Jefferson which appeared on page 75 of *Great American Homes*. It was an unconscious mimicry, in which life imitated art, bringing its inert forms to life once again.

And I wondered at times how much Bhatia knew of Jefferson's personal history. Did the fact of Jefferson's early widowhood cause some worry to Harminder's wife,

roundness of the columns as if they were touching some marvel of calligraphy or stone inlay. Building was in for a radical change. And even as the cows and pigs, wine growers and farmers watched, architecture hung precariously on the tenuous notions of infinity, absence of mass, to the inherent value of space and emptiness. The architect was a superhuman in an age of imaginary anxiety. The architect was Le Corbusier, an artist anxious to spread his ideal to an international horizon, before it slipped out of his own hand.

7. Obsessive allegiance to history is in fact an old English virtue. I remember once spending a weekend at a friend's place in Smithton, a tiny village of no more than eight houses, 35 miles north of London. David and Susan Scranton were the unfortunate owners of a watermill house that was listed under the Historic Buildings of England, which required them to have an 'open house' every Sunday. Not the best way to spend a weekend. Three damp and dingy rooms were stuck inside an old stone hall with a gigantic wood wheel that chugged away languorously with the help of an indoor stream. A century and a half old, the water wheel's bearings had obviously rusted with age, and it made the fearful continual noise of a metal trunk being slowly dragged across a stone floor. But the local historical society would conceive it unthinkable to change the original mechanism or provide a bit of grease to reduce the noise. Nor could any mortar be applied to the hall's rusticated stone wall, which to me seemed to be giving way to age and to a family of lizards that had made—dare I say, a much more comfortable—home in its crevices. A hefty £100 was sent to the Scrantons monthly to keep the watermill running, squeaking and groaning rather. The money was to be used additionally to entertain visitors on Sunday and provide them enough refreshments that they keep the historic tradition alive. After 30 years in the mill, Susan had become a bit deaf, but after 40 years of marriage, she needed no language to communicate with David. I asked her how they managed when they were away on holiday. 'I can't sleep with all the silence. We have to return quickly,' she shouted at me, while busy baking biscuits and scones for the Sunday crowds; a harried Saturday of preparations left her exhausted, but strangely smug and satisfied that she was part of some larger noble cause. Sure enough, the next day, a few of the local couples trooped in between 11 and 4, to partake of Susan's fine baking, and to discuss local issues, staying as far away as possible from the seasoned history of the water mill, its origin, its function. Between the Saturday football game at Old Trafford and the factory strike at the new brewery, the men hung around the garden porch with lager. Susan put out the tea service for the ladies and opened the discussion with a, 'Did you know that Julia has to head back to the hospital, her hernia has been acting up again'. The women dipped into the spoils of the bakery and gazed out with immense satisfaction towards the garden, all with raised voices to outshout the grind of the ancient water mill. A weekly party funded by the Historic Society. It was a truly English scene, and in true colonial tradition, a way of salvaging architectural heritage with genuine English etiquette and civility. Without files, bureaucracy, or the odd historian looking over their shoulder.

who would make sure that the kitchen knives were safely put away at night? Did Jefferson's sexual encounter with one of his favourite slaves bring Harminder to look at the range of female servants in the household with anything like a twinge of desire? That the founding American father may have, in fact, fathered a number of illegitimate children, who once roamed about the large Virginia estate, was a facet that Bhatia may have admired in secret, but could hardly put to test in the delicate morality of a Punjabi joint family.

But the sociological implications of this historic association did not seem to matter to him. In his spare time, of which he seemed to have a lot, Harminder thought Monticello, he brooded Jefferson, and he xeroxed. Wherever there was a passing reference to either, Bhatia was there, ready with white slips to mark the pages for the assistant in the electrostat shop. Wherever a colonial portico appeared in the pages of a history book or on the cover of a novel, the picture was invariably reclaimed in a smudged xerox copy for his Delhi Home file.

Now there we were, with this grown man and his open magazine. For all the world, like a repentant murderer in a church pew, he beseeched us, eyes heavy-lidded, to build for him an archaic product out of a foreign catalogue. He was willing to pay professional fees. It seemed hardly the time to point out the ridiculousness of his vision.

12. Architecture Consumer

I wondered then if our architectural culture was always one of borrowing? Did every Indian office have its very own Harminder? In the 60 years since independence little has changed in Indian urbanism or architecture, or ways of thinking. No attempt has been made to define in a common language the kind of places we would like to live in.

No one has initiated a perceptibly different idea on preserving the culture of historic quarters, or creating a fresh approach to the design of new towns. If the fortress towns of Jaisalmer and Jodhpur are battling modern problems of incorporating increased utilities and sewage disposal into a traditional city structure, the state capitals of Gandhinagar and Bhubaneshwar are repeating the urban mistakes of Chandigarh—vast, sprawling and characterless, they continue to straddle the uncomfortable mix of discarded western planning ideals with Indian living patterns.[1] If the rich straddle the picture-book worlds of foreign magazines and films, the middle classes fill the bureaucratic wastelands of chipped and peeling housing blocks. The state of architecture persists without any ideals of domestic images.

To begin with, the illegibility of the Indian street is related not so much to public indifference, but architectural irresponsibility. One of the truly unfortunate sights in the Indian landscape is that of a glass shopping mall in a town like Bikaner or Jaisalmer. Coated in desert dust, broken window panes, heated into an unbearable summer stillness, and visibly uncomfortable in its historic surroundings, it tells with no uncertainty the tale of Indian despair, the dispirited flagging imitation, and leaves you with a nagging question as to why so little of value has come from Indian architecture.[2]

The disconnectedness of the city from its citizen, the house from its resident, however, has had a long evolution. Rapidly increasing population, the growth of urban centres, chronic unemployment, a marginalized economy and unstable political situations have, during the last 60 years, set the tone for the built landscape of the city. Housing blocks filled city space, as sub-divisions grew and land disappeared under private co-operatives or public housing schemes; increasing urbanization necessitated large designed commercial zones within the uncontrolled sprawl of the old town. The expanding industry may have created burgeoning facilities for commerce and trade, but growing pressure on urban land congested city centres and led to enterprises that gave an altogether new scale to public space and urban architecture with little or no relation to small human endeavours.[3]

1. How do you even begin to apply this cascade of borrowed and untested pretensions to vague unmade places? What would it take to get state governments to realize the long-term tragic consequences of their impulsive actions, and get India's new capitals to downsize? Can state governments reconsider their standard call for elaborate structures, of the kind the Mughals and the British built, to places humbler, and in keeping with the desperate conditions of the city majority, the poor? Sadly, in the seven states that have been added by subtraction into the union, none has seen the capital as a potential for new ideas. In an uncontrolled and overpopulated situation without urban norms, the government needs to question the motives of any and all new construction. What is the value that new cities bring to the lives of people? More than ever now, the new model for the Indian city should accommodate its residents through conservation rather than excessive construction. Without a precise model of urban life, the handing over of large chunks of disputed land to foreign designers in the hope they will create solutions to India's cities, is the ultimate sign of desperation and defeat.

2. Once on a site visit to a hotel under construction in Lucknow, I was appalled at the poor quality of the building: misaligned brick work, crooked walls, windows ill-fitted into frames, light switches fixed without switch plates, broken tiles plastered over with cement. Even though I pointed out the flaws, the contractor failed to understand what all the fuss was about, but reluctantly agreed to remedy the mistakes. In the redone version as he stood proudly by, I saw that all the flaws had been diligently corrected, but he had liberally and carelessly spread his mistakes to other details: a misaligned mirror, cupboards that wouldn't shut, window polish smeared on glass. In a place where these are acceptable standards of construction, it seemed futile to point out the errors, or suggest their correction. Second rate has always been the only measure of quality in India, and the presence of anything first rate often leaves people gasping with surprise. When the Delhi Metro first opened 12 years ago, the look of mild shock on the commuters' faces said it all. How was it possible that a public transport of such clinical efficiency with immaculate stations and train interiors could be conceived and built in India? Isn't it for the same reason that something as innocuous as a new bus depot or a flyover is inaugurated with such fanfare?

3. The Indian citizen has consequently adjusted to a life of entangled and perverse urbanism. The architectural imagery of the city presses across his eyes in a multiplex of conflicting frames that impose and superimpose a vast frenzy of building forms, types and environments. The absence of a singular clarity destroys any common meeting ground whereby the visible building world can be neatly packaged in formal classifications, historical or stylistic categories. In such an architectural scene, the atlas of the impossible allows for the existence, and in fact proliferation, of complex multiple realities. Indian street life is placed, misplaced and arranged in a temporal contentment that has roots in smaller sustainable measures, far removed from the utopian ideal of freshly laid city plans with flowered avenues, manicured commercial and public plazas. Unfortunately, architecture's utopian tendencies hold the promise of myth and fable, the longing for some pictorial perfection where life is lived in an exaggerated nursery story. Living happily ever after happens only in guarded vaults, behind the high boundary walls of country villas, gated communities and theme parks, places so socially isolated they hardly qualify as architecture. For the rest, the city is formless wasteland.

The architect just withdrew and watched, as unknown masses of people—mallers, migrant labour, sidewalk shoppers, subway riders, office goers, apartment owners, suburban residents took over. Their higher numbers and brisk contempt for pre-meditation foreclosed all signs of architecture. Everything could be bought and sold—buildings could be borrowed from archaic eras, and cross-bred with history or with any emerging style into an altogether new clone. Roman pallazos could be air conditioned; Greek orthodox churches could become Rajasthani wedding halls. The desperation of daily life was a conflict being waged on the streets of the new India, part of the 21st-century itch to become the most notorious consumers. Setting a path to the unfamiliar, to a perennially increasing gross national product, every Indian was on a warpath to make his own substantial contribution to the annual growth rate. Flatron TVs, LEDs, DVDs, Stainless steel fridges, American call centres, solar microwaves, cell phone cameras, camcorders, poolside barbeque grilles, Brazil vacations, BMWs and Maybachs—everything was vying for space in a house, that was itself leaning on Europe for style, and America for girth.

Risen from the ashes, its owner was in stiff competition for global goods and services, unsettled and unsettling a mercenary, setting international standards of consumption and obligation. With him, architecture had embarked into a new future buttressed by the hopes and fresh impulses for the good life. Buy a villa in Tuscany, a house in Goa, a vacation home in the hills.[4] Whatever it is the building need say nothing about bringing its occupant in tune with its surroundings. The house was a multi-dimensional enterprise, as much shelter as hedonistic pleasure. Its striking modernism had expelled any vestiges of culture and history; it was now merely a technological device, an instrument of expediency. As simple as that.

The better architecture was one with greater inputs of wiring, more kilowatts, more generators, better alarm systems, greater fire fighting equipment. A state of architecture could be achieved by programming the building to react against all possibilities of threat—natural, manmade, local calamities or global catastrophes, fires, burglaries, armed robberies, earthquakes of unimaginably high levels on the Richter, nuclear holocausts, missile attacks, floods and all the other indicators of the frailty of the human condition.[5]

Meanwhile, the city around it bristled with frantic signals of commodity. Everything in sight could be bought and sold, rented or leased. Technology had produced a range of items and activities on demand.[6] While it trivialized and traded all urban action for commerce, it also broke down barriers of caste and class. The mall was a democratic place, so was the office and apartment. On the 40th floor North edge

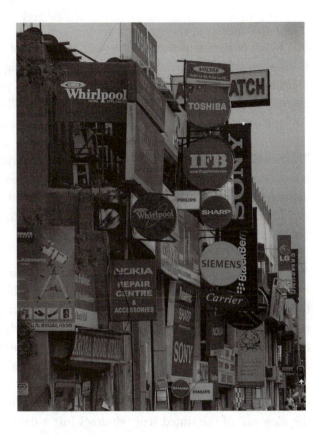

4. For many looking to buy a house in the mountains of Himachal or Uttarakhand for a summer weekend getaway, there are cottages available for 6–8 crores in a secluded forested section of the hills hidden away from the cheap 40 lakh rupee builder homes. They come furnished with pine flooring and granite kitchens, and except for their location, are close replicas of the 40 lakh builder houses. The chance to buy may not have come your way because their sale is By Invitation Only. A famous watch company has been selling hand-crafted wrist watches in India for 10 years, each ranging from 1.2 crore to 8 crores, but for a mere 2 crores extra the dial can be gold embossed with the family name or crest. The Mercedes club of Indore is a gathering of Mercedes lovers. With a potholed road outside the family garage, the mere ownership of the German car is an upliftment to club status.

5. Once, while flying over Rajasthan, the stewardess emerged on takeoff and gave a long lecture on floatation devices and life vests in the event that the plane alighted on water. It hardly needed pointing out that the chances of drowning in the Thar Desert, possibly the driest region on the planet, were so remote that the jargon about water safety was but a deliberate and unmistakable parody. But the show of words had to go on.

6. Technology's ability to give greater access to a range of activities is a good thing, but there is always the danger of technology's abuse. Sometimes, thanks to technology, incompetence and virtuosity can compete on the same stage. A female Russian rock star successfully mouthed Madonna's lyrics at concerts till one day the electricity failed, and the audience discovered her voice was actually closer to Louis Armstrong's. In fact, when Louis Armstrong's own voice is not good enough, it can be put through a synthesizer and made to sound like a better Louis Armstrong. Would Louis be happy with such manipulation? Will the Taj Mahal look better with another beautiful electronic dome on top?

of a block of flats, it mattered little who your neighbours were, where they come from, what they did. In the background of places originally divided on ethnic and regional lines—Punjabis, Bengalis, refugee colonies, professional boundaries—the abstract egalitarianism of the marketplace was a wholly new, almost civilizing, idea. Anyone could buy one house, an apartment, two houses, two apartments.[7]

The newest occupant of architecture was impatient with history, unconcerned with connections to place and time. His edginess to move on gave a new restlessness to architecture. Space was democratic, a device for continual movement. The perennial demand for architecture was no longer related to containment and enclosure, but to create a reminder of the beyond.

As if the temporality of a room was a desirable condition, every vantage in a building rendered every other vantage in the building visible. You saw at once, your desk in your 5th floor office, your colleagues in the open plan layout, your car in the company parking lot, and your secretary in a paperless office pool. Your occupation of space was convenient and transitory, not familiar or comforting, because it always let you know your position in the architectural scheme of things.

On the streets you moved about in chauffer-driven Toyotas and Mercedes Benzes, the view out of the tinted rear windows just a daily documentary of people and places. Viewed on the move, familiar buildings appeared and disappeared, places got crowded, crowds thinned, trees were felled, saplings planted; you saw an old woman selling garlic on the sidewalk, she was soon replaced by a barber. The cityscape existed only as momentary passage. Real life was elsewhere: confined to home, office, hotel or the club.[8] The space in between was just a minor inconvenience. In fact, its most visible aspect was its invisibility. You saw, but you didn't.

The architectural scheme you occupied provided constant reminders of the other India. And the necessity of distance. Outside the hermetically sealed walls of the office and mall, this India awaited admission. Labourers milled about in restless squalor behind the plate glass. The pi-dog sniffed turd on an unfinished road. Nike, Benetton and Adidas outlets formed the frontage of a slum. In a crowded street along a sidewalk overrun by vendors, 40 men washed themselves at a hand pump; not too far away, one man swung a club at a 40-acre golf course. India allowed everything to coexist: mineral water and cholera, the laptop and the hand plough, private steam baths, broken public urinals, lesbianism and arranged marriages.

But what was often sad and funny and stupid at times was the sad and funny irony of juxtapositions. A towering stone mansion, slapped with stone veneer and a medley

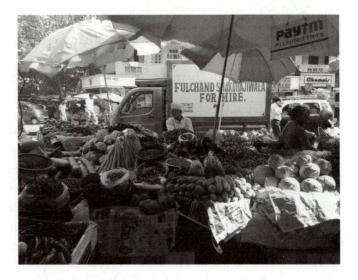

7. If anything, the government needs to take a serious criminal view of real estate speculation. Premises, public or private, that remain unoccupied for a period of more than three months are liable to be repossessed by the government, on the grounds that they are being used merely as a money-making venture. Raising the occupancy of buildings through the city is essential for the safety and social benefits of the residents. Such a directive should counter the vast tracks of empty apartments decaying all across the city, most having been sold by unscrupulous builders to customers wishing to park their black money. In conjunction with the Lok Pal Bill all private property should be registered only in the name of the resident. The occupancy of the property should be checked periodically.

8. Look anywhere and you will find office structures, apartments, IT buildings in tinted glass, walls leaning or angled in uncomfortable asymmetries, light falling in accidental reflections. Have these structures altered the old understanding of architecture as a stabilizing influence on its surroundings? Or has architecture come to redefine natural laws of gravity? The architect will confidently explain how the façade is a fusion of historic tradition and contemporary technology, how indeed the sheer scale of the structure is a metaphor for the growing confidence of the economy. But verbal and visual justifications do little to appease the chaotic character of the urban experience. What will remain in memory of the new work? Will the Ambani residence in Mumbai be remembered for its owner or for its design; the Commonwealth Games for its expenditure or for its structures? Will anyone even care to inquire of the new capital city for Chhattisgarh, currently in construction, the way Nehru did for Chandigarh?

of international styles becomes delightfully funny and sad when viewed across a grim cityscape of mud shanties, with tarpaulin roofs and open sewage. That the residents of the shanties have helped build the mansion only makes the irony sadder and funnier.

Such ironies hit you every day. A three-bedroom apartment across from the world's largest slum, Dharavi, costs the equivalent of one million dollars. And there are enough takers for it. As there are for the neo-classical and Pagoda-style houses of Amby Valley, a leisure home reserve of artificial lakes and fake ski slopes and beach-fronts built north of Mumbai, but physically protected from the city. Move higher up and away from the rarified atmosphere of Amby Valley and include the perspective of the surrounding countryside, a rawness hits the senses. When viewed with the parched village ponds, and the dusty rural lanes that criss-cross the weather-beaten surrounds, the blue lakes and artificially vegetated lagoons, all flicker in a mock hyper-reality. Against the denuded backdrop of dry fallow fields California houses huddle, embarrassed by their lushness and blue smudges of private pools, even a little uncomfortable in the Indian sunshine.

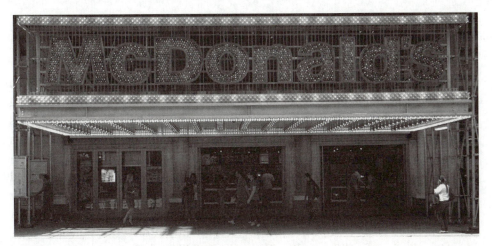

13. Architecture in Urbanism

So out of touch with reality, every builder's act of excess is followed by actions more outrageous, more magnified. On a hilly picturesque landscape beyond Pune along the edge of a lake, a different sort of city has been built. In its brochure Lavasa is a city of generally fair-skinned people laughing and frolicking in clear European sunlight.[1] They are in shirt and tie or skirts, smiling and healthy, sipping cappuccino at cobblestoned sidewalk cafes, far removed from the messy brown-skinned reality of India.[2] They punch laptops, shop at boutiques, and are surrounded by pastel-coloured unblemished European buildings reminiscent of Monte Carlo. A boat is moored on a distant bank. The picture instantly attracts by its mere foreignness, its promise of a different life. The real possibility of efficient work combined with the heady pleasures of daily living. Observe people in the picture: their movements, their activities, their needs, modes of entertainment, their obvious contentment are all visible in precise and amiable encounters around landscaped parks and completed streets. The good life is not an expectation in some remote imaginary future but exists in a living happy reality. Even though a setting of such pastoral splendour as Lavasa is not just unusual in India, but is itself cheating the standard features of the Indian landscape: the dust, heat, excessive rain and usually flat featureless countryside.

No one would argue that architecture's central premise is aspirational. People come together in a city to live better lives, and to find newer opportunities to improve their condition. And Lavasa itself is not a new idea. Developers have been ranting and raving over their California clones for years. Live a new life at Pune's Campbell Towers or Come to Ahmedabad's new upmarket Malibu Gardens.[3] But why does the imagery promoted by the builders and developers always suggest European and American models? Is it merely a failure of the imagination, or the distressing belief that little of value has been done in India? Are there possibilities of creating imaginative local models?[4]

Naturally society's wants take a secondary place when architectural effort is directed towards personal fulfilment. The hedonistic pleasure of architecture as an upliftment of the human spirit is a notion that does little but reduce building to a trivial visual act, firmly disconnected with public life. In fact, the architect's inability to intuitively design for a common purpose has left a lasting legacy of such utter civic remoteness—isolated landmarks, derelict plazas, inaccessible parks, disjointed commercial and housing pockets—that urban life's satisfactions can now only be

1. On television, a white woman walking down the street runs for cover as the sun hits her face. The voiceover says, 'protect your whiteness from the harmful rays of the sun'. In print ads for hair transplants and liposuction, the before picture is invariably of a dark-skinned Indian, but after the operation, the subject is thinner, with more hair, and decidedly white. In another ad, a Bombay film star shows off her hair colour, an unnatural Auburn blonde. As she runs her hands through her golden strands, she says, 'Try L'Oreal for that natural you'. Since when has fair skin and blonde hair been a 'natural you' for India? Why indeed do the print media, television and film support such overt prejudice? The search for 'fairness' in a country considered a variant from milk chocolate to bitter chocolate, cuts across borders. Amongst the elite group of cricketers, Bombay film actors, TV personalities, club- and bar-hopping glitterati in the metros, to rickshaw drivers, and Congolese- and Nigerian-beating shop owners in Delhi, the assertion of whiteness is a lifelong quest, and one that has become a badge of pride.

2. How many Indian ads for real estate use young, blue-eyed, blonde white foreigners to sell houses and apartments. There they are, shiny faces preparing a Sunday afternoon barbeque, swinging a racquet on the tennis court, some merely lounging in their spacious living rooms. How much nicer to feel that members of a good-looking advanced culture are lying in the couch of your future apartment. And in buying the same apartment you can gain the status of being an honorary white. At Indian adoption agencies and orphanages ironically, fair-skinned children are picked up first, and mostly by Indian couples. 'Dark complexioned kids,' says Manjula, from Delhi's premier orphan centre, 'are adopted by mainly white foreigners.' Try selling a BMW with a dark pan chewing Bihari, the type who most naturally gravitates to such cars, on the back seat, and watch the sales graph plummet.

3. The guilt of providing only for the rich makes builders separate a small parcel of land for the poor. Away from their profitable projects. Keep them hidden away behind high walls and along the open drain. Housing for EWS, the Economically Weaker Section, the LIG, the Lower Income Group. Euphemism upon euphemism; euphemisms mount, till they fill the pages of a government ledger: Build for Work programme, Nirman Yojna, Kanya Yojna, work for food programme. 8,000 shelters built in rural Orissa in fiscal year 1999. Spiritless grey cement cubes, expensive, ill-lit and unventilated, from which 30 engineers have profited, and into which people, normal breathing, sun-loving people, refuse to move. No tree in sight, no leaf, no shadow, nothing to say that the place has been built for habitation, where people can live with pride and dignity.

4. Most Indian places suffer from a complete lack of cultural identity. How do the new airports in Mumbai and Bangalore give evidence to their presence in India? Show someone a photo of the new terminal in Delhi, he would not be too far-off in identifying it as a hospital in Rio. By contrast, movement through the international terminal at Jakarta is, well, unique to Jakarta. Accentuated by courtyards of tropical plants, it is an experience that is not only visually gratifying but is a conscious reminder of the difference between landing in the Far East, as opposed to Scandinavia. Such an attribute, though not a requirement of efficient airport design, leaves a vivid and coherent impression of the place.

measured in two trivial public pursuits: eating out and shopping.[5] Moreover, as foreign ideals become a reality in smaller towns, the city is less likely to confront its day-to-day problems of overcrowding, crime, ill health, transportation, etc. As more wealth is directed towards a visible global glass-and-steel ideal, it becomes more likely that ordinary ambitions of urban safety, good sanitation, public education, easy access to local facilities and recreation will get overlooked. Long-time residents will hanker for old, forgotten ideals: the tranquillity of the park where people came to rub their feet on dewy grass, afternoon tea in the family verandah, a walk to the neighbourhood tailor…. Only a heterogeneous city with multiple and mixed uses can accommodate both impulses.

At a time when art was relieving itself from the oppressive regulations of its many schools and academies, architecture was being bonded into the slave trade of the city's all too powerful lobbies of builders. The primary focus of Indian architecture in the past few years has been the sheer neglect of the Indian template, and the production of shining, silvered and mirrored objects in the landscape—malls, offices, and housing. Bereft of the conditions from which they have arisen, or without serious comment on the lives of the people inhabiting them, the structures were a formless pretence to a cold unconnected internationalism.[6]

All across India, architects and their firms were subsumed under the larger umbrella of developers. The purchase of land and buildings was a convenient commodification of an earlier practice that had been exploratory, artistic and uncertain, and had consequently produced unexpected results. Unlike the builder, the architect need never guarantee the success of his project or the fluency of the lifestyle. When design was reduced to an easy applicable formula, it became harder and harder to respond to the ordinary abstractions of technology as insightful work, and to people promoting themselves as cultural reactionaries and rebels.

Even architecture's high command had struck down the old moral codes and left a landscape that had begun to outwit itself. Noise, clamour, fatigue, drama, delight, boredom, hope and hopelessness all combined in equal measure to sustain the Indian image, whatever the medium. A simplistic message merely indicated technological progress—aspirations to the highest ideals of mankind, but dumped relentlessly into garbage. Even the stereotypes were missing.[7] A failed imagination could turn the architectural message quickly to abstraction or historicism, that nobody could question. Architecture was defeated before it began; architecture had become a history of defeat.

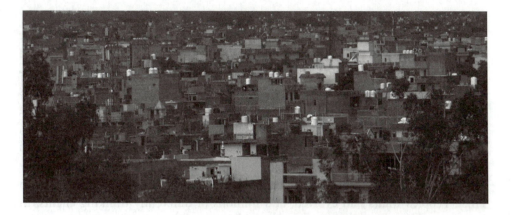

5. In our race to become globalized consumers, as in everything else, there is an attempt to make India a poorer extension of the American suburban mall. Air-conditioned hermetically-sealed places full of people in Bermuda shorts, carrying shopping bags and licking gelatos in waffle cones.

6. Information technology and software wizardry all speak only of a new culture of logistical imitation and false borrowings. Only because there is Hollywood, there is Bollywood, because there is Silicon Valley in California, there's another in Bangalore. We make our life through favourable comparisons. Nothing but the second best. Because there's art in Madhubani, there's life in the drawing room.

7. If ever there was a country that survives solely on the strength of its stereotypes it has to be Denmark: Hans Christian Anderson, Tuborg beer, Danish pastry, Danish sausage, everything straight out of the tourist view of the place. Take a walk out of the central station in Copenhagen, and you will merely relive the tourist brochure in 3-D. Cobbled footpaths, neatly fenced parks, public gardens filled with flowers and fountains, and happy Nordic people with shimmering hair; monochrome buildings scrubbed and awash in a northern light, sitting assuredly behind landscaped plazas. A picture so perfect, any minute you expect Hans Christian to come around the corner on his bicycle, holding onto his copy of *Bedtime Stories*. For an Indian, used to paan-stained walls, dirt piles, public urination on the roads, and policemen asleep in Police Beat Boxes, the perfection was disturbing. I quickly traced my steps into the comforting dark of a bar in Stroget, the prime commercial hub, hoping for the image to pass. Three beers later and a bar bill that cleaned out my full budget for the day, I re-emerged onto the street, knowing full well why the Danes needed to have one of the world's highest per capita incomes to survive. I retreated to my expensive hotel room to count the currency and reallocate funds.

174

The architect washed his hands of his responsibility and handed buildings to the local money lender. He bought land, sold houses without building them, auctioned office blocks and rented space. The city was a place of momentary opportunity. Style was irrelevant, as was architecture. Occasion mattered. And the act of designs was an event. Nobody needed the architect. Versailles could be created by a wedding planner, the Taj Mahal, by Pappu Tent House. Put up for an only son's marriage, it was correct to the last detail, even better than the original. The bulldozers and the scaffolding and brick walls were no longer the tools of the trade. Just a finely stretched fabric on a frame. A catalogue of available spare parts and the labour to erect. People's wants had evolved, and millions of differently thinking clients, in business and retail, in sports, recreation and entertainment were clamouring for more: brighter lights, higher atriums, bigger malls, glassier lobbies, crazier weddings. Architecture was a stage-set of mesmerizing scales, a plot to create noisier and more vocal scenes of distraction, and a professional willingness to encourage greater forms of disbelief. The idea was not to seek permanent solutions, or to back some archaic ideology, but to find the quickest route to a new potential reality. Those who accepted architecture's resolution as short-term were quickly successful.

Even as planning moved out of the congested city into suburban Bangalore, Delhi, Pune, the architect moved into parallel developments, as promoter and builder and financier. No need to create opportunity, no need to create or invent, but go where the opportunities are: in the suburbs in speculative housing, in retail space and amusement parks, airports and bus stop design, metro stations and malls. Follow the movement of money and people. You couldn't go wrong.[8]

Just as the impact of monetized economy had affected materials, technology was visibly influencing landscape. Design has altered in many ways. New materials demand their own methods of assembly. Earlier generations perhaps took great pride in being poetic and artistic about building. Even a display of modesty that removed architecture to background.

Modesty was an old hang-up, it didn't go when the architect was a cult figure, like Armani. Even intellectualism had drifted into a profession that once had practical and artistic inclinations. The perception that buildings were not just cultural products but were instruments of social change.

For most architects trained to consider architecture as a noble expression of the highest order, such a view was not just a professional shock but a serious disorder, of

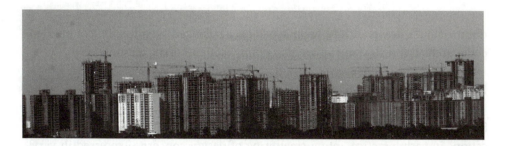

8. When there are no heroes in the sight line, no artistic, intellectual or architectural creation in recent memory, no scientific success to speak of, no new invention to attribute to Indian genius, then the heroic act assumes a marked reduction in scale; imagine the old heroes are still there but they are shelved and reduced to caricature. Mahatma Gandhi, a distant guardian of independence, CV Raman of Science, the anonymous Craftsman of art, Ramanathan Krishnan and Milkha Singh of sport. Grinning down their respective shelves, a little weary, a little sad at the changed condition of India. The new heroes are now ordinary money-grubbing parasites, like you and me. People whose sole ideal is to be a millionaire by the age of 30. Is that the India of the millennium? Just look around. There are no Mahatma Gandhi Margs, no new Jawaharlal Stadiums, no Satyajit Ray Chowks. Only Ansal Plaza and Raheja Towers. Builders commemorating their own actions in their own lifetime. How laughable. How utterly, a taste of India?

dimmed and a desperate motives that had once belonged outside architecture. How could architecture be done for anything but serious aesthetic reasons?

How could architecture not be controlled by the drawing board?

So far the architect's role has been unfortunately confined to professional qualifications in early practice, into a smattering of design concerns expressed in varying scales of work. Later, for most, architecture even kindled a harmless form of social activism. The role, however, is often limited and despairing. A background in design is neither an effective launching pad for professional integrity, nor for developing a moral or social code.

So you build and resurrect ideas within accepted international norms of acquired aesthetics, remaining resolutely within the formalism of design. Sometimes, you stretch, wherever possible, the boundaries of space and structure, but remain within professional conventions. Then after a while, when design's intrinsic banality, and insufferable pretensions sink in, the practice steps away, into a more hope-filled direction, and a new concern for social consciousness. Architecture begins to recognize all work as social service, a saviour. You begin to see that architecture, and its many associations are beset with national problems. The numbers of homeless people is staggering; every year architecture helps to reduce the statistics. But the hoards of poor are on the move. Unable to build anew, or to keep the numbers at bay, the strategies change. The slum is recognized as livable; it is upgraded. Dharavi, once described as an agglomeration of the world's poorest, is suddenly given social respectability; the standard measures of poverty are changed. Quality of life acquires a less materialist, more sociological meaning.[9] The architect escapes the city to build for the rural poor. Victims of tsunamis, poverty, hurricanes, malnutrition, disease, floods, and earthquakes, the professional ascribes altruistic motives to design. In a poor country the architecture must necessarily be poor. To build for the poor, you lower standards, lower quality of construction, reduce specifications of design and space. The buildings sit comfortably with the belief that at low cost any building is a blessing. Any roof over a head, however ill designed and unsuited to its environment, if cheap, is a triumph of architecture.[10]

Professional dislocation is neither the responsibility of the architect, nor the planner, nor indeed the people demanding buildings. It is merely the outcome of collective failure. As marginal interventions, each makes a personal contribution to city life, adding an appendage in a city of appendages, however outmoded for its time.[11]

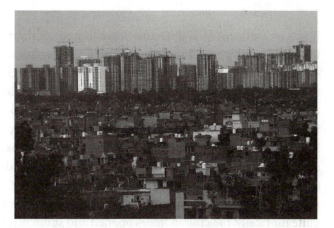

9. Some years ago, while on a visit to Delhi's Tihar Jail, I realized how the place was a true microcosm of a functioning city—Delhi without its hierarchy, or anarchy. People lived together, they ate, worked and worshipped as they would outside; there was sports and recreation, lectures and yoga. Things worked within the strict framework of a prison, much like Singapore. Does that mean people need monitoring and confinement before they became worthy citizens?

10. In the past 30 years, the continual expansion of population into the hills has already left a passive trail of devastation; tourist hotels some as high as six to eight storeys perched on cliffs, empty summer houses of the Delhi rich, hillsides devastated and unstable and expanding road network, commercial activity along new tourist routes and a rain of garbage along hillsides, loss of tree cover and an expansion of agriculture into forest land. Is it any wonder then that environmental disasters don't happen often enough? Religious tourism has to a great part contributed to the excessive and unchecked development around shrines. Most places are littered with make-shift shops, hotels, sarais and dhabas that come up as temporary shelters for quick commerce, but become 'regularized' because of their endorsement by the local religious authorities. The ramshackle and putrid air of many religious sites is in part due to the laxity of local government to interfere in matters of religion. Consequently, the religious experience includes chai stalls, trinket shops, dhabas, cold drink stands, garbage mounds, litter, defecation in the sacred river, picnics and urinals. An Indian religious Disney. The convenience of driving your own car to the front door of religious shrines for a privileged peek of god is an Indian expectation. But if states are serious about 'ecotourism', there needs to be a severe and restrictive strategy that limits tourist numbers and creates more equitable public modes of transport and clearly defined precincts for food and lodging, except for the drive-in churches of California. Inconvenience and restrictive practices are essential to any serious religious experience.

11. It has taken Delhi four years and 35 crores to upgrade the Feroz Shah Kotla grounds. Four years to increase seating and add lights for night games. Using post and beam construction technology of the Greeks, thereby restricting the view from numerous seating areas. By comparison, the three years of construction of the 60,000 capacity birds nest stadium in Beijing is an engineering marvel that has no structural counterpart anywhere. It sits in an ethereal landscape that is informal, innovative, experimental in design and engineering. The steel mesh that encloses it defies gravity and all the conventions of architecture, and creates an unsettling sense of wonder and newness. As extraordinary structure, more sculpture than architecture, that looks like a piece of cane furniture, with the cane gone a little haywire. Yet this framework is ingeniously conceived to contain everything within its eccentric pile: stairs, walls, roof, facilities, rainwater collection and passive cooling. It stretches the bounds of engineering, design and services, integrating them in a way that conventions of façade, floor plan or roof cannot be applied.

It was as a student of architecture travelling in southern France that I first realized the remarkable possibilities offered by the combination of architecture and urbanism. The amalgamation was most obvious in the medieval city. The approach to the cathedral in the small town of Le Puy was a roadway lined with stone shops and houses. The cathedral was the central composition in the townscape, and as I got closer to it, the road became steeper and steeper; along with the buildings it kept rising till it became a ramp. The cathedral got closer, and the ramp became a cascade of steps, rising higher and steeper. As the cathedral front loomed, I realized the steps were in fact heading underneath the building, and I was ascending below the nave. I kept rising up and up, till I realized that I was under the building; then quite magically, the church floors opened and suddenly, I was face to face with God. Not my God, but God nonetheless. As I turned around, I saw the city far below, the entire length of the street from where I had come, and I sensed how the street and building had combined to give me the complete kaleidoscopic experience, how indeed the cathedral's high elevation had been used to extend the church into the town. The town, the hill and the cathedral merged in such a way, it was hard to tell where one ended and the other began. It was an experience so architecturally gratifying and monumental, and made, both by the cathedral's location on the hill, and the rise of steps that connected it to the city. The hill dictated a possibility for the layout. The medieval architect multiplied it tenfold into a truly concentrated ideal.[12]

How many Indian cities ever consider their position or seek any real advantage from their unique landscape? Does Bombay's sea location create any special conditions in urban layout, or architectural design to catch the sea breeze or evening light? Is the mountainous terrain visible in the architecture of towns in Sikkim or Himachal?[13] Is the desert or the river location of north Indian towns, with the exception of Varanasi, a criterion in their layouts?

To attract residents to the sea, the small town of Cape May along the New Jersey shoreline, oriented its entire grid of streets on a diagonal. Whatever the street, you are either going towards the beach, or away from it. A plan of such astonishing simplicity, yet so effective in urban terms, was made by a mere deflection of the conventional street pattern. You are either with us or against us, so the urban design says.

A concern for new ways of orienting ordinary city life makes many architects seek unusual combinations of the public and private face for their own buildings. In Madrid for instance, with dense and crowded ground conditions, an enterprising builder chose to move the urban dimension of his apartment block to the roof. In an unusual connection to all the apartments, the roof offers the essential pleasures of

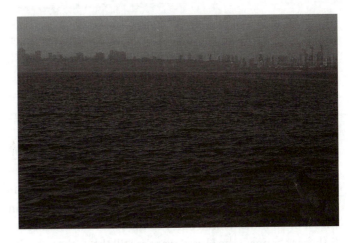

12. Multiple contrasts influenced Corbusier in his design of the Marseilles Block. 'Why do I have to look at the impressions of the formwork every time I lie in bed,' asked an apartment owner. Corbu was quick to dismiss him. 'Anyone can see that the concrete impressions are merely surface blemishes, like the markings of age. As proof of life.' He pointed to a set of wrinkles on his forehead. 'I can make beauty out of contrast,' he smiled, relishing the effect of the important statement. 'I can establish a play between crudity and finesse, between the dull and intense, between precision and accident.' As he said this, he cast a disparaging glance at the residents. Corbusier loved to subvert the classical values of the region. The people of Marseilles it seemed, loved the countryside, and most of them associated it with the ground, with trees and green grass, so it was but natural that Corbusier placed the garden on the roof, on the 20th floor, and surfaced it entirely in concrete. The locals also thought streets were generally outside, and had sidewalks along which you walked, sat at a café, drank and then vomited in a nearby drain. They had arrived at this notion by years of thought and painful deliberation. Corbusier decided to place the street in the darkest part of the building. The residents had no choice, but to walk along it, drink, and vomit in a nearby drain. The commercial life of Marseilles occurred along the streets; people bought, bargained, abused and returned things in the expected banter of a Mediterranean town; Corbusier, therefore, lifted the entire shopping life away from the streets and brought it bang in the middle of the apartment complex.

13. The development of a coherent townscape should be a matter of serious urban concern. Just look at our small neighbour. In the low spreading flatlands of Bhutan, as you negotiate the streets of Paro, it is hard to believe this is a 21st-century city—with cyber cafes, coffee bars and a populace as intensely urbane as any in the world. But the cityscape speaks a different story. All around is an architecture so historic, firm and schooled in the strictest tradition of the mountain kingdom, it appears as if no new building has been added after the 19th century. No glass beauty parlours, no malls, no industrial sheds, no row upon row of public housing. All you see are the coloured cornices and window trim of traditional Bhutan. Without the self-consciousness of personal architectural expression, city façades are swallowed up into a neutral background. A triumph of urbanity over architecture. The city is guided by the urge to suppress the visibility of individual places at the expense of making whole neighbourhoods, whole sections of the town… well, look whole.

public life usually reserved for the ground level: meetings, cabanas, clubs, theatres and restaurants. Besides extraordinary views of the city, the reversal of convention between the public and private gave an entirely new expression to the architecture, the urban design, even zoning. The private street and the public roof were proof that it was possible to do something more than just the predictable and the banal.

If you stand on the concrete tarmac that forms Le Corbusier's capital complex at Chandigarh, you will notice two things: the jagged line of the Himalayas to the north, intended as a monumental backdrop to the grand composition, and the unwavering line of messy buildings to the east, signalling the ceaseless physical thrust of an India denied entry to the city. In the half century since the conception, little has changed: the Himalayas are still there, though a little denuded and sad; and the hordes pushing at the seams are stronger than ever.

Like all formal structures in India, the city survives only because of strict zoning and paralysing building regulations, rules as old as the city itself. Had India been unleashed on the city over the period, had waves of rural migrations been allowed to make space within the plan of a continually changing city, Chandigarh could have been judged as an urban experiment that could reasonably be applied to future cities?[14] In its sealed state, with a prescribed logic and half a century of bureaucratic control, Chandigarh remains a model of draconian legislation. Its false sense of livability is fostered by the experimental form of urban conservation, similar in intent to the fencing around ancient monuments. The extra care lavished on its parkland, leisure valleys and sculpture gardens, its wide avenues and bureaucratic bungalows is an aberration, an artificial construct in a manmade vacuum. A brilliant, monumental lie.[15]

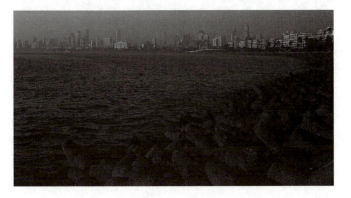

14. It is hard to understand the Indian obsession with new capital cities. Since independence, five states have chosen to build capitals at unimaginable expense, hardship to farmers and at a colossal waste of material resource, energy and manpower. Nowhere in the world do countries build whole cities from scratch when all that is required is a place to conduct the affairs of government. Countries that were born out of the breakup of Yugoslavia merely moved their capitals to places that had a long history and enough space to accommodate government functions. Zagreb became the capital of Croatia, Sarajevo of Bosnia and Herzegovina. Slovakia, born out of Czechoslovakia in 1993 shifted its capital to the medieval town of Bratislava, while the Czech Republic retained Prague. The 2011 split of Sudan turned the county government of Juba into a national capital for South Sudan, without expense or fuss. If countries can accommodate their capitals within existing cities, why do Indian states insist on constructing new ones? After the division with Telangana, try asking a state like Andhra to adopt a small town or village for its administrative needs, and all hell will break loose.

15. The new states that keep forming out of division, the latest being Telangana, all follow the standard route for planning their new capital. With Hyderabad going to Telangana, the government proposed a new capital for Andhra Pradesh called Amaravati in Guntur District. After an invited competition to select the architect, an expert committee chose a well-known Japanese, Fumahiko Maki. Maki was asked to confine his designs to the master plans of a Singapore-based consortium; the Singapore consortium were themselves told to conform to Indian Vaastu principles. After some time the Andhra government began to have second thoughts about the selection; they decided they wanted an Indian, rather than international expression for the building. So, an Indian architect was called in to collaborate with a reluctant Maki. A few months into the unenthusiastic collaboration, the Japanese architect was dismissed and before questions could be raised hastily replaced by a British architect. The change came about without any of the standard government procedures of tendering, competition and selection. Maki then filed an official complaint. To further confuse the equation, the government also added a prominent film director to the mix. Forced into an unwilling professional association, the British and Indian architect are today working on a ₹58,000 crore project expected to begin occupation in 2024 and slated for completion in 2029.

182

14. Urban Art

Much like architecture, sculpture and painting too are hemmed in by the limits of formal practice. The artist is forever cautions, afraid to go outside some self-created aesthetic boundary, unable to reach into the public dimension. Enclosed inside a high boundary wall, against a specified backdrop, within the safety of private enclosure, aesthetic baggage can be quietly unloaded and practised, the small canvas in a private gallery.[1]

How then do you evolve universal symbols in a culture whose primary expression is historic, political or religious? Where street corners were defined by religious shrines and road junctions fortified by glaring freedom fighters, political figures or statements from history books. In such a place, using personal or idiosyncratic sources rather than familiar ones, to make public environments, was of course riddled with the possibility of obscurity and unrecognition. To use realism, ambiguity, or forms of irony and contradiction, in a culture unused to these in visual language was risking the intention to confuse, rather than communicate. Yet art's essential imagery had to somehow relate to people's personal experience of the city. Even the response to the environment could only be triggered by some psychological signals that turn the viewer into an active participant.[2]

The concern to enact a dramatic artistic explosion in city space is less a requirement of art, than an obvious impact on a place existing in a perpetually grey dereliction. The city's low standards of daily encounter and exchange has the effect of dulling the senses, and indeed lowering levels of energy.

Therein lies the more significant question of the requisite content for urban art. What are the forms and concepts that can be clearly identified with the viewing public; what precise imagery drawn from ordinary experience can help to enrich and highlight people's perceptions? Is art merely a bright spark, a pleasant moment of contemplation, in a narrative of dereliction and decay? Or is it part of the required contaminations those at once evoke and provoke, that restrict the deadness, the restrictive character and stench of an unloved city?[3]

The agitating forces of the Indian city often require artistic and architectural interventions that either counter or simulate that restlessness. The beautiful object in a city park, or another in a restful benign backdrop of a cobbled square only reinforces further the isolation of art from public life. As if art's whole purpose is beauty, and its only existence is in isolation. Such a limiting definition, combined with

1. For many years I had lived with the notion that art was generally done by older people after they retired from the Indian police service or an insurance company. And to fill the time between nap and walk, they set up an easel in the flat and painted a scene with a boat on a stream with a backdrop of snow-clad mountains. Meaningful art itself was meant to be nothing more than a painting hung behind the drawing room sofa. The painting not only had to look good but also had to match the sofa fabric, the paint on the walls, the texture of the floor rugs. Art was a piece of décor that fit the style of furniture, the upholstery, the colour of the coffee table book. It was a comfortable vision, and it had lain unchallenged. Three years ago a painting with a green square and a red dot sold for 4.5 crores; at the time, an oversized plastic leopard, complete with painted fur and stripes, went for another crore. Then a concrete sewer pipe with a live Rajasthani family in it was picked up for a few more crores. As was a dead fiberglass donkey strung upside down from bamboo poles.

2. In a preview of an art auction in Delhi, it came as no surprise that as the wine and kebabs began to do the rounds, the conversation turned to prices. That a one-foot square painting had a starting bid of ₹2 crore was of far greater interest than the painting itself. That India's most venerated painters were hung in the same room mattered less than the sheer untamed pleasures of the prices they commanded. It was a matter of great pride that the marketplace had finally come to art. The importance of being Indians was finally being recognized. Art had for long been saddled with the responsibility of conveying a serious message about society itself; at the time the role of media in such a task was entirely underdeveloped; but in the 1980s visual arts' social relevance was usurped by television, advertising, marketing, and other forms of visual stimulation, attesting as the change does to the reduced and flighty attention spans. Forms of painting themselves stared altered. Like advertising, visual art is no longer subtle, with an accumulation of slow subliminal messages. It is blunt and racy and stupid, merely another device—digital painting, photoshopped images, manipulated to suit a particular message. Today art has become short form for political protest.

3. No longer an expression of the beautiful, the wondrous, and an image worth beholding, the reverse is now on show—an indication in art that society is on the decline. The ugly face of life. A reality represented by Inversion, a reversal of subject and context, such that the excitement of cricket is expressed as extreme boredom. The dangers of the nuclear threat represented as ordinary light-hearted comic routine. The other method reinforces the stereotype, the minister as fat, truly ugly, or overtly sanctimonious. Sachin as God, and God like. The mother-in-law as truly vacuous and cold, with malicious intent. Finally, as deliberate falsification: Knowing Mother Teresa as a paragon of goodness—to paint her as a finalist in the Miss India beauty pageant. Or as the devil incarnate.

184

bureaucratic indifference to culture, has imparted to city space a generally half-hearted sclerotic view to the provision of visual relief. Art is merely used as a means to erase the dreariness of urban experience.[4]

Certainly, the acceptance of ugliness as the central feature of city life does give art some precise and chosen opportunities. In fact, some of art's most prolific reminders are of course forms of misrepresentation. Forms that realign our understanding of conventions—height, scale, shape, or placement of an object are questioned by deliberate misrepresentation. Claes Oldenburg's positioning of a giant golf ball in Chicago, or a clothes pin in Philadelphia was a much-needed delusion for people mesmerized and controlled by office routines. The self-conscious irony of the ordinary day-to-day objects, their mismatched size and placement, and the intended seriousness of the urban effort, was the much needed psychic disturbance required by overworked office workers who view it every day. A minor accidental pleasure in a humdrum work day. For a short spell while walking along the city sidewalk, the smile posted a different message to the brain.

Oldenburg, like many other artists in the 60s and 70s attempted to take art out of the pretensions of the gallery.[5] Beyond the closed-door wine and cheese tastings, and onto the street. The three-storey-high clothespin sits in a city square surrounded by formal civic structures. Every year someone attaches a clothesline to it and hangs oversized coloured briefs, panties and bras. The public's attempt to complete what Oldenburg had started, is not only a sudden stimulus to the formal city space but gives added meaning to the original work.

Modernism had in fact severed the connection between such public participation in art and architecture, leaving behind an industrial age legacy that saw building as mere abstract enclosure, and art, when applied to it, as an accessory. Like the hood ornament of a Jaguar, the place of art as secondary and often entirely unnecessary has become a perverse bureaucratic demand that sees the city as only a collective of utilities and infrastructure. Roads, housing, offices, parks and shopping centres, are, and always will be, in short supply, and require constant infusion of funds and plan sanctions. The mere act of their provision is viewed as a form of success in improving the city's livability. How art alters lives, or engages city users in the long run is immeasurable in bureaucratic terms.

The limits of art, as defined and specified territory in the Indian city, is in fact the antithesis of its traditional definition, wherein art's subject, scope and influence was boundless and infinite. The despairing and dispirited quality of Indian urban

4. At the massive exhibition halls in Delhi, the recent art summit had replaced the machine tools, cars and industrial objects normally displayed at Pragati Maidan. The place was now home not only to Rodin's Thinker and Anish Kapoor's enigmatic sculptures, but to hair-pieces strung on walls, androgynous men and women in dog fur, and animal innards in glass boxes. The old belief that art was a reflection of reality was being questioned by the new wave of artists. Because reality was not only depressing, but conveyed very little about life, art could only be a reflection of art; art was for the sake of art. The central feature of most pieces was to delve into obscure and divergent realms and create their own reality, away from ordinary life, away from the messy despair of people caught in the frightful web of ordinary life in India.

5. *Review: In the loud and often brazen world of art there are few shows that thematically connect to a single idea. Artists are so protective of their individual expressions, few would forsake or alter them for a broader speculative idea. But in a recent show called Living off the Grid, the grid evokes multiple meanings at numerous levels. To the photographer, the dark implications of jack boots across the railway track of a Nazi concentration camp; to an artist, the snowflakes and cellular amoeba in a kaleidoscopic projection; to the architect, the geometric layout of solitary buildings, receding in soft perspective. And to the sculptor, the shadow of the steel structures projected on the wall. Part real, part illusion, the curator, plays with sound, material and light to bring the idea of the grid into focus, and tie together these varied expressions. By perceiving an implied order in each of their works, the show works effectively in the controlled space and light of the gallery. In fact, the darkness and focused lighting adds an element of mystery, while creating visual space for each piece. The overall impact is as intriguing as the uniquely individual pieces on display. The walkthrough is certainly a spatial experience worth the visit to NOIDA.*

artworks is a reflection of the severe restraints imposed by city governments and the limited options available to artists to practise ideas on a monumental scale.

The inability of the Indian public's comprehension of new art is today I think a more serious challenge to the Indian artist. To convince, display and engage with the seriously altering sights and sounds of changing India is a far more difficult play to stage, than merely the quick transit from a private Delhi or Bangalore studio to a London gallery.

In a country whose urban life is entirely out of doors, the invitation to open the gallery doors is a natural expectation. Obviously, the public's participation with art can only come through intense visibility. A serious public interest is possible only when public art becomes as messy and vital and chaotic and sweet and stupid as Indian street life.

The response to the environment can only be triggered by some psychological signals that turn the viewer into an active participant in the scene. By themselves of course, the abstractions of architecture merely expressed as assemblies of concrete, steel or glass offer no emotive connection to culture. Searching for an expressive thread requires more potent imagery that can only come from art's interplay with the environment. In such a scenario, a piece of art can become a more effective form of communication when it becomes enlarged in scale to encompass space—when in fact art becomes architecture. By drawing people into the art, moving them through it, or suspending them within, they experience an altogether different dimension of the work. Such fusion can be successful only when it conveys a new symbolic value to architectural form.

Any and all aspects of urban art assume monumental public responsibility. An unloved and disjointed place needs regular and sustained inputs of self-belief, an affirmation that there is another life within the daily drudge. And art can act as a bloodless transfusion. Its presence has manifold importance. To first create a sudden positive spark of visibility, and in a monochromatic background, to draw attention to itself. Second, its engagement with the place creates the much-needed link with the surroundings, as if to assert that the real message of art is outside itself. And indeed, that the work's relevance comes from the setting and landscape. Third, urban art's prime concern may be its visibility, but its real test is also through the environment of the other senses: the possibility of tactility, the touch, smell or sound that may be additionally brought into play. At its highest level, therefore, public art becomes architecture. It allows the public to move through it, on it, under it.

187

As a physical connection between places, between two sides of a street, between building and landscape. Enhancing the experience of movement, even becoming the pause in the movement. By drawing people into the art, moving them through, or suspending them within it, they experience an altogether different dimension of the work. Such fusion, however, can be successful when it conveys a new symbolic value to architectural form. A reading, that is at once, building, art and landscape without boundary, without category.

In much of the recent work of the last quarter century, the decades of post-liberalization, architecture concerns have been largely abstract and technological. Much of the imagery has been drawn either from post-modern sources, or from available abstractions of history. Among the three main architectural types to emerge from the arena of middle-class spending—the mall, the office, and the apartment—there was never an attempt to search for a new way to communicate new architectural content. No attempt even to subvert or to invent a response to a hitherto unknown building context. Or to discover a medium based on the public's new relationship with the shopping centre, the office and the home.

Given the displaced nature of the profession with its practitioner, the potential for the discovery of a cultural form for the new architecture was quickly and soullessly abandoned, all in preference for existing images. Foreign catalogues, half a century of recorded mall architecture and the history of the American highrise, were available for easy adaptation. Architecture's imitative capacity combined with the country's history of cultural adaptation made for despairing results. Throughout the course of the new work, there has been a recalcitrant failure to take building beyond the convenient expressions of historicism or abstract technology.

Architecture's most desperate need to step outside of the cauldron of fear was what made it cling even more desperately to tired and tested imagery. Historic reminders were as irrelevant as those based on an abstract future. Without a more hands-on attitude that rid the profession of arbitrary design ideas, and the picturesque and pandering views to style, there was no possibility of a genuine response.

Beyond history and technology lay the more fertile field of information, an era that demanded more substantial expressions of architectural dynamism and change. The static pictures of building elevations reflecting Neo-Greek and Roman façades, or abstract steel and glass geometrics used to construct offices were so regressive that architecture had been reduced to a caricature: merely a focus of observation on the street. Or a backdrop to a black top parking lot. The refusal to accept that

art and architecture expression formed out of a public consciousness, rather than private taste, left the professional and the artist in personal doldrums. Displaying selected images in enclosed galleries or struggling with private elevations on the computer drawing board, the form-giver withdrew. Unable to reconcile the restless streetscapes, or the volatile fluctuating marketplace, the polemical position had begun to stagnate. It rested on the age-old belief that art was not for everyone.[6] The exclusive terrain was riddled with potholes. So out of touch with common consensus and ideas, it had even lost the ability to consider a fresh symbolism, or approach solutions whose communicability was simplified and coordinated to common city images. The deeper constraints of art instead got progressively higher, more remote and inaccessible. Studio work was hushed into private ironies, lapped up by an elite intent on acquisition and a necessity to belong. Art was a favourite buzzword. When comparisons were invariably made, they were made to projects of a similar scale and intent in New York and Barcelona. Photos were submitted for the Dresden Art Show, the Venice Biennale. The discontent with local moorings was a positive thing, a sign that art and architecture were producing a language and vocabulary that only a few select members of a club spoke or understood, an international membership that met to applaud each other at chosen locations.

Throughout the recent catalogues of architecture, the pervasive mood similarly oscillated between despairing nostalgia and futurist abstraction.[7] For some, an unfettered resolve to rouse the sleeping stonecutters and woodcarvers into a resurrection of the quaint and the picturesque. The ruin had become fashionable again. The architect was left with the age-old hankering that craft skills were being lost, which led as many architects down the path of revivalism and the belief that architecture's destitution could be countered by an active promotion of history. This was recalled in a number of professional sounding phrases: historic conservation, material preservation, heritage rehabilitation. Others felt that sound international technology was the only way to practise art or architecture. Whatever the cause, the important thing was to believe in something, anything. To believe once again in the hope that your own work would be swept along with the renewed meaning and status conferred on the profession. And whatever you did, used or displayed, had monetary, hence artistic, value.[8]

In a rundown neighbourhood in South Boston, the side wall of an apartment block was chosen by a local painter as his canvas. The blank face of the five-storey building fronted a public plaza, and was the natural setting for a display of public art. To keep the work topical, the artist painted his view of what he imagined to be happening in the apartments behind the wall: a child reading on the staircase, a family

6. If art was changing, the real change was in the age group of the artists. No longer the retired set, and no longer mere dabblers, the new age artist was a mere teenager in relative terms. A socially active and worldly-wise type devoted to a lifelong pursuit of personal ideas that would yield substantial financial rewards. Undeterred by the narrow straitjacket of a society still shackled by traditional moorings, the artist installed and painted and sculpted in the hope that private ideas would be granted public recognition. Of the many who participated in public art shows, private gallery exhibitions or art summits, there were clear signs that Indian art's most effective jabs were in the international arena, solidly behind the West's avant garde.

7. That artistic effort is limiting, shows in the perverse misuse of technology. Computer drawings used to be cumbersome and tedious, calling for numerous commands and combing multiple layers to make a simple line. But now a tablet attachment allows drawings to be made easily. You merely draw freehand; as if by sheer magic, it appears on the screen. Looking just as it would on a piece of paper. The same goes for film. The heightened potential to make animation as real as possible through advanced technology gives a result as good as realism itself. Animators are in fact surprised that Satyajit Ray managed such extraordinary realism in *Pather Panchali*, given that animation was still 30 years away. In the recent release of *Tintin*, Steven Spielberg used real actors and turned them into cartoon characters—a reversal of animation's real intent. Today there is little difference between the seriously advanced and the utterly primitive. Soon it'll be hard to tell them apart altogether. Is then, the current view of sporting endurance, entertainment excesses, convenience technologies, economic and political progress seriously flawed and misunderstood? Are we now misfits in games of our own making? Maybe it's time to sit in the courtyard in the winter sun and make a drawing in the mud.

8. Cricket memorabilia is today available in some of the finest stores around the world. At the Pitch, London's first cricket supermarket, fans from all across the world can buy used razors from their favorite players. A Sachin Tendulkar blade used during India's 1993 Test at Lord's sold for a whopping £30,000; an unused Hashim Amla razor for a little less. Who can forget an English steel magnate of Indian origin making a successful bid for the two infamous four letter words uttered by Saurav Ganguly after the 2003 India-England match at Lords? Keenly conscious of his newly acquired Anglo-Saxon heritage, the happy industrialist was quick to note, 'I was keen that the curses stay home in England where they belong.' Even the toilet paper used by the Nawab of Pataudi, during the country's 1973 tour of England has been on view for 35 years in a special display at the British Museum. Of course, the failed attempt to steal it in 2007, has led to tightened security around the popular exhibit, which today is surrounded by plate glass and round-the-clock electronic surveillance. Sadly, because of the sealed enclosure, many visitors from India can no longer smell the exhibit, and leave disappointed.

at a dinner table, a man arguing with his wife in the bedroom, another lying in the bathtub, a thief carrying away a TV. The imaginary composition did not just give artistic life to the plaza but combined all the components of the area into a singular entity. It threw artistic insight not just on to architecture, but the plaza, and the lives of the people who lived in the building. By its direct engagement with people, architecture and surroundings, the piece of work spoke a language everyone in the neighborhood could appreciate. People came, they marvelled, laughed and argued about the content.

In the neglected neighborhood, without the picturesque paraphernalia of design—street furniture, cobbled walkways, trees and fountains—the piece of art created an urban cohesion, and a new way of appreciating city space. In light of the new attraction, things like benches and paving seemed less important. Art was an integral part of the urban design and instilled a new pride in the neighbourhood.

Its identification with the people who experienced it daily while walking home or to work was part of the consolations of an urban experience strung together as many minor experiences throughout the city: a shaded walkway, a hot dog vendor, a passage through a park. Art was part and parcel of the urban movement.

Urban art in India, on the other hand, has unfortunately been reduced to the picturesque. Unconnected to the city, it has the same quality as winter flowers on a roundabout, or a Pepsi hoarding on a sidewalk. Its presence or absence contributes little to the quality of urban life. When Mumbai chose to shift tourist attention away from the slums that line the drive to Santa Cruz, the local authorities similarly opted to install pictures of Indian birds on concrete hoardings. Rather than upgrade the slums, it was hoped that foreign couples on their first trip to India would marvel at the larger-than-life portraits of Kingfishers and Mynas, and not notice the shanties behind it, or the line of naked men defecating in the drain below it. The idea, as with other instances, was to solve the problem by diverting attention.[9] For too long this has been a successful strategy for municipal governments. The purpose of beautification presumes the city an ugly place in need of visual uplift, and distraction.

Art's role to give permanence to the transitory incidents and occurrences of ordinary life finds few takers in the Indian city. That it exists and is given place in urban situations is itself a surprise, given that art rouses no spirit in the Indian consciousness. Placed mainly in the 'leftover' spaces of the city, art is reduced to an appendage, a brief captive miniature moment in a city of monumental moments. Its often

9. Government road signage already does that quite successfully. It generally works on the principle of 'the more the merrier'. Outside my house is a massive directional sign so large it could be visible at high speed along a 6-lane highway; but the sign occurs along a narrow residential street where traffic moves at a pace so miserly, pedestrians are always ahead. The sign informs the driver to take a right for Malviya Nagar. The sign might as well have said London Next Right. There are seven colonies between mine and Malviya Nagar, but there is no road information available on them. The sign for Malviya Nagar was obviously available and needed to be planted somewhere to ensure the public felt their funds were being put to good use. The judicious use of signage ensures the road environment is not cluttered and forms as neutral a background, so the passage through it is swift and without confusion. Unfortunately, most signage is not only misleading but is a complete misinterpretation of reality. At a nearby junction is another sign with a large painting of a traffic signal indicating a red, yellow and green light with the words Stop, Get Ready and Go against each of the appropriate colours. Is this supposed to be a driving lesson, a sort of learn-on-the-job situation, or should someone with a licence be aware of it before they take to the road. Should there be other signs then stating 'Turn steering to the Right for a Right turn' and 'To slow down use Brake'?

194

complete incompatibility with its surroundings is a sure sign that the artist and the municipal authorities have not spoken to each other.

In small towns like Kanpur and Aligarh, a blue-suited Ambedkar shares the street with vegetable venders, pi-dogs and the homeless. In Lucknow, a sandstone Mayavati, complete with scarf and handbag, stares down from her immense height at cyclists and pedestrians (substitute a Jayalalitha cut out in Tamil Nadu). A giant Sardar Patel has been sanctioned for the Sardar Sarovar Dam in Gujarat.[10] An equally large statue of Shivaji on a horse is soon to rise in the Arabian Sea off Mumbai. In most Indian cities, the unwillingness to part with precious public space gives rise to two forms of artistic retrofits: one, as backdrop to a plaza, the other, in the round, at traffic junctions as fillers to empty roundabouts. Ambedkar, Gandhi and Nehru have often found themselves looking down at a chaotic stream of traffic, or contemplating the crowds in a noisy bazaar.

Such public art is just an unflattering form of political deification. As a mismatched moment in a public scene of such debilitating flux, it often goes unnoticed. It often casts doubt on the 'public' nature of urban art itself. When representatives of political or religious ideologies combine with repressed groups, they promote art that only propagates a political agenda.[11]

In the brisk tumultuous atmosphere of the Indian city, public participation is not merely a visual challenge but becomes an opportunity to lift ordinary and mundane routines to a new level. Naturally, the social nature of a society itself moulds attitudes to art. And a piece of public sculpture will never elicit a common universal reaction. Cultural beliefs and ideas combine with private imagination to produce unusual reactions to art, especially so when the artist has succeeded in conceptualizing a prevailing condition.

Disagreements and provocations in artistic reactions are expected in work that is not dominated by religious or political zeal. Merely expressing a common feature of ordinary life, a memorialized idea from history is hardly an exercise in art. Certainly the Dandi March sculpture is an expressive thought and occurrence shared by millions, and its true value lies in the re-enactment of Gandhi's experience, but art's most exacting forms create a central disturbance. Stating an unknowable in some physical, acoustic or tactile form. Some years ago, a prominent sculptor proposed a larger than life-size installation of a pot-bellied minister in white alabaster; his dhoti raised, the man was depicted urinating against one of the columns of Delhi's Parliament House. However lewd and outrageous the idea seemed at first glance, in

10. While a public commemoration of Sardar Patel as the architect of the Indian republic could hardly be underplayed, a display of such heedless gigantism does little to convey the man's stature. At a cost of ₹2,500 crore, many people argue that such money should go to public health, education and the tireless battle against poverty; against the onslaught of wily political craft and expediency, they will cry themselves hoarse. To assuage its own feelings of guilt the government wants to assemble the statue from iron scrap contributed by the poor, an old devious strategy to strike at the moral Hindu heart, and—like the RAM inscriptions on bricks planned for the Ayodhya temple—make this a people's demand. A door-to-door campaign to canvas for the metal is being waged by an NGO called Citizens for Accountable Government. Almost two lakh collection boxes have been set up throughout India, and marathons called Run for Unity being organized. Awarding the construction work to the company that engineered the world's highest tower in Dubai, the Burj Khalifa, is a way of sending a message on the seriousness of the intention. To give additional weight to Gujarat's biggest venture in public art, the statue will house a memorial, visitors' centre, hotel, convention facilities, amusement park and research institute—all the usual paraphernalia inserted when no serious usage is available. An open lift alongside Sardar Patel will carry tourists up to his head for a panoramic view.

11. Of course, the idea of public deification is an old Indian tendency, and indeed, colossal statuary is nothing new to India. But in recent years, religious trusts emboldened by new technology and excess funds have gone on a building spree. The 58-foot Buddha in Hyderabad is now dwarfed by the Mytreya Buddha in Bodh Gaya at 150 feet, equivalent in height to the concrete Hanuman, also near Hyderabad. The Indian heritage of figurative statuary oscillates from the sublime to the ridiculous. Besides Lucknow's numerous Mayawatis and Ambedkars, some years back the Maharashtra government came up with a giant commemoration of Shivaji, a 310-foot high statue set a mile into the Arabian Sea, a project now given the environmental nod. Is Kolkata then likely to ask for a 700-foot-high Mother Teresa in the Bay of Bengal? Will Tamil Nadu propose a 900-foot-high MGR along the coastline? Or Kerala a 1,000-foot-Vasco da Gama? It is just a matter of time.

all respects it was an unmistakable comment on the state of politics, public debate and the relationship between the government and its most hallowed institution. Its bluntness was appreciated by some who saw the piece in the artist's studio; most people, however, dismissed it as provocative, obscene and offensive. The project was ultimately rejected by the artist himself. The public is too illiterate for irony, the artist felt, and returned to drawing flowers on canvas.

Why should elected officials and ministers be given permanent space in people's memory? The place of sculpture in the city is a controversial issue in a country that still regards statues of political figures, living and dead, as the only form of public art. Because public self-scrutiny is a wholly un-Indian idea, most urban art in India is picturesque and meaningless. Where the public plays no role in the selection of its public art, the art is naturally second-rate. How different are Mayawati's statues from those of Lenin installed by the Russian communists? Why indeed should the ugliness of Indian political life be projected into public space?[12]

Only theocracies and dictatorial regimes use art as just another form of state media, a more permanent way of sending a very temporary message. An open liberal society, on the other hand, allows a pitiless evaluation of itself, through art. The idea to investigate societal flaws or break with traditionally accepted models, is a full-time experimentation that throws open surprising ways to interrogate, what we do, how we live, how indeed we may live. And the artist's role each time a work is produced also provides substantial clues to how he values his own art and what effect it will have on the environment and the viewing public.[13]

For British sculptor Anish Kapoor, such a debate is wholly trivial and static. Government-selected artwork defines neither a place for art, nor does it allow the artwork to inherit the values of the place in which it finds itself. Kapoor's own art, by contrast, is full of surprises. It exudes every bit of visual pull to draw the viewer into its ambit: colour, reflections, movement, action. At first glance it is hard not to be intrigued by the primary geometry of his compositions. Shimmering pieces of mirror, or perfect globes of colour, they attract merely by their Euclidian simplicity. As if in the urgent need to attract the eye from the surrounding chaos, sculpture's aim is reductivist and planer, celestial and geometric. Substance is more noticeable in the absence of complexity.

But the real thrill of Kapoor's art is the very personal way it opens doors into a monumental public brief. At Chicago's Cloud Gate, a monumental convex mirror in a busy square, an impersonal unnoticed city is suddenly miniaturized into a

12. The ugliness of Indian politics is in great part the outcome of negative campaigns, personal barbs and malicious vendettas that have little relevance to governance but are consistently used to send subversive messages against an opposing individual or party. In a parliamentary system that encourages such destructive exchange, the real ideas of politics get submerged in the muck of words and personal sentiments. Profanity upon profanity, indignity and shame are heaped in generous doses. For the newly arrived, there is great satisfaction in negative proclamations, it cleanses the slate for their own participation in politics and accords them an honourable position from which to begin. It may be hard for Indian politicians to make statements whose intent is not to malign, but it will certainly generate greater interest in actual politics and governance if the public mention of an opponent or opposing party were to be made illegal. The act of continual accusation has made debate redundant in India. Every minister, MP, or party spokesman who stands in front of the television screen puts up a defence of policy that is an offence against the opposing MP seated in the same debate. As the recriminations get more malicious and spiteful, the state of politics is lost in a battle of words. The TV moderator cringes in despair and launches another futile attempt. 'If it takes two Christians four hours to convert seven Muslims into Hindus, how long it will take an Australian missionary to travel by jeep to Orissa and confront a violent mob?'

13. When I first saw The Last Supper, Leonardo da Vinci's great painting in a book on Renaissance Art, I couldn't help thinking 'what a waste of paper'. All I could see were some hungry looking apostles sitting around Christ at a long table waiting for the pizzas to arrive from Dominos. Same goes for the Mona Lisa. Here was this sly Italian woman half smiling half mocking, staring out of a picture frame. What was the big deal? The big deal was that I didn't understand the painting. And needed an art historian to tell me why it was great. You see the composition is coated with a delicate sfumato so perfect that its frame encloses a glazed almost ethereal, light. And the forms. What forms, they are built up from glazes so gossamer thin that the entire panel glows from within. But Mona Lisa'a fame emanates not from the pictorial subtlety alone. No. Even more beguiling is the psychological fascination of the subject's character and personality, how the work tends to foster limitlessness not found in other high Renaissance works. Leonardo's painterly eye, volumes and outline merge. On the one hand Mona is perceived as an individual material object with skin and bone, as a solid tangible body, while on the other, the landscape of her background is seen in the wider apprehension of the world as a shifting, almost liquid semblance. The artist has brought the two opposing dualities into a delicate balance. The smile too may be perceived in two opposing configurations: first as a timeless symbolic expression of the enigma of the human condition, or perhaps as an echo of a momentary mood in which Mona is giving to Leonardo the wry smile.

shimmering mirror that is at once sculpture, architecture and fun fair gizmo. Changing with the light and reflections, changing with the curving surface you can be inside, above and beneath the sculpture to get altering perceptions of the surrounding urbanity. The mirror's sheen acts as a sudden release from the repetitive daily weariness of city space.

One of the most compelling sights in a museum of Kapoor's work is the absence of wall space. The backdrop of sculptures is often neutralized into a white plane. Certainly, unlike Chicago's Cloud Gate or the gigantic mirror in London's Kensington Gardens, the museum sculptures do not have the advantage of participating in the surrounding landscape. Their action comes from the contrast of the colour with mute white walls, or through physical collisions. At the Royal Academy, Kapoor commits the blasphemy of intentionally soiling the classical architecture of the interiors. An open wagon of blood wax on rails squeezes through Renaissance doorways to splotch the walls, the wax assuming the shape of the doorway. The moving artwork mocks and defaces the structure, while reminding you of its classical shape in the altering redness. In another piece, colour is fired from a gun. How would you classify a cannon that fires splotches of red wax on a back wall; is it installation, is it painting, is it even art? For a man who has obliterated all the boundaries between painting, sculpture and architecture, it is an inquiry of mere academic interest.

For many, the gigantism of Anish Kapoor is first itself disturbing. As is the earlier work of Claes Oldenberg, the golf ball and the clothes pin. Oldenburg gives great scale and space to ordinary objects; in turn their formal surroundings, city squares with classical buildings, cause the unease of two opposing visual juxtapositions. The golf ball is as much a parody of middle-class life as the art is of itself. When the trivial, the serious and the city square become part of the same frame, a form of public art is achieved.

Expressions in art and architecture are the expressions of daily life in progress. There are clearly changing shifting patterns in all the processes around: the family, the neighbourhood, changes in social behaviour, the way we live, work and recreate, how we move through the city, or engage with others around us. Changes too within the human mind and body. These can be viewed as disturbing shifts, or as positive features in a changing society. In adapting a wider sense of optimism, art becomes a medium for the events to come a coherent visual image that embraces the change and connects it clearly to the present.

Even the movement of art out of the enclosed gallery onto the street is more than just a shift of venue. The private freedom of expression in a room is discarded in preference for a more collaborative interactive symbolism, with a shared message. A conservative placement is suddenly idiosyncratic and lively for the multitudes that participate in its viewing.

As social and political upheavals radically alter society, an image of the future can also be built. Architecture lies in two places, within the comfort of familiar images, and beyond in the extension of imaginative flight. The two together can make a future legible, the connection with the imagination can be explained, conservation and continuity can be displayed, architectural experiments can come to the fore, lifestyle choices delineated. The range of choices that lie ahead can be brought to the present.

An extension of sculpture or any other form of art in the landscape requires a hybrid sensibility. The cautious artist is unable to jump into the public dimension and connect with the public. Equally, the conventional architect is unable to use building as a form of communication, wherein architecture becomes a commentary on architecture itself.

The artist works free of the environment in which his work is to be placed, involved as he is in private ideas and references. The final work then becomes a physical representation of a consolidated thought, a model of personal impression. Often timid and artificially imposed, its generic misfit in the city and landscape is merely the result of the mismatch between private content and public expectation.

How then does public art help to bridge a gap in the lives of people who encounter it everyday? Does it in any way help to improve or complete their experience of their surroundings. Should lesser individuals and public acts be subjects of commemoration? Beyond its commemorative and celebratory role, urban forms in art and architecture can charge places with moments of wonder, as if in the transit through the day, its continual upheavals, there is a release of sorts that is not earned but occurs as part of a limitless expansive view within the tedium of daily experience. It requires no logic, no explanation, no study or analysis. Like the geographical feature of a wide valley that suddenly appears off a long and constricted road. It is neither an expectation, nor a sustained image. Just a fleeting, pleasant disturbance in the back of the mind.

15. City Cosmopolitan

If modern architecture in the 20th century had lost its ability to communicate and engage with the viewer in any meaningful way, the problem lay in its outright rejection of ornament and popular imagery: all the narrative messages and iconography projected in earlier buildings that had been crucial in defining the religious and social life of the times. Their presence as an intrinsic part of architecture was so crucial to the life of buildings. They were viewed as society's progressive arms, a means indeed of a society feeling good about itself.[1] People built, inserted messages on pediments, sculpted God on columns, wrote out whole sacred texts along sides of buildings. The archetypes and icons were such an intrinsic part of society that they were the natural expressions of a place's traditions. Society's more imprecise invisible sensations were picked up in the work and expressed in a recognizable way that made instantaneous connections to a common sensibility. People connect to the artist, as the artist does to an unconscious presence. Architecture was sculpture, was art, was life itself.

Yet modernism was not based entirely on the absence of iconic content, but sought relief in abstraction. For most of the architects of the 20th century, cubes, cones, planes, were all imbued with transcendental meaning. In the absence of narrative expression, abstract geometry acquired a special significance. Yet much of the work was devised as formalist style and its importance was directed at artists and architects alone. A new iconography was in the making, based on the exclusion of the public, a sort of self-styled and self-indulgent understanding of art as formal geometric exercise. Mainstream architecture movements that emerged from this enthusiasm were an internal professional preoccupation that resolutely kept the public in the dark. People couldn't care less what artists and architects were doing or thinking. The divide was complete once and for all.

Off a side lane behind Mumbai's Peddar Road is the home of one of the wealthiest men of the city. Italianate statuary across a secluded private road carries you to a Baroque mansion with some of the finest collection of art. Unlike Mumbai's business elite, the owner is a recluse, enjoying his wealth without ceremony or flash. In the evening, he has a painting removed from his vault and moved to a special room for viewing, where a chair is set alongside a table with his favourite whiskey. A few miles away, lies the world's largest slum. A warren of alleyways that house the city's poorest, in densities so desperate that it is difficult to establish boundaries or ownership. Ironically, both these extremes form a benign, positive relationship with the city.[2] One remains a mirage, a free-floating molecule, without citizenship; the other,

1. Nehru insisted on deviating from these traditional leanings and look outside for inspiration. His own uncertainty on how architecture could be used to reflect India's new status as a democracy sought out a French architect. Le Corbusier's buildings in Chandigarh can hardly be faulted for their symbolic value as important artistic markers. Different, unusual and admirable, their design and curious profiles easily stand apart from the messy ramshackle outlines of the Indian city and have been eulogized in stamps and Swiss currency. Yet, how have these buildings created a 'democratic' and inclusive architecture? The aerial view of Chandigarh, Gandhinagar, Naya Raipur, Bhubaneshwar all suggest the same devices of civic planning: a central commercial district surrounded by public housing, the presence of government at the head, and a vast enlarging periphery of slums.

2. The city is the single biggest democratic institution in the country, bigger even than the government. It is neither about the survival of the richest, nor a provider for the poorest. Its largest most vocal contingent is the middle class, a majority of its citizens' only connection with the place is of demand and expectation. Delhi, Bombay or Bangalore, it is hard now to make a distinction between the urbanity of what were once three different places, with historic, cultural and regional identities. The decline in their identity is the result of their amorphous development, the promotion of a sort of building that is self-centered and enclosed by high gates. Rather than making a contribution to urban life, it sucks the city dry in the most parasitic way possible. Yet, strangely, this absence of a public consciousness causes no guilt, no alarm among the residents who have only grown to lead private lives. The single-minded devotion to family is always at the expense of the community. The world beyond home and boundary wall is amorphous, and too uncomfortable a reminder of class and position. Outside the family you are always an unequal. Someone in your sightline is worthy of emulation, someone else in a state of humiliation, another in desperation. Every reminder, every collision, makes you acutely aware of your differences, and restates again and again that there is no common ground for a collective life. The internal conflicts of social class will never let you become part of shared public space.

a complex web of communities sustained by their intimate links to each other. The parasite is the group of people in between, those riding cars and subways, strolling in malls, entertaining in clubs, eating at Thai restaurants, occupying homes and apartments, people for whom road space, parking, electricity and water is not just a birthright but part of the relentless daily expectation of urban life—the middle class.[3]

For this group, the myth of Mumbai's cosmopolitanism is perpetuated by fear.[4] The elite, shaken by the terrorist attacks, occupies the business and commercial centres at Colaba and Nariman Point. They frequent the Taj and Oberoi hotels; they spend their evening entertaining at the Gymkhana and Wellington Clubs; their homes occupy the high reaches of Malabar Hill. Given their low numbers, their influence on the city's cultural and business life is remarkable, but in no way do they constitute the urban culture of the town.

The city's urbanity is more mythical than legendary. It exists in superficial and convenient global comparisons, to London, to New York.[5] And it arises as much from self-doubt as from self-interest, and the need to belong to something more than just the immediate neighborhood. Given these conflicting attitudes and the two Bombays, how then is it possible to govern a mass of people so disjointed in civic purpose and responsibility? In urban terms is there any condition that unifies the lives of, say, a factory worker in Mahim with, a company secretary in Bandra. The lack of urbanity in Mumbai makes it possible for the two to lead parallel, entirely unconnected lives, people linked to the city only for the demands of survival, sharing utilities, not space.

So smaller cities form. To survive the city is to stick together, to stick together is to remain apart from others. In Delhi, journalists acquire land and live together in Press Enclave; lawyers live in Niti Bagh; Jews in Cochin, dwindling to a few hundred, live in Jewtown. After the riots, polarized Ahmedabad created defensible positions, setting religions against community life. In places where the ghetto is not a planning concept, riots make it so. Eventually, cooperation comes to mean cooperating with people whose proximity will not produce cultural, ethnic and economic ripples.[5] It is a much safer bet to live with a neighbour who is racially, morally, and spiritually your equal than attempt to savour the uncertain benefits of diversity, one of the prerequisites of a cosmopolitan culture.

Compare the situation with New York. Within the larger frame of Manhattan, survive neighbourhoods of such ethnic diversity, it is hard to believe they are set in

205

3. To say that the Indian middle class in civic terms is pampered and spoilt is to make a statement of little value. Throughout the world it is no secret that the middle class determines the quality of urban life. Its ability to buy or rent space, its capacity for consumption, its requirements for office, schools, parks, recreation, shopping, indeed its needs for transportation, all set the tone for the city. Yet, little in the actions of the Indian middle class shows concern for citizens that don't belong to it. It uses the city in its own terms, with a selfish demand for convenience, requiring unencumbered access to shopping, insisting on alighting and parking only at door steps, waging continual territorial wars over private space, and usurping all that is in the public realm—grabbing sidewalks, seizing air space, cantilevering illegally and reclaiming all that belongs to others for their own private purposes. However miniscule a minority, the middle class has the power to hold the city to ransom. And does. In genial drawing rooms of rayon and satin, over the splash of Chilean wine in Danish crystal, the voices are raised in a uniform condemnation of the new mode of public transport: I spent two hours in traffic; I was stuck at the light for 45 minutes, Yaar, this BRT just doesn't work. Why don't they scrap it? The same people who will spend hours labouring on New York City sidewalks without a squeak, or carrying heavy packages in and out of the London underground without so much as a groan, will mount a scathing offensive if made to walk in Mumbai's Cuffe Parade or on Bangalore's Brigade Road. Without a driver waiting with an open car door at curbside, no trip in the city is possible.

4. But Mumbai also survives under a sinister shadow. Economic and political undercurrents control the city in ways that doesn't allow it to function as an operable civic model. Can a city with a grim underworld of crime, a police force that thrives on daily wages from drugs and smuggling, a bureaucracy that regularly transfers unsullied officers, and politicians who shamelessly promote religious and ethnic strife amongst communities—can such a place ever benefit from conventional urban governance?

5. On a trip to Lahore I was struck by the cultural similarities between my hosts and myself: we shared the same food, lived in similar surroundings, and shared the same jokes. It was an altogether friendly experience separated by a border. On a short trip to the Northeast, I realized how different I was from the local population. Despite the cordiality, the cultural and ethnic connection of my hosts was closer to China. Yet I felt gratified that our differences were not a source of alienation, and that thankfully the boundaries of nation-states are in fact not cultural, social or culinary boundaries.

the world's most cosmopolitan city.[6] Like Mumbai's Parsis and Bohra Muslims, the minor neighbourhoods belong to communities as old as the Italians of 200 years and the Haitians of 20. Everyone living together and contributing to the cosmopolitan cesspool of New York: Greek sidewalk food stalls in Washington Square Park, curry places in Little India, cheap Chinese watch shops along Canal Street. People ply their trades in their own languages, live amongst their own, read their own daily language paper, discuss the politics of their own countries, eat their own food and carry on as if the Manhattan skyline in the distance is just an extension of Canton or Cairo. Yet the acceptance of their differences contributes to a unique metropolitan mix.

Unlike the western city, the basis of the Indian town is convenience. The dabbawallas—like the BEST buses and Irani restaurants—are merely the byproducts of economic and domestic expediency, nothing else. Even though city chroniclers have given them legendary status, Mumbai has the knack of making the most banal of necessities into a successful cooperative venture. The cultural upheavals, the excesses of banking millionaires that give vibrancy to New York, Hong Kong and Tokyo by producing centres of art and music have by and large escaped Mumbai.[7] The current city is merely an agglomeration of accidental forces—migrating labour, entrenched middle classes, daily human toil, public expectation, random division of physical space, and attempts at law and order. With no control over the numbers, or placement and movement of people, goods, cars, etc., the city functions as an anarchic incoherent organism. Its semblance of workability comes from small private endeavours—a shop here, an office there, a factory, a cricket match—disjointed places, incidents and events that impart a sense that life is carrying on. The need of its citizens for dire and daily sustenance keeps it throbbing, commuting and eternally jostling; and so, perpetuating the mistaken belief amongst its residents that the sheer movement and urban agitation bestows their city with cosmopolitan purpose.

Is there in fact a qualitative difference between village India and urban India? How are the small villages within and outside Delhi, with brick and mud houses and dirt lanes, different from its Baroque colonies? How is Whitefield in Bangalore a city, but Kadugodi, a settlement of small brick and thatch houses four km away, a village? Rural India has always been a model for urban India, and even today, the two worlds, separated by time, style and technology, are in fact sociologically entirely similar. People protect their small holdings of building and land, they work locally, they compete and agitate for better conditions, they look for water, steal electricity…. The only clearly defined place in both city and village is the home, walled

6. Without question, western democracies still remain liberal at the core. However, the abject failure of multiculturalism is today most noticeable in societies once perceived as liberal and pluralistic. Denmark, UK, US, France and Germany were in the 1980s not merely 'tolerant' of their immigrant populations but encouraged the differences that made society more varied. On paper at least, multiculturalism was a thoughtfully wonderful idea. English chicken tikka masala, the German currywurst, the Harekrishna street chanters of San Francisco, are all the sillier manifestations of the larger failed idea. But the turban, the burqa, and the minaret are now the xenophobic blinkers around European governments, symbols of the rising mistrust of brown immigrants. It is hard not to notice the discomfort of the Western politician when confronted with issues of race.

7. It is hard to believe but there exist astounding similarities between the Indian city and 19th-century New York. Some of its earlier citizens had however gained vast wealth through business and industrial enterprise. Pitted against the background reality of poor immigrants, the few who gained materially remained free of the morality of egalitarianism or sharing anything of their vast fortune with the huddled masses. But some among them stretched their largesse to a belief in the goodness of urban life and became invested heavily in the civic structure, contributing to the social, cultural, physical health of their less fortunate fellow citizens. Money had not been an altogether one-sided affair, and the city gained substantially from private philanthropy. Lincoln Centre, museums, galleries, theatre, gardens, universities and libraries may have emerged out of private intentions and desires, but grew into the social infrastructure of the city. In its own way, private capitalism delivered. Even if it created vast personal reserves in property, objects and social life, it recognized the shared importance of the city as cultural space. And the investment in the construction of cultural institutions was as much a belief in a shared future as a hope in the greatness of the city itself. In the spread of its colleges and galleries, private art collections, rare manuscripts, libraries and the profit makers showed their more generous side. Moreover, their philanthropy linked the more savage history of the city's immigrant past with a more genteel future. In so doing the city, enmeshed in deeper stages of human development, arose from the level of a temporary encampment to be plundered, to a place of global significance. While the city and state continued to make New York into a concrete connective tissue of housing and highways, private lives yearned for an urban future more dynamic and enduring. With private coffers brimming, the urge to engage streets and neighbourhoods as cultural extensions of their affluence—the theatre districts, gastronomy, art of knowledge were given a new lease—and the hope one day of giving value to local space, local institutions. It signalled a new urban self-confidence and a preoccupation that the city would be made better.

in with precise boundaries, a cubical box of brick and cement.[8] Beyond it lies the undifferentiated disorder of public space. Without will or strategy, this lacklustre public arena only encourages a future of further destitution.

Except for Lutyens' colonial layout and the grave mistake that was Chandigarh, there was never an attempt to define the components of a modern Indian city. Most attempts at city planning relied only on Western models. The application of outmoded 19th-century principles to places like Gandhinagar and Bhubaneshwar have left them with a yawning cultural emptiness, and land subdivisions based on social and economic hierarchies. Sun-baked lifeless plazas, wide axial roads, great distances between home, shopping and workplace, presumed that in the crowded messy reality of India, emptiness was a desirable public asset. Even the new capital of Naya Raipur, now under construction, is a direct copy of the English garden city, an idea entirely misplaced in the barren wilderness of Chhattisgarh. After displacing 40 villages, Naya Raipur has swallowed up over 8,000 hectares of arable land, filling the forlorn countryside with secretariats, roads, legislature buildings, offices and housing. The city is an example of outmoded 1950s planning when land was cheap and readily available. Sixty years after Chandigarh, to spread such vast quantities of concrete on precious agricultural terrain is a shameful act of urban tyranny. Demonstrating moreover the ineptitude of a government incapable of rethinking new forms of governance, or a more efficient way to house it. The inevitable demands of social status and bureaucratic hierarchy have spread the layout into a vast hive of antiquated assemblies.[9]

Even the utilization of public space is an inefficient and inequitable component of Indian towns. An examination of civic and commercial infrastructure will reveal that only a quarter of the city population uses most of the public facilities in the city. Roads, subways, housing, malls, markets, offices, parks, and museums, virtually every aspect of the city is meant for middle-class use. Consequently, the middle class also contributes the larger quantum of waste: home garbage, raw sewage, air pollution, and commercial and industrial waste. By all measures, the middle class first occupies the largest share of city land and space, consumes the biggest slice of its offerings, and wreaks the highest level of destruction.

New census figures on urbanization have suddenly revived the age-old debate on a phenomenon that has existed since the rejection of the Gandhian view that village life could be filled with enough dignity and virtue to make the move to the city undesirable. Sadly, the argument of a return to the village is today tinged with the hollow laugh of cynicism: derelict teacherless schools, abandoned health centres,

8. 'The house is a mass produced machine,' Corbusier said.

'Mass produced housing is a guarantee of beauty.'

'The spirit of mass production is the spirit of the house.'

'And beauty is the spirit of the machine.'

Corbusier's brave new world was wallowing in a hauntingly beautiful image of industrial progress. The colours of the picture were muted, and the frame contained all the desirable icons of the

changing times: A repeating cubical mass of tenements. Children playing along a road; behind them, a line of workers heading for the factory with their lunch boxes. A thin minaret rises into the grey sky, an industrial smoke stack belching the smoke of rapid production and emitting darkened slime into the waters of a river slowly snaking its way behind the factory. An icon of the new age. Since machines were to be used in the construction of these new landmarks that were themselves like machines it was safe to assume that life itself had become mechanical, if not by preference, at least through a lack of interest in anything else.

'Calm, order, neatness impose discipline on its inhabitants.' Corbu carried on till the perspiration soaked into his black clothes and wilted his black bow tie.

'But won't mass production produce sterility?' somebody shouted.

Corbu carried on undeterred. '… housing schemes for garden suburbs… a radiant city… freehold maisonettes… the beauty of reinforced concrete. A new epoch has begun.'

'Everything mass produced is good.'

'Everything mass produced, pre-cast, and repetitive is better.'

'Everything mass produced, pre-cast, repetitive and made in concrete is the best.'

9. There are three serious reasons to reconsider the bureaucratic culture of new capitals. First and foremost are the inevitable demands of status that spread the layout into a vast hive of antiquated assemblies, where every official has a prescribed place in the hierarchy. The need for VIPs to begin behaving like ordinary people would call for an elimination of costly architectural perks like free housing, special offices and private facilities for entertainment and recreation. The establishment of a new capital is a prime opportunity to demonstrate how the city can become a great leveller. More crucial is the question of land acquisition. If the smart city is based on an efficient business model, the capital city still retains its allegiance to the bureaucratic model. Wasteful of land, it swallows up vast swathes of acreage in housing, roads, parking, ponderous office buildings, cavernous secretariats and bhavans. While elsewhere around the world, countries are downsizing big government into more efficient governing partnerships, Indian bureaucracy spreads its tentacles into all aspects of life. A new capital can create a more efficient working model, even testing its validity in the architecture. Third, over the next decade, the Indian city is going to be the epicenter of the largest rural migration. Already today most metros measure the daily flow of over a thousand families in search of work, home and a secure future. Is a Singapore consortium or an American architect, despite impeccable international credentials, in a position to gauge the influx and design accordingly? The integration of the rural dispossessed into the culture of smart cities will only be possible when the government begins to dissociate 'smartness' with appearances and looks at towns as growing changing landscapes.

waterless parched lands, a continuing social divide, makes the city slum and foot-path an attractive option.

The majority that make up the urban poor, live on handouts or make a life in urban services. Their voice is not just muted but missing altogether. There is no one to demand housing, better health, better sanitation, more water, etc. Even though every Indian city has a large population of the poor, never has there been an attempt to create living conditions ideally suited to their perspective. No regulations or standards exist for a home, street or neighbourhood; nothing defines their needs for space, community or privacy. Everywhere they are merely unfortunate appendages to middle-class values.

Though Indian cities are stifled by construction regulations, the illegal nature of slums allows an easy and welcoming tolerance to human density.[10] Even in the regulated part of town, tightening space constraints have made the urban home more compact and functional, altering the 1970s bungalow, to a 1980s townhouse to a 1990s flat. Constraints in slum areas have imposed similar conditions. The slums of today, whether in Ahmedabad or Bangalore, are far denser and more squalid than those in the 1960s and 1970s. A spacious well-settled slum may sound like an oxymoron, but the informal space of cities two decades ago was in fact far more accommodating and hygienic. When the primary thrust is in infrastructure, health and education, the environment is seen as superfluous and redundant. The increase of pollution level in the city, though an outcome of many factors—more vehicle, more coal burning, illegal fires, industrial effluents—is largely due to the higher densities, and an increase in large- and small-scale factories within city limits. In the last 50 years, all public action related to the influx into towns has only accommodated trends, and so endorsed a defeatist policy. The increasing numbers has consequently led either to an increasing density within the town, or to a widening sprawl of city boundary. The Indian city has neither the regulations that endorse particular urban values, nor the will to govern the increasing numbers. With no restrictions on cars, no congestion tax, uncertainty about mixed use living, changing and changeable building norms, thoughtless codes on historic preservation, there is a complete absence of urban insight.

The city is moreover little more than a modern-day trading outpost.[11] Since the common goal is a commitment to nothing, the ground of shared ideals that make the city livable is constantly being compromised. There are daily wars dealing with urban water supply, roads, electricity, banks, school admissions, government departments and bureaucracy. By all counts the degraded life of the Indian town is beyond

10. 60% of the capital is today composed of recognized and illegal slums, a figure expected to rise to 90% in 2025 when the city expects to host a population of 28 million, the second largest urban agglomeration in the world.

11. Sadly, despite all its claims, Delhi always has the feel of a frontier town. As if everything is on trial. Testing out pedestrian bridges, road signs, new building types, cabling systems, rapid bus systems. So tentative are the steps that nothing is completed enough to be successfully tested. Bus lanes peter out into mid-stream traffic, signs are international looking, but misleading; new building technology is visually appealing but falls apart within a season.

redemption. Its downhill direction is visible in all aspects of lifestyle—shrinking homes, deteriorating air, depleting water supply, poor sanitation, over-stretched transportation, road rage and water wars. Reined in by limitations, strangled by bureaucracy, ruled by antiquated by-laws, and practised within the narrow scope of hundred-year-old colonial regulations, the Indian city continues to be a despairing and unsightly blemish on the landscape. The daily sighting of the city is always one of a wasted uncharted territory. Usurped, encroached land and space, free for all.[12] A marketplace for extracting favours, exchanging goods, cash and livelihoods. More and more, the Indian city is more slum than regulated town.

It is no secret that the most environment-friendly cities are also the richest. They have money for experimental transport systems, energy installations and waste management and recycling, that third world cities can ill afford. In the thrust to design the new environmentally conscious city, planners have chosen in most places to discard the economic model of city planning and instead created an altogether new environmental model. In the past decade, sociologists, and architects, have sought out expressions of limited and controlled growth in urban centres that would be in sync with the expanding city. Cities around the world have innovated their own environmental mechanisms for a better city. Copenhagen has devised cycling pathways.[13] London levied a congestion tax on cars, Bogotá promoted an efficient bus transport system. Barcelona's pedestrianization, Bangkok's recycled waste, and Kampala's urban farms, all suggest that the world has embarked on its own methods unique to its cultural setting. An environmental urbanity that emerges from a local reality will similarly be the only answer to India's urban future.

The new inhabitants of the city come with lessened expectations of home and with the modest ambition of employment. In the stark rarified stratification of a city of walled compounds, the welcome is less than muted. Doubtless, disparities between rich and poor will always exist, doubtless too, there will be skirmishes over water, land, air, and noise pollution.[14] But beyond the city as a permanent battleground lies the more serious challenge of accommodating people living together in such close proximity.[15] Every city lives by its own social codes of both private and institutional protection.[16]

In the new century, the old Gandhian slogans and the self-made hand-crafted home was but a forgotten ideal. The statistics have mounted over the years and left the builders no option but to seek technological and industrial models, low-cost structures, factory made, and erected without time and labour cost. The new models are catalogue houses made of reconstituted factory waste, compressed into walls and

12. Among the social circles of Delhi there are few things that propel a cocktail group into ferocious debate than the topic of sealing and demolition. Ironically the discussion is most virulent among people who are least effected by the issue. The elite long ago gave up on the city and decided to take things into their own hands. For them, architecture is merely the frightened response to the surrounding blight, the slowly encroaching conditions of despair. The sewer pipe houses, mud shanties, increasing insecurity and disappearing city services. Architecture accommodates. If security is threatened the boundary wall rises, a guard cabin appears on the gate. Who needs the city's overburdened services, water supply, electricity, when a generator and electric pump can lift water from 400 feet below, in your own backyard. A city with global aspirations continually forgets to remind itself of the needs of its long-time residents, the millions facing a chronic shortage of clean water, air, and adequate power supply.

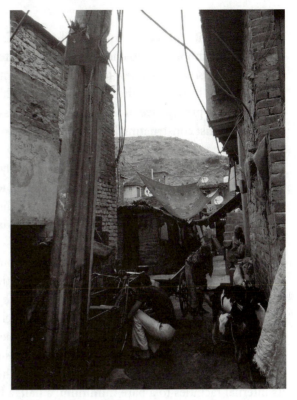

13. I remember years ago, on my first trip to Copenhagen, a friend had suggested a visit to the Ostre Gardens in the city. Go on a weekday afternoon, he had said, it is the only time the flowers are out. Not a great one for flowers, I had grudgingly given up an island-hopping boat ride to act on his advice. The park was truly magnificent. An undulating green of topiaries and fountains spread in carpets of Nordic summer blooms. But the park's truly spectacular sight was something else: the throngs of young office secretaries out to sun themselves, topless. I realized then, what flowers my friend meant. Blond women leaned back on low benches staring at the sky, or eating their lunch, completely oblivious to the pair of Indian eyes in frantic focus. Everyone did what they normally did in the park. Suited executives walked in rapt discussion, couples strolled, mothers pushed prams. A Muslim man unrolled his carpet towards the adjacent museum, presumably also the direction of Mecca, and threw himself on the ground. Unable to absorb the changing visual stimulus of the scene for too long, I left. The Muslim in the park has made many appearances in my memory. Where is the man now? In an easy liberal society like Denmark he could be anywhere, and completely untraceable. An academic, teaching philosophy at the local university; or a radical priest assembling a bomb in a Copenhagen basement. Maybe the man runs a family restaurant outside the garden. Who knows? In my mind he will always remain an incomplete, and incomprehensible, life. The uneasy presence of multiple and schizophrenic personalities is the hardest, most disquieting feature of liberal democracies. But for most, I suppose, it is a risk worth taking. A nation's ability to subvert ideas, speak out, cycle for free, sun their breasts in public, or pray to a different God is something worth preserving. At the time, I had seen the park as a wonderful anomaly, something that mixed, in a picturesque sort of way, bare breasts, cultivated daffodils, and Muslims with prayer mats. No one had batted an eyelid, not for the woman lying half naked on a bench; nor for the unshaven man prostrate on the rug nearby. Thinking of the scene now, I thought how complete a picture of democratic rights it was: Personal Liberty on the bench, Religious Freedom on the ground, Great Danes.

roofs, bolted without foundations into the ground. Like car parts, their components use Korean technology, and cheap Indian labour to keep costs low. Private builders continue to promote such new technologies but without much success. Privileges of building brick by brick, in the handmade Swadeshi mould and with an eye to quality is now the prerogative of the rich, the businessman building the family house, the industrialist constructing his farmhouse.

In a country where 200 times the average monthly urban income goes into buying a new home, affordable public housing is an alien idea, a time lapse of over 20 years invested in a poorly constructed, ill-ventilated building with a life span of a mere 25 years. Is this the only way to acquire private affordable real estate in India?

By itself the phrase affordable housing is a misnomer; it makes no reference to the land occupied by the house, its location and position in the city, all the factors that go into making a house affordable. Proximities to city centres naturally make any housing expensive and out of ordinary reach, which is why most low-cost housing is built in distant suburbs. New private housing projects near Mumbai become accessible to low-income families primarily for this reason. The plan provides small open plan apartments within a single hall, redefining the lifestyle of the house, reducing its internal facilities to a bare minimum: a hall, a bath, a kitchen. Reduced to bare bones, affordability becomes possible only in the extreme definitions of an austere lifestyle, far removed from the centre of town. Given the unrealistic land rates, the affordable has neither place nor possibility in the city.

In the several decades of government housing agencies and development authorities, the situation remains unchanged. Set up to provide low cost and affordable homes to the urban middle classes, their approach as land developers has merely created profit-making public building agencies rather than constructive or innovative alternatives to expensive private builders. Over the years, most have become synonymous with mediocre and incomplete projects: dark airless buildings, without parking facilities or landscape. You see them everywhere, in Bhopal, Delhi and Jaipur, congested and monsoon-stained, spiritless and decaying, stretching and repeating to the horizon.

In the search for urban housing solutions it is unfortunate that the government has set no standards or benchmarks in design, structural innovation, land ownership, or finance to make low-cost housing possible. To build affordable housing in the city, private land ownership and long-term leasing on property needs to be strictly curbed, and a new system of housing exchange and rental proposed. So far the

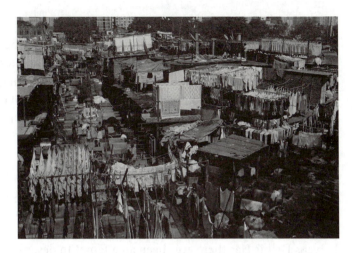

14. A survey of crime from independence to now, by the National Crime Records Bureau provides a graphic comparison: 60 years of freedom has seen murder increase by 250%, kidnapping by 750%, and rape by a whopping 870%; terrorist activity, a relatively unmapped phenomenon, is on an annual rise of 10%. Is the tragic statistical reminder of Indian city life now the only measure of its shortcomings? Or is the increasing graph of crime a cue that the direction of the growing Indian city needs serious restraint, and reversal?

15. On several earlier visits to New York, I had stayed in a sleazy Lower Westside hotel called the Brownstone; the place had the distinction of being in the city's most dangerous neighbourhood. A week before I checked in, I read that a gang of teenagers had assaulted an old couple and slit the man's throat for a few dollars in his wallet. The sum was so small, that out of sheer spite, they slit the wife's throat as well, shoving their bodies under a parked car. Another time, there was news of a 72-year-old woman who was raped in the 12th street garbage dumpster. Once, while asleep in my fine 8 x 6 room with attached door and wall to wall flooring, there was a massive commotion on the floor below; a retired Vietnam veteran shot his wife, because she had finished all the hot water in the shower. What a city. After a few visits I realized the Brownstone wasn't in a dangerous neighbourhood, but the Brownstone itself made the neighbourhood dangerous.

16. The transformation of New York City from a crime-, graft- and drug-ridden capital to one of congenial and exemplary metropolitan life is attributed to Rudy Giuliani. As mayor of New York in the early 1990s, Giuliani's clean-up was physical, psychic and professional. While large parts of the city were upgraded, corrupt administrators were prosecuted and drug gangs busted, all in an effort to aggressively promote business, education, economic growth and tourism in the city. Once known for its dangerous streets, mafia culture, muggings, drugs and smuggling, New York is today one of the safest cities in the US and recognized for its quality of urban life; so much so, that the city's law enforcement strategy is now a model for other cities around the world.

approaches to accommodating increasing numbers have been marred by a colossal administrative failure and a lack of will to investigate untested solutions—an attitude that has left Indian cities imprisoned behind the stranglehold of conventional planning. There are obviously serious flaws in which India operates its cities, neither as an efficient machine nor as a workable business model, nor indeed as an urban welfare state.[17]

What would Mumbai be like, if the FSI were allowed to rise to Singapore or New York levels? Would it reduce land costs, or would it raise the poverty levels? How can Delhi's inflated building costs be brought down to provide more reasonable affordable housing to its citizens. Does it require a rethink of the density of Lutyens Delhi? Has there ever been an attempt to describe in clear common terms the kind of life urban Indians would like, through investigation of land value, design and planning?

The continued expansion and growth of the city today is conceding defeat in the multiple corridors being developed between the metros, a way to include the many villages and small towns along the path. The seriousness of the attempt can only be seen if there is a genuine desire to create appropriate space and livelihood in the corridor. The densification of villages into cities can be a success only if the social and cultural constraints of rural traditional lives are taken into account to urban prosperity. Moreover, it is only in its public works that the government can make serious and sustained gestures towards a new urban lifestyle. Ideas on restricted car and motorized access, an encouragement to pedestrianization, piped cooking gas, solar heating and cooling, and a greener, more energy-conscious home life can only be truly accepted if public housing makes a radical shift from conventional practices. Making statements about affordable homes for India can happen only if the larger mass of the urban population is given the opportunity for change.

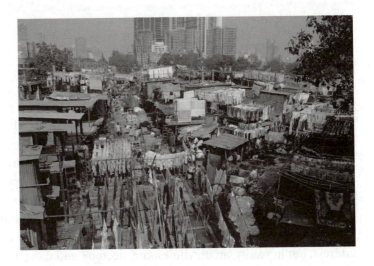

17. In recent years the conflicting models of the city as either a subscription to suburban middle-class life or a dense urban development has left planners in doldrums. The bungalow ideal of independent city living has always been at odds with the more cohesive overlapping patterns of older denser communities. The Mumbai chawl is an architectural type that emerged out of the need to house industrial workers for the mills of Bombay, the 19th-century migrants from all across rural Maharashtra that flooded the city. The chawl is a form of industrial housing, which defines home in the most rudimentary type of confinement, 'a dislocation of the sky and earth'. The only connection to the outside is a single window. Everything else is shared: verandah, water tap, toilet, garbage dump, play area, temple. For believers of the middle-class lifestyle, it is hard to imagine the possibilities of dignity, privacy and nurturing relationships in so compressed a form of living. Yet the honeycombed overlapped life of the chawl is oddly not a compromise on these needs, but attracts instead, people with the natural ability to collaborate, to live not with the privacy of walls, closed doors or windows, but with human regard and judgment, sometimes three generations to a room, and what appears to the outsider, a messy and impossible life. Yet, if the self-indulgent life of the middle class that has shaped cities so far needs serious revision, the chawl, in a revised design form, as a possible middle-class home may be a serious contender for future housing in the big cities.

16. City Space

For the past 25 years I have lived in a small south Delhi colony. Despite all the shortcomings of the place it is still considered a 'posh' address, a place clearly preferred over posher, newer and better serviced colonies of west Delhi. And yet in the period since the 1980s, when I first moved there, the decline has been as fast paced as the growth of the city itself. Construction debris lies on roads, houses are sold as flats, and private cars block public sidewalks. As daily battles erupt over parking and water rights, uncollected garbage overflows, plastic bags lie on roads; a rundown municipal market, unlit and urinated upon; colony gates shuttered against robberies, an occasional murder, private guards, barbed wire and electrified fences. A posh address, but in reality, an unwholesome, decrepit and dangerous place.[1]

At one time, the colony was a shining example of neighbourliness and urban manners; people walked to the market; they knew who lived next door, who down the street; garbage was collected from service lanes, and the parks were used as much by children as the elderly. If there was picture book suburbia of Indian life, this was it.

My neighbourhood lies on the fringes of one of the city's largest slums. A place cluttered in an urban density so high that all its open spaces have been effectively privatized. Houses are part brick-part mud, covered in plastic and asbestos sheet; for the outsiders the warren of alleyways within are hard to negotiate. There is a permanent river of slime that snakes through; coated in a perennial swarm of defecating children and breeding mosquitoes. During monsoons the drain happily encroaches its bank into the surrounding houses. But the residents, so used to its presence, tolerate it with benign resignation.

Over the years, the boundary between the posh colony and the squalid slum has blurred.[2] Other than conditions of hygiene, there are now startling similarities in the two places. Both attach a clear acquisitive purpose to life: in one, car, microwaves and foreign vacations, in the other, motorbikes, TVs and gas connections. Commercial facilities in the two are strikingly similar: grocery stores and street vegetable vendors. Housewives emerge in their night clothes to haggle; recreation is street cricket in one, park cricket in the other; in both the elderly sit by the road to discuss flatulence. While one constantly has upgraded utilities in one at election time, the other is in perennial decline, its roads encroached upon, its water and power reduced, its tree cover under threat. In a few years the two will be altogether undistinguishable: the posh colony will be a slum; the slum an upgraded neighbourhood.

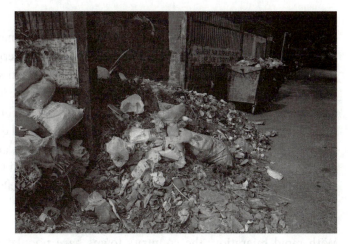

1. Curious for a bit of sociological statistics, I had inquired from the hotel receptionist about annual crime figures for Copenhagen. The surprised man gave a baleful shrug and said, none. As I walked away, so as not to disappoint, he added that there had been two thefts. But one of these had occurred in the same family. And I thought how odd to have a city so completely open, so without the conventional fears of self-protection, ownership and privacy. I didn't want to ask if people locked their houses. The man would merely have said, what for. Just to make an additional point about safety, I was told that the Queen walked all over town on her own, without protection, buying vegetables, shopping for lipstick and lingerie. Just like any ordinary citizen. (When was the last time you saw Narendra Modi squeezing tomatoes at Subzi Mandi, or trying on export-reject jeans at Sarojini Nagar?) The next day I returned to Philadelphia. Annual figures: Murders 1087, Rapes 118, Burglaries 860, Grand Thefts 16, and there were still four months left in the year. It felt good.

2. The city's unnaturally segregated development is part of an unfortunate discriminatory legacy of colonialism where the served middleclass and dispossessed servant class were isolated into different areas. Slum colonies that sprouted around middle-class neighbourhoods in Delhi and Bangalore have, however, over the years consolidated their municipal position with electricity, roads, water and other utilities to such a degree that they are now on par with most city colonies. By contrast life in middle-class neighbourhoods has markedly declined. Lack of space, overbuilding, loss of tree cover, and hostilities over water and parking, have left these areas bereft and despairing. The life of the poor is comparatively richer, filled with more varied social exchanges, more abundant and positive relationships, more shared possessions, and more enduring connections with nature, in other words, genuine neighbourliness. Doubtless a place that takes into account these values will be more humane and livable.

Between the slum and the colony, two types of people make the city: the migratory population of the dispossessed, and the greedy self-perpetuating landed. Their common goal is a commitment to nothing but their own survival. In such a scenario, the ground of shared ideals that make the city livable for all are compromised, and little of value remains outside the boundary wall. The public realm is of no importance, since no one possesses it. So, the resident will do everything to make it his own: extend his compound to get more garden space, and road space opposite his house will be duly marked as his. An illegal wire will be extended for a more abundant electric connection; he will boost his water intake with a suction pump and ask his driver to defecate in the public park opposite.

With rapid migration, the country's towns have populated to dangerously high levels. What this foretells in people's stake in city utilities, civic infrastructure services is one thing, but the increased numbers doubtless create greater levels of personal insecurity and a constantly shifting new citizenry on the prowl. The close packing and congestion consequently increases crime and violence and the widening economic gap spurs the well-to-do to raise their boundary walls and protective armour against the clamoring onslaught around. Everywhere are tell-tale signs that movement in public place is risky and fraught with danger.[3]

Increasing crime however is directly proportional to the privatization of urban assets. More and more, city life has become a series of closed systems, where fear and insecurity confine the resident to increasingly private realms. The house is surrounded by high boundaries; it employs guards and electronic surveillance to keep all unknown threats at bay. New apartment complexes even promote community and sporting activities within the complex, creating a complete stage-set of private privileges; with pools and entertainment on the premises, social and cultural life is also privatized. The gated community, once seen as an indicator of the rising graph of crime around it, is now itself a symptom of the increasingly divided and violent city.[4]

As a result, the Indian city ensures that the residents remain entirely dissociated from the norms of collective living. No social order exists outside the bounds of family. The world outside the home is a wasted place, its people and places, a sort of proverbial enemy, to be tolerated but never befriended. The absence of walkable space, usable parks, libraries, meeting areas or any activity of cooperative intent, makes the city merely an assortment of private houses and institutions.

No spitting. No Urinating. No Eatables. No littering. And No Molestation. The need to institutionalize public behaviour and graphically display it on signboards is an

3. Days before the much publicized and infamous Delhi gangrape, a 24-year-old woman was gangraped by five men close to Delhi University. The local police refused to register her complaint and asked her to return after two days. She persisted. Only after the intervention of an NGO was the incident recorded in the police file. After much reluctance the police inspector who delayed the FIR was suspended and eventually an order given to track the rapists. Why such extraordinary callousness in a crime over which an entire nation has erupted: the victim was a Rwandan woman.

4. The excesses of Bollywood which earlier merely relied on palatial marble backdrops and silver tinsel clothes to get across ideas of affluence, now work the same magic with extreme action: namely, glorified violence. In the bathroom scene at the end of the 2012 film *The Gangs of Wasseypur,* a gangleader is shot so many times while seated on the commode that he begins to drown in his own blood. Bullets rupture and enter his skin, blood spurts and splashes in cruelty so gruesome, unthinkable and senseless that the director again becomes mesmerized by the excess. To convey the full force of the violent act, the scene is shot in slow motion, carrying on for so long, that the shock of the brutality quickly dissipates into silliness and eventually into farce. A lazy storyless story, without any developed empathy for character, place or relationship, it drifts mindlessly from assassination to bombing to murder, till, unable to edit himself, exhaustion and fatigue again overtake the screen. Violence so grim and relentless loses all power to shock. By not allowing real characters with real lives to emerge and touch upon human dimensions like emotion, love, empathy, com-passion or other forms of frailty, the director creates a virtue of incoherence and relentless action. The director in fact defended the film as a realistic depiction of the sadism of the coal mafia and the truthful rendition of the badlands of Jharkhand.

inevitable necessity in a culture that has scant regard for public space, and little interest in preserving anything outside the domestic domain. You move through the city, never as a responsible individual, but either as disjointed gangs playing by gang rules, threatening and intimidating women, or as whole families, usurping compounds, filling restaurants, strolling in malls. Both sub-species so self-absorbed, they are incapable of surviving any other way.[5]

That public place belongs to everyone is an oddly Western notion. Every time you are abroad, you became acutely aware of your rights, your space, your trespassings. Places to eat, sidewalk cafes, parks, libraries, stadia, galleries and museums, you are in constant collision in a culture of varied offerings. You make yourself fit in, because without it, you became a palpable threat to public order.[6] The structure of all public activity is governed by unwritten codes: to be silent in a library, wait your turn at a ticket counter, shout at the pub and the horse track, but not at Wimbledon.[7]

The problem lies squarely in the social inadequacies perpetuated by the Indian city: the endless long commutes in a place that isolates and distances workplace from home and provides no public social and cultural amenities in between. Growing cities, with increasing car and migrant populations, displaced pedestrians, and lack of public social opportunity makes for a deadly urban mix.[8]

It is a well-known fact of urban design that a criminal behaviour has a direct correlation with a building environment that is becoming increasingly insular. Shared spaces for recreation, neighbourhood meeting areas, and squares for discourse and commerce have been the hallmarks of traditional towns, where the home was merely a focus of domesticity. Unable to afford the private leisure of pools and home entertainment families sought out chowks and maidans in the evenings. Dense city living necessitated the inclusion of open spaces in residential neighborhoods.[9]

However, when private space is protected and enhanced with privilege, public space is condemned to squalor. A society that recognizes only the family as the social unit in the family compound. A complete disregard of each other as individuals in a civic set-up, makes people desecrate monuments, abuse road privileges, electrify fences to stop encroachments, and build gated communities. In other words, self-regulate when no civic rules hold. The Indian public's inability to engage with the city and its neighbourhoods is a direct fault of architecture and its missing urbanity. Architects have themselves narrowed the scope of their influence to small parcels of land bounded by high walls. This inability to think and react outside an insular framework has left the city as an unremarkable and wasted place—a leftover stretch

5. Is it the background of invasion, migration and bloodshed that has produced a people so painfully conscious to identities and territories—so protective and fearful? Films cannot malign mythological identities, Hussain cannot comment on Hinduism, Salman Rushdie can't raise a voice against Islam; and now Naipaul. An intellectual misinterpretation of history or distortion of fact is a prerogative of free speech, but it takes on an ugly hue when it is uttered and perpetuated by a public figure. Of course, many agree with Girish Karnad's view of history; many Hindus say that the Muslims deserved their fate in Gujarat; many Muslims maintain that the Hindus asked for it in Godhra. Some Hindu extremists believe that Christianity was the undoing of India. But these are all private voices and personal distortions of history, thankfully hushed by underexposure. As private citizens their freedom of expression is protected by the constitution. That it isn't often guaranteed by the government is of course another matter.

6. Will the Siddis, Indians of African descent, settled in Gujarat, Maharashtra and Karnataka ever be truly accepted as Indians? Would Ugandans, even if settled in India, become citizens with full rights, just the way 12,000 Indians have in Uganda? Indians from the Northeast are not accepted in the mainstream, does that then weaken the case for Arunachal Pradesh being an integral part of India? If indeed mainstream India is unwilling to accept the Northeasterner's allegiance to the country, why then is the Kashmiri's position in question? Is the Indian Kashmiri's applause for Pakistan at a cricket match as much of a betrayal as resident Indians applauding the Indian team against England in England? The answer probably lies in the larger issue of who is an Indian anyway. Once cultural and ethnic contamination is accepted as the overriding theme of Indian identity, questions of who is more Indian, becomes redundant. Some years ago Indian students, mainly of Punjabi origin were beaten in racist attacks in Australia. Incensed and outraged protests were staged against Australian racism, and calls were made for diplomatic ostracism. Had those students been of Northeastern origin would the protest have been as muscular and vehement? Why is the Indian outraged at racism directed at him abroad, and not at home? Psychologists will say that the Indian's deep-seated inferiority is rooted in a past of subjugation, the colonial despair of feeling second rate. But the deeper resentment now emerges as a cloak of bipolar urbanism where the protection of self and turf happens at the expense of any foreign invasion—Ugandan women in a Delhi Mohalla are an unacceptable intrusion in middle-class urban culture, as are Danish and other Europeans, if they abandon the tour buses and start walking the local streets. The assertion of self-worth is always more palatable when weighed against the cultural comparisons. Moreover, the high walls and narrow bylanes of the Mohallas, the gated middleclass, and the lack of community makes every urban move a hostile act. The insularity of neighbourhoods is oddly viewed as a positive attribute.

7. Antiquated norms in India are the result of having accepted and wholeheartedly embraced old colonial ideals as our own, and an unwillingness to remove moral policing out of the judiciary and politics. As society changed, rules and legal codes continued to change in England. But India has remained steadfast in its adherence to old foreign ideas in bureaucracy, civic regulation and other matters of governance. Moreover, social and caste forces today not only make generations unsure of each other but create new barriers of misunderstanding. Nowhere is this more obvious than in the broader definitions of individual freedoms, the freedom to speak freely, make sexual choices freely, marry freely across caste lines, use the flag or any other national symbol in personal expression, travel across borders, exchange ideas across the internet, and buy products online.

of roads, sidewalks, subways, shopping centres and parking lots, open to a range of criminal acts.

Woody Allen famously wrote in *A Brief Yet Helpful Guide to Civil Disobedience*, 'In perpetrating a revolution, there are two requirements, someone to revolt against, and someone to do the revolting... but if either faction fails to attend, the whole enterprise is likely to come off badly.'[10] In any protest, drama and visibility are necessary to communicate both cause and effect. From the Washington Mall to Tiananmen Square in China, to Tahrir Square in Egypt, cities around the world have always provided space for protest. Perhaps not designated as such, but the public square in the centre of town was space available, as it always has been, for art, culture, social life, commerce, and most of all, public grievance.[11]

Urban visibility provided focus to the seriousness of the protest. When the million man march descended on Washington, the great flank of museums and memorials enclosed the protesters in a momentous public display of popular strength. The numbers were all that were needed to make the point. With the Lincoln Memorial as stage and the Tidal Basin as the public enclosure, the cameras captured a historic moment, recorded around the world. The eloquence of Martin Luther King's 'I Have a Dream' speech was all the more heartfelt when it resounded against the backdrop of such urban monumentality.

Urban governments abroad have long since realized the importance of the symbolic public space in the city. Tahrir Square was the epicentre of the Egyptian uprising that overthrew Hosni Mubarak and paved the way for a new government. At Tiananmen in Beijing, the 1989 student protests were made more public by the sheer scale of the square itself. For once, there was no place to hide, and the Chinese government's atrocities lay exposed to the rest of the world.[12]

Indian public space, by contrast is constricted or non-existent. The absence of squares in the centre of Indian cities make all forms of public protest secondary and insignificant.[13] While older cities in Rajasthan and elsewhere made clear public markers through street chowks and maidans, newer cities make no distinctions between places for protest, sports, recreation, parks, baghs or maidans. The public is free to choose its own use for any available public space. The Prime Minister speaks at the Red Fort, Ramlila is performed at the Maidan, minor protests are staged at Jantar Mantar, celebrations at India Gate. For the government, the larger significance of a Mughal or Colonial backdrop has no historic or iconic meaning.[14]

8. In the United States on long weekends and holidays, while whites lie on beaches, the 7-11s and K-Marts are manned by Indians eager to work the double shift and send more money home. As targets of holdups and shootouts, it would be easy to say that Americans are racist on weekends because they shoot Indians. But the sad truth is that 14% of all holiday commercial activity is handled by people from the subcontinent, compared to only 6% on ordinary workdays. There are just more Indians to hold up. In Australia, Indians make up barely 1% of the population. The larger percentage is Chinese and Southeast Asian, while the remaining are from Africa and the Arab countries. Yet there are few recorded incidents of racism directed at these groups. In fact, Chinese assimilation into Australian society is so complete, that few question their allegiance or remark on their racial difference. Africans, though a small group, are similarly integrated in ways that few stand out. The Indian abroad however, perpetuates the culture of the ghetto: students room together in the poorer sections of Melbourne and middle-class Indians in leafy American suburbs get together in the evenings to discuss Indian politics over dal and roti. Among college clubs, the Indian Students Association is made up of a large, culturally bereft group of students, seeking the solace of others like themselves—homesick and hankering for Bollywood, a taste of Indian cooking, or the noisy company of a cricket match. Out of touch with local reality and lacking the social skills to fit into a bar or night club, or ease into an informal rugby match, the Indian is a problem unto himself.

9. In the Western model, the city has been dissected and analysed like a frog in the biology laboratory. Its reasons for design, layout, urban dimension and connection, relationships between residence, work and recreation are not just the stuff of history books, but informed data to be used as a tool to chart people's movements through the streets, even to study the effects of densities and isolation on human behaviour. Indeed to plan future cities. However, in the complex structure of Indian urbanism, with undefined practices of privacy, control, mobility, etc., precise factors of formal urban patterns cannot be easily enumerated. The practice of architecture and its planned interplay with its surrounding environment is no guarantee that the reality of its eventual occupation will also follow architectural cues. The various economic, class and social forces that confront and define the informal character of public urban space in India, rarely allows the formality of structured plans to exist in isolation. Too often, it is instead the peculiarly Indian will to occupy, encroach upon and mould to private purpose all that is in the public realm that remains dominant.

10. Four decades of filmmaking and writing have stretched the boundaries of Allen's imagination to the outer limits of comic despair. His work oscillates between the absurd and deadly serious, between moments of deep psychosis and paranoia to the fantastic and completely farcical. Every story of Allen's in that sense is a kind of disjointed autobiography. In the 1950s and 1960s when French Existentialists like Sartre and Camus argued about man's fate and the purposelessness of existence, Allen countered with his own philosophical hypothesis in a speech to the graduates, '… more than any other time in history mankind faces a crossroads…. One path leads to despair and utter hopelessness, the other to total extinction. Let us pray we have the wisdom to choose correctly.' In a scene from Allen's earliest film 'Take the Money and Run' the thief caught and convicted, is meted out the harshest form of incarceration. Not just solitary confinement, but solitary confinement with a life insurance salesman. It takes a peculiarly obtuse mind to subvert ordinary people and situations into such deadly farce. The quintessentially Allenesqe scene has the convict descending into a manhole with the salesman reciting the policy details in a deathly monotone.

Despite the increasingly vocal staging of recent public marches and the enlarging numbers, city ordinances try to contain the activity by disallowing large protests or confining to restricted areas. Nor do Maharaja Jai Singh's celestial timepieces contribute any visual thrust to the protest. The open ground is merely urban convenience. Just the way, the open park becomes a cricket pitch, the sidewalk an invitation to commerce, the larger paved plazas are parking lots. The uncertainty of public designation makes every form of Indian city space into a free-for-all.

Some years ago, I was part of a small crowd of about 200 protesters at the candle-light vigil at India Gate to demonstrate against the Indian explosion of the nuclear bomb. We were, however, clearly outnumbered by families who had come to the park for an evening stroll, an ice cream and some illicit lovemaking. In a city so completely lacking in urban space, India Gate had become the hub of all activity, social, political, commercial, in the truly Indian aspect of turning any public event into a mela.[15] What then distinguishes India Gate from Pragati Maidan, Pragati Maidan from Connaught Place, Chowpatty Beach from Hanging Gardens?[16]

When a city is visually incomprehensible, private actions can be easily enacted in the public realm. Cement bags, bricks, construction debris, uncollected garbage, rusting metal, electrical units, all litter streets already overrun by encroachments. Without an explicit and visible definition of public space, the most rudimentary acts of terrorism can be easily enacted.

The current dangers of rape, molestation, robberies, water wars, electricity pilferage, deflated tyres, road rage, private gates on public streets, high boundary walls, and electrified fences are all the unfortunate byproduct of an urban culture of religious polarization and growing insularity.[17] A fear that whispers into private ears: protect yourself and your turf. In the past decade the commercialization of India has itself ensured that public life in the city is confined to malls and restaurants. Even the tree-lined street in residential neighbourhoods has been replaced by glassed-in shops for Bvlgari, Revlon, and Rolex, making a clear and unequivocal statement that if you have nothing to buy, nothing to sell, there is no place for you in the city.

In the struggle to make Indian cities livable, there is perpetual talk of public space. The belief that somehow public space will save the city from its street crime, rape and inequities, and magically bring the citizens together is an odd myth. What use is public space without public culture? A purposeless citizenry will only use that public space for its own private purposes—selling, hawking, encroachment and

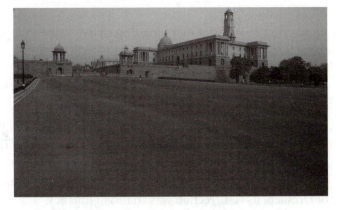

11. In 1971 at a student rally in the US, I was part of an anti-war demonstration against the US involvement in Vietnam. An enraged group of some 20,000 with placards of 'No War' and 'Get out of Vietnam', we shouted slogans against the US government and heckled in front of the White House. I carried a 'Napalm Pentagon' sign amongst many other foreign students who also opposed the war. As a resident in the US I had every right to raise my voice, even though I was ineligible for the draft or the vote. The freedom to protest was not confined to American citizens. India, however, denies democratic rights not just to the foreigners in the country, but to its own nationals. While Indian NGOs are regularly targeted for harassment by the Indian government, Hermann, a German on a tourist visa in India was recently deported by the home ministry for participating in the anti-nuclear protest in Tamil Nadu. Defending his deportation decision, Home Minister Chidambaram said, 'there was information to show that Herrmann had links with the anti-Kudankulam stir', that was inconsistent with someone travelling on a tourist visa.

12. Protest is a singularly democratic method for any government to soften its shrill and dogmatic line and is tolerated in most places around the world. The cross-border protest against Dow Chemicals sponsorship of the Olympics is a case in point. Should Britain, like India, then outlaw demonstrations against actions that fall outside its boundaries? Should the US try and control demonstrations against itself in Venezuela? It is well known that the nuclear debate in Europe and the propagation of new power plants by some countries there garnered massive opposition from Greenpeace and local parties, enough to alter the thinking of some governments. The protesters were an international coalition whose remarkable anti-nuke cause was without boundaries. As a result of their success, almost 40% of Germany's energy needs are today met by alternate sources.

13. Despite the occasional internal skirmish, in many ways the country had happily reconciled to its many-faceted religious ancestry. At the government-sponsored celebrations for the demolition of the Babri Masjid, the annual riots have become a peaceful affair, conducted with utmost care so as not to incite rival communities. In an attempt to distinguish the Hindus from the Muslims and Christians, many Banjar Dal issued colour-coded badges to provide proper identification during riots. A district collector justified the idea by saying that many rioters were frustrated at trying to identify an enemy who looked, behaved and lived exactly as themselves. 'Colour coding', he said, 'would also help us target one community.' After the riots, where unfortunately some Hindus also died accidentally, the government even issued riot instruction manuals. These could be purchased from the Shakha Publications Unit at subsidized rates: ₹10 for Hindus, ₹30 for Muslims and other religious communities.

14. Since the CPWD has chosen to redefine the cultural life of the capital after Lutyens, is it a wonder then that television news reports from India invariably use India Gate or the Rashtrapati Bhavan as a backdrop for their story, and never any other architecture built after independence? If there was ever a new symbol of India's post-independence architecture it would have to be the Bhavans that every state capital has added in its most prominent locations; these, in addition to the thousands of government housing colonies and self-financing schemes that repeat in virtually endless smudges across city horizons. In fact, in the urge to reflect India's high economic growth in its buildings, some in the administration have

more crime.[18] Without ascribing descriptive value to a particular amenity, public space is meaningless.

The reconstruction of Dresden's public space after World War II was a civic imperative for a city that had lost so much of its cultural heritage in the rubble. The importance of Baroque churches, theatres and museums cannot be disputed, but their real value lay in returning the city to an active cultural life. The restoration of specific activities that enhanced social conditions far outweighed the building's symbolic standing. Today, the city's historic centre is a hub so intimately connected to the life of Dresden, its resurrection was an urban urgency.

In cities that are increasingly being designed by builders, for outrageous private profit, the worst is yet to come. Every Malibu Towne and Beverly Heights being built as extensions to the old city is turning inwards to its own private merits—home, shopping, recreation, pool, and community within the high wall—without ever needing the outside, without the ugly face of the real city. So, you sit alone, connected only on social media, in a ghostly buzz, living in cyberspace, a place at once inviting and menacing, the blue screen always flickering. Your social relevance is measured by the number of followers, the number of tweets, and the number of friends on Facebook. You learn to revel in the false seduction of social connection, in the excess of information and the promise of its senseless performance. You learn to wallow in private occasions, knowing full well the absence of a real view out of your window: the public opportunity that accidentally brings people together and makes cities livable, lovable and human.

Should the Indian city follow the American model of homeland security to keep its citizens safe? Video surveillance and monitoring of public activities, GPS patrols, increased security of transport facilities, 3-D mapping of walled city areas, crime auditing, management of public spaces, street lighting, patrolling of parks, increased presence of paramilitary forces, and police reform, even if virtually all ideas have a streak of the police state in them. Does it make sense to watch and grill new paranoia into an urban population already riddled with fear?[19] Is such a strategy a deterrent for a terrorist or rapist? Or merely another reason to ensure that you don't venture out of your guarded home or gated community? More than ever now, the Indian city needs to seriously reconsider its future design options. To rethink the culture of privacy that has driven Indian urbanity to such high crime statistics. What it may require are planning principles based on integrating home, school, park and marketplace, in a way that opens up whole neighbourhoods into

suggested a complete revamp of government architecture, and the redesign of the entire Central Vista. The Shanghaification of the Indian city is also the dream of many architects who feel that Indian reality—nepotism, archaic construction methods, poor craft and a general meanness of architectural spirit—is best covered up in chrome and glass. A suggestion that is as ludicrous and extreme as awarding all public works to the Department of Public Works. If Lutyens is part of our architectural heritage, so indeed is the CPWD; however archaic and mean-spirited its architecture, it reflects clearly and honestly India's current reality.

15. Luckily for us, there are enough fringe groups, rabble-rousers, thugs under the guise of activism, who will drown any attempts at free speech with their own free speech. I will defend my right to be abusive till your death as long as you defend your right to be heard with your life. In an open, democratic, secular, free-speaking society, God-forbid if somebody is in fact openly democratic, secular and free-speaking.

16. When the city is no longer even a caricature of a civic democracy, why is there a desire to glorify political symbols? At the time New Delhi was built, its architectural vision was an appropriately fitting expression of imperial power. Yet ironically, that archaic ideal has outlasted the Empire and is still used to construct new capitals and part capitals. Civic structures today choose to express either a bland monumentalism or regress conveniently into pictorial images of temples and palaces. Of the new divided states, Uttarakhand's district-level architecture is a cross between a banquet hall and a government school, while Chhattisgarh applies an equally plebian modernism, somewhere between a *gaushala* and a parking garage. The ideological battle between universal symbols and regional identity has set a new low for public architecture. Karnataka's assembly building follows a Neo-Dravidian style, while Maharashtra's Vidhan Sabha is a Modernist honeycomb-shaped concrete dome, stating something of each state government's confusion about style and symbol. There is no denying that the 20th century was an era of political power and nationalism. Emerging nation-states establishing a foothold on the world stage used the capital as a centrepiece expression of nationhood. Recent Indian capital cities however have projected political power so inaccurate and exaggerated as to be almost farcical. That the government is greater than the citizen may work well in totalitarian regimes, but in a changing civic reality, democratic ideals will have to be expressed in moderation.

17. Some years ago, when my sister was in India travelling with her white American husband, she was presumed a woman of loose morals trying to gain money and short-term respectability by attaching herself to a white man. In most dealings, from shop salesmen, to hotel receptionists, to restaurants, she was made to feel inferior in her own country. Short of the jeers and taunts that accost Africans in India, her brownness too was a serious impediment. Cases of violence against Africans in Delhi are so barbaric, psychologists maintain they stem from a deep-seated hatred. Just outside the village of Kishangarh in South Delhi, three men forced an African male out of an autorickshaw and bludgeoned his skull with boulders. That too, in full public view on a busy road. A few days later in nearby Mehrauli, a Nigerian priest, returning home with his wife and four-month-old son, was dragged out of the car. After smashing the windshield, the attackers hit him with cricket bats, but he managed to escape. When questioned by the police he admitted that this incident was but one in many where his family had been harassed and taunted over several months. The violent nature of such incidents often takes such a gruesome turn, it is hardly the outcome of mere urban irritation. The arguments over a restaurant bill or an autorickshaw fare are but triggers for something deeper.

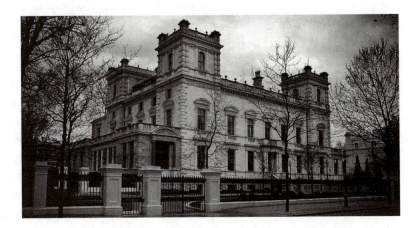

18. A successful African-American businessman was harassed while on an Incredible India tourist walk through Chandni Chowk with his wife. Presumed to be a Nigerian drug peddler, he was refused service in a jewellery store, and reported the humiliation to the local police. Social injustice in India is always clouded by personal prejudice. Moreover, such incidents speak of a public culture that is shaped by private inhibitions and lacks any civic rules of living collectively in a city. In my own neighbourhood, a Tamil student was denied rental accommodation, because the landlord felt the student was in fact African but was trying to pass off as an Indian. If the face-off weren't true, it would be a sad and funny joke, the subject of black satire.

19. Much of this was not even possible in the 20th century. The state's maintenance of personal, professional and national boundaries at the time was taken for granted. Today, of course, changes in technologies, social mores and instant communications has, for all intents and proposes, created its own order. In a world so closely connected the state's imposition of its antiquated models calls for a fresh mandate. The hokey and trivial patriotism that had plagued an unconfident India of the 20th century will hopefully be dumped in the garbage heap. Burning a flag or protesting across international borders can no longer be treated as a crime. The government's recognition of a new reality will only bridge the growing divide between the state and the citizen. And protest is the singularly crucial measure of the differences remaining between the two.

17. Architecture as Luxury

Unused to material luxury, I was at a complete loss when once asked by a builder for a 'high-end' design for a mega apartment complex in Patiala. In the eyes of the builder, air-conditioning valet parking, pool, roll-out bar, electronic security, barbeque were all now necessary requirements. Luxury was something else. Luxury was the magic that separated the super rich from the ultra rich; the merely elite from the super elite. For a long period, I racked my brain, fingered Brazilian vacation magazines and scrolled through Mediterranean holiday websites. But there was nothing out of the ordinary there. Just a lot of bored white people lying around half-naked on the sand. Luxury needed a gripping new irrationality, some inessential mindlessness that would renew people's, rich people's, faith in architecture.

The exchange with the builder went something like this:

Lakshmi Mittal has a squash court in his house, I'd say.

Then we must have two.

His garage has wall-to-wall carpeting.

We'll put it in our driveways as well.

Mukesh Ambani has a snow-making machine in his house,

We'll have a full-time resident fortune teller.

Dubai has a ski slope in a mall,

We'll have a beach with sand and waves. Everything.

The biggest thing that emerged from the design discussions was the basic flaw in the location of consumer facilities. Most golf courses, tennis courts, swimming pools, car parking, etc., were built directly on ground thereby disturbing natural flora and fauna, and consuming precious land. So, in the new skyscraper scheme, they were lifted into the air at considerable cost, and made as extensive bridges, between two towers of the apartments. You could walk out from your 60th-floor living room, and stroll across as if on ground and play a few holes of golf. Or do an easy breaststroke in the 40th-floor pool, the evening lights of downtown Patiala in the distance

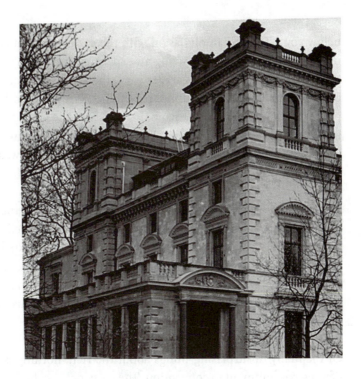

below you.[1] The Indian obsession with the car meant that apartment owners were unhappy with the idea of leaving an expensive and much-loved family member in the parking lot. Individual garages were, therefore, inserted in each apartment and owners could ride up the ramp, to say the 70th floor, and pull into their private porch. So that instead of the panoramic view of the landscape you could be watching your own jaguar from your entertainment den. Meanwhile since the basement was now free, and generally airless, dark and damp, it was ideal for the servant quarters and generator sets.

But the real thrust of the luxurious life lay elsewhere in the mid-level bridge that connected the two towers. Designed like a street from Delhi's Paharganj, Kolkata's Sonagachi, and a combination of Mumbai's Falkland Road and Chowpatty, the eclectic pickings would allow the residents the final aspect of Indian street luxury: pleasure. The two resident paanwallas, Kulfi and bhelpuri emporiums, a Rolex watch store, a Japanese restaurant, two small brothels, his and hers, and to give a real feel of the Indian city, a government electricity office.

Of the many unsurprising things about the rich, nothing is more perverse than a lifelong commitment to convention. The wish, despite the financial ability to explore new ideas and frontiers, to remain within safe and tested waters. The singular ordinariness of their lives expresses itself in their deep and abiding love for tradition, and the dignified pleasure of repeating the all too familiar history of affluence; a history that acts as a protective guard against the terrible strain of their former life.

Over the years rich Indians have begun to express their arrival on the world business stage with megalomaniacal architectural intentions.[2] After buying homes in Indonesia and Trinidad in 2004, Laxmi Mittal bought Kensington Palace Gardens, a luxury mansion in London's billionaire's row, a 12-bedroom classical manor with a Turkish bath and white marble interiors. The tabloid press dubbed it the Taj Mittal. A few years later he purchased two other mansions down the road for his son and daughter. Just a little something for his growing family. Keep them close, but independent.[3]

Mittal's real estate excesses, however, do not reveal anything of the civilized restraint expected of his acquired Englishness. He belonged in fact to the school of English democracy that happily allows wealth to be spread around as long as it remains within the immediate family, complete with all the dreams of power, history and capitalist desire. So, the acquisitions continued. He even had an old Scottish villa demolished to erect a luxury house in its place. Next to the famous Gleneagles

1. I was so intrigued by the rarified beauty of the skyscraper, the shimmering summer view of the sun against glinting steel, it was hard to imagine that close up some could be as ugly as houses in Greater Kailash. Walk up Fifth Avenue and see for yourself what millionaire Donald Trump has done. Next to Bonwit Teller is the Trump Tower, modestly named after the man who owns it. Step back on the sidewalk and watch the towers, black glass and brass, rise to some 50 storeys in geometric step backs, each spilling trees and plants into the floor below. The awkward organic addition of plants looks so absurd, as if its builder, knowing the soaring manmade tower to be a thing of ugliness, wanted to hide it behind canopies of green. But 50-storey glass buildings refuse to hide behind shrubbery. And the whole composition was as silly as an apartment block in Mumbai made to resemble a Greek villa. Inside, the monumental ugliness stretched to encompass a brass and chrome lobby, with walls of blotchy streaked red marble, the whole effect so hideous it looked like something out of a 1950s Las Vegas casino. But ugliness doesn't seem to deter Trump, who continues to build expensive real estate all over the city; and as a mark of good taste, give each an unusual name like, Trump Tower II, Trump Plaza, Trump Citadel. Is it a wonder that his wives keep leaving him?

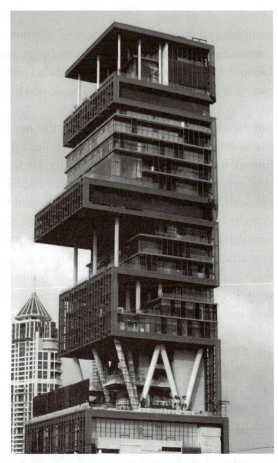

2. For billionaires like Mittal, in the heartland of Indian business, surrounded by staggering statistics of illiteracy, malnutrition and ill health, the prime concern is the movement of markets and a regular public proclamation of private wealth amongst the city's business elite. Owners of business houses are in financial competition amongst themselves. To create personal wealth, raising the bar from Three Hundred Thousand Crore to Three Hundred Million Crore, is a personal initiative that dives headlong from a mere family business, to influencing the national economy to finally becoming a political tool in itself. The thrill is in numbers and a conspicuous display of consumption; to buy a Greek yacht for a family member or to present a private plane to a son graduating from Harvard Business School is a lifestyle statement. It is also the sad reach of Indian business philanthropy that retains complete control of gifts, generosity and the compassionate spirit, all within the folds of the family.

3. *The MITTAL WAY London, 25 Dec 2014. Through its sources in Paris, the Mittal Corporation, now rivalling the GDP of China, revealed its acquisition of Versailles Palace last week for the Namkaran ceremony of trillionaire steel baron Laxmi Mittal's godson, born to his old family retainer from Kolkata. During the transaction, Mittal also bought the Champs de Elysees, the Elysees Palace, the Eiffel Tower, the Louvre, the Left Bank, the Right Bank, the World Bank and Jacques Chirac, for future functions that may or may not be held in France. The meeting was conducted in complete secrecy with just the G 16 leaders, the media, select film stars, sports personalities, the London Philharmonic Orchestra and a pujari. It was held in the Apollo Space Shuttle which Mittal purchased last week.*

golf club and away from the business tensions of London, the vacation house was customized with Ralph Lauren furnishings and wooden flooring flown in from Germany. If that wasn't enough, Mittal also picked up a bunglow in Delhi's Lutyens zone just so his India connections remained firm.

But as is fitting for a man of means, the need for something that reflected both social status and social cause, Mittal would do everything in his power to prove himself unequal to the rest of humanity. He was on the prowl again. His latest real estate venture traversed an even more ambitious terrain: a 340-acre estate in Surrey, outside London. Every aspect of the proposed building's design and architecture is stretched to define aggressive new levels of appreciation. By signalling to all his business detractors, and his once hostile French partners, his allegiance to the abstract idea that in matters of business all men are created equal. Mittal's 10-bedroom mansion boasted an art gallery, indoor outdoor swimming pools, tennis courts, a sculpture garden, croquet and all the minor facilities needed to keep a family from boredom during a snowstorm.[4]

The primary architectural feature of the new scheme, however, was not the flamboyant design, but its carbon negative footprint. The ecology-conscious estate, once built, would be heated by giant biomass boilers and solar panels. Part of a forested site, a hundred tons of wood would be chopped annually for the boilers and replacement trees planted by farm workers. Solar panels on specially designed roofs would supply heat to the rooms through solar courtyards, while underground steel chutes would channel cool air from the forest directly into the house in summer. Environmental sewage and waste disposal systems additionally minimized pollution.

Whether the green aspect of Mittal's new country estate was merely a ploy to get it through the sticky council committees, or a serious signal for a new kind of environmental lifestyle, it was hard to say. But for a steel company that has a carbon footprint equal to the Czech Republic and has actively opposed Europe's climate change regulations, the house was merely an appeasing of the Gods. A quick Ganga immersion after a lifetime of sins.

The nearly one billion-dollar Ambani home in Mumbai further confirms the rich man's enduring search for architectural fantasy. Its promised relief from boredom came at a truly capitalist cost and incorporated facilities that were more institutional than residential. Antilla is a 27-storey home with six parking floors, roof-top theatre, health spas, swimming, terrace pools and gardens, floors for the family,

4. Luxury apartments along the East Side of Central Park cost anywhere between two and four million. What that figure gets you cannot be measured in architectural terms. But landed people are not looking for architecture. For a man who earns half a million a year, buys orchids for his wife, owns two cars and orders wine by the crate through a Rare Wine Auction House, architecture can go hang. What matters is a place so exclusive, that even he has a problem getting past the concierge. But once you do, the place radiates facility; you turn the key to operate the elevator to your own home in the sky, where, as you turn the key again, you wait a while before switching on the light, for there before you is your dream, in complete and final submission—New York, New York, lights twinkling in the autumn dusk. How you've worked for it, and how you deserve it. Just a sweet moment with your fantasy, before you remind yourself of the perks of the good life: maid, valet, pool, bilingual secretary, hairdresser, health club, personal trainer, rooftop tennis court and pool. And all yours. For the Low Monthly maintenance of Twenty Thousand Dollars. Of course, when friends come, and wonder why your daughter doesn't live there, you can just dismiss them with a wave, 'O Celine, she has her own place somewhere near Riverside, with a lot of Negroes and things.'

238

others for guests, yet more for entertainment, helipads and of course six floors for support staff. For the sultry Bombay afternoons there is even a snow room where a machine showers and teases the guests with real snowflakes. At the instructions of the owners, no two floors were alike in material, texture or design. An insistence on the Indian theme, the house also demanded every modern amenity.[5] Retractable showcases for art, concealed audio systems and stage sets, state-of-the-art LCD monitors set in an interior of Indian tradition and shaped to reflect the perfect alignments of Vaastu.

So excessive is the demand of architecture in the homes of the super rich, that restraint is altogether abandoned for an infantile delight in technology and culture. The architect naturally treats his clients like infants, allowing every fetish to prevail: pastel painted walls, sofas in finest chintz, rooms filled with technology's expensive toys, encouraging every tantrum present in corporate privilege. An oversized child in a mother's womb, a baby in your own lavish nursery.[6]

The desire for exclusivity is an obsession so perverse that in every act is an obligation to re-invent. At the Ambani house silver railings, handwoven area rugs, and glass chandeliers were individually crafted. Every piece of cutlery and shaving kit and glassware was customized to provide the inebriation of ownership. Despite the availability of the widest range of international home fittings, the sinks were handcrafted and shaped like ginkgo leaves, organically curved to contain and direct water down the stems. The attempt to keep an Indian flavour allows the designer to take absurd liberties with Indian symbols and their interpretation, producing in the end an effect so obtuse that it becomes a caricature of India. Even if the original intention is to create a thing of beauty, subconsciously, the designer comes dangerously close to a new form of ugliness.

To follow the lifestyle of the rich, as expected by the rich, and as defined by their peers is today the stuff of some of the dreariest journals, mesmerizingly faithful to every detail of their lives: what they wear, the texture of their bedspreads, the label of their luggage, their wine preferences, their shoe size… the houses are like fashion catalogues, a tedious life of excess fittingly translated into living space. Ordinary society is so makeshift and tentative, it becomes important to assert your difference and ceaselessly manufacture class distinctions.

In the squalor of Mumbai, or in the anonymous English countryside wealth and its symbols offer the last hope of permanence and history, the most visible way to ward off the painful shadows of forgetting and passing. So you build. You build pools and

5. Janet Nicholson, a classmate of mine from architecture school days, lived somewhere high above Central Park. Married to a banker, Janet's life was doubtless made. But not having met in a quarter of a century, I didn't know whether she was still around or had moved to London or Tokyo, the way successful banker couples move. The concierge at her apartment glanced balefully at my muddy shoes, and before he could direct me to the service entrance, I had pressed the elevator button No. 52. Fifty-two floors above Central park, Janet had wasted no time in using her architectural skills and husband's income to good architectural effect. Walls in a buffed Texas Travertine, led me past the formal rooms into a terrace garden that paralleled the greater park below. At the edge of the terrace was the paling blue light of a pool as big as the Delhi Gymkhana's. 'Oh there's a pool with the building,' explained Janet, 'but George likes to swim nude….'

6. Few among the small array of Indian elite who find their personal lives probed as in a gynecologist's exam, care for the modest personal moments of luxury. Their names are visible amongst the highest ranking in the Forbes Rich list, the tallest house in Mumbai, the fastest growth in stocks, the most active form of company diversification, the largest turnover, the biggest pay package, the most…. Isn't this all just a part of a businessman's working routine? By the same token, I should be informed regularly about other professions too: say a successful doctor in Ludhiana; the number of surgeries he performed, the number of outpatients he saw, details of his Rotary Club membership, his golf handicap. The business world's mindless elevation of ordinary people to national stardom is both petty and provincial. And leaves you with nothing but a host of niggling questions: How has this wealth altered their perception of life? Has it in fact opened new vistas for luxury or enjoyment, or spawned newer interests in art or film or literature or farming or stamp collecting? Or is Indian wealth only creating a narrow one-dimensional human, who has no interest beyond his business? Is this true too of most Indian entrepreneurs who have prospered in recent years? The rich business people of India would doubtless disagree with that statement. This mistaken link of wellbeing with wealth and materialism is one of the truly unfortunate dilemmas of luxury in India. Among all the heavy weights, like the Ambanis, Vijay Mallya, Narayan Murthy and others, the acquisitive approach to daily living is also equated with living well (OK, maybe not Narayan Murthy). The joy is in the contrast: that in a land where the farmer is reduced to eating cow dung, there are those who can still get fresh truffles flown in from France. In a place known till recently only for deprivation, the sight of a personal jet is not just comforting for its commuting convenience but a symbolic reminder of plenty amongst the deprived. If human relationships are the backbone of the good life, the rich would doubtless argue that yachts and Rolex watches make human relationships possible the way a shared dal and vegetable never can.

croquet fields, private arboreums and tennis courts and sculpture gardens—places you may never use; you build classical loggias and wings and galleries at the end of long endless driveways, past gate houses, over moats, and secure yourself with a private police force. You build, knowing full well that the house has no architectural value, the estate, no intrinsic measure as landscape, or the place, even a serious record of ancestral memory. The real test of the home is its assessment as the social equivalent of the stock market. And the incessant urge to acquire.

With money and property on distant shores, you can, finally, shed your Indian skin. To be carefree and easy in the English countryside or in a Budapest restaurant is now merely the requirement of the business elite. The super rich are as guarded about their privacy as they are carelessly magnanimous about their family expenditures. To host a wedding in France, buy a house in England, or be seen at Davos is the quiet publicity essential to projecting the essentials of success. Doubtless, as Indians we take a certain pride in his flamboyance. Had Mittal chosen to marry off his daughter in a quiet ceremony in an unmarked locale in Provence, the country would have felt cheated. He chose Versailles instead, the Taj Mahal of France, a grandeur not merely defined by monarchy but by the country's most extravagant piece of architecture. There were enough members of the world media at the ceremony to display its excesses to the world, and let people know they were not on the guest list.

Over time, even the colour of his skin will get muted by the colour of his money.[7] As a new settler in the Surrey countryside Mittal's ancestry will eventually dissipate like fog over the moors, and English reticence and diplomacy will never openly question his foreignness. Oh yes. The gentleman with the new house down by the stream. By then it will be time to move on.

Years earlier, while designing and building houses for similar clients, I was always struck by the sheer poverty of personal choice and expression in their lives. As if the intensity of their business life had deprived them of the real reasons for living. The new houses were mindless derivatives from European magazines. Desperate to plunder various foreign cultures, a savage taste was promoting a culture of false mannerisms, where wealth had no history. Everything was to be copied, right down to the artworks on the wall, but in Indian eyes money elevated all to stardom.[8]

Day by day, in meeting after meeting, the houses merely grew in extravagance. Extreme affluence also allows the practice of idiosyncrasies. With a Mumbai film actor whose design meetings stretched over a year, we met every few weeks

7. When rich, brown people become almost white. Delhi and Mumbai's escort services for instance, are run on Russian and Ukrainian women who demand a higher nightly rate than the Chinese, who are themselves paid more than dark-skinned Indian women. Such preferences make modelling and advertising work hugely profitable for East European women, where white skin is their only skill. A survey done last year in the service industry—hotels, restaurants, airlines—found that 70% of Indians, male or female, prefer to be served by whites, male or female, over other Indians. The idea that the white server is placed in a demeaning position is an instant uplift. It makes us feel almost white.

8. The search for an Indian Hero, invariably reaches into the four primary sources of celebrityhood: film, politics, business and cricket. And comes to a head annually in the 'Indian of the Year'. Each year the same faces are paraded across the television screen. Amitabh Bachchan, Shahrukh Khan, Sachin Tendulkar, Sonia Gandhi, Ratan Tata, among others. Each time, the public assessment of their worth is linked to their achievement in their professional capacity, and/or their monetary worth. Bachchan, a movie star whose appeal and extraordinary talents remain undiminished by age; Tendulkar, a sportsman in the league of Woods and Federer; Mittal, as skilled in business deals as in the steel industry. Without doubt, each a glowing ambassador of his trade. Certainly, the spirit of philanthropy doesn't deny them the fruits of their labour, neither does it demand an egalitarian spread of their wealth into charitable institutions, but merely expresses a concern for interests outside their careers which may benefit society. To be merely 'great' at what you do, is that enough to earn you the mantle of 'Indian of the Year'.

to discuss a house that had grown amply during the period. The living room had acquired wings and galleries leading to the raised level of an outdoor barbecue; the private quarters had carved an oversized pool within the closure of their courtyard. And the front entrance had developed a porte cochere in the manner of an English court house, so that the long drive past the high iron gate and compound across the formal tree-lined drive, could end comfortably in the recesses of an arrival colonnade. There was no other way to achieve grandness of entrance. The beige raw silk curtains of the car, I imagine would be tightly drawn to contain both air-conditioning and privacy; the driver trained in noiseless maneuvering would slowly ease the expensive steed around the gentle turning radius of the cobbled pavement, its radius designed for the German car. The roughness of the stones, and the circular movement of the arriving car would ease its occupant from his gentle slumber, and he would blink lightly as the vehicle entered the engulfing shadows of the house. This was the way life was meant to be.

In all respects, the house was a composition of leisure, and I thought with its open-ness and ease of movement, it would simply draw its residents into continual acts of ceremony and celebration: there was ease and laziness written in every aspect of its design. Space moved about with the restful geniality of an abandoned colonial club. The room opened into a verandah, the verandah eased onto the terrace, the terrace merged with lawn, the lawn with the surrounding countryside. If a phone call had to be made, the instrument could be brought to the pool, or to the bathtub, or the owner strolling among the tulips from Holland simply dipped into the pocket to retrieve his cellular phone for a call to his agent; if snacks were needed they could be prepared in the main kitchen, or in the secondary pantry behind the entrance vestibule, or in the poolside colonnade.

The only sound was the silence of space, the only sight the green of overwatered grass, and of pools bubbling and forever lapping. The services and servants needed to maintain even an establishment of such proportions would always be within ear-shot, but always obscured by the architecture and the foliage.

In such a setting my own ideas of home had become indistinct. In cultures where architecture does not spring from the immediate economic and sociological envi-ronment, there is a need for architects to rationalize their work in academic terms. To make claims for buildings that are compatible with a prevalent theory or to con-demn those that fail to live up to it is a constant refrain of architectural practitioners in the West. However, when the conscious search for a theory behind every act of building becomes the main preoccupation of the architect he becomes the creator of a form determined by his own laws, for his own express purposes.

243

By contrast, manual sensibilities and the habits of the past still survive in cultures where architecture has not given way to the assembly line approach. The particular economic conditions of a place, seen in the light of the professional challenges they pose, tend to produce an architecture with little theoretical or academic basis. Materials and methods are limited, and there is an implicit acknowledgement among professionals that the craftsman's role is critical in the making of a building. Beyond that, there is little need to offer polemical justifications.[9] So perceiving himself an architect-craftsman, the architect derives his professional sustenance from outside self-determined bounds. He performs no acts of personal creation but the building he makes does absorb, and suggest, many of the conditions specific to the region. Architecture exists in an effortless continuity determined by tradition and conditioned by natural laws.

For me, it was difficult to tell if the buildings were being created for family comfort or as a visually commanding private institution, or as an open-ended chamber of familial pleasures; nonetheless it was a place which imparted a strangely false sense of appropriated aristocracy.[10] I could well imagine the annual photographs of the house's occupants taken in the winter light of the South lawn, depicting the hierarchy in a severe and controlled pose: a picture of 400 people, gardeners, servants, valets, gatekeepers, drivers, mechanics, gardener's assistants, driver's assistants, cooks and head chefs, nannies, wardrobe cleaners, floor cleaners, bathroom cleaners, pot washers, storekeepers, washermen, librarians, music and film cataloguers, billiards table brushers, linen ironers, electricians and plumbers, all standing in stiff sobriety, staring at a camera.

When the final site plan was being prepared, I noted how the plan had changed from the original conception. An ordinary piece of fallow land had first sprouted a small farmhouse, as insignificant as the other farmhouses around. The farmhouse had then acquired wings and loggias, deep porticos and service areas. A wide flank of servants' quarters, virtually a small suburban township of support staff and ancillary facilities, like laundry, stores, parking yards and workshops, had appeared in the far corner of the drawing; a coagulated cluster of outhouses for receiving goods and related personnel clung to the rear wall. But away from the front gate and these distant service arenas, a salubrious architecture had risen—private terraces connected to personal wings, pools across bedrooms, and gazebos tucked in the deep rows of rare flowering tree groves. Herbaceous borders sprang alongside indelicate rockeries, water channels snaked along sandstone walkways and emptied their shallow contents into the manmade lake made to resemble, through its rough, serrated edges, a natural reservoir.

9. Unless you were Walter Gropius. 'The Bauhaus will represent the opinion that the contrast between the industry and crafts is marked less by the tools they use than by the division of labour in industry and the unity of the work in the craft.' With statements like these it was obvious that Walter too was a thinker, and not a doer. 'Production in the Bauhaus will not represent any competition for either industry or crafts but will provide an integrated form of development. The products reproduced from prototypes developed in the Bauhaus will be offered at reasonable prices, only because we will use quick methods of standardized reproduction at a mass scale. If for some reason the product is cheap looking or of inferior grade, mass production will ensure that this is true of all similar products, so that no one customer feels cheated. The Bauhaus will counter any attempts at fine workmanship and superior quality; including hand-made products of individual merit.' To show his personal commitment to the cause he added, 'I myself will continue to fight for an honorably medi-ocre way of life.'

10. Affluence even generated its own language. People spoke a language only they could understand, which didn't make any sense, since all of them wore suits, even the women, and were obviously wealthy. When they spoke amongst themselves about the methodology to be adapted to contain the rising fiscal deficit within the parameters of the equity framework for national development, there was a hollow echo of concern in their voices, which gave them away as rich people with nothing to do. Though they all continued to harp on the ethics of open trade policy among the most favoured nations, you could tell that all they wanted was to lie around their swimming pools, grilling reindeer meat on their barbeques.

But architecture was not made by just the addition of these varied elements. Architecture was realized in new levels of commodiousness. The idea was not merely to fit a house on a spacious estate but to combine the liberating aspect of the openness with the building. A retreat, a country estate, a stately manor or a farmhouse, the nomenclature mattered little, but the design insisted on rambling across the manicured grass; verandahs curved across the rooms and added ancillary porches, wings grew from the corners to enclose yet more garden acreage; and arcades appeared around pools to provide shade to the tinkling fountains and gently rippling water bodies.

For there they were, a family in the lonely confinement of architecture's overabundance; taking sundowners on the lawn, living a life of healthy reclusion, buttressed by the knowledge that the slightest of desires was only a nod away.

Leo Tolstoy once asked 'How much land does a man need?' In a situation of overpopulation, the anxiety to possess a valuable and limited resource becomes the most potent symbol of wealth. The open-ended nature of rooms that looked onto ground self-owned but unoccupied, moving to a listless horizon, also bought but unused, formed a display far more arresting than any singular object in space. No gold fixtures, no authentic Elizabethan sofa, no period antique or family heirloom could ever compete with the sight of buildable land left unbuilt. Permanence was doubtless an important consideration in establishment of any household. Objects and buildings and furniture endure, but measurably less than the lasting qualities of a piece of land. To the consumptive materialist, ownership of goods is seldom enough; once he reaches his natural limits he naturally begins to acquire things that are themselves potentially boundless. A lucrative subtler manifestation of acquisitiveness, the big man learns to use land aggressively and less economically than the ordinary citizen. Material wealth, now cloistered behind secretive and forbidding boundaries is never visible to prying eyes; but the public display of power appears in quest for territory, in a possession of the earth itself.

Such lifeless buildings are at the very epicentre of the life of the Indian elite, and mark the singularly hollow tragedy of their affluence: a sign that they measure their success only on world terms, without anything of their own faiths or beliefs, likes or dislikes. For all their show of real estate, Mittal and Ambani were a type. Bound to business and without any notion of personal aesthetics, they relied chiefly on the conventions of art and architecture to proclaim their taste. If their heroism is applauded in the financial markets, it does little for the millions in search of real heroes.

248

Even now, visiting these houses years later, it is hard to note anything inside of personal value: no family photos, no trophies, no favourite painting, no old carpet, no pieces of sculpture or favourite books. Nothing. Nothing to suggest a religious belief, a marriage gone sour, an achievement, a remembrance, a past encounter, etc. As if, in the statement of a life the real has been wiped out, and all that remains is a stage-set sanctioned by wealth.[11]

A full-page advertisement for luxury apartments that appeared in the newspaper not so long ago, showed a young couple lounging under beach umbrellas, sipping cocktails beside the blue waters of a pool. They were dressed and posed in the yuppie way of a successful working couple for whom architectural luxury was not a long-term hope but a routine expectation. Lolling about their plush home, the image could well be from Rio or the Riviera.[12]

The apartment for which they were the advertising candidates was hardly the normal expectation of an Indian middle-class couple: a five bedroom condominium, set in a twelve-storey structure in suburban Bangalore, there was only one apartment to a floor, open plan, jacuzzi, bar, two kitchens, two servants' quarters, separate service entrance, heated terrace pool, barbeque, solarium, central air conditioning and complete service backup. Insisting on the exclusiveness of his venture, the developer had added a rider to the ad: By invitation only. In a country where shades of caste and status add premium to any idea, the clause of restriction could only work in his favour. By conducting interviews for admission, he elevated the status of the project from mere apartment house to fancy club. The developer was a Punjabi, familiar with the workings of the Indian mind.

The primary interest in such projects has always been directed towards excess: fanciful space, new materials, structural assemblies that defy gravity, an attraction for the loud and supercilious. The sudden rise of credit culture and the easy demand for an aspirational life decreases, in architecture at least, people's awareness of their surroundings, the value of their neighbours, their concern for their climate; moreover, lessening their capacity to assimilate, and remaining connected. Isolated in the supposed luxury of their 5-bedroom apartment, dipping their toes in their pre-warmed pool, the loving couple was doomed to a life of mental therapy and stress.

Everywhere, a battle was being waged between commodity and community, and in every respect commodity was winning. Every aspect of architecture and urbanity was tending towards an increasing isolation of the population. More flyovers, longer expressways, empty sidewalks, speedier transit, allowed old places to be

11. In the West, the history of business is closely tied to philanthropy; the lives of individual family fortunes have found ways to improve the lives of others. American Paul Mellon, heir to the Andrew Mellon fortune, was a collector of British Art, for which he set up a fund. The Mellon Centre for British Art is open to the public today. Andrew Carnegie, at one time the World's richest individual, was a founder of libraries. The Rockefeller Foundation was set up with the portentous goal of 'promoting the wellbeing of mankind throughout the world' but contributed to research that lead to the 'Green Revolution' in agriculture. Could Ratan Tata's model for his auto business ever rival Edsel and Henry Ford, whose Foundations' assets of 4 billion dollars are annually used to fund projects on human achievement, poverty reduction and justice? 'The man who dies rich dies disgraced,' Carnegie wrote and so believed. Instead, Indian business philanthropy retains complete control of gifts, generosity and the compassionate spirit, all within the folds of the family.

12. For perhaps another few decades the rich will be a poor parody of themselves. Like a standup comic who laughs at his own jokes, the sudden material metamorphosis has exposed large gaping holes in personalities which had remained dormant in poor times. As Spiderman's uncle Ben explained to his nephew in the movie, with great power, comes great responsibility; it is hard to envision the Indian rich ever acquiring a public dimension, and becoming the Indian elite. For that the wider concerns of society, still desperate, wretched and wholly dependent, will have to be seen as worth the investment.

bypassed and so make possible new places, further apart. Dispersal and distant physical connection made movement possible but destroyed all links to immediate neighbourhoods and familiar movements. Isolation was the unfortunate and inessential byproduct of too much mobility. But in the commercial urge to make the sale, the builder and architect began to promote commodity as community. People with a common lifestyle purpose were herded behind high boundary walls in gated communities to share the spoils of private enclosure: pool, sauna, private parking, tennis club and golf course. All the facilities that said, Private. Trespassers will be Shot…. The controlled reintegration of the dispersed family back into a formalized neighbourhood. It was a return of the Nazi drama enacted into an intolerant urbanism: the perfect community. However hard the architect tried, the isolated families of the new city were now only isolated with each other.

The futility of the pseudo community was felt everywhere; everywhere in the expression of leisure and work and play. In the private housing, the swimming pool and the weekend barbeque, in the Japanese work ethic, in the factory, destroying professional differences in day-night cafes and virtual ping pong; in the institutionalized leisure of time-share vacations and pleasure cruises.[13] The images of these places, part Hollywood part Disneyland, were daily reminders that community could be bought and sold, bartered and exchanged for more convenient dates, more choices on the pleasure calendar. Indeed, they were remarkable only for their enforced message of a shared life.

Throughout history, architectural choices had belonged to rulers and aristocrats. An increasing middle class was now demanding a greater share of architecture's appeal, to draw on the specialness that design bestowed on building. Yet in the commercial surge to make and sell increasingly large numbers of houses, the results were tinged with the despair of the new conditions of space and construction. Building in the air, rather than on land; building high rather than sprawling; building with the technology that allowed stacking one above the other, architecture was a relentless massing of repetition, pitiless in its occupation of the sky. The appeal to the masses was an appeal of the massing. An advertising, not architectural, belief that everything big and bold was part of the future of new India. At the core of the city lay the optimistic though misguided suggestion that the application of the industrial process to housing would not only help alleviate the shortage but create a better architecture. The buildings, however similar, autocratic and monstrous, were seen by their residents as symbols of rising material power, reflecting, quite literally, the rise of the middle class. Their own rise.

13. After designing spas and hotel swimming pools, I had begun to believe in the autono-
mous nature of watery luxury, where even moments of hedonistic pleasure had been effec-
tively institutionalized. Water was spa, or infinity pool, or hot tub. Its meaningless structural
and industrial thrust needed to be replaced again by personal belief, and the long-forgotten
idea that water's fluid attribute could construct many private games.

Central to places like Malibu Town and Southend Towers, their restless repetition of flats and offices, lay the authoritarian decisions that had reduced architecture to an abstraction of statistics. Unable to alter or benefit by the industrial process, buildings arose in an unquenchable thirst for numbers, and a repetition that had no limit. Any alteration in plan would upset the vertical assembly line. So, the crane lifted material into place, one after another, after another. As long as there was spending power, the formless mass of building kept rising. Surrounded by others, like itself, destroying the distinction between city and country, urban and suburban, housing was the new debris gathering on the outskirts, like the unwanted waste of the city.

But the more building there was, the greater the belief in the rightness of the course. Illusion though it was, architecture was being constantly legitimized by numbers. The dictatorship of consumption kept the illusion from flagging. And the participation of so many, architects, politicians, builders, buyers, labourers, all helped fuel the belief that the physicality of construction could hardly be illusory. Instead it was an assertion of the obvious, a triumph of the new sensibility, forged by new partnerships. The pessimists had long since been buried or were living outside India.

Architectural heroism of a different magnitude was being practised outside India. I saw it first from a tourist van that sped along the coastal road in Dubai to the Palm Jumeirah, a sea-front artificially extended and made in the shape of a palm tree. Its true architectural layout could only be grasped from an airplane; the same was true for its sister development 'The World', with countries as islands extending into the sea. The road ran along the trunk of the tree, upwards and outwards, to the fronds that extended from the upper level of the palm. Million-dollar houses stretched out in a relentless line, like suburban American track housing. Row upon row, back to back, they faced the shallow waters of the artificial inland sea. White sand in truck loads has been spread above the artificial concrete breakwaters to give the illusion of a natural beach. Across the way the houses, a stylized mix, part Mediterranean, part Florida and topped by an artificial wind tower to lend an air of Arab authenticity, looked across to similar houses on the neighbouring frond. A friendly suburban New Jersey air, where barbeques were shared, and wives were swapped in discreet weekend privilege.[14]

Surrounded by such megalomania, even ideas of leisure stood changed. No longer the scented garden; no longer the lingering walk past old tombs, or shaded stone seats along a water channel, consumption was describing new architectural patterns. The shopping mall was extended to encompass restaurants and art galleries; the cinema had lost its independent identity and was submerged with the mass of

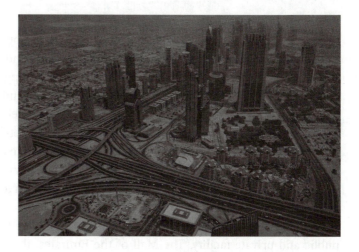

14. Who could imagine that the relentless terrain that sucked life out of all living things could ever be truly made in any constructive natural way. In barely a generation, the natural ecology of the desert, the rough, parched, and pitiless landscape has been given the opposite lease. Manmade to the dimensions of a whole country. Unnatural to the order of Disneyworld. Desalinated and air-conditioned like Las Vegas. Walk along the golf greens for the Dubai Desert Classic, the soft earth and grassy mounds have the tropical feel of monsoon places like Indonesia and Thailand. During the short spell of a Dubai winter, television cameras follow Tiger Woods and Colin Montgomerie leaning on their clubs on thick grass against a background of formidable skyscrapers and a sunny blue sky. A mix of tropical lushness surrounded by Western urbanism. Is it Hongkong? Is it New York's Central Park against the apartments of the East Side?

stores, a hotel was added along a side wing, offices and business centres occupied the floors above. On the roof a private club, play areas and recreation. In the convenient joining of likely functions a new building was being born: a multiplex-food court-hotel-shopping-office complex. Inebriated by size and scale, the building was blighted by the consumptive need to perpetually sell itself. Rent office space, sell shops, lease the hotel, promote the club, market the marketplace. The internal organization for its administration was itself mammoth, akin to the bureaucracy needed to run a small city. In the process it had become too heavy a burden on itself, and, as with many that had assumed urban proportions, begun to be consumed by itself.

So the malls came. Mile upon mile of concrete roofscape filled with every form of public and private facility. The Mall of the Emirates, three million square feet of retail. The Dubai Mall, even bigger, 4.5 million square feet: commercial palaces glittering with gold souks, jewellery stores, aquariums, ski slopes, skating rinks, movie theatres, restaurants and the West's most popular offerings: McDonald's, TGIF, Kentucky Fried Chicken, Cartier, Burger King, Rolex, Tiffany's, Walmart.

From the Shhh of the taxi to the Humm of the mall, from air conditioning to air conditioning, it was a movement from one darkness to the next. Spread out and sprawling, the difficulties of orienting in so demanding an obstacle course required continual direction. At every junction, information counters gave diligent answers in the West's recognized languages: English, French, Spanish, German, and Arabic. At the largest single aquarium in the world, the glass-encased seascape rose to three stories; sharks and octopi look out through their spacious confinement at Gucci and Louis Vuitton and Chanel. Given the monumental scale of such consumer proximity, they must wonder how the ocean floor had suddenly acquired this high end commercial edge.

So you eat, you drink, you gawk, you file past empty gold stores, 50–60 of them in a darkened cavern of flickering star lights, like something out of Arabian nights; you walk another mile to a Costa, a Barista, a Starbucks; under the canopy of a European street café you sip a Latte and nibble on a blueberry muffin. You piss in a sanitized restroom diligently manned by an Indian, Pakistani, or Sri Lankan, in black uniform, dispensing towels, reflushing flushes, wiping sinks, a simpering background slave stuck in the innermost service recess of an interior wonderland.[15] You walk for several hours oblivious to the sun's movements in the sky. The lights are always changing in the mall, giving the illusion of daylight, or evening, even night. Electric reflections in tinkling water falls and shiny floors in granite and glass.

15. An open bus, a windowless heap of clanking steel passed us along the highway. I could see the dark faces, much like our own in the tourist van, chattering under the yellow hard hats, heading out of their shift. It was India in captivity, a miniature moment of displacement, a scar on a shiny new landscape meant only for white expats and white-robed Emiratis, a life that was elsewhere. In the late afternoon, with the sun gliding across the southern horizon, I took a taxi into the workers' encampment, the distant blur of concrete I had seen earlier in the day. Mohsin Ahmed couldn't have been more than 20, but he had lived there for two years, working as a wage labourer on a coastal construction site. His 12-hour work shift, 16 with overtime, left him too exhausted for anything. I asked him if he had seen anything of the city he was constructing? 'I don't have time to wash my clothes,' said Mohsin. 'In my free time I drink and sleep.' He had a middle bunk in a room for 18 people, a dismal four-storey barrack of repeating rooms, without cooling or ventilation. Some of the bunks were occupied; the room looked like a luggage rack at a railway station and smelt of fetid sweat and urine. At the other end, between the bunks were fresh vomit stains. Mohsin had come to Dubai along with his elder brother Sohil, but saw him only on Fridays, the day of rest. 'They try to keep family members apart,' he said. Then a little ruefully, 'they took away my brother, and my passport… but I can't complain.' He pointed to his own bunk in the room. A small suitcase served as a pillow, and a fresh shirt hung at the edge. 'I make 600 Dirhams a month; my company will raise it to 800 when I turn 21.' It was hard to understand Mohsin's optimism in the squalor. Room after room, the depressing dormitories stretched endlessly. Block after concrete block in rows so geometric, repetitive and endless, it was a Nazi concentration camp all over again. A 21st-century Treblinka. At the edge of the block, a shit-caked common lavatory straight out of *Slumdog Millionaire*. Far away, the Dubai skyline mocked the monkey life of the workers. The shimmering skittles in the desert sun filled with Muzak, synthetic love and laughter, a pretend shoppers' paradise with all the illusions of the high life. The extravagant mega malls and ski slopes and McDonalds and Dunkin Donuts built on the backs of shrivelled labour from the subcontinent.

In a conspiracy of absolute mistrust for what lay outside, the new architecture only contemplated a complete control of life within the boundary. The community of facilities in a mall, or the gated community of houses, both functioned like small independent cities. Without history or connection to local craft or earth, the place was a mere expression of social power, the absence of tradition another indication of the subconscious urge to destroy the city. The single-minded economic pursuit, regardless of its impact on the progress of the town or the country worked away at an order that was neither town nor country. In the process, it created not a split between the two, but only hastened their simultaneous destruction. As unseemly appendages they could exist anywhere, regardless of the urban reality around them, mocking the society that enabled their survival.

Such projects clearly demonstrated the isolating solitary impact of the countryside. The idea that nothing of value lay outside the gated community. A false sense of urbanity could be created inside the boundary wall, between members of the same family. But for the internalized community, choosing to occupy space without a personal history, urban values remained inaccessible and distant. In the pretence of community, sharing pool, sauna, parking and tennis court, the new peasantry had no natural link to the town or the country. Like many of the isolated dwellers of the rural areas, the traditional peasants, their geographical dispersal into isolated pockets of apartment blocks and far flung office towers prevented them from making decisions or even becoming a social force to reckon with. They remained in many ways, the isolated residents of transit camps, caught in the cycle of commerce, and forever moving with the flow of money and material. The isolating ignorance and powerlessness of the natural peasant had now given way to a disjointedness in exclusion, in a private landscape of seduction. So clean was the break with history that the placeness of places in a miniature universe of its own design could no longer rely on design, urbanism or technology for identity. It fed instead only upon itself, like a carnivorous reptile, nibbling on its own leg for survival. A revolutionary intoxicating idea, where the only hope lay in its complete consumption of itself.

Without history or a concern for the future lay the perpetual struggle between tradition and uncertainty, as a convenient fall back to tradition, comfort and familiarity. But change, however ungainly, always won. The eventual victory of innovation was viewed as an expansion of a culture's pool of knowledge and experience. However false.

In Dubai, what struck me immediately was the sheer weightlessness of the constructions, a city made from an instant mix, a child's Lego set at the monumental

scale of a metropolis. The displacement was palpable; wherever I went, I was always left with a nagging feeling that this was only a temporary encampment. Perhaps it had something to do with the desert's erosion of boundary, where earth and sky are always a seamless brown swirl of sand cloud; where height and colour refuse to survive in so vacuous a landscape; maybe it was the anachronistic sight itself. The visual improbability of glass and steel so high to ever exist in undefined space, detached from ground.

Throughout history, the treatment of architectural space in the desert had demanded an internal view, the courtyard, the make of manmade shadow; the critical mass needed to set enclosing walls against a climate so harsh that without it, the sand took over completely. Like snow, the desert's erosions and accumulations were forever nibbling away at architectural battlements, restraining and restructuring geometry into wind shapes, reducing everything to absence, to an image of itself. Drive anywhere, a short distance from sea to downtown, or to the older areas of Bur Dubai, the desert was always looming; however hard you try to mask its presence, there were always formidable reminders of its insidious actions—a dust haze, a sand storm, and always a yellow reflective light that invariably sought you out, followed you, penetrated the cracks. Never let you be. Sure, somewhere below its surface, life existed; creatures and plant life survived, but by its very nature, the desert had effectively obliterated its visible presence.

On a day like any other, I rode up the electronic hiss of the elevator of Burj Khalifa. From ground zero to the 132nd floor, the black soundless box of the lift gave no indication—visual, tactile, acoustic—of this enormous height. I was deposited soundlessly on the observation deck. Looking down, the other glass towers below appeared diminutive and frail, dwarfed by height, and grounded in yellow dust. In places of luxury, built instantly, when the end comes, it comes swiftly. Without history, there is no possibility of a return to an earlier time; without recognizable locale or population, the possibility of renewal dims, and the new piles of steel and glass—including the receding curves of the world's tallest building—return to the dreary desert dust. Dust remained suspended around the glare of mirrored glass as the brownness extended all the way to the horizon. Like a miniature city swirling in a muddy water tank.

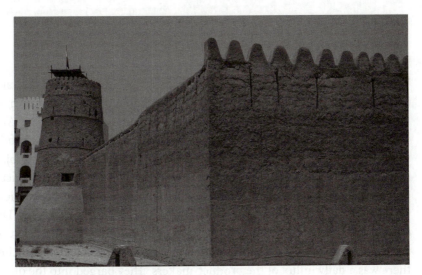

18. Architecture as Commerce

The more people I met in the profession, the more I understood that architecture had turned away from the act of making space habitable, its professed aims of sheltering and nurturing, and had become, instead, a product-oriented art. Architecture was merely an assembly of richer, newer products whose use and usefulness were suspect. The idea was not to make beautiful buildings out of ordinary objects, but to make ordinary buildings out of beautiful objects. Every few days the office would be invaded by manufacturers of newer and newer material: glazed ceramic dado tiles with built-in anodized aluminium holdfasts, permafluid long-lasting Duramount exterior wall finish. Spectra colour paint, Aquamatic pool tiles, fake fireplaces, veneer doors made of imitation wood, imitation bricks made of reconstituted resin, there was a daily influx of the product-makers. They barged into the office with the seemingly efficacious authority of an inventive genius offering ideas to a potential marketer.[1] We were expected to be grateful to them for coming to us; and in the tactful innuendos of the exchange, I realized we would be amply rewarded if we could only convince the client to use these products in the new building.

Whether hotel or home, I came to understand from such encounters that the more profitable trade was in objects and places that helped to enhance the identity of its purchasers through a process of hyper consumption. It was a phenomenon that suggested a work ethic, the sole purpose of which was the purchase of commodities for investment—houses, antiques, farmhouses, vacation houses, paintings, etc.—objects capable of sustaining succeeding generations. Architecture too was only a marketable commodity prone to the changing whims of commerce. In it was a happy expression of a manufacturer's enterprise and the freedom of a consumer's choice; you made what you could sell, you bought what you didn't need, you built what you saw in a shopper's catalogue of architecture, you even paid to get your news in the paper.[2] In the end, everyone was happy.

Such blatant commerce of what was once an artistic endeavour made the city into a free-for-all display—a tentative theatre of surfaces, made and proliferated by the forces of the country's push towards a free market economy. Architecture was in the advertising. Its signs were everywhere. In the hoarding for a scented soap, the façade of a modern house, the showroom of a new product, the city was made of signboards selling, enticing and coaxing with shrill messages. But the medium was not always explicit.[3] And it seemed to me like an advertisement that always kept you guessing as to what product was being projected. A house that looks like a Spanish hacienda is not occupied by a toreador, but by a scooter spare parts salesman; a

1. Even newspapers today make no pretence of selling out. Some years ago, papers started tentatively placing half-page ads on the front page to test if the public would notice the change. It didn't. Soon enough, ads became bigger, more colourful, and began to bleed into the text. Newspaper headlines and lead stories shrank to accommodate the new demand. When business houses wanted bigger ads and were willing to pay, editors gave in, quietly and without fuss. Some readers may have noticed that former Prime Minister Gulzari Lal Nanda's death could not be covered because Colgate and Coke had both given full-page ads that day. Editors went so far as to request the Nanda family to postpone the death by a day, but Nanda, being an obstinate politician, carried on with his original plan; his death received a two-line obituary below an oversized Coke bottle. But that was long ago. Today every paper comes coated front and back with commercial space. When only a half a page ad is sold the paper comes cut in half. Try holding a half paper in your hand along with the morning cup of tea. And you'll know the real power of commerce. Plagued by commerce, infatuated by technology and clearly incapable of restraint, the results are despairing and mediocre. Excessively emotional correspondents, editorialized and personal news stories, and an imbecilic reverence to commerce makes media offerings a minefield of uncertainty. You tread cautiously, hoping to pick out something of value in a shopper's stop of journalism. Are Doordarshan, Pravda and the *Budapest Times* the only models left of old journalism?

2. At a recent opening for a friend's art show in Delhi, I was asked to stand aside while a small group photo was being taken. A local photographer was covering it for his newspaper and was under explicit instructions to photograph only those who had paid the requisite fee for the Page 3 slot. So blatant was the commercial angle to the page that the photographer was under quite some strain to weed out the non-payers, though he could easily have edited them later with Photoshop. Newspapers today make no pretence of selling out. In the world of formula journalism, where the fight for commercial space is the final frontier, the selling of success is equivalent to the success of selling. The formula is simple: Start with a free-wheeling interview with Shah Rukh Khan. Ensure that Shah Rukh Khan gets full coverage at the Kolkata Knight Riders match. And follow it up with a few ads for Skin Whitening Cream by Shah Rukh Khan. When Shah Rukh Khan is in town to open a new coffee outlet, give it full coverage. If Shah Rukh Khan is not in town to open a new coffee outlet, invite him to town to open a new coffee outlet. You won't regret it. Throughout the day, bring in a story or two about Shah Rukh's harassment at US immigration, ending the day with a movie starring Shah Rukh Khan.

3. Journalism had been a different profession once. My father was the Washington correspondent of the *Hindustan Times*. His work day started early and ended within an hour. The study where he sat at 6 am was the hub of an agitated newspaper office. A wide oak desk lay littered with a string of files with notes everywhere, elaborate hand-written notes on scraps of loose yellow paper, notes for yet another piece on Richard Nixon, the president he hated with undisguised venom. He loved the man's lies, the serial liar, the kingpin of the Vietnam war, whose secret tapes he heard and reheard in countless sessions, making his scribbles for a book he hoped to write. Richard Milhous Trickson, he called him, and then he'd laugh at his own joke. Every move that Nixon made had to be recorded, and dispatched to India, in time for the early morning news. A half day difference allowed the dispatch to be made in time for the Delhi editors to find a place for it at night, before the Linotype metal took over and nothing could be changed. So, the morning agitation was essential, a flurry of intellect gathered the night before was physically pulsed from hand notes to typewriter to teletype in the hour. At the end of which Papa sat, exhausted and relieved, like a high scoring basketball player at the end of the game.

colonial façade of a modern office building does not project the appropriately haughty image for the British High Commission, but merely projects the success of the pharmaceutical company behind it. Architectural academicians have happily explained the confusion as a search for cultural authenticity, a value absent in contemporary society. They call it complexity and contradiction, ambiguity and paradox, the richness of experience. But eventually, the justification is related only to the owner's concern for the right image that could effectively suggest commonly understood signs of affluence. The manufacturer of computer software wants to make it amply clear that he is a manufacturer of computer software and a successful one at that. He is a stylistic entrepreneur and it must show, as easily in the exterior of his house, as in the interior of his office. Architecture, and the packaging of architecture, determine for him whether the sign is to be explicit or implicit. But it must demonstrate that he comes from a long-established line of successful people, generations of family successes in a range of businesses.

With everyone playing architect, much of recent architectural work could only be enshrined in a fragmentary and partial understanding of tradition and technology. It appears primarily as a promoter of change, without actually being so. In a half-baked way, attaching archaic and historical ideas to buildings, or employing technology as a means of suggesting a future. Such incomplete imagery can hardly act as a serious endorsement of a new form of architecture. In fact, in the absence of complete knowledge, architecture's validity becomes suspect. And all that remains, the fake reconstructions, incomplete language, and illusory symbol of life, needs to be wilfully destroyed. Without serious evidence of its destruction the chances of anything new arising seem remote. The birth of a real community and its expression in architecture can come only when the old references are forgotten.[4]

Everywhere, society had come to a new dead end, the worship of the spectacle. It was not a raising of the conventional bar, but a side step where every cultural action became an event of fantasy. Cricket uniforms changed colour and the game was tuned to a restless audience with limited attention spans. Films adapted to 3D mode and a fiction so far removed from the present that both future and past could be invented. News came in flashes of trivia. Human taste buds and digestion conformed to an international invasion of culinary diaspora and celebrity chefs.[5] There was no national dish. Indian Curry, Chinese Noodles, English stew were exchanged for English Curry, Chinese Stew, and Indian Noodles. India's best mangoes were consumed in Dubai; Italy's best Sicilian pizza was found in Queens, New York; Florida's finest water theme park was built outside Ahmedabad; the Natural History Museum in Washington DC had a better Brazilian rainforest than Brazil; and the

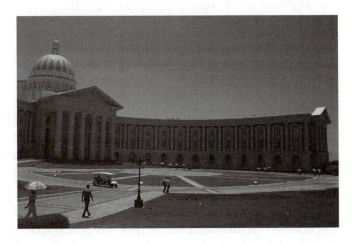

4. The more you experience building, the less physical they become in your perception. The complete sensation of a building is in all the things that describe it: site, materials, light, details, size. As if in order to arrive at its central idea, the structure has to discard these physical details, discard the material and style, the layers of plaster coats, all its protective aesthetic armour before it becomes architecture. That's why in so many cases, the attachment to maternal newness, to bold forms and extravagant spaces detract from the eventful reading of architecture. The mundane qualities of building, the ordinariness of material and texture is I think an essential pre-condition to architecture. When things are composed of familiar things in familiar ways, they create an area of soft focus, a space of absences, a space in which architecture can be achieved.

5. What's surprising is that such cooking shows have huge followings. Grown people skip out of parliament, cancel business meetings, just because the competition is down to the last three: Emily who made the 'delicious' lemon meringue with curry powder, Edwin who created the 'fiery' chocolate mousse with green chillies, and Lisa with the 'fantastic' ginger bread loaf in brine. Each of the three must fight for space in the stomachs of the three heart-less judges. Of the three, Matt Preston, leans forward on a dish displayed for him as if an artwork still wet—a few pieces of meat and lettuce hiding under runny yellow gravy topped by parsley. He swishes a forkful in his mouth, churns it around, giving nothing away with his eyes, and as the food show goes into its seventh commercial break, the audience and the participant are left in stark fear and bewilderment. Will Cathy's fourth attempt make the grade? Will she join Jack and Emma in the semi final round? Or will she, like Novak Djokovic at Wimbledon, lose out as a disappointed quarter finalist. You have to wait and see, if not for Cathy's sake but for your own self-esteem, knowing full well that the evening topic at the Gymkhana and Golf Club will require intimate knowledge of the winner, the recipe, the ingredients and the precise opinion of the judges.

Taj Mahal was one of the finest casinos in Atlantic City. Consumption of the spectacle required every icon to be transferred, transfigured and transported to new dimensions, to new places and to an entirely new imagery.

A hybrid and partial preserve of an ideal, the will to communicate afresh, allowed the cultural atrophy of the original. How strange, thought a wandering tourist, that a Mughal Emperor should use an American Casino for a model for a mausoleum in India! How odd that a French engineer should copy the Eiffel Tower in Dubai for a location in Paris! The specific intent to preserve only the pseudo-novelty of the original made even connections to history an uncertainty. So successful was the erasure that after a while the new not only surpassed the original but passed for the original. Only then was the process of commodification complete.[6] When a museum is marketed as a stage management of historical events, rather than a repository of artefacts, there is trouble.

It was hard to miss its utter disconnection with the landscape. Outside Mysore in Southern India, a high boundary rose up like prison walls, lashed with barbed wire above. But the high walls were a necessity. As the first of its kind in India, a campus for Information Technology, the company needed to guard its secrets from competitors. Particularly in a country where many smaller Infosys had begun to spread their tentacles into computer technology merely on the success of India's first technology outsourcing company.

A fortified gate led to a reception where every visitor was carefully screened before entry. As a day visitor I was not free to roam but was entitled to a formal tour guide, and a small bus took us, as in Disneyland or NASA, on a preset tourist itinerary of the campus. It was hard to form first impressions in a place where the official commentary overwhelmed everything else, and the first sightings were through the bus windscreen. But the singular wish of the official tour was to impress on the visitor aspects of neatness, discipline, rigorous maintenance and the scrupulous landscape of trimmed hedges and painted buildings that pass off as a displaced American college campus in India. The pains taken to drive that mediocre ambition home were desperately displayed: manicured grass, surrounded by mulched beds, and a tedium of sidewalks and ring roads, that gave due expression to every bit of landscape detail, within which a range of undistinguished buildings were placed at steadily increasing intervals, as need arose.

Crowning the simplistic plan was a Graeco-Roman composition that formed the administrative hub of the complex. Part Rome, in fact many parts Rome, an

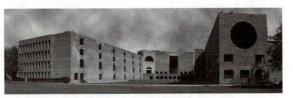

the original was of course irrelevant of techni_____ ____ __ ___
more secure. Fume better than the Fumans once there done ___ ___
__ _natched and released in full colour slides... ____ ___

6. Only architect Robert Venturi endorsed the wilful imitation of history. And the necessity of falsification in the new city. Main Street, with its flashing signs for hamburger joints and gas stations was not just Almost Alright, but it was also Quite OK, because 'its civic monumentality perceived by a motorist speeding on a highway was the result of its increased scale'. At the mention of articulations Bob's brow furrowed, 'The expression of structure and programme and truth of materials which came from the particular articulations of its form.' The whole office watched him out of the corner of their eyes, suspicious of the words that seemed to be flowing out so naturally. Bob, it seemed, was always ready to talk. After a newly completed project there was also a lot to say. So, he started, he talked of the difference between abstract architecture and one that was composed of colour and texture. He spoke of 'decorated sheds' and 'false façades', the 'civic character that resulted from a building's exterior', and the 'arrangement of functions that decided the interior.' He spoke of 'ugly ducks and the Chartres Cathedral…'

Only Steve had the good sense to interrupt him. 'Bob, what are you saying?' he asked.

'All I'm asking is why we uphold the symbolism of the heroic via the sculpted duck. Because this is not the time and ours is not the environment for heroic communication through pure architecture.' A whole range of difficult words had accumulated inside the Venturi brain. When they were all trying to come out, was no time to interrupt the man. 'Each medium has its day, and the rhetorical environmental statements of our time—civic, commercial or residential—will come from media more purely symbolic, perhaps less static and more adaptable to the scale of our environment. The iconography and mixed media of roadside commercial architecture will point the way, if we only look.'

inspiration that took in Bernini's colonnade at St. Peter's, splaying outward but incomplete in the summer Indian sun; a circular interior Pallazo, a Renaissance façade several stories high approached by rings of circular staircases; and deeper in, Michelangelo's Campidoglio design as floor pattern. To make the copy better than the original was of course merely an act of technology, not heroic architecture. But there it was, Rome better than the Romans could have done; Renaissance crafts-manship matched and perfected in full-scale computer mock-ups.

It was hard to gauge the seriousness of the effort that went into making the perfect copy.[7] Had all the historic flair been realized with the ineptness of Indian detailing and the general ramshackle air of most civic structures, it could have been rescued from oblivion by the hope inherent in its own steady decline and eventual collapse. But the absolute precision and the frightening accuracy of the construction made the architecture a deplorable act of inverse imitation, and impossible attrition.

The wide-eyed teenagers and young graduates of the new computer academy were hardly aware that they were the new inheritors of the Classical traditions. They walked about the arcaded hallways, past Ionic colonnades, reaching up carved bal-usters, smiling to themselves, as the participants of the brave new world of blink-ing screens, everything compressed and understood in soundbytes and gigahertz. Outside of that screen, little mattered. I was left wondering, had the building been shaped like a human being or an orange, would it have made a difference?

The building's artistry was a selective diffusion; its success was in the creation of a perfection that somehow failed to demonstrate the immediate nature of archi-tecture, its design and technology. How the Classicism displayed on its walls con-nected to its housing an institute of information technology. A falsification and pretence had risen all over the place, in the imagination, on the drawing board, and it made everyone believe that what had been put up was for the public good, not just the pleasure of a single conceit.

Years earlier, I lived and worked on the campus of the Indian Institute of Management, a complex designed by Louis Kahn. My room in one of the dormito-ries was a monastic shell, closed in space, open to the light. Surrounded by brick-work, a safe room it was and one that awoke every day to new light—red, then pink, and white even, following the habits of the sun. With each passing day there, I learnt to recognize the changing light by the way it moved across the plain walls. Slowly, I was drawn to the architecture of the place. In the morning, on the way to work, I walked along high corridors, traversing the deep cuts and shadows of the building

7. Architects Louis Kahn and Norman Rice were a team. But with a major in Philosophy Kahn always took the lead. At times, Kahn would mask his suggestions in a way that would be more palatable to Norman even using a reverse psychology to set him back on track. 'What does a brick want to be,' he would ask.

'Laid, I suppose,' Norman would reply with sagely repose.

Lou would then be forced to explain tactfully, 'No, Norman, an arch. How many times have I told you, a brick wants to be an arch.'

Kahn always brought a touch of philosophy to the situation. The problem had to be approached in oblique peripheral ways. 'Come with me. Norman,' he said. And placing his arm around his colleague he directed him towards the large tree outside the drafting room. 'Look Norman, there's your answer.'

'Where?' Norman asked perplexed.

'Right there!' said Lou. 'Right under that tree.'

'I don't see anything,' he said.

'A school,' said Lou patiently. 'Don't you know that's a school?'

'A school is the shade of a tree,' he said.

'A man doesn't know that he is a teacher, is talking of his realization to a group of people who don't know that they are students.'

'But if they've registered they should know they are students.' The confusion set in on Norman's face.

and, in time, began to detect a certain resonance in the stillness. 'A school begins with a man who does not know he is a teacher, talking of his realization to a group of people who do not know they are students.'[8]

You enter the school along pathways regulated by a grove of neem trees. Before you enter the severe geometry of the brickwork, you walk through shadowy passages, external arcades and walled walk-through shadowy passages, external arcades and walled courts, that lead to classrooms and flanking verandas. But wherever you are, space recedes and sunlight draws you along the wall, beyond its redness, to places graded in varying intensities of light. Places that are themselves open or enclosed, completely or partially, some revealing the sky, others surrounded only by low walls, all suggesting an unhindered sequence of genial discovery.

In the late afternoon, when darkness had begun to descend on the building and its halls and I looked out on a landscape, it seemed like a world crouching against the shrill summer light. At the edge of the encircling brick parapets, away from the building, it was easy to see something of the undisturbed landscape within which the buildings had grown. A bald stretch of earth rustling in low thorny bushes, bathed in a permanent hot whitewash of sky, airless, without depth, without volume, capping a sweeping open plain. Empty soundless ground. Raw, mud-coloured dry.

Beyond, along the stretch of road that ends in the cluster of low whitewashed dwellings of Vastrapur, I walked in the evening through open fields half a mile away, just so that I could look back at the building. At the profiles of brick that rose out of the scrub-black circles in red-yellow washes of watercolour fading quietly into darkness with the ground. Architecture slowly dying with the light. Within it, the whole complex had the look of a ruin—massive walls, fortress-like, the circular openings in them reduced to the utmost simplicity, their alignment and repetition, the result of a primary ordering. A hard-line geometry so precise, so sharp-edged that as the sun fell away around the brickwork, it cast an impenetrable glow on the surface, what Kahn called 'the building's share of light, a slice of the sun'. You knew then that architecture was just another part of the ground, an act of light, held in captivity, and like the landscape that it occupied, the building's position only amplified that space.

Along the outer walls of Mysore's Roman duplications, on the other hand, an inverse Colloseum spread in a sandstone arc into the hybrid landscape. It was not merely the back of St. Peter's but had acquired an identity of its own. Architecture's scope and breadth was a practised visible deception, and imparted immediate value to the

8. The Bangladesh Assembly Complex similarly arose out of the unmeasurable flatness of the delta. The green, fertile and perennially moist ground had been relieved of its local inhabitants—villagers, cows and buffaloes; their damp mud houses had been razed. Most people had been moved to other damp mud houses in distant villages. Those who had resisted had been shot. Their buffaloes had been relocated to newer pastures, those buffaloes that had refused had been quietly beheaded. The palace had been made entirely open, free of

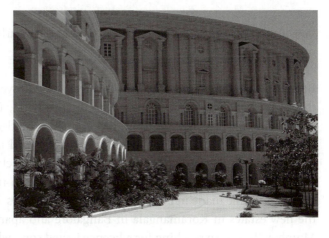

buildings, people, trees or any other forms of life, so that architecture, international architecture could now be made. But, it was not going to be easy. Making monuments was a monumental task. Lou looked at the vast stretch of the flat horizon and breathed a difficult architectural sigh. There was a dictator waiting nearby pointing a gun in his direction. He had to start soon. Lou turned to his unfailing reserves. He searched for a measurable application deep within his own supply of immeasurable realizations. 'It's best,' he thought, 'to start by making Citadels, Squares and Plazas. Places that have nothing to do with building, nothing whatsoever to do with a client's demand. You begin by first creating architecture, within which mundane actions of buildings can take place. You begin by creating the immeasurable, within which the measurable can occur.'

'In other words,' clarified Norman Rice, 'you construct the building and you let the General decide what to do in it, bloodless coups, state dinners or whatever.'

'Architecture must have presence,' Lou shouted to Nick walking about with a Sola topee in the flat delta.

'You're right Lou, architecture must have presence,' Nick hollered back. 'In fact, if architecture doesn't have presence, it is difficult to find the front door.' Nick was always the one to inject humour into a strange foreign situation.

Lou picked up a brick and placed it squarely on the ground, hoping that its position was somewhere in the middle of this vast and physically unmeasurable site. 'I think we can begin now,' he shouted to everyone. 'All right guys, let's do architecture.' So architecture was done. Architecture with a Capital A. On those balmy Bangladesh mornings, a million slaves came, carrying bricks and pieces of marble they came with cement bags and handheld concrete mixers. Architecture had brought new meaning to their destitute lives. In the far distance, under the shade of a dusty canvas tent, the General's men watched, rifles cocked, directing their sleepy eyes at the great enterprise, shooting an occasional native, looking at the foreigners with a mixture of awe and respect and revulsion, hoping that one of them would trade in his dollars for a bottle of genuine Bangladesh whisky, his Timex watch for a night with a local girl. Refugee families made even more destitute by annual floods and despotic leaders came into the sacred fold of architecture. Bowls empty of rice, they tried hard to grapple with the metaphysics of unrealized realizations, and so built plazas, and citadels and squares and assemblies; they raised dark Piranesian arches by hand, hundreds and hundreds of them, so that some tourist from France could come and admire their handwork; they raised circular buildings for the civil servants; they put square inside circle, circle within square, so that no one, not even Japanese auto manufacturers, would be able to say that Bangladesh is without architecture.

falsification. As if the eyes were the true and only harbingers of the architectural message.

But the lie had enormous powers to seduce, to circumvent reality. The buildings on the campus—from Classical to Modern to Dymaxion, Tensile—recreated an altering skyline from the moving van; they seemed unsettled and slightly at sea under the sharp glint of the afternoon sun; they tried hard to project their own ideals condensed in precise pictorial images. But the fake classicism, the prefabricated entablatures and mock plaster cornices smiled down much like a hoarding for a French perfume made in Ludhiana. Just like the houses in Greater Kailash in Delhi, the new estates in Koramangala in Bangalore and apartment towers in suburban Mumbai, they were reaching for a licence issued somewhere in the West.

Throughout the ride, I was left only with the gnawing impression of the campus as a temporary settlement. A fair ground that could be easily uprooted once the school had run its course, simply dismantled and moved to another location. The ground's temporal nature was merely fuelled by the sensation that real architecture had an altogether different purpose. When viewed as a practical abstraction, it allowed the much-desired withdrawal from the inescapable visible image of a building that was trying hard to be a contemporary artefact. And had the campus been conceived as a singular masterstroke of an 'abstract' ideal without its subjugation to the conventional forces of architecture, an altogether different place could have been generated. The ideal lay squarely in the hands of a man who could have proposed an architecture that grew from the germ of the Information Technology industry itself, and resonated for the pure lack of precedent. A liberating experiment in living and working, as much as the experiment in the business itself.

Freedom from conventional beliefs has always stuck the Indian mind as a strangely Western idea. At the heart of the deadening experience of the Infosys campus lay the innately Indian disability to bring a new experience to reality. The fear of failure marked everything with the cursed stride of yet more missed opportunities. The chance to revel in something greater than what had gone before. The repeated failures in architecture, urban design, in the city and in the smallest farmhouse and apartment was the final atrophy of a spirit that recognized failure as the only living possibility. And so reversed all chance of it, by never attempting it.

Constructing was a matter of commitment to place, an admission of belonging, and that need to belong was potentially the most valued admission of architecture. No building could ever be immune from the conditions that surrounded it.

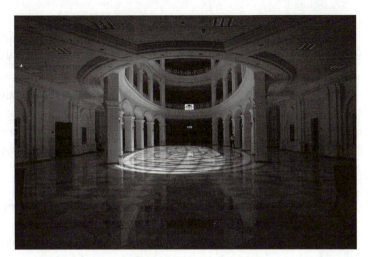

But unable to reconcile the environment, the boundary wall had promoted architecture's isolation into a milieu that was wholly self-contained. Within it ideas of light and space, design and history and comfort, all the universally accepted ideals of the profession, could be put to test. Within the enclosure, literal and symbolic meaning could be given to life. The building could be made, designed and constructed without the fear and loathing of surrounding streets, without the ceaseless wondering of its strife-torn inhabitants. One man's experiment in idealism. Architecture was just that form of escape.

The campus structures of glass and steel, the Roman imitations, made statements inconsistent with the way things were realized in India. Far too many things fell beyond the architect's control. The quality of bricks available was dependent on the firing process, which in turn was influenced by the type of clay in the pond, and the agricultural cycle. The availability of labour too was linked to periods between the sowing and harvesting seasons. In a largely 19th-century agricultural economy, the 21st-century matters of men and materials were relegated to time slots determined by custom and rural tradition.

The dust, the rising summer storms, the agrarian unskilled labour on the site, the excesses of sun and rain were the greater, more palpable forces that affected architecture. The visible hardness and sheen on the granite and the seemingly permanent Renaissance style were the props necessary to keep India at bay, and in constant denial of reality. Yet, the denial was never adequate. Elemental forces wrought the kind of havoc unforeseen by the mimics. The fierce tropical sun made a discordant visual medley of each building. The domical mirror of the Fuller-type hall retreated under too much light. Lunch room tents gathered dust, grilling the occupants; polished chrome and plaster façades were washed free of the monsoon moss and damp. The building tried hard to erase all memories of location and climate.

Day after day, as I walked past the walls of IIM in Ahmedabad, I began to understand something of its underlying message—the message that architecture stank of a sort of despotism, a despotism of scale and size and a frequency of structural repetition. For a building to be good, it had to display its elements in continual progression. At the Institute, there was a forbidding aspect to the design, an architectural severity which, surprisingly, I began to see as a positive attribute. The student dormitories were planned in an austere distillation of the barest essential elements—a bed, a table, a window—sleep, study and light translated into physical terms. The library's halls and portals also appeared in stark monumental confinement of light and shadow, the unrelieved expanse of brickwork promising the monasticism

273

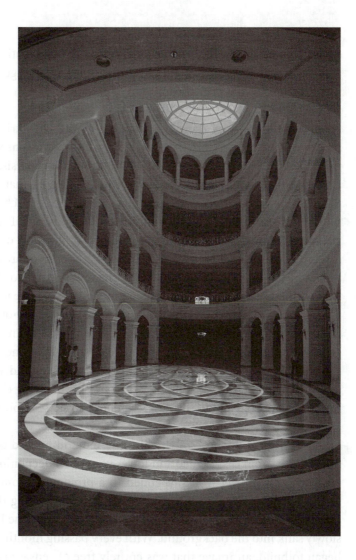

essential to academic life. There were none of the conventional images of comfort associated with a reading room. No stuffed sofas, no lounge, nothing. Architecture was expressed as the primal condition of existence.

I also sensed how important repetition really was. How critical that same window repeated from the same brick wall was. How futile, how senseless, design and inventiveness were to architecture. Throughout, repetition persisted. It was a sensation first, and then slowly conveyed its reasons. I realized that during my daily walk through the grove of neem trees into the brickwork of arches, my mind perceived nothing. No aspect of building, nothing of the landscape. I saw no change of material, detected no change of texture. Repetition of the most ordinary kind was creating the visual absence so necessary in the experience of architecture. The unifying aspect of the experience was only the shadow, the shadowline of trees that gave way, without sound of deliberation, without even a change in step, to the shadow of the building. The same neem tree repeated, one after the other, after the other till the repetition dissolved the individual entity of the tree into a line, the line into a grove, and the grove into a thick smudge of shadow on the ground. I began to see the building in exactly the same way. As a series of reminders of the daily and seasonal change of light. The building was part of everything else; part of the weather, the atmosphere. Just as in the desert you lose all sense of boundary, so it was here.[9]

Is that really the purpose of rhythm, the method behind boredom? To steal you away slowly from dissonance and lower you into a deepening chasm of silence. To lull you but still keep you suspended in a prolonged moment of contemplation? Over the course of two years, two years of walking along the walls of offices and classrooms, along dormitory bays all exactly the same, the building and its details slowly sank into the background. With every passing month, a sense of quiet repose began to build, an image that was entirely free of sensation, visual delight or disgust. Despite the precision of the brick planes and the sharp edges that ended the buildings, the mind began to perceive a boundless landscape. There was always something beyond. The building was always more than what it was. It offered a sort of clarity you sense only in the dark. You know the sky is there, even though you can't see the stars or the clouds. But there was never any colour in the light, only an intensity that grew and died around the brickwork every day. Every day, space enlarged and dimmed around me, rising and falling, like water across the bow of a ship. Not effecting movement, never impeding progress. The architecture it described reverberated, exercising a gentle pull, making me aware only of myself, my insides. Free of style and history, and even of the materials of which they were

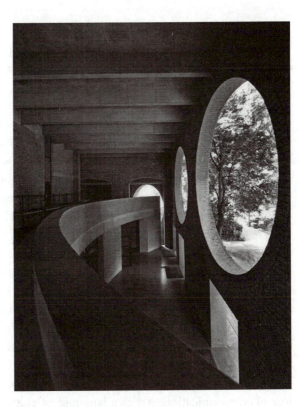

9. Today while architects talk of green architecture, the needs of the rural poor, or discuss national policies on housing in the developing world, Hafeez is building. While we talk of revolving restaurants and deduce that their architecture has come from Mughal minarets, Hafeez is constructing revolving restaurants shaped like Mughal minarets. If architects spend time putting together papers arguing that our architecture is rich with metaphysical meaning and creative energy, Hafeez spends his issuing plans for new towns and institutes.... The perpetual, and often petulant, belief in utopist solutions, that someday life will be better, keeps us architects accepting the present dismal and degraded state of our cities and buildings. We write about ugliness because we haven't come up with anything better. We build for the rich because the poor and middle classes cannot afford our expensive dreams. Except Hafeez. He builds. He builds in the only way he knows possible. Spinning together pictorial yarns for the builders and the middle classes, people despised by 'professional' architects. Publicly he is hated, but secretly he is admired. He has been called 'Half-Fees'. Architects even joke that the man is not an architect; after all he is a Contractor. But the joke has misfired. We try desperately to unlock his formula for success, to make deals with builders. To try and out-Hafeez Hafeez. Yet in the schoolbook version of architecture we cling to the misguided belief that however private the act of architecture, even behind high boundary walls, it has a public dimension. That it is indeed possible to influence people's way of living and thinking, by making thoughtful, culturally relevant buildings. And that architecture was not just a bad mistake being taught at architecture schools. Except for Hafeez. He broke away from the pack to set up his own way of practice. In a profession that had made no significant contribution to the quality of people's lives, buildings or cities, and had sadly begun to stagnate in the seminar room, he took his tools directly to the building site. And though a lot of his work could be termed socially irresponsible, or culturally irrelevant by architects, he, and only he, has had the sheer guts to propose radically different solutions. Some outrageous, some even comical, he has not been afraid to work at gigantic scales. Love them, or hate them, his buildings are hard to ignore, for they are the shape of the new suburbia.

constructed, the buildings lay bare no logic, no expression, denying even their own existence as big physical things.

The dissolution of culture becomes inevitable when the sole purpose is instantaneous communication, and the larger spread of its message is not to its immediate user, but to a global population. The need to create complete images out of cultural bits and pieces strung together to support some internationally accepted idea. Neo-Greek colonnades at the Infosys campus in Mangalore, Neo-Greek colonnades at the Belvedere Park in Delhi and Neo-Greek colonnades at the University of Nevada are simply the successful selling of Neo-Greek as a style. Its application to buildings of diverse functions merely makes it an architectural formula to resolve building into an acceptable image of community. Architecture's originality rests on conformity. The construction, consumption, and distribution of Neo-Greek was a roving community, like mangoes and curry, across borders. A sure-shot winner out of the latest catalogue. Yet there is no stranger history than changing monetary value applied to commodity. What the car was to early 20th century and computer and electronics at the end of the century, culture had become in the 21st. Art, architecture, music, film, entertainment had measurable figures in a nation's gross domestic product. Their commodification had produced enough examples to suggest the complete loss of communication. Art as a language of cultural discourse was different from one that derived its meaning from the décor of building space.

The museum and gallery ensured that no real communication was possible. Repositories of selected bodies of work where all movements were accepted in equal value, art's demands were far too grandiose to be meaningful, moving as it was further and further from self-realization. Instead its real worth was tested in its own demise, the slow dissolution and eventual transcendence. The fleeting glimpses and fluid expressions that radiated from the daily and immediate impulses of culture and urbanity.

19. City History

Once while ambling around Rome, in the unstructured way architects do in search of building snapshots, I chanced upon the ancient Baths of Caracalla. Having already seen many ruined monuments that day, I trudged in with low expectations, anticipating broken walls, overgrown shrubbery and a building state closer to geology than archaeology. I was surprised.

Inside, the place was humming with modern activity. Electric equipment, sound amplifiers, focused stage lights were being set up. Wooden plank seats had been erected within the ruined Roman enclosure, in an area which presumably two centuries earlier had served as a towel dispensing room for the emperor. Modern toilet fixtures had been temporarily retrofitted into a side chamber. The building, I learnt, was the setting for Aida, courtesy of the Departments of Culture and Tourism. Every summer it became the setting for opera performances. In June, seating, stage sets and lights were erected inside the ancient shell, and the Roman bathhouse became a modern opera house. Two months later when the season was over, the modern intrusion was removed and the building reverted back to being a ruin.

The Caracalla Baths were not an isolated example. Barely a 20-minute walk back up the old Appian way into town, another monumental structure, the Baths of Diocletian, found yet another novel insertion into its ramparts: a museum of antiquities, a structure built after Michelangelo had earlier fitted the Basilica of Santa Maria del Angeli into it during the Renaissance. The permanent display was so ingeniously inserted that it gave new meaning to the exhibits, at the same time preserving the grand scale of the Roman ruin and the Michelangelo church. At once, contemporary museum, church and ancient bath, the three worked to complement each other. A practice of establishing layers of history within the same building is familiar within the United States. Cast iron warehouses are converted into apartments, a barn in rural Pennsylvania into a school, a church into, unbelievable, but true, a bar and restaurant. This retrofitting of old buildings with new functions is one of the more successful outcomes of American conservation. And carries within it the tacit position of compromise, reconciling the money-grubbing instincts of the developer with the conservationist will of the historian. Moreover, it recognizes the city and its archaeology as ever-changing. Action upon action, the consequences are always visible in the vibrancy of city form. It is after all, the cumulative outcome of several decisions, some wrong, some right, some wilful, some smug and selfish, involving diverse goals and agencies, but in the end producing a place of the present.

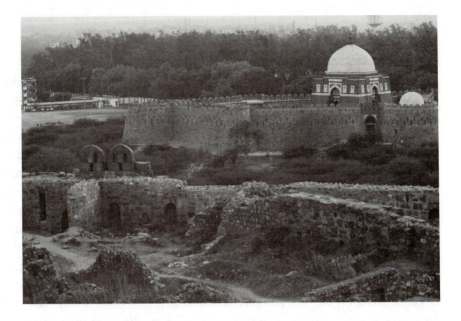

Some years ago, a fashion show was held in an historic garden and the old fort was used as theatrical backdrop for a play. The two events could hardly be considered controversial in a city where whole dynasties have been swallowed up by ramshackle modern structures, where Mughal tombs are used as defecation grounds, and ancient city walls are constantly being felled to make room for new roads. Compared to the ease with which Italians retrofit whole complexes, this mild misuse raised no ideas about the possibility of using archaeology for newer, more serious purposes. Precisely because of the way archaeological and architectural remains are strewn all over both cities, comparisons between Rome and Delhi are not uncommon. Yet attitudes to history in the two places are entirely different. Delhi retains the past as a death knell of royal life preserved and embalmed. The Italian notion of overlapping, and often contradictory, histories is seen in a positive light. Old, new and ancient architecture surrounds completely, or appears in unexpected but thoughtful juxtapositions; Italians transform ruins, they live in them. If their sense of continuity with the past remains alive, it is largely because it has been strengthened by the ideas of many generations of builders who have mixed and matched ancient architecture, contemporary technologies and created new, and truly unique urban opportunities.

Few cities in the world have the historic, archaeological and cultural sweep of Delhi; yet few have eroded this advantage in a mess of bureaucratic myopia.[1] Delhi exists, like other cities in India, to merely provide electricity, water and drainage to its citizens while its cultural artefacts decay or are denied to its citizens. Because of the continual presence of history, old cities like Delhi, Ahmedabad and Mumbai can offer choices infinitely richer, more complex and responsive to the diverse needs of their populations.

The city, however, does not become historic merely because it has a collection of monuments, or because it has occupied the same place for a long time. The past makes no impact unless it is somehow memorialized in the present, in tangible ways. Monuments after all, are not mere historical records of time; their stated position in a living city, filled with people with desires for visual, acoustic, gastronomic and other sensory pursuits, hardly befits their position as unique buildings occupying unusually prominent real-estate in the city.

In India, conservation of monuments has always been of the sterile archaeological variety. For the Archaeological Survey of India, protecting over 4,000 monuments nationwide, preservation begins and ends on the presumption that monuments, having seemingly outgrown their usefulness, are worth saving only for their intrinsic

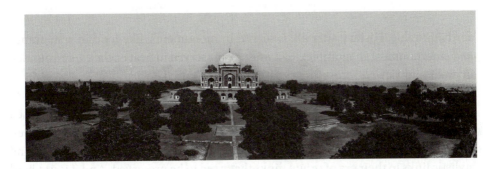

1. Opposite my house in Delhi is a decrepit broken-down mosque from the 15th century. In the 25 years that I have lived there little has changed for this small structure. An arch may have collapsed; masonry may be a bit more eroded and vegetation quietly creeping in. Such benign neglect is obviously expected of a monument not in use. In the last few weeks the structure has however seen frantic activity. Its walls are today being plastered, fallen arches reshaped, and a fresh pigment coating the surface. What was once valuable centuries-old rubble, now looks like an uncertain and temporary stage-set. What the larger purpose of the restoration may be is difficult to say. Is the idea merely to ensure that a country with a modern outlook should also have modern-looking monuments? Or is there a more serious archaeological intent behind the project? The reshaping of the mosque clearly raises as many questions about the reasons for restoration, as the methods employed. To my mind there are only two ways to go: either let the structure happily decay with the forces of nature or restore it to the exact specifications of the original using documentation for authentication and a physical recreation of the precise time it was built. There is no middle ground. Just slapping up a little plaster and covering up the Pappu loves Babli graffiti, does not amount to a serious policy on conservation. Unfortunately today, only conservation architects and agencies like INTACH can provide the professional and historic review necessary for serious work. And as a starting point there can be no better standard for restoration than the painstaking work carried out on the Humayun's Tomb in Delhi by the Aga Khan Foundation.

aesthetic value. History after all, is served in monuments, like food in restaurants, and entertainment in multiplexes. It must be preserved in neat enclaves, surrounded by walls and viewed across gravel paths and manicured lawns.

Of course, the solitary ruin, the monument set in a landscape of erosions, itself makes a powerful pictorial presence.[2] Ancient temples, Mughal tombs, mosques, shrines, colonial bridges and railway stations, all present discernible historic and stylistic links to their era of origin, links that need to be preserved. And it is not hard to see the pleasure English historians and lithographers derived from the Indian ruin. By its very nature the ruined monument offers a variety of interpretations to its observers.[3] Because it is made in different time periods, the interpretation obviously contradicts the premise of the original. For some, the monument suggests an ordered exemplary time, for others, a dream-like nostalgia. But always, the past retains its reminders of a certain and steadfast ancestry, always there, always reliable. Like an aged grandparent on a verandah, a comforting presence.

In New Delhi where I spent my childhood, and later practised architecture, the city never anticipated the real contribution of history to urban life. Life in the scarred, often unhealed tissue of an Indian city was the background from which I had come. I grew up in Delhi, a city built on invasion and decline. Ruins of Mughal buildings, ancient tombs, funerary monuments with broken arches, overgrown burial places, most of the surviving archaeology of the city was itself related to death. Death was etched in the undergrowth of history. Decay built into building, not in the Roman understanding of antiquity, but as a formula for life itself. Buildings were old before their time; new buildings looked old even before they were finished. I couldn't understand how life could be constructively lived in surroundings of such perennial decay. How do you plan your future when the past and present were festering and crumbling?

When a city's cultural past is given greater value than the present, the decline is obviously more visible, more real and rapid. Much of Delhi's literature, poetry, music and architecture, its mixed culture of Sufism, Hinduism and Islam, once reverberated against the pastel faded walls of its many ruins but can now unfortunately only be viewed in a tragic light; their time has passed. Delhi's was a nostalgic, frequently troubling destiny. Mughal courts, miniature art, culinary treats, and scented gardens, were all reminders of its long-lost grace. People who once connected with it were now in a pleasant state of bereavement, unfamiliar with urban values long gone. The settled city of the past had become a city of refugees, an inversion if you like, of Manhattan's immigrant experience. Delhi's present was New York's migrant

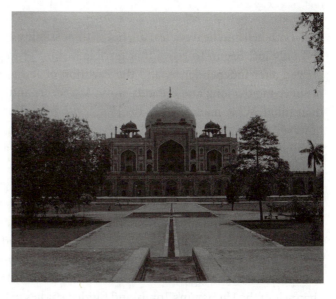

2. I remember on those Delhi winter afternoons when my father packed his Golden Eagle beer into the wicker basket, there was no choice but to head to Tughlaqabad, the deadest place on earth. Nothing but an unimaginable derelict pile of wasted stone, strewn over a huge area of scrub and low thorny bushes hiding snake holes and killer ant hills and beehives on ancient walls of red stone, high, secure and commanding at one end, crumbled, scraggly and overgrown at the other. Not the sort of spot normal people picked to spend their leisure time. But everywhere along the city's southern stretch were titles of dead kings. Shahjahanabad, Indraprastha, Lal Kot, Raisina—names with inexplicable meanings and references, names that referred to geological strata as easily as geographical locations or Mughal royalty. And if you stood there on top of the stone rampart of the crumbled old ruin, high above the scrub, and looked away from the town, away from the spine of the ridge on which the city stood, for a while just letting your eyes edge outwards, you saw a different place. Nothing, nothing at first, just the sweeping open plain, and sparse bushes loitering on its surface like green insects spreading desperate tentacles in search of water. If you strained your ears you could even pick up the che-che of crickets and waterless bugs resounding to the far end of the earth. Nothing else. No house, no village, no nothing. Just empty soundless ground. As if the density of the city, its fancy buildings and women in gold saris, was just some distant aberration, this strange and horrible pus wound on the land. And the real India lay beyond. Raw, mud-coloured and dry. Truly unmade in any picturesque sort of way. Just an old relic of archaeology.

3. The first sighting of the stepwell outside Ahmedabad is something I still remember. My memory is that of a landscape that records only the ground's absences, my landscape. The absence of flower, scrub and hill makes the land and horizon and sky a singularly powerful presence. There is, after all, nothing else. And the progression from this wide brim of earth into the sudden hollowing of the ground, the change from light to dark, the feel of coolness on the skin, the resinous musty smell of damp stone, the reverberations of steps against masonry walls, first four then six then four again, the music of shadows… are, at first, a leap into an arena of pure sensation. Architecture that is seen, tasted, heard, even smelt. It is as if the structure is exercising a gentle gravitational pull, drawing me inside, not as a distracted observer but as a participant in its making. Deeper in, slowly, carefully, into an architecture beyond sensation. Inside the well, having stopped, barely aware of my own breathing, that irrevocable moment of truth comes to me when, for a moment, in the stillness, the building loses its individuality, its attributes of location, its surface decoration, its qualities of structure. And drops below the surface of judgement, into some level of pure existence. It is just there, where it is meant to be. The strength of its architecture lies in the building's capacity to rekindle something of the spirit with which it was built, the way it was conceived. Architecture's bounty achieved through simplification. By dissociating the structure from the flesh and bones and skin that defines it, it has freed itself from the burden of examination, analysis. For that brief moment, I feel I am part of the ground and stone and masonry that surrounds me. I feel I am its architect, as if I have experienced something of its creation.

past, both hell and heaven, fearful, but with possibility of future redemption. Delhi had only just begun to relive that terrible history of migration. The families that arrived after independence, and the Partition of India, learnt to bear the cruelty of surviving the long and difficult move. Music, art and culture were farthest from their mind. What mattered was the break with history and the wish to start afresh, however desperate. Surrounded by the effigies of ruin, the new inhabitants saw nothing of the pleasurable background of the old, but a deadly parasitical reality, and one of their own making.

Oddly, only the last decade has seen a sudden revival of a Western style of historic preservation in India. Landmarks are no longer just visible but are stuffed with newfound purpose. Unable to pay for their upkeep, and at the same time fan the nostalgia of princely India, forts and palaces have become grand hotels. Or sold for new purposes.[4] The Aga Khan has paid to revive the structure, garden and water channels of the Humayun's Tomb, and funded studies of houses of the Muslim community, among other projects. Business houses have adopted monuments. Other unusual partnerships between commerce and archaeology are being considered.[5]

Many years back, on a visit to the Rampur palace in UP, I saw how quickly an unused building could go to seed. In the main structure, the arches had cracked, peepul grew in the brickwork, and the rear had collapsed completely. Water had seeped into the walls, threatening the entire masonry structure. Inside, the wooden floor was rotten and snakes had moved into the floor boards; precious carpets, still hanging, were rat-eaten. The sky was visible through breaks in the ceiling. The remains of the once royal family were now themselves living in the remains, behind a small bricked-up courtyard.

By contrast, an historical structure of equal eminence in Kerala, the Padmanabhapuram Palace, once housing the royal family of Travancore, was lovingly restored and opened to tourists. Its architectural magnificence though, was put to no substantive use and, to this day, the building remains an empty shell, as if waiting for the royal family to move back in. Everyday, busloads of people walk through the emptiness in awe, completely disconnected from its history, admiring a way of life entirely distant from their own. Unlike Rampur, the structure is preserved and maintained with the prescription of 17th-century Kerala palace architecture. But to what effect? Does the mere knowledge of its once cultural magnificence help elevate current standards of living, or increase common awareness of architecture? Is the empty preserved shell of Padmanabhapuram Palace any different from the ruin of the Rampur palace?

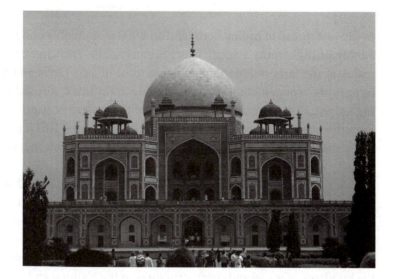

4. Is tourist convenience the primary reason to maintain heritage? Are history and archaeology of value only when viewed through the eyes of numerous Japanese and American visitors on a six-day five-night tour of the golden triangle? Doubtless, earnings from tourism are not to be scoffed at when they pay for the upkeep of major monuments, but the success of any travel is invariably linked to a complete cultural experience, rather than the controlled glimpse of isolated landmarks. There is no lift to carry tourists to the top of pyramids, no chairlift to ferry visitors to Machu Pichu. The mountainous isolation of the place, the difficulties of approach is part of the attraction. Would a helipad at Mt Everest bring more tourists into Nepal? Should the sculptures of Khajuraho be transported to India Gate, so more tourists can conveniently view them? By taking the Taj ropeway idea to its logical conclusion, should a covered walkway be built for those visiting the monument during the monsoons? And for those hot Agra days, a 400-ton AC installed under the dome?

5. Of course, the chances of converting the Fatehpur Sikri complex in Agra into a dental college, or the Delhi Red Fort into a riding academy, are for the time being, thankfully remote. If at all the citizens are to benefit from these buildings, a more enlightened policy on their re-use needs careful consideration, something that takes into account local requirements and national ideals. Will the Colonial bungalows surrounding Connaught Place be demolished to make room for 20-storey highrises, or is it possible for both structures to coexist on the site? The truly innovative feature of future conservation will be to bring together the present city within the rarified frame of history. Like the Italians, we may find that an experience of origins is perhaps less important than the appreciation of an ongoing process.

In the vast spread of Indian heritage, the 4,000 monuments under the Archeological Survey of India form a small select minority. The great masonry mountains that make up the forts of Rajasthan, colonial post offices, forest rest houses and PWD bungalows, wooden stations on mountain train lines, disused havelis and hunting lodges, all require a serious rethink of their place of history. Do all palaces in Rajasthan need to become heritage hotels, or museums? Isn't it possible to maintain our historical buildings without always succumbing to international tourism?

For the most part, an examination of India's treatment of its archaeological remains suggests two conditions: either a conservative preservation that saves the structure in its historically correct state, or abandoning it to complete dereliction. Structures like the Humayun's Tomb or the Gateway of India, always in the public eye, will nevertheless be saved, and restored. But what of the numerous churches of Kumaon, the hundreds of wood and stone structures in the Nainital and Almora districts that lie abandoned, many with collapsed roofs. Or for that matter, the wooden temples of Himachal. As buildings, are they of any less value than the better known structures of Delhi or Mumbai?

Such selective preservation of one and not the other, only distorts history and creates a mismatch between reality and the eternal promise of the historic ruin. How does the inhabitant of the tarpaulin tenement gain from his proximity to the elaborate stone madrassa, the Housing Board colony in Lucknow from the Imambara? A closer association between the needs of the city and the potential of heritage buildings could make for more vibrant urban neighbourhoods. Doubtless economic necessity imposes its own choices. But whether these safe and tested approaches are right or wrong, it is difficult to say. Commerce and tourism are not the only paths to building preservation, and obviously monuments need to remain accessible to the public. Converting the Fatehpur Sikri complex in Agra into a dental college, or the Lucknow Imambara into a health and fitness centre would make little sense, as would condemning all the palaces of Rajasthan to a life in tourism. But one thing is certain. Architects and urban professionals willingly admit that monuments are the only significant vanguards of design and high-quality construction in a country littered with mediocre buildings. In virtually every respect, the legacy of historic building is in startling contrast to the shoddy ineptness of current architectural practice—the weariness of design ideas, the lack of building standards and quality control, and eventually the complete joylessness of the environment. Often monuments are the only real source of pride in a city space full of dereliction and decay; their symbolic reminder of a long greatness is only added proof of our present construction inabilities and incompetence.[6]

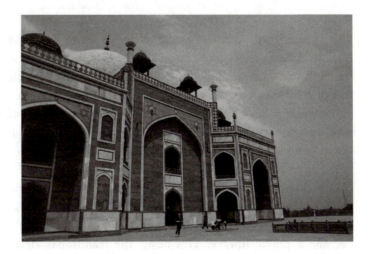

6. Among the many landmarks of iconic value, few can match the regal feel of Lutyens' or Baker's buildings. For whatever the tragedy of colonial rule, colonial architecture still epitomizes for most an urban monumentality and symbolic vision missing in the structures of free India. For the correspondent who stands at India Gate, or those who follow the drum beat of the republic with the domed classical skyline of the Secretariat as backdrop, the Lutyens legacy far surpasses the anonymous history of the more recent city: the smudged lines of government housing blocks that lend a ramshackle air of industrial sameness to the skyline.

The country's receptiveness to the obviously more skilled ideas still visible in historic landmarks is enough reason to preserve them. Only a constant exposure to structures of such quality can effectively reverse the public indifference to matters of architecture. If at all the citizens are to benefit from their presence, a more enlightened policy on their reuse needs careful consideration, something that takes into account local requirements and national ideals. This is not to suggest building low-cost housing inside the Taj Mahal, or malls outside it.

A serious and structured reuse of monuments may in fact encourage a more wholesome engagement with our heritage. Could Safdarjung's Tomb become a concert hall, the ruins of Hampi house a college or the unused part of Rashtrapati Bhawan become a public library? Obviously, the traditional view would baulk at such outlandish suggestions. But given that glass malls and peeling walls of endlessly repeating housing complexes are our new heritage, it may be harder to answer the thornier question: how would these present-day monuments come to be viewed by future historians?

But it is possible that if we started to use the environment to teach change instead of permanence, we might find new ways of making our heritage more meaningful. Like the Italians, an experience of origins is perhaps less important than the appreciation of an ongoing process. In creating effective solutions out of their own situations, cities abroad have embarked on a range of urban ideals. As mentioned, in Rome some of the greatest opera is performed in summer at the ruined Roman baths of Caracalla.[7] The insertion of the glass pyramid into the plaza of the Louvre in Paris has shown a four-fold increase in the number of visitors to the museum. In Copenhagen, a local initiative of providing free cycles for use to its residents has not only relieved traffic congestion but has produced a healthier urban population. Many such initiatives have come about through an active partnership of private individuals supported by public or business enterprise. The best among them have been created by overturning and rewriting conventional city practices.[8]

Notable amongst them is the extraordinarily versatile sidewalk of Hong Kong. Crowded and densified by highrise buildings, the city's expansion was contained by its island confines. Moving people across narrow streets on the ground was cumbersome and inconvenient. Conventional sidewalks eventually gave way to a three-dimensional network of pedestrian movement that linked buildings with sky bridges and street escalators. This parallel system of movement allowed pedestrians to move easily from building to building without even descending to the street level. Unconstrained by urban by-laws, has an innovative builder even attempted to

7. Where does the iconic nature of public building end and prosaic usefulness take over? Throughout the world there are examples of landmarks easily retrofitted with all the gadgetry and convenience of modern life, shored against earthquakes, fitted with electronic security, fire alarms and emergency escapes, all made to guard against manmade and natural threats. The original White House, for example, was commissioned by George Washington in 1792. Porticoes were added by different presidents for ceremonial reasons 30 years later. Subsequently, both Teddy Roosevelt and Harry Truman renovated the building to suit changing requirements. Security and nuclear threats during the cold war required more construction, even the addition of a nuclear bunker. However, throughout its 200-year history, the alterations firmly retained the architectural character of the original. Similar upgrades were carried out on the Capitol Building, home of the US Congress. Closer to home, derelict forts and palaces in Rajasthan have been recast as luxury hotels, fine-tuned and renovated with air-conditioning, plumbing, security.

8. Throughout the world, there are examples of how cities have conserved their heritage and made it more accessible to the public. But they are done with a sensitive eye to preserve the monument and its surroundings in their original form. The glass pyramid at the Louvre in Paris increased the popularity of the museum four-fold, generating, through the unusual architectural juxtaposition, a greater interest in the art collections. Would the authorities ever consider a similar intrusion into, say, Delhi's Red Fort or the City Palace in Jaipur?

connect the roof tops of apartment houses, to create an unusual landscape of clubs and cabanas, like recent projects in Madrid?[9]

Certainly, the development of something new within the acknowledgedly historic has perpetually posed problems to architects, planners and bureaucrats. Unable to stretch the boundaries of the urban imagination, the safety of restrictive development is far more preferable to the risks of applying new untested ideas. While lauding their efforts at maintaining an architectural status quo, such committees sadly overlook the potential of their precincts to generate a more vivid engagement of their citizens with their landmarks.

In an urban study done several decades earlier, Leon Krier, a Dutch architect had foreseen the state of the Indian city and suggested the possibility of providing space to its migrant poor. Through elaborate drawings he found living space on the great open plazas of Le Corbusier's government buildings in Chandigarh, along the open flanks of Fatehpur Sikri, in old forts and tombs, and in other large-scale monuments in the country. Employing the sacred historic space of Indian landmarks, he found ways to accommodate some of the millions who trespass into urban areas daily.

Unlike bureaucrats and historians, Krier did not see antiquity and the modern city as incompatible. Both belonged to the citizens, and if imaginatively harnessed, their spaces could be used equitably and efficiently. In the present state of urban indifference, both exist as unnatural enemies, needing each other but carefully marking boundaries. The fear that if you give them an inch they'll take a mile, keeps the daggers drawn on both sides and perpetually at each other's throats. Would a less cruel citizenry make more allowances to the new citizens to provide space for everyone?

Most Indian cities have already witnessed the actions of heaving populations that surround uncomplaining monuments, just short of tearing at their walls. Where visual plunder has occurred, can physical plunder be far behind? Mosques, madrassas and tombs in Delhi, Georgian neighbourhoods in Mumbai, Nawabi architecture in Lucknow, the hill cottages of Shimla, the old architecture is besieged by the incipient squalor of unrepentant city growth. Three, four and five storeys of ramshackle plaster walls in a relentless cordon of blight surround the ancient face.

In a civic stratum of such diverse and conflicting social and economic values, how then do you balance the needs of a homeless citizenry with the requirements of urban history and scholarship? Should the rising tide of unanchored and restless migrants not be allowed to make their homes in the city's unused space, the empty

9. Look at New York's High Line park. At the top of the narrow steel stairs, raised barely 15 feet in the air, there was a sudden change of scene. It is hard to believe that here, raised above the clamour of a New York street is a strip of rural Kansas. A rough grassy wheat field covering a city street and providing, by sheer scale and contrast, a view of the agricultural heartland in miniature. Between 10th and 11th Avenue, this is a friendly monument to nature, less profuse than Central Park, austere in design, almost simplistic in layout, but nonetheless, a profound marker to a new landscape reality. A singularly powerful statement for a city at ease with the culture of walking. Doubtless the place has serious repercussions for the conventions of urbanism, standing as it is for a new way of possibly greening future and already built cities. The success of the High Line is a story of reclamation. Tons of steel suspended above busy avenues were once part of the structure that transported meat, dairy and industrial supplies into New York known as the lifeline of the city, the railroad that ran over the tracks was suspended in the 1980 and the line lay abandoned and unused. Then, over the years with a natural seeding of the place through birds and wind, nature began to reclaim it, taking root in the gravel ballast of the tracks creating a naturally self-seeded wild landscape. The political will to save the High Line was the outcome of an unusual and enduring partnership between business, the local community and elected leaders. For over a decade a community group called Friends of the High Line campaigned to save the track structure from demolition. Eventually combining forces with the Mayor and the New York City Council, the group made a successful bid to preserve and open the High Line for use as a city park.

tombs and bereft mosques? Would the Humayun's Tomb in Delhi or the Gateway of India in Mumbai as temporary homes for migrants, appease the guilt of the city's affluent?

In the search for equitable solutions to settling diverse populations in space already allocated, could the ancient monument find new justification for its place in the city?[10] Saved from wanton physical plunder or from equally severe atrophy and decay, the old structure is always occupying a changing place in its surroundings. The side-by-side existence of the permanent and the temporal can hardly be a matter of policy when physical activity spills into historic ground so frequently. Certainly, the idea of long-term settlement implies a city with a varied history, where historical remains are not merely consigned to a dead archaeological heap but participate in daily reality. In India, the value of much of archaeological history is suspect. Sporadic walled compounds of madrassas and tombs that appear in erratic corners of Indian towns remain fleeting reminders of some past glory, nothing else. Other than odd moments of pride, their participation in civic life is hollow and disjointed. Is it any wonder then that they need to be physically protected from vandalism by its own citizens? Moreover, without the practical immediacy of cultural, social or literary connections, they are a waste of city space. A Delhi resident gains as much from the city's 1,000-year history as a Chandigarh resident from his 60-year-old town.[11]

In my own neighbourhood in Delhi, a Sultanate madrassa stood for many years in splendid isolation. But when the colony began to grow from single- to three-storeyed homes, the ancient structure was unfortunately dwarfed and soon became an insignificant reminder of its own history. A few years later, builders expanded into apartments and built high walls along its southern face, threatening the building. Since then some of the domes have collapsed, and at night the old structure is used by the floating population of migrant labour as shelter. A sign at the entrance remains the only reminder that the building was once a place of great eminence.

Old values of architectural thought of course are perpetually on the warpath of progress. Historic cores of old cities needing to be conserved and monuments having to be preserved and retained in their insular historic state. There was also a daily dose of wellbeing nurtured by diverse populations living close to monuments, an active tactile and sensory relationship with people and places. An uncomfortable relationship with the city of history, and the history of the city, presents a difficult dilemma to those whose interest lies in its future. In most Indian towns, the past lies

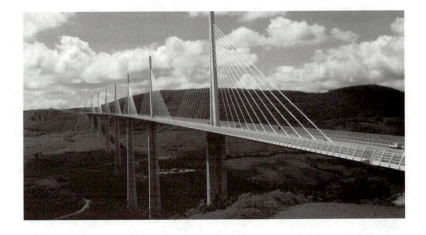

10. Travel anywhere in a traditional Indian city, your progress along its centre will be impeded by a building of some significance. In the south, your passage will be blocked by white walls that enclose the concentric layout of a temple. In Rajasthan, similarly, the town centre will be occupied by a palace. Even abroad. That Grand Central Station sits smack across one of New York's most significant Avenues, is the outcome of the city's most important rail-head being given the importance it deserves. Look down the wide flank of Park Avenue and the stone arches of the train station cut across the sight line, dwarfed as they are by the office slab of the Pan Am building behind it. The 110-year life of Grand Central has still not diminished its importance as a stately arrival point for New York trains. Had Grand Central been in Delhi or Bangalore, it would have either been razed to make way for apartments, or given a fresh coat of paint, surrounded by high boundary walls and an entrance charge levied at the gate, so no one outside of the Nine-Night Ten-Day tourist would have access to it. In India, history is either preserved in dead monuments, or not at all. There is of course a third equally valid view, a view which recognizes the city and its archaeology as dynamic and ever-changing. Buildings have a life, just like their inhabitants; they grow old, they die. Such an attitude allows monuments to age, erode and return to dust in their own time. The Humayun's Tomb may survive a thousand years; government housing may last forty, a glass shopping mall, ten. What makes one structure more valuable than another is largely subjective. If the Lodi tombs are a significant record of the funerary architecture of their time, the shopping mall is a relevant symbol of our commercial life. Without obsessive allegiance to history, both should be saved, or both should be allowed to die.

11. Some of the world's most enduring cities are conceived, built and changed in small doses, but always on a platform of diversity. If there are broad commercial plazas, there are also secret gardens and historic treasures; if there are noisy highrise business centres, there are also miniscule private museums, church courtyards and cloisters nearby. The enormous range of Delhi's monuments could have been knitted together into a gentle organic overlay on the loutish planned city. Each monument conceived as a much-needed haven in a sea of multicoloured grime. Inebriated with sky-rocketing budgets, mesmerized by the gimmickry of shallow design ideas, Delhi remains a cheap pretentious imitation, part Dubai, part Las Vegas, part Ludhiana. But never a whole city. The city has been treated like a Lego set, a massive urban game board that has been punched, kicked, infected and whimsically plastered with the sort of excessive colour, texture and detail that is normally associated with gambling den and brothel interiors. Remarks among architects and Delhi bureaucrats have come up with appropriate stylistic slogans, from Early Whorehouse to Brothel Gothic.

disconnected with local lives, frozen in a time warp, by an administration so intent on its preservation that it remains a mere nostalgic possession of its citizens.[12]

Would it not be better to worry about how the present city would be perceived by the future historians? How indeed, dust-laden glass malls, and the peeling malls of endless repeating housing complexes will be represented as our heritage. It is a question that asks to be revisited by the very people who have let the city go to seed. However informed they may be of its historic significance, the conservative view of perpetuating archaeological sites into the future, leaves its presence, disjointed and empty. And the city no richer for its presence.

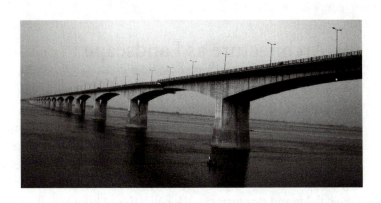

12. Where change is allowed, it is usually for the wrong reason. The government's resigned acceptance of dirt, noise and filth as the eternal condition of Agra, conveniently uses technology as a means to bypass the affliction. London Eyes, cable cars and sky lifts are not merely seen as tourist conveniences but become a source of pride in a nation sorely lacking symbols of pride. When built, more people will come to see the Agra eye, than Agra. There is however another angle to the high-tech venture. Much of Agra's historic architecture is based on the Mughal ideal of spatial invisibility. You move through courts and buildings in a soft focus of surprise and revelation, every movement, orchestral and controlled. High walls enclose. In them gateways reveal only a partial section of that experience. You walk along an axis, in a sequence of courtyard to garden to building, that slowly builds up to greater, more monumental forms within the architectural storyline. To elevate the tourists on skywalks would be as good as revealing the murderer in a suspense novel, before the reader has a chance to pick up the book. Certainly, the application of new technology to heritage has perpetually posed problems to architects, planners and bureaucrats. The safety of restrictive development is far preferable to the risks of applying new untested ideas. As mentioned earlier, there is no lift to carry tourists to the top of the Egyptian pyramids, no cablecar to ferry visitors to Machu Pichu in Peru or carry mountaineers up to Mt Everest in Nepal. The isolation of these places and the difficulties of access make the experience of visiting these places even more worthwhile.

296

20. Architecture as Landscape

Part of the appeal of architecture lies in its very desirable empathy with the natural landscape. From the recognition of the valley, the mountain, the coast or the plain as 'place' come the first statement of building. The physical immensity of uninhabited terrain suggests the first possibility of a language. For place to be made, lines are drawn on the ground, and architecture begins a life in geometric or organic orderings. It is there in the planting of crops, the manmade rectangular definitions of wheat fields and rice terraces, the collective of houses at the meeting of these fields.

It is architecture that is testing flashpoint, the creature of imbalance, that puts to test ordinary sensations, sometimes realigning perceptions altogether. A hut I lived in for one year in Himachal stood at the edge of a promontory. Huddling below the snow-covered ranges, its solitary and regulated form at the time I first occupied it made it seem like the simplest, most fundamental, of human habitations. Of inarticulate rural appearance, round and rugged, structurally unimpressive, with no connection to town or neighbourhood, it seemed physically cut off from the world. Even the accommodation seemed barely adequate: two rooms, one on top of the other, in a stone building with a timber-frame structure filled in with mud, and whitewashed. A narrow staircase rose through a hole in the floor to the room above. Its windows were deep openings in the wall, slatted in pine and recessed with window seats. No attempt at ornamentation, no distinguishable complexities of materials or design, hardly the way architecture is meant to be. When I saw the hut for the first time I immediately became conscious of its lack of design. I interpreted the simplicity with which it had been put together as an absence of conscious thought. How could architecture be made without the visible application of design? How could something be appreciated without an obvious depiction of ideas on its surface? Slowly I came to understand nature in man-made terms. Flatness allows water to be retained, plants to grow. Flatness makes plinths allow water to be retained, plants to grow. Flatness makes plinths possible. Plinths become the basis of building and habitation. Where nature indicates a potential for movement, paths are made. Where rock lines the ground, it becomes the natural foundation for building.

Once the ground acquires the capacity of receiving its contents, it is occupied. Occupied in so many different ways. The means by which walls are constructed depends on the materials available: stone, mud, clay or wood. How they are quarried or felled or cured or sun-dried or baked depends on local practices. How they are assembled depends on methods of building. The design of structures is further

based on needs, on labour practices and community organization. Details of construction emerge out of social needs, ways to combat weather, keep away excessive snow, rain and sun, counter earthquakes. In every act, a decision. Architecture coming to terms with the location, with itself. So, over the period of my stay there, my view changed. My experience of the site produced in me a growing admiration for the simple attractions of its architecture. The rocky site on which the house was built could hardly be separated from the rough rubbie walls of its construction. The sloping slate roof and small windows made a cave-like interior, an introverted darkened enclosure built on flattened land giving an immediate sense of protection, protection from the steep hillsides and the climatic uncertainties of the outside.

Across some of the most fertile rural landscape of southern France is a 200-feet high ribbon of concrete, a suspended roadway that cuts through a lush green valley. An engineered suspension so high above the ground it barely casts a shadow. Yet its eight lanes of roadway deliver traffic north and south with an efficiency which would not have been possible had the road been built directly on ground.[1] The rarified air of its mid-air suspension is a masterstroke of conservation in a place that views its farming countryside as untamperable valuable heritage. While cars and trucks hurtle at high speed above, life carries on at ground level, at a slow rural pace. A sheep farmer walks his flock beyond the meadow. A wide bed tractor threshes wheat on a farm nearby. An old man on a bicycle carries fresh baguettes in his carrier. Within the same visual frame, the persistence of 21st-century high technology in a historical 10th-century scene is the deliberate appreciation of both eras. An inclusive approach that is at once radical and experimental, as it is conservative and defensive.[2] The promotion of both ideals within the same landscape is appealing to both the radical and cautious elements in France.

France's programme of road construction and design forms one of Europe's most carefully calibrated and thoughtful highway systems.[3] With Paris as a focus, national roads were laid out to connect city-centres with the main agricultural regions and points of distribution. Designed on Roman and Persian models, most roads were skilfully planned to retain the rural landscape with least damage to existing terrain. Following the curve of the hills, and carefully skirting river beds and areas prone to flooding, they were sited to connect villages and rural towns with moderation and conservation. Those on the plains were broad and shaded with a continuous perspective of local trees, many of them declared as national monuments.

It is a lesson worth considering. However, in the urge to embrace new technology and ideas, older societies like our own are rapidly losing the battle of landscape

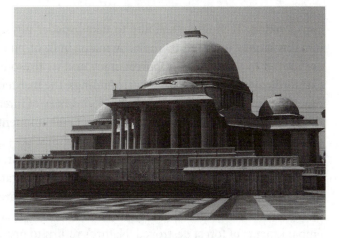

1. If you take the Broadway Local downtown to the Brooklyn Bridge stop, it is very likely that you'll be mesmerized by your first sight out of the subway tunnel. For right there before you is the most celebrated piece of cabled roadway, an extraordinary structure that carries you from one side of the East River to the other. A stretch of cables and Gothic towers that has been photographed, engraved, embroidered, and eulogized in words and paintings as often as JFK and the American flag, even Marilyn Monroe. Unless of course, you feel the NOIDA-Delhi bridge is the last word in engineering design, you'll like what you see. The story behind the Brooklyn Bridge is to my mind as intriguing as the bridge itself. I won't bore you with its details. I won't tell you that the total weight of the bridge cable is 15,000 tons and that the roadway rises 3 feet in every 100 feet. And that the river it spans is 1,600 feet wide even though the total length of the bridge is as much as 6,000 feet, and the weight of each cable is 1.7 million pounds, the same weight as the beef consumed in Manhattan in one year. No, I won't. But I will tell you that John Roebling and his son Washington spent a quarter of a century working on this single piece of construction. The Brooklyn Bridge is to the Roeblings what a Kashmiri carpet is to its weaver. You start one piece of work in your lifetime, and let your son finish it in his. What's remarkable about the bridge though are not the statistics, or the time span of its construction, but that even a century and a half after its conception, this engineering endeavour still stands as one of the truly magnificent works of humankind, somewhere between Beethoven's Ninth Symphony and the Moon Landing. I personally feel it's better than the Ninth, and I'm sure if Ludwig were to walk across the bridge, he'd feel the same way.

2. In the government's eyes the physically visible landscape has always been the most potent sign of progress. The sudden urge to connect all major metropolitan cities in the 1990s with the Grand Quadrilateral of highways was meant to be a symbolic reminder of India's arrival. On the highway in Western UP, the road has all the attributes of the American Expressway: high speed driving and a surface so utterly smooth and flawless, it is hard to imagine you are on an Indian road. Till suddenly, without warning, you encounter a broken guardrail and a crossing of bullock carts. In the urge to be global, the minor details of Indian rural life got missed. And over the course of a year, the surrounding villages created the necessary cross traffic required to connect them to each other during the harvesting season. A complete adaptation of an American road with none of the attributes of the Indian conditions in which it is set. The project's flaw becomes apparent only when forces of rural life adapt it to suit their purposes.

3. Recent work on Chinese infrastructure is both instructive and unconventional. Seventeen bridges are under construction on the Yangtse River. Many of the bridges are conceived with a 100-year maintenance plan built into the design: tunnels allow engineers to observe any fault that may develop over the life of the bridge; electric tramways are used for such observation. A planning that is unprecedented and thorough, and in Indian eyes, inconceivable. Many bridges will break world records for the longest span, the highest tower, the tallest suspension. The value of such a book of records approach is of course another matter; however, these engineering feats are yet more tangible evidence that Chinese skills have surpassed Western ones.

conservation. Technology's ability to take broader physical and imaginative leaps remains largely untested in India. A major bulk of public infrastructure projects are moved in the tedium of bureaucracy and its tiresome processes.[4] In the most extraordinary of situations and surroundings, the insistence on the lowest technology, the cheapest tender creates the most ordinary of interventions. Bridges built in the plains of Bihar, road heads cutting street embankments in Uttarakhand, or tunnels and viaducts along pristine hillsides of Himachal—all produce a dreary repetition of convenient time-tested ideas.[5] So antiquated are construction techniques, that nature is altered often in the most violent and cataclysmic way, a situation that takes many years to repair itself. Whole hillsides are reordered by avalanches and landslides; riverbeds strewn with endless rows of concrete pylons; protective embankments of forest destroyed. Nature's return to order is naturally slow.

A massive single span bridge across the Ganga outside Patna is a simple plane of concrete, connecting two sides of the river. It was raised on piles that began on land, sped along the river bed and finally ended on the other side. No attempt was made to distinguish the bridge from its land connections. No variations in materials, structure or altitude was worked into the scheme to suggest that a river-crossing was being made. Nor did the design make any concessions to the flat plains landscape. A general time-tested and workable scheme repeated across every culvert, ravine, riverbed throughout India was available, and pulled out of a used bridges drawer. In one single public works department stroke, an ancient riverbed plane classical landscape of North India lay desecrated. Divided by an uncompromising line of concrete. Is this any way to treat nature?[6]

When I first saw it some years ago it was hard not to be appalled by the scale of the desecration, and the singularly destructive act. A once beautiful countryside, its open agrarian fields and wide waterways had been condemned by a manmade instrument so banal, it could be considered nothing else. It was tantamount to putting up solar panels on the dome of the Taj Mahal. Yet, that summer night, for most Patna residents strolling about the bridge sidewalks, ice creams in hand, the structure was a source of infinite pride; I was the sole exception. People made special trips to show off the bridge to visitors, an engineering marvel to rival any.

Does standardization stunt creativity? A mere glance down the East River in New York is a confirmation of the immense creative power of bridges. At 181st St. in Upper Manhattan, massive stone portals of the Washington Bridge cross the river; the High Bridge on 174th Street is an ancient Roman aqueduct, the Queensborough Bridge a delicate iron trellis. In Lower Manhattan, the Brooklyn Bridge, considered

4. *Jumping aboard the State Transport bus, the two managed to cover quite some distance. Then, as expected when travelling by State Transport, they came to the banks of a river, face to face with a board that said 'UP State Construction Corporation—New Jamuna Bridge Protect. Your Taxes at Work.' It was a beautiful sign, the letters in slim italics, light green on a peach, almost gold, background. A great deal of thought had obviously gone into its design and placement. But of the bridge there was no sign. The river it was meant to span was a major tributary of the Jamuna. Almost twenty-feet wide during the peak monsoon season, its three-feet deep water harboured a delicate marine life ranging from toxic waste, dangerous chemicals and used tyres to a variety of tetrapacks and plastics. The road they stood on was a thousand-mile long national highway that connected all the major towns of the burgeoning northern state. Its only missing piece was the twenty-foot stretch across the turbulent, ancient and mythological river. The driver happily pulled up the hand brake and went off to a nearby chai stall. People got off the bus and remarked with growing anger at the inconvenience of their plight. They ranted and raved at the callousness of a government that had sanctioned several bridges for the location but had not made sure even one had been built. They raised their fists malevolently at officials who had siphoned off the funds for their daughters' weddings, their sons' foreign education, their wife's jewellery, till an older, wiser passenger reminded them that they were in Uttar Pradesh. Then everyone calmed down instantly.*

5. By its very nature the presence of a building in the landscape, creates a reserved sense of order. It either reiterates nature's position as supreme by following the lines of surroundings or by revelling in its own loneliness it states the same thing in a different way. But mistaking originality for a defiance of the natural order as much as the recent work in the West has done, makes a falsification of the idea of architecture as 'heroic' rather than 'humane'. The hedonistic pleasure of architecture as an upliftment of the human spirit is a notion that does little but reduces the act of building to the visual, and the visible. A light acrobatic melody of steel and glass enacted for the mere presence of the gallery. Architecture in India has lived for too long under no such pretensions. It continues to be the stepchild of engineering, a bastard without a voice in the family.

6. Mies van der Rohe's idea hinged on a sacred architectural belief that the landscape was not to be disturbed, a belief that had earlier been echoed by a whole range of eminent architects. Frank Lloyd Wright didn't want to disturb the landscape so he devised a theory about organic architecture, where building was merely on outgrowth of the land, just like trees, bushes and used-car lots. Le Corbusier didn't want to disturb the landscape so he lifted his building off the ground and devised a theory where architecture was merely an outgrowth of the land, just like trees, bushes and used-car lots. Architects thrived on this almost biblical presumption that nature was a valuable asset, their own buildings were not; and they exercised this view by extending its application into the erroneous idea that 300 tons of concrete or an equivalent amount of anodized steel, placed in nature's confinement, was not going to disturb the landscape. The despotic impregnability of their insistence made any reasoning impossible. Building was a piece of architecture because it existed with the landscape, or about the landscape. The Farnsworth house was doubly dutiful to the idea. Not only did the house lift off the ground on a light steel frame, but it denied its own existence by becoming an extended cube of plate glass. The landscape watery stillness was reflected in the windows and multiplied the nature around.

by many to be the greatest piece of 19th-century architecture, is a hybrid of Gothic towers and advanced cable technology. The Verrazanno Narrows, the most recent 20th-century construction, spans the East River in a gigantic sweep of steel. In one simple glance the eye takes in seven bridges; in each bridge is a history of its construction, in each succeeding bridge an expression of advancing technology.

Travel to any of the mountain towns in North or South India, the landscape is denuded and deeply fissured. The four-line highway planned for Shimla and Almora has torn large swathes of hillside and created irreparable manmade landslides. In remote towns in Himachal, hotels rise to six and eight storeys; apartment blocks are placed on precarious mountain ridges and sold as a second home in the hills. Cardamom and tea estates are similarly converted in Ooty and Coonoor for vacation houses for nearby Bangalore. Stretches of land around old stone habitation explode with ramshackle brick and cement highrises jammed against each other, leaving little space for green. What was once a landscaped mountain slope, had been artificially flattened into a desolate repetition of Delhi's Paharganj. Its imbalanced density of construction as you approach Shimla, Solan, Darjeeling or Gangtok, is a tragic reminder of human excess, and a future tragedy waiting to happen.

Religious tourism has to a great part contributed to the excessive and unchecked development around shrines. Most places are littered with makeshift shops, hotels sarais and dhabas that come up as temporary shelters for quick commerce but become 'regularized' because of their endorsement by the local religious authorities. The ramshackle and putrid air of many religious sites is in part due to the laxity of local government to not interfere in matters of religion. Consequently, religious experience includes chai stalls, trinket shops, dhabas, cold drink stands, garbage mounds, litter, defecation in the sacred river, picnics and urinals. An Indian religious Disney.

The way rivers behave, change course, flood, the way soil erosion occurs, or the way forests affect wind patterns or create catchment areas, is as much a mystery as it is a matter of careful science. The mindless regulation that no building will be built within 50 feet of a lake edge and no house constructed within 100 feet from the road is a colossal misinterpretation of the methods of nature. That the Himalayan belt forms an ecologically sensitive zone of great bio-diversity, that requires care and preservation is already well known. That the government has never formulated a serious policy towards it is equally true. Doubtless the government of the hill states will be blamed for not having environmental precautions against natural disaster. But that is so merely because Uttarakhand is the focus of a fresh tragedy. Few states

in the South have created natural buffers against the tsunami and Maharashtra still continues to devastate its mangrove protections against floods. Similarly, little work is done in Rajasthan or Gujarat to guard against continued desertification. Sensitivity to ecology at a time of global warming is both a necessity against disaster and a new way to forge a different, less destructive form of development. But sensitivity to the idea of development in an area of such ecological sensitivity would be a beginning.[7]

Sadly, in India the advantages of technology, and the peculiarities of site and vegetation are considered superfluous. Even when landscape is in perennial erosion, even when manmade ideas are imposed on it. Places change, perhaps a little reluctantly, and there is a patient adjustment to new circumstances and new conditions. Much like people accommodating a passenger on an already crowded train. For too long, the Indian landscape has suffered at the hands of those in power making arbitrary decisions: strangulating rivers, proposing dams, cutting miles of roadways through forest or ecological preserves. In many places there already exists an inexhaustible history of local ways and an impressive devotion to common-sense solutions. Any and all large-scale work needs a careful evaluation against the weight of vernacular ideas and newer technologies. Taking into account long-range objectives, we need broader and less locally damaging leaps of imagination and ideas.

Unless there is an attempt to view landscape too as natural heritage worth conserving, it would be hard to find serious interventional solutions to the rising demand for roads and infrastructure. Without it, the waste, weariness, and decay that is so much a feature of the Indian city will also mark its countryside.

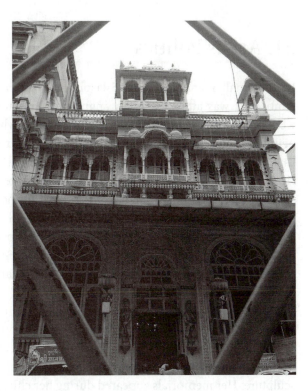

7. It was scarcely a rumble at first. Like some distant cloudburst. I thought someone was shifting furniture on the upper floor. Then when it hit, there was no time to escape. Within seconds the ceiling had tilted and taken down the front wall. We were staring into the street and across to the school opposite. My roommate and I ran out and saw the whole structure crumble before our eyes. It was eerily quiet, then the screams started. This is how Frank Smithson, an American exchange student in China, described the catastrophic quake in Sichuan. It took barely 30 seconds for 18,000 buildings in the city to self-destruct and leave an estimated 70,000 dead, many among them schools and housing. The scene has an all-too-familiar echo at home. In Gujarat, the builders once inundated with similar accusations and a flurry of legal cases, took the painless route out: they quickly settled out of court, so they could resume their work. Today many of the illegal constructions that collapsed have been replaced by more illegal constructions. Who amongst the new residents of the multitudes of highrises in Ahmedabad is in a position to check on the seismic flaws of their own building. The practice of construction bestows great profits on builders, the practice of illegal construction, even more. The state of corruption in the industry goes unnoticed, till such a calamity as an earthquake. In the normal course of construction, for any large project, say a school, housing or an office building, the steady movement of thousands of kilos of steel reinforcement, bags of cement and acres of expensive granite from a building site into the contractor's pocket is the natural progression of the building process. The builder-contractor-architect form a small club of beneficiaries. False bills are raised by the contractor, sanctioned by the architect and sent to the owner for payment. Unable to verify the quantities of materials required, he pays quickly, so as not to stall the construction. The club prospers. The northern region of India falls in Category 4 and 5 of seismic possibility. The figure is an indicator of the strength of the quake expected, and consequently its need to be sufficiently counteracted by the structural strength of buildings in the region. It is a well-known fact that only 12% of the approved structures conform to the code. This doesn't include the almost 60% of illegal constructions that are precariously balanced in three and four storeys of handmade techniques that grow in towns throughout North India. The possibility of fatalities and the sheer scale of numbers if a Sichuan-type earthquake were to strike the region is too numbing to mention. But if the bleak scenario has any silver lining, it is that the builder nexus may also be buried under rubble.

21. Art as Politics

In the small mandi town of Bilaspur in western UP, a nondescript statue of Ambedkar was attacked by an angry mob of students some years back.[1] They were protesting the fact that those among them who had failed their exams were being kept from proceeding to the next class. (A reasonable demand in a system that only seeks to buy a diploma.) The blue-suited statue, pink-faced, with black-rimmed glasses, had withstood many such protests. But in the ensuing clash, someone knocked off Ambedkar's nose. Within hours, a Dalit rage engulfed the small town, leaving many injured and a few people dead. In an effort to quell the anger, the city administration quickly fixed the nose and, to keep the statue from further facial disfiguring, surrounded it with a high-strength steel cage, a structure so tightly welded, only barely could Ambedkar peer out at his devotees from his new jail cell.

That memorials have only a political dimension is apparent in the kind of hectoring-from-a-high-pedestal statuary put up around the country. Of these, Mayawati in Lucknow took the prize for the most shrill and pushy form of public sculpture. Her memorials appeared during her chief ministership in virtually every public maidan, every respectable roundabout, and any place given to large-scale visibility. A larger-than-life Mayawati glared down the Bahujan Nayak Park. A bronze Mayawati stood at the Ambedkar Samajik Parivartan Sthal, Mayawati's own memorial to Ambedkar.[2] At road intersections there may have been no policemen, but four Mayawatis stood tall, in bronze or stone; passersby view her front, back and sides, all at once. She stood larger than real life, higher than ordinary life, letting people know that one in flesh and blood and freshly poured bronze also walks upon this earth. Always there, always with them, at the low summer discount sale of rupees two to four crore per statue, not including VAT and Entertainment tax. Gift-wrapped, and unveiled at critical state occasions: her birthday, Kanshi Ram's birthday, Ambedkar's....[3]

'I always felt that memorials should be built during the lifetime of icons,' Mayawati said without a hint of irony. 'That is why I got the statue of my mentor Kanshi Ram installed in Lucknow during his lifetime. But because he wished that I should also have my own statue next to his, I decided to go ahead.'[4] The absence of statues in Dalit history provided Mayawati the star-power of an idol. Here was a woman, a Dalit, who had taken centuries of oppression and turned it right-side up, into

1. The political statue too, belongs to popular culture, not to high art. There are enough of them at provincial street corners, in parks, and roundabouts: reminders of the sullied greatness of once great men. Nehru in *achkan*, Gandhi *topi*, rose in button hole, gazing into the bright future of a Free India, with streaked hair, and the fixed pitiless gaze of running an un-runnable country, Gandhi, with the enigmatic toothless smile, unsure why he has wasted a lifetime procuring freedom for a perpetually quibbling mass of humanity. Warm poses they are not, just the easily recognizable faces, their familiar stances in frozen body language. Collective images bred in stone. They stand there, by the roadside, at intersections, bereft and ignored, gathering dust, like files in government office. Polychrome faces and marble bodies, shrivelled in the summer light. If they have lost their ability to extract the intended awe, it is only because they have become standardized items of the streetscape. Like a list of government approved items in an office—one desk D/2/Vig Bhav/ Rm 7/ Chair, No. 3, Paper Weight—two nos, Portrait of Gandhi—one nos….

2. The mismatch of India's real history with its street reality calls for clear action. It should hardly be incumbent upon a Dalit leader to continue proposing more statues of Ambedkar all over India, or a government to only propose memorials to a chauvinistic national greatness. No country's history is so shamelessly one-sided that it revels only in victory. From public representations it would appear that the Freedom Struggle was the singular event that defines modern India. What then of social and economic struggles? Should a Patna gallery enact the major Bihar famine? Should Bhu-Daan and Narmada Bachao be preserved in some physical form? Rather than mindless statues of a suited Ambedkar, should there be a museum at India Gate dedicated to caste and Dalit oppression? A more inclusive history would move from symbols to defining a picture closer to reality. The world over, governments are choosing to right the wrongs of history. Canada and Australia have apologized for the mistreatment of their indigenous people; German cities continue to build Holocaust memorials. If our government's public memorials are to have a semblance of fairness, for a while it will have to forget the grandiose and the monumental and concentrate on smaller corrections: return King George to the chattri at India Gate, assemble the rubble from the Babri Masjid into a gracious setting of forgiveness in central Ayodhya; then act on local efforts: acknowledge the good education work of Christian priests in Bihar; rename streets and squares in Bangalore after Kannada artists, Kerala roads after local writers. To let future residents of these places know that their country's greatness was not just in freedom struggles, but in local, sustained and ordinary battles.

3. Every seasoned politician knows the dividend gained by claiming the moral high ground, and the great potential in garnering goodwill through the noisy act of choreographed selflessness. So, the padyatras come, long spells of endurance across India. So too come the fasts, always unto death, always in full view of TV cameras. The noise and clutter of physical action, and the need to express indignation at a national scale far outweighs the possibility of reconciliation through debate. No one knows this better than the older politicians who know how easy it is to quickly feel the blaring pulse of India and move on. That statues of elephants can be built in place of schools, and vast memorials of self-portraits erected in the time of malaria only shows that politics is just another endurance sport. Like athletics and marathons, you cheat and lie and drug yourself to stay in the game.

4. Certainly, the Indian parliamentarians made some wise choices, but coincidentally, they were also the choices of Indian bureaucrats; which in turn also concurred with the decisions of the Indian judiciary. As a three-tier working model that supported one another through safe transfers of officials within the system, and cash transfers outside the system, the

an asset. The oppressed still remained oppressed, but in symbolic terms they were riding the popular wave. Mayawati had pushed the Brahmins, the freedom fighters, the Nehrus and Annie Besants off the pedestal, and without so much as testing her own political strength, proclaimed her power.[5]

It took only a short drive around the streets of Lucknow in those years to know that Mayawati was the new Gandhi. There she was, unlike a feeble Gandhi on the Dandi March, unlike an intellectual Ambedkar with his Constitution, handbag on her arm, gaze firmly fixed ahead, to a new future, her future. Her sculptor, Prajapati, had a set of standing instructions to always sculpt her features as if in an attitude of triumph. Image mattered.[6] To counter any ill-fated attacks on her nose, he was instructed to make her in unbreakable bronze.

It was Mahatma Gandhi who said, the poor imagine God in a loaf of bread. Before the election which brought Mayawati to power, the poor imagined God in her. They flocked to the parade ground to view her just like devotees at a temple; they prayed to her statues, as if to Goddess Laxmi; they sang her praises, in a hypnotic religious trance. And they forgave her excesses. Even when they had to pay bribes for a street cleaning job; even when they were denied a water connection in their colony, knowing full well that the water was being directed to the fountains at her memorials, it didn't matter. Mayawati was a sister, a Dalit, oppressed for a thousand years. And now, by becoming just another politician, she was correcting the course of history, for herself, for them.

A government clerk's daughter, for many, Mayawati was the Indian Obama. Similar portraits of the two appeared in magazines: Obama under the looming shadow of Abraham Lincoln at the monument in Washington: men of ideas, statesmen-like, whose lives had become entwined by political concerns and ideology.[7] In her own portrait, Mayawati likewise stood under a statue of Ambedkar, seated ironically in the Lincoln pose.[8] Clutching her handbag, she offered the same visual presence as the American president: confident, pensive and caring. Reporters and journalists who questioned her on development and rural reform left her with no option but to answer by unveiling more statues of herself. A monumental memorial unveiled on the outskirts of Delhi, others planned in towns all across her state. Her personal life of acquisitions, monuments built, houses bought, helicopters leased, diamond jewellery hoarded, extortion wealth amassed, came looming into the frame. It was Mayawati's way of scoring a point and letting everyone know that

flexibility of this novel approach was lauded by the rest of the world. India was hailed as an exemplary democracy. Many of its subtler political variations were adopted by newly emerging societies in Sudan, Angola and the Congo.

5. Thanks to this paternalistic attitude of reverence, politicians in India get the same treatment in death as in life. As the single-most lucrative profession, after prostitution and drug smuggling, politicians occupy the largest real estate in the capital. Whether dead or alive, their entitlement to remain permanently in their constituents' memory has left acres of green, making Delhi one of the largest necropolises in the world. Its position as a world-class city of the dead is paramount: beginning with the Sayyid and Lodi tombs, to the Mughal dynasties and colonial landmarks to dead kings and the collective cemetery of India Gate, the history of the city is itself preserved only in death. By adding the vast retinue of Indian politicians in Lutyens' row and at the various shanty sthals and shanty vans along the river the modern dimension of remembrance becomes enshrined further. That Mahatma Gandhi and Sanjay Gandhi are commemorated a stone's throw from each other says something about the persistence, rather than the content, of the recall. In death, Delhi turns even the unholiest of crooks into martyrs.

6. Even the perverse misuse of technology to achieve the right image manifests itself in multiple ways. Computer drawings used to be a cumbersome and tedious calling for numerous commands and combing through multiple layers to make the simple line. But now a tablet attachment allows drawings to be made as easily as on a blackboard. You merely draw freehand; as if by sheer magic, it appears on the screen. And if you use the special smudge command in Photoshop, it can be made to look more messy and human. Same goes for film. The heightened potential to make animation so real through advanced technology gives a result as good as realism itself.

7. Two of the more critical monuments of recent African American history have been judiciously added to American cities to correct the country's past. The Museum of African-American History is a burnished bronze structure with a decidedly African profile, set among the sandstone and travertine Neo-classical architecture of Washington DC. Within its comparatively humble interior is a varied and random set of items strung together to give a disjointed but true picture of Black history: a pair of handcuffs, a slave cabin, metal shackles used in slave ships, a slave auction poster advertising 'a general assortment of Negroes', boxer Muhammad Ali's head gear, writer James Baldwin's passport, even the inauguration day newspaper of America's first black president. The other, less a national landmark, is a city's tribute to one of its famous sons: a lifesize statue of Arthur Ashe, the tennis legend and activist, holding up books and a racquet on a city road in Richmond, the capital of Virginia. Both commemorations fall squarely in the awkward setting of white American history—the museum sited among monumental buildings that portray America as an imperial power; the lean figure of Ashe, similarly surrounded by bloated emblems of Southern slavery: General Lee and Jefferson Davis. Any visitor to Richmond or to Washington will clearly sense how the supremely white Anglo-Saxon view of history is now being balanced by the inclusion of African-American achievement. The only way to deal with the past, say local historians, is by inclusion, not by removing inconvenient monuments, but letting conflicting actions and people live side by side. If the city is a living gallery of history, there is room for every possible addition.

8. Sixty years ago America was not an emblem of racial integration. There may be African-Americans as CEOs of companies, as state governors and in the NASA programme. And in placing himself at the forefront Obama certainly breaks away from black stereotypes: basketball player, entertainer, drug peddler, prisoner—a far cry from the days of all-black

if there were enough visible signs of her presence, the poor would take care of themselves.[9]

The urge to appropriate real estate among the political class in Delhi was only a minor aberration when compared to Mayawati's search for immortality in nearby Lucknow. In what was doubtlessly the most brazen act of self-promotion, large tracts of urban land combined with funds for public housing were used to erect bronze memorials to herself. As a Dalit and a woman, Mayawati had not found a cause greater than erecting row-upon-row of stone elephants, fountains and statuary all across the state to ensure that people were constantly reminded of her as a woman of the people. The same people who had lived through a summer of drought were all too often reminded of their water-free state when walking about the fountains of Mayawati's memorials. It was a paradox too delicious to bring to the attention of their leader.[10]

Much before Mayawati's memorial building spree encountered rough weather, a Delhi architect, a Dalit himself, had proposed a 30-storey statue of his leader to be built as a focus of a memorial in central Lucknow. The monument was to be 340 feet high, and if built would have dwarfed not just the tallest building in Lucknow but the Statue of Liberty as well. All 30 floors contained a variety of spaces: two museums to Dalit history, another to Dr Ambedkar, and a fourth on Mayawati's own life story—all encased in an outer structural steel and concrete shell depicting Mayawati holding her favourite handbag. With an entrance near her toes, the building's two elevator banks would rise up Mayawati's legs to a series of mid-level restaurants in her stomach, past offices in the chest area and emerge into the museums located inside the head. The detailed plans, secret though they revealed a careful resolution of all the essential services: air-conditioning, garbage disposal and plumbing, all concealed within the chief minister's body, a body which served a dual purpose: enthralling the public on the outside by the sheer size of her presence, and enclosing the weight of her intellectual message inside, in museums, research libraries and restaurants. Fortunately, the plans of Mayawati in the form of a building were safely secured in the drawers of an architect's office, the work, thankfully, never to be built. But the sheer audacity of its scope demonstrated not just the exaggerated possibilities of public expenditure, but the grotesque magnitude of political power gone to seed. The mere fact of its conceptualization also raised larger questions of urban appropriateness and the public's view of politics as art.

Naming roads and renaming railway stations and airports, had led every elected government down the path to urban sycophancy. Yet names by themselves were never as effective as physical representations of the hero. In a culture which reveres cardboard cut-outs of politicians, the search for an extravagant expression for a national icon invariably leads to a larger-than-life manipulation of statuary.[11] It

311

basketball teams and Miss Black America beauty contests. Would similar parallels of integration ever be visible in Hindu society? Could an increasing tolerance among Hindus enact changes within the caste system? The sight of a Brahmin carrying human excreta on his head before saying his morning prayers is unthinkable. A Dalit drinking out of a Brahmin glass is eons away. Can the Hindu far right ever accept the minority neighbour as an equal? Unlikely.

9. Given the bonhomie between the masses and their masters, it was but natural that people celebrate their good fortune by toasting their politicians. Ravaged by floods, many homeless people in the northern state of UP toiled tirelessly to instal stone statues of their leader. Despite her protests that they use the funds to rebuild their homes and villages, the rural masses pressed on silently in the hot sun making monumental elephants and oversized women with handbags, all in the belief that one day their leader will be rewarded with a prime ministership.

10. While much of Indian life is a daily stage of religious ritual and offerings, American rites are more controlled. Recent remembrance in America

follows a cycle of ten years. A decade after the 2001 attack New York is expected to unfold the new scheme for Freedom Park; two fountains pouring a continuous string line of water into the hollows of the Twin Tower foundations. In the mid-1980s similarly, the testimonial wall of the Vietnam Memorial opened to public view a decade after the end of the war. In both, the sentiments of national grief were to be absorbed in an architectural abstraction, a collective catharsis that could be shared by the thousands of private names on public view. The personal and private nature of American memorials is part of a tradition which publicly celebrates history as a living memory. 9/11, Vietnam, Korea, become deified into public memory through time and the passing of generations. Indian memory has a mythological dimension that often makes the physical memorial a distortion. Unlinked from the present, statues and structures are literal rather than imaginary or abstract reconstructions. At Tees January, where Gandhiji was assassinated, his footsteps are painted in red cement. The Ram Mandir, if built, will doubtlessly be the physical representation of a perfect structure, as are the larger than life memorials to Ambedkar and Mayawati. Unlike the American view of remembering ordinary people passing in difficult circumstances, the Indian vision is heroic and elevates the remembered into mythic giant proportions, removed from the puny humanity they represent. Whatever the decision, it will doubtless spark heat among the rabid members of both ends of the political spectrum. The RSS and the Bajrang Dal on one side, and Muslim organizations campaigning for mosque reconstruction on the other will surely welcome any decision as long as it is in their favour. Passions will not only run high, but with political parties watching on, can ensure they be made to run high. The courts' usual method of delaying judgement in the hope that time will heal religious wounds, and perhaps lead to an out-of-court settlement, may yet be the most effective path. Though well known that Muslim emperors razed temples and built mosques on their foundations, the call to historic correction in a new time is dangerous and regressive. Does establishing that the Portuguese and the British looted India in the 18th century allow those in today's India the right to claim compensation? Can we fight a legal battle with the heirs of Vasco da Gama and Mahmud of Ghazni now? It is a question without end.

took the Maharashtra government three centuries since Shivaji to finally come up with a Mayawati-like commemoration of the Maratha warrior. 309 feet high, set a mile into the Arabian Sea on a plinth containing a multi-utility complex, the public sculpture would be India's Statue of Liberty. What in the present scheme of things stirs the state into decision is of little consequence.[12] In times of religious polarization and identity politics, the idea didn't hold water. That Mumbai's sizeable Muslim minority had no say in the selection of a Maratha icon is also drowned in a sea of Hindu voices that see Shivaji's presence as a vindication of all the ills that have plagued the city.

In India the standard response to public deification is a form of exaggerated monumentalism. To take an individual or an idea and build it tenfold; in so doing, convert a serious intent into a Disney cartoon. A 300-foot Shivaji on a horse out in the sea not only denigrates the serious philosophy of the man but casts it, Bollywood style, into the realm of the unreal and fantastic. That Shivaji worked with ordinary people, peasants, and had a humane policy towards his administration and army is made entirely irrelevant. Moreover, the political purpose implicit in such public art denuded the piece of all artistic merit. That a political party endorsed it in its manifesto and was willing to shower funds for its construction reduced Shivaji to puny irrelevance. The Maharaj, as just another party worker, needing sponsorship.[13]

11. Sitting on a committee to select a sculpture of Indira Gandhi, I once watched how works of art were commissioned by the government. Sculptors had submitted sketches; Rajiv Gandhi was to make the selection. From about 20 drawings that showed Indira Gandhi in rough loose chalk strokes, to a pensive Indira in formal view, to a comic Indira missing below the waistline, there was only one that could satisfy the criterion of sculpture for mass consumption: a larger than life size Indira set on a high pedestal in direct frontal view, face grimacing downwards presumably hectoring the masses at an election rally. What could be a more fitting portrait of an Indian leader? Rajiv set it aside from the rest.

12. It has taken the Indian politician and bureaucrat 60 years of tireless foreign study tours to look for urban solutions to Indian problems. A two-week tour of Sydney to study Olympic facilities, a week to study expressway interchanges in Los Angeles, a month of grave scrutiny of the Brazilian rainforest, a careful week-long assessment of the Russian metro system, a thorough investigation of Singapore and Hong Kong airports, and when all else fails, there is the two-week executive course at Harvard. And to what effect? Is there any similarity between Hong Kong and say, Delhi airport? Are Indian forests any better preserved after the international study?

13. When L.K. Advani announced in all seriousness that the proposed Sardar Patel statue in Gujarat will be the tallest in the world, he sounded like a Dubai sheikh taking credit for the highest building, the biggest island, the largest aquarium. Something, not for public good, but for the Guinness Book of Records. Once complete, the 600-foot statue, the brainchild of Narendra Modi, made of iron and concrete with a bronze outer layer, will shine in the afternoon light as it faces the Narmada Dam. Leaving aside the sheer audacity of public expenditure and the grotesque misuse of political power to electoral ends, the statue's conception raises questions of ecological malpractice and the visual destruction of the landscape, not to mention issues of the public's view of politics as art.

314

22. Greening Architecture

I am an architect. Much of my professional time is spent in promoting green buildings, cajoling clients to adopt ways of natural cooling, insulating walls, building solar shades, and using planting to offset the heat. The idea is to convince them to make changes to their over-consumptive lifestyle and begin to take a small step in a more natural direction. This is usually done in a room full of six other architects, chilled to arctic temperatures by a four-ton air-conditioner with liberal juice and water stock from a 200 BTU fridge in the drafting room corner. In the mornings after a talk on electric cars and the importance of public transport, I drive off in a 300HP SUV, doing a measly 6 kmpl, to a building site. Meanwhile my wife and son have separate cars clogging and polluting the city. While pushing a different life onto others, I am reminded of Gandhiji saying, 'Change others before you try to change yourself.' If green hypocrisy were a virtue, my life would win many awards.

At a screening of Al Gore's film *An Inconvenient Truth*, the hall was filled with people like myself, staunch believers in climate change, armchair radicals and new-age optimists filled with outrage about a world that must mend its ways or face doom. People raised pertinent arguments against living a developed world lifestyle in a developing country, curtailing fossil fuels, and seriously examining the introduction of wind farms in the suburbs. Then we got into our SUVs and left.

The search for a green life propels most educated middle-class Indians into a similarly hypocritical and hopeless existence. The Indian middle class feels a strange entitlement to a culture of waste, despite continual reminders of frugal lives all around. It is an odd sort of material masochism that comes perhaps from living so long among the deprived; a need almost to buttress yourself against the surrounding blight by deliberately adopting to the other extreme. Many spend whole lifetimes enlarging distances between the 'us' and 'them'. Replenishing where there is no need; hoarding when no crisis exists, only to ensure that the future is safe for many generations. I have friends who buy apartments as future investments for their children; or get an American green card for their kids, so they would have an option to hop to a secure first world country if India plunges into chaos. They travel for vacations in a motorcade, empty cars following them in case of a breakdown in a country without back-up facilities. Many hoard gold, create foreign accounts, or shell out most premiums for life insurance merely to assuage the fear that they live in a place of perpetual calamity. And there are vast fail-safe systems in place.[1]

1. Though weather patterns have not changed significantly, the pattern of water usage, its procurement and consumption, have drastically altered in both town and village, over the last two to three decades. 25 years ago, a middle-class urban Indian required 60 litres of water a day; today that requirement stands doubled. Are people drinking more, having more baths? Unlikely. 10 years ago, the ground water level in my neighborhood in Delhi was 25 feet. At the time, the tube well used to supplement the home's essential supply. Today, the water level has dropped to 180 feet, and much of the water, now saline, is used to water decorative shrubs in the lawn. In the hills, a similar story. For the last 10 years I have been a frequent visitor to Ranikhet in the Kumaon. For the local residents, I notice, there has been a perceptible decline in the quality of life there, much of it related to water. Many of the once perennial streams are now only active in the monsoon, and the old water catchment areas are denuded of trees. In the summer, water tankers ply the road filling the plastic tanks for vacationing Delhites. Each time I go there now, the water inspector takes a small bribe to ease a few litres into my tank.

Lifestyle is part of an erroneous system of personal values, promoted by architects, planners and designers. Look at the middle-class use of motor cars. A 30-ton instrument of steel that is charged with fuel, electrical battery pack and electronic systems to merely transport one person across a few kilometers of city space. Not to mention the padded sofa sets and air-conditioning systems and a driver to keep the person comfortable and in good humour. Is this the most efficient way to move around in a city of 20 million people all aspiring to get their own 30 tons of air-conditioned steel to pick up a loaf of bread from the market?[2]

Compare the middle-class Indian home to say a European one and you'll get a clearer picture of waste. 1,600 sq ft and a family of four in Delhi to 800 in Paris. Space is a premium like insurance against flood, and gold bars in a locker.

In the small village of Kalika in Kumaon, Sarla Devi and her daughter spend the day scrounging the forest for firewood. Her son takes the two family cows to pasture within a kilometre of the house, while her husband works as a day labourer for the roads department. The 800 square yards of land the family owns, provides them with seasonal corn, bajra and vegetables; on it is a mud-plastered stone house of two rooms. By any measure, Sarla Devi's family is typical of millions of families in rural India. Its carbon footprint, if the global measure applies, is a mere half ton of carbon per person. Laughable by Western standards.

By comparison, a middle-class family in Delhi lives a more abundant lifestyle. Cars and SUVs line the drive of a four-bedroom ground floor flat. The father drives to work 30 kilometres a day to NOIDA; his son takes the other car to college, the SUV is used by the driver for a range of daily chores. Within the house, an assortment of electrical gadgets, two TVs, a fridge, a freezer, three computers and a music system, line the walls. The family lives in a perpetual haze of gadget upgrade and international vacations. At 16 tons per person, their carbon footprint comes close to the American average.[3]

In the desperate urge to replicate the outmoded Western model of development, the Indian government wishes to turn the thrifty mountain family into the middle-class city one within three generations. At a time of enormous challenges in climate science, urbanism and technology, India sets itself imitative goals. Along the worn and tested path, the country's ambition is to become the America of the 1950s, happily complacent in its middle-class affluence, a state of self-righteous contentment that poses no demands to develop new ideas related to energy-efficient design or green technology or test its will to enact real change. The parallel outcome is not just

2. Japanese firms have been quietly and effectively working on hybrid cars, taking them from mere experiments to marketable commodities. And each year refining the technology and design. Among them Toyota and Honda have diligently reduced cost, increased electric and fuel efficiency and added features to cool the interior without air conditioning. Their understanding of driving conditions in the city and those on long country stretches has revealed yet more possibilities of changing hybrid technologies and minimizing environmental impact. A Chinese inverter company has produced a cheap electric car of such high standards that it is to be marketed in Europe. Chevrolet, an American subsidiary of General Motors, known the world over for its gas guzzlers, is also promoting a new hybrid version, the Chevy Volt. An electric scooter has been introduced by the Italian firm Piaggio. Is there a Bajaj hybrid scooter in the making?

3. If America polluted the world in the 20th century and enlarged its carbon footprint to 20 times the world standard, the 21st century belongs to India. The opportunity to pollute in equal measure must not be denied, so the argument goes. To enlarge Indian norms for carbon, every Indian should now own two cars, a four burner gas stove, numerous televisions and home electronics, a basement deep freezer, travel incessantly around India on vacations, entertain on a lavish scale, buy plastics for daily use, increase meat consumption, and produce 12 times more waste. It is an entitlement that follows a tit for tat view, a position that is untenable, outrageous and unreasonable, and amounts to a form of retribution and revenge. Persistent droughts in MP and Maharashtra, the melting of Himalayan glaciers, the recent floods in Chennai, and those earlier in Kashmir, make it all too clear that we can no longer sit on the fence. Quick to point out the sins of the rich world, the real offences have a decidedly local origin: among them, overbuilding, constructing in shallow riverbeds and flood plains, uncontrolled migration into cities, proliferation of illegal polluting industries, lack of environmental controls, no restrictions on transport and sale of cars, and absence of clear green alternatives. Without initiatives of our own, or the ability to think independently, India is a disaster waiting to happen.

painfully obvious but comes at a time of global energy, financial and climate crisis, when the rest of the world is rejecting such growth as wasteful and redundant.

With the advent of an open economy, green had become a new cultural impediment, ironically, in a country where the value of 'green' was an old cultural ideal.[4] It needed no push in advertising or the marketplace. It was hard to believe that people could succumb so easily to the gimmickry of green living. In the back of people's minds lay an ingrained belief in ecology and a deep-seated connection to climate. For almost half a century, an anonymous architecture supported by strict common sense had made its way into town and village. These buildings had an aura of quiet assurance, which came as much from their economic expediency as from their expressive strength—the ability to transform traditional ideas into a wholly contemporary usage—an instinctive outcome of local economics and environmental conditions.[5] Using hollow walls, insulating techniques and waste material, the work re-oriented traditional craft to contemporary purpose. A new minority of architects and social planners have begun to view architecture as a catalyst for change, and the apparent need to evolve structures in accordance with the aspirations of the vast majority. They echo the view that there was no alternative to a new frugal architecture. And if anything, the desperation to measure the greenness of buildings was an ironic overstatement in a country that had traditionally sought environmentally appropriate solutions, and the willingness to simplify.[6]

The new green projects however were a strange transmutation. As if the earth, complete with its foliage and undergrowth, was being pasted on the sides of buildings, appearing full blown on roofs. A curious ironic inversion of the organic idea of the earth's growth. The sight of a 30-storey glass structure supporting full-grown trees was an anomaly in a place where the tree generally dwarfed buildings.

Swimming pools, fully air-conditioned luxury villas, clubs and saunas and underground parking lots. The beneficiaries of the high-end marketing campaigns were ironically attempting to be at once green as well as luxurious. Private swimming pools were heated by solar energy. Wind energy was used to power the air-conditioning of a weekend villa. That two parallel discourses were in progress was not only an obvious conflict of interest for the other, but provided comic relief to a profession that was too often viewed by outsiders as ineffective and utterly incompetent. All set to become tomorrow's ruins, caricatures of a way of life that had no future.

The idea that every Indian must first consume like an American before becoming a responsible citizen, seems an absurd lopsided form of entitlement. Wouldn't it make

4. The Indian Neem tree is a social institution. The physical aspect of its position on earth is fairly simple and straightforward. A seed springs out of an errant pod, bounces around the mud surface. It knows its chances of gaining a quick foothold are fairly good, this being India, where the greater part of the ground is covered in mud. Once it sinks into the mud, all it has to do is wait for the monsoon, so the sprouting process can begin. Its emotional life at this stage of its existence, oscillates between two extremes, fear and desire. Fear that when it emerges from the ground it might find itself part of a larger collective of a cash crop plantation for a toothpaste company, grown with the express purpose of quickly extracting its finer properties. In such a case, all it can hope for is a poor monsoon, and a quick earthly withering. But if it is lucky, the Neem may sprout in the courtyard of an ashram in Shantiniketan or in the back garden of a Hindu priest, only to enjoy as long and illustrious a life as the priest itself. All it needs to do then is stretch its roots deep in to the ground, spread its branches in an ever widening circle of shadow and develop a gnarled, twisted trunk which will give the ashram an aura of timeless serenity and grace, and the priest a place to lie in summer when the temple account is not working. Before long a tea stall will open nearby, and the happy ashramites will also sit in the shade, drinking, doing yoga, and discussing their bowel movements. And life will stretch on endlessly and blissfully for the tree, safe in the knowledge that as long as there are Hindus on earth, life will go on.

5. Just look at the 100-year old houses in Ahmedabad, Rajkot and other parts of Gujarat. Simple courtyard buildings, they recognized the parched conditions in which they were built and made steady design improvements to capture and retain the monsoon rain. Sloped roofs were so oriented that their water drained into a massive tank below the main courtyard of the house. Its capacity was enough to meet the needs of the household till the next monsoon. No genius innovation, just sensible planning.

6. The simplest way of seeing life is to view it as an unfurnished room. You enter a world of just bare blank walls and a roof. As life progresses into adolescence, the room acquires fancy furnishings—a chromium plated chair in the corner, a heavy gilded sofa set; in responsible adulthood you acquire Scandinavian lighting fixtures, a couple of paintings for the wall. A colour television console is installed near the window, so that neighbours can admire its flat 29" picture screen. The window is fitted with a burglar alarm so that a passing burglar can only admire the concept of the screen. The window cooler is replaced with a split unit window air-conditioner, and comfortable, oversized family chairs by squat unsuitable Shekhavati ones. For a short while, life is wonderful. The room is featured in *Design Digest*. It is awarded the Annual prize by the International Interior Decorators' Federation. Pictures are taken, dinners had, interviews given. But after a while the room lapses into a sort of aesthetic gloom. Surely there's something else. Something of more value. One day, in a fit of enlightenment, the owner sells everything; he builds himself a garage in the back, so

more sense to evolve a more deliberate pattern of consumption based on an Indian lifestyle?[7]

Everyone knows, that when global tragedies—famine, floods, water scarcity, deforestation, tribal wars—strike, they principally affect the poor, so mandating emission cuts in the rich industrial nations, becomes a matter of conscience, a Christian belief that we live in an equitable world. Deprived of arable land, water and habitation, food and water riots in the poorer countries could spill into the affluent North. The primary motivation to act on climate change then was the fear of upheaval, the fear of the sweltering hordes of climate refugees climbing border fences.

That may never happen. But while the rich world obsessed over alternative fuels, smart electricity grids, and carbon credits, the poor needed a different route.[8] A transfer of technology from the West to curb large-scale carbon emissions was certainly essential, though less in India's interest than developing low-scale applicable Indian technologies. If unelectrified villages in Bihar and Jharkhand were beneficiaries of such technology, the burden of conventional electrification would become unnecessary. Traditional water conservation measures and improving solar cooking technologies were equally essential. A sizable population that lived pre-industrial lives, allowed a greater leverage in bypassing the pitfalls of conventional growth altogether.[9]

If the mountain family had a future it was unlikely to come the conventional way. To follow an American lifestyle or to create a uniquely Indian one, to build indigenous electric or hybrid cars, solar houses in villages without electricity, or design communities without cars had become a pressing Indian need that stepped outside the cycle of American consumption.[10] More than ever, the Gandhian message of self-reliance that the truly Indian house will be built of materials gathered within a five-mile radius of the site had become relevant. In it, were traditional solutions that were not new, or Indian, and entirely without Western lineage. When the crisis hit, it was the only future possible.

At the turn of the century, architects genuinely believed that the modern movement would provide new techniques and materials to serve the needs of ordinary people. It seemed as if technology could provide a solution to the persistent problem of housing, and it was believed that high-tech buildings would ultimately improve the standard of living for everybody.

Housing unfortunately has come to be dominated almost entirely by commercial builders employed by local governments, both of whom look upon a house as a

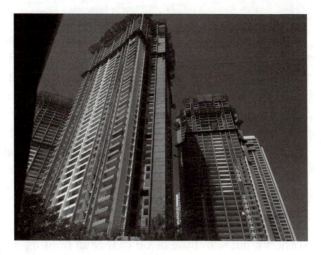

that he can have a garage sale; then disposes of everything. Sitting near the entrance he dispenses with each item with a nonchalant detachment, telling the people that his materialism phase, or what Kant called the Aesthetic Stage, is now behind him. But the process of de-materialization is not over. As the room returns to its original uninhabited state, so must the body and mind. The process begins. He climbs treadmills, jogs in the park, tries acupressure and acupuncture, receives a Mantra from Maharishi Mahesh Yogi, dispenses allopathy, moves to homeopathy, abandons homeopathy in preference for Ayurveda. The rigours of the therapeutic life leave no time for other details. He looks forward to that time, when he can catch up with work and family, find out who his wife is and what makes her tick, why they are married, how many children he has and what their needs are, if any. In his room he suddenly realizes that there are things around him he has never seen before. The floor has a dull stone finish with grains just as in the quarry; there are impressions of hands on the wall, the very same hands that had once applied the plaster to it. And look at the window, what an incredible window. Would you believe it, no bevelled glass, no mouldings, nothing. Just a missing part of the wall. An absence. How enticing, the emptiness. Then for no reason, even the absences become a burden, they begin to acquire metaphysical form. And in another crazed fit, the man organizes yet another garage sale.

7. Architect Laurie Baker wrote: 'I believe that Gandhiji is the only leader in our country who has talked consistently with common sense about the building needs of our country. What he said many years ago is even more pertinent now. One of the thing he said that impressed me and has influenced my thinking more than anything else was that the ideal house in the ideal village will be built of materials which are all found within a five-mile radius of the house. What clearer explanation is there of what appropriate building technology means than the advice by Gandhiji. I confess that as a young architect, born, brought up, educated and qualified in the West, I thought at first Gandhiji's ideal was a bit 'far-fetched' and I used to argue to myself that of course he probably did not intend us to take this ideal too literally. But now, in my seventies and with forty years of building behind me, I have come to the conclusion that he was right, literally word for word, and that he did not mean that there could be exceptions. If only I had not been so proud and sure of my learning and my training as an architect, I could have seen clearly wonderful examples of Gandhiji's wisdom all round me throughout the entire period I lived in the Pithoragarh district.' Baker's instinctive response to Gandhi's simplicity and his acceptance of the frugal style of life in Pithoragarh stems perhaps from his Quaker background. The rigorous Quaker upbringing, with its emphasis on simplicity and austerity, its rejection of all ornament and luxury as sinful self-indulgence, was reinforced by the theories of modernism that were current during his architectural training, the one complementing the other. And so, though Baker's work appears to emanate from the functional doctrines of the modern movement, it is largely the outcome of his Quaker past. If the modernist ideology dictated that design be

commodity to be produced and sold in large numbers. The once-new technological solutions of the modern movement have fossilized into rigid inflexibility in their hands. The comfort and lifestyle of individuals for whom the mass-housing schemes were intended were rarely considered. The results were all-too-visible; as governments struggled to house the ever-increasing numbers of urban dwellers, the inadequacies of the century-old doctrine of modern architecture was brought more sharply into focus. Moreover, as the gap between available resources and the need for housing increased, the inflexible sterility of the modern movement became even more apparent.

Emphasis on the improvement of living conditions is a result of the new market economy, but with little or no change in housing design. In fact, living consider-ations are no longer the primary logic for the evaluation of architecture. In the design of a recent house in Delhi, I was intrigued by how the owner's interest in the building was sustained merely by the gadgets that were part of the home. While the rooms were dark and depressingly similar, all had air conditioners and humid-ifiers, each fitted with its own fridge, television and home entertainment, internet, security and alarm system. A private lap pool and barbeque extended along the side of the house; four cars were parked in the driveway. Gadgetry proclaimed inde-pendence for all the residents of the house, while old ideas of comfort, familiarity, family togetherness were all but forgotten.[11]

It was easy to see how in the past 20 years, the idea of private ownership had had a huge debilitating impact on urban life. The city had changed from a congenial space of shared amenities and relationships to a fearful nightmare of private strongholds and walled compounds, insecure, insular and isolated. As the boundaries of the city expanded to take in more people, the real boundaries around residents closed in. In Gurgaon outside Delhi, Vastrapur in Ahmedabad, or Whitefield in Bangalore the gated community coaxed the home owner into believing in the security of living among people like each other. The house came now with greater inputs of private facilities: private parking, private entertainment, private library, private pool, pri-vate barbeque... there is no need to go out.

How had the continual expense on the good life produced anything but a lazy and bland convenience? If anything, wasn't its larger impact a more pervasive isolation and despair? What indeed was the effect of the bloated house on the consumption patterns of the neighbourhood, the city?

In the 1970s, with little use for a car, my parents opted to share the expense of a car and driver with five other homes in the neighbourhood. The efficient use ensured

determined by purpose and by the mechanical process by which it is realized, the Quakers arrived at a similar conclusion from a different starting point. The sort of burdened and forced functionalism that the modern doctrine enforced with elaborate theory came naturally to those whose religious beliefs sought to express in their handiwork the desire to labour willingly and honestly.

8. For us, one of the unfortunate ironies emerging from the Paris talks on climate change is in fact the discrepancy between the Indian position and the Indian situation. Compared to the worst examples in Africa and Latin America, in every respect, India is the site for the most extreme forms of environmental degradation. Pitted with Columbia, Nigeria, Gambia and other countries of West Africa and Latin America, and unlike these smaller countries, the scale of its operation is large enough to cause a noticeable coal dirt cloud over the world's clean energy horizon. We have neither funds nor technical knowhow to ease poverty without resorting to fossil fuels and the Western model. Home to 11 of the 20 most polluted cities in the world; major rivers degraded, silted and dead; forest cover denuded to 23% of land area; the highest global figures for respiratory and water-borne diseases; and contaminated water whose availability is today reduced to a grim 200 ml per person per day.

9. In 2003 in the hills of Almora, a village woman named Kamala, woke up at 5 am to scour the hillside for several hours to collect enough hay for the two cows. After feeding the cows and preparing food for the family she departed again for five hours to fetch water from a distant rivulet, making several trips to fill the household utensils. Upon her return, she completed her household chores and left again to search the forests for firewood, arriving home only after dark to prepare the family dinner. After dinner she was beaten by her drunk husband. Kamala died at the age of 27.

10. *Untouched, and therefore unspoilt, by the government's National Canal Irrigation programme, was the natural lake that was home to a young, upwardly mobile turtle called Kambugriva (Sanskrit for 'Friendly Respiratory Infection'). Kambugriva was a happy free-wheeling soul, and like any concerned occupant of the biosphere, he was committed to environmental action. Two swans, Sankata and Vikata, also residents at the lake, shared his ecological concerns and were his close friends. Clad in their biodegradable swimsuits, the three of them would pass the day by the lake, shooting bull and narrating stories about saints, hermits, ministers and other species capable of influencing the grassroots eco-development movement. As active members of Greenpeace, they often spent their evening atop chimney stacks of nuclear plants, protesting against waste emissions. (All three kept up with the latest UN figures on acceptable levels of pollution.) And then, after an all-natural barbecue dinner in the lake-view restaurant they would head home to the water at sunset. The years rolled by and life continued in this humdrum middle-class manner, until one day there appeared on the ecological horizon a danger signal: a fair-skinned human accompanied by some others in safari suits. This was enough to warrant further investigation. The three friends swam to the shore. The World Bank was funding a project nearby. And as happened in projects with international funding, villages had to be relocated this time to make way for a small environment-friendly hydroelectric power project. The village folk had been told by the earnest-looking man from Washington that the project would contribute to rural upliftment. The lake, he explained, was a sluggish cesspool with a messy earth embankment that eroded every monsoon. 'The nice new hydroelectric project, with concrete works and spillways, will generate a million megawatts of power. The canal network will irrigate 10 million hectares of land, including some of the sleepy mud villages along its course. But not to worry, they'll be replaced by shiny asbestos roof settlements. Besides, everyone will receive handsome compensation, and a new synthetic wool*

324

that the shared car was fully employed during the day within selected time slots. Five houses came together to share one car; today each of those houses has 4–5 cars, mostly clogging the driveway. At the time, the local market had several lending libraries with the latest books. The system of short-term borrowing insured that every book was happily thumbed by many interested readers, as were magazines and later, videos. The larger thrust of the shared life also extended to living spaces within and outside the home. The absence of multiple TVs and fridges allowed the family to share time together, as did the community park, where people met in the evening.

Throughout the world, cities were attempting to create optimal conditions for shared interactive lifestyles. Suburbs in Washington and Boston encouraged car pooling by creating special fast lanes into the city. In Orlando, tightly knit townhouses opened out into a common garden. Offices in Bogotá hired taxis to ferry their staff into the city. Other initiatives such as co-housing in Denmark supported communities planned and managed by the residents who shared responsibilities of child care, recreation, and security along with social activities.[12] Some new Chinese cities discouraged any form of private ownership, whether house or car, so people lived close to places of work in rental housing. Shanghai meanwhile turned the Western model on its head. Discouraging private home ownership, the local government created large pockets of rental housing such that people do not form a long-term attachment to a place, but instead move freely and reside close to the workplace. A novel private car time-share facility allows people to rent out their car during periods when it is not in use. An attempt both to reduce congestion and pollution, and in the long term, create a more livable, egalitarian Shanghai.

Obviously when domestic life is measured as an outcome of scarce resources put to efficient use, affluence begins to appear a terrible waste. The undying urge to excessive material possessiveness had produced a selfishness that had a contemptible and miserly social dimension.[13] With only one time or one person use, the possession itself lost its utility and usefulness, and became redundant. The multiple uses of cars, homes, gardens, city space, books, films, etc., in the long run could reduce private possession and increase public dependence and interaction.

Buying a home in the centre of town and private car ownership are now both archaic and unfeasible. The future city can no longer be seen as a collective of purchasable products, but rather, as a service: a dense habitation where all facilities, home, car, office, shop, are available on rent. A permanent place where residence is impermanent.

blanket each. The three friends were deeply concerned. Was this what development meant? Wasn't there another way? Perhaps. Perhaps not. Maybe the man was right, they said to each other. Too rigid a clampdown of environmental controls could stifle economic growth. After all, technology wasn't all that bad, was it? Sure, an excess of it could produce social alienation, but used as an instrument of development, it could stabilize existing patterns of consumption. Their debates carried on far into the night.

11. The idea of drought in Gujarat and Rajasthan is lamentable, given that both states have a history of innovative water harnessing. Besides aqueducts and irrigation channels, there are 2,000 known and catalogued step wells spread across the greater part of Northern and Western Gujarat, and parts of Rajasthan where the drought is still at its severest. Built along the old trade routes, the underground monuments, sometimes six to seven storeys deep, supplied water to local villages and incorporated a sophisticated system of gravity irrigation, besides being notable for their architectural details. Unfortunately, most of them have fallen into disuse and neglect. A cursory study of their rural location, hydrology and structural conditions makes them obvious and potential sources of water for future summers. As a long-term measure, it is imperative that the two state governments begin to look at the possibility of their revival.

12. Copenhagen is absurdly small; it could fit neatly into one corner of Dharavi. With less than half a million people, it barely stretches a few kilometres from the harbour. You can walk it, but with cycles available for free, most Copenhageners choose not to. An ingenious system of cycle tracks grids the entire town, connecting every major landmark and district. You merely feed 10-kroner into a public cycle slot machine, and the 2-wheeler is yours for the day. Ride around the city, gliding along waterways, through parks, into shopping districts, and when you've had enough, just return the cycle to a nearby cycle lot and get your 10-kroner back. Is that the way to live, or what?

13. *In a jungle now denuded of its stately Deodars and whistling pines there lived a lion called Kharanakhara. Now Kharanakhara was an animal with strong political views, but he adapted easily to the changing times. If you recall, during the heady days of the Chipko Movement he had organized local animals into saving the trees earmarked for felling; but his friendship with the local timber merchants had made him alter his ecological stance; for a small fee, some free furniture and wall-to-wall carpeting for his cave. 'Animal frailties,' he would say, waving his paw dismissively. Kharanakhara was a benign ruler. Moving about the stumps of the protected forest, leaping over half-dead eucalyptus saplings, he liked playing king of the jungle. It was an inherited role he enjoyed immensely.*

326

There could of course be colossal economic and environmental benefits of a shared life—fewer cars on the street, more people accommodated more comfortably in less space, larger common open areas and greens, consequently increased personal security, healthier cities and a happier, more connected citizenry. If such an ideal were to be tested in India's new towns, planners would have to create conditions where people didn't need to buy cars or houses.

Obviously, the present structure of city living is unlikely to accommodate such concerns.[14] But given that cities are expanding and new ones being proposed, it may be useful to explore and state a new set of regulations for a shared public life before any construction begins. If such ideals were to be converted into by-laws, the larger benefits of sharing could be enjoyed by all sections of society.

Unfortunately, the fear that any radical approach will mean the downgrading of lifestyle, has kept us resolutely on the path of increasing carbon pollution and urban chaos. However, this dogged pursuit of development at any cost is both unrealistic and unimaginative. Certainly, the country's path to material progress for three quarter of a billion people cannot be altered. Yet this one-track approach to prosperity has none of the urges and inclinations expected of a country embarking on such a heroic task: no dreams, no new ideas, no professed aims; no philosophical deviations to chart a different line to affluence; no technical or scientific approach to offer short cuts. In a time of such broad leaps in agricultural science, domestic technology, automotive engineering, and industrial design, the application of serious environmental ideas to reinvent Indian lives remains woefully inadequate.

But for an animal of such status it was important to be seen at the right places, displaying the right concerns. During the day, Kharanakhara could be found at the jungle bar discussing the cost of the capitation fee at schools, or the current premium for a ration card, even nattering with the monkeys about the sudden rise in banana prices, or interrupting a group of leopards to throw in a word about the lack of quality in public life.

'God! Times have really changed,' Kharanakhara would shake his head sadly.

'Yes, haven't they! Urbanization has created such a sense of alienation.'

And everyone would sip their cashew feni silently.

'Animals feel isolated in their own neighbourhood.'

'What neighbourhood…. Even in their own home.'

'I remember, in my grandparents' time, animals would breastfeed their neighbour's baby if their mother's milk had dried up….'

'What baby… they would breastfeed the neighbour if they had to.'

'Those were good days.'

'Yeah, weren't they?'

'And water… remember, water used to be free….'

Everyone's eyes would mist over with the recollection of days when there was no toll barrier at the watering hole and animals were allowed a limitless supply.

But no more.

The streams had since dried up and the sacred river had changed course. Some animals had moved away; others had passed away in search of better living conditions and life insurance benefits. The athletic otter had even cemented over the swimming pool. Things had really changed. Kharanakhara would sigh a long breath of carbonated air and order another round.

14. Severe building height restrictions in Mumbai, for instance, create a living space density so high that it can only lead to squalor and overcrowding at the ground level. Compared to Shanghai's 150 square feet per person, Mumbai residents occupy barely 30 square feet. Such neglect of living conditions has been largely encouraged by height restrictions. Even when the changes are made in the FSI they are so miserly as to make little difference.

23. Architecture as Photoshop

If the culture of appearances has official sanction it begins to justify its presence over time into a subjective consciousness. People begin to believe in its very baselessness, that the new foundations of art and architecture is formed out of the mere wish for spectacle, even a belief that culture requires no background or history. The absolute form of authoritarianism corrupts completely and effectively erases all public beliefs and memory. The artist, the builder, the architect, the financier and the politician succumb to the success of a sales pitch and measure their contribution solely by the shrillness of daily noise and publicity.[1] Obscured is the cultural, artistic and architectural worth of their endeavour by the spectacle of sheer size and height; that unchallenged belief is in fact endorsed day in and day out, with the rising graph of onlookers, the new believers.

Public Relations is everything. The magnitude of private influence is matched by the sheer spread and visibility of net worth on the air waves.[2] Building transcontinentally, in small towns for the lower strata, in big towns for the rising middle class, and in the mega cities and suburbs, a serious refinement of luxury for the landed classes, tinkling fountains across long gravelled driveways, summer pools and evening barbeques, lifestyles can be completely made to order. A new range of surplus and parasitic facilities that elevate architecture to the level of private community. Your own pool table, your own tennis court, private pool and games room, a level of personal consumption so irrational and socially irresponsible, it becomes a new heightened measure, an aspiration to a private morality.

But it was hard to draw the private farmhouse, the luxury apartment, or the concealed city mansion into the argument of exaggerated consumption. Neither had anything to do with the old 20th-century view of an honest day's labour or 'living according to my station in life.' In places where commodity and the marketplace determined the laws of acquisition, the private life of places was merely an honest representation of economic forces. People possessed, made, built, added and replaced, in a continuum of living the spectacle. There may be no place for swimming in the pool, the poolside barbeque may be lovingly arranged everyday without use, but the owner was a faithful guardian, displaying the wares like a jewellery shop owner, but never once hanging the necklace around oneself.

A culture that had formed out of images had no need for connection to land or history.[3] Place and position were no longer a rationale for assessing reality, or passing moral judgements on people's expectations or extravagance. If the serious need

1. No news was good news, but all news was breaking news. When reporters weren't being shown chasing a water tanker that discharged 2,000 litres in the chief minister's home swimming pool, a serious debate on the Indian prisoner caught for spying in India by Indian authorities was on the screen. The same five experts were present LIVE on all six news channels, including the same Pakistani generals, who graciously soaked in all the abuse meted out by the Indian moderator. In the relentless public view of the power game, the nation's daily debates take place from uncertain, immoderate positions. Everyone must have a say; everyone must disagree; everyone must express their belief in public forums. Everyone must be known for their volubility, their public presence, their hits on Facebook, the number of followers on Twitter, the number of disciples at a public fast, the number of cars in the garage.

2. When people look only to private media for factual information and news, chances are that a lie doing the rounds eventually establishes itself as truth. It travels the full course, passed on from Facebook, tweeted into shared accounts, across thousands of unsure minds, spreading like wild fire without proof or doubt, till opinion becomes fact, and belief becomes total. The dangers of such internet media are now beginning to be felt in India. We have today 160 million WhatsApp users, 150 million Facebook followers, and over 22 million Twitter accounts. A right wing WhatsApp group sends out thousands of nationalist videos around the country every day, spreading a host of lies: that Muslims will overrun the country and North Easterners are Chinese agents. The BJP's proficiency in the new media was itself visible throughout the recent election campaigns. Knowing full well the advantages of such instant messaging, they pushed their agendas on Twitter aggressively. Whatever the messages, they are often taken on their word, private opinion mistaken for public proclamation, propaganda accepted as news. Whom to believe, how much, and under what circumstance becomes impossible to verify when the source is a tweet, a private opinion, a 'like'.

3. Earlier, the absence of social media allowed incendiary private opinion to die before it could leave the walls of your home. No more. But when people look only to private media for factual information and news, chances are that a lie doing the rounds eventually establishes itself as truth. It travels the full course, passed on from Facebook, tweeted into shared accounts across thousands of unsure minds, spreading like wild fire without proof or doubt, till opinion becomes fact, and belief becomes total. In a new world where there is no difference between broadcast journalism, print or social media, anything is capable of becoming news. The tweeting of any information by a public figure or celebrity gives due credibility to the information itself. An Amitabh Bachchan tweet on communal harmony will have a much greater impact than one from a professor of social sciences from JNU. The larger the number of followers, the greater the propensity to influence public opinion. When legitimate news and institutional media is smeared as biased and an outright lie, reality becomes real only on the reality show. Perhaps this has something to do with the lack of faith in established institutions: government, banks, universities, hotels. How do you explain the proliferation of private currencies, Airbnbs, Uber and Ola, the rise of internet tutorials, the people who willingly purchase a second-hand car from a website, or those who trust another

for private sensationalism was the result of technology's excessive intrusion with multiple images and media, then architecture, its owners and builders were only practising a natural process. In the widened arc of influences, building was only one expression of an expanding reality. A reality that included film, magazines, travel and movement across borders, transport of produce, technology, automobiles, expansion of professional boundaries, exchange of fast food and coffee shops, transport of wood from Malaysia, and kiwis from New Zealand. Everywhere, new trade policies opened borders among nation clusters.[4]

Though to set a position purely from the vantage of the past would be regressive, society's reliance on images for its progress lends no weight to the old claims that the measure of life was social life and morality. The technology of communication was itself responsible for creating newer forms of dependence, which themselves induced the inclination to spectacle.[5] The ability to see was controlled by the image. The eyes were always hooded. You looked through magazine pictures, internet downloads, at phone screens, video games, computer-generated images, animation so real that it recorded extraordinarily perfect states of reality, even the physical exertion of virtual sports was a close approximation of the real. However virtual the action through images, the sensation was always in complete umbilical control, even though the image had equally complete control of your visual and perceptual apparatus. Your appliance was as good as you, only because you were as agile and gullible as your appliance, your belief in the virtual was total and unwavering.[6]

Architecture too was unfortunately in control of business management; the lowest common denominator of building design was being pushed and proliferated by mid-level managers, people whose belonging to business itself had begun to define lifestyle. A new class was in the making, outside of first, second, or economy. Business class in the air, business travel, business centres in offices, business conferences and hotels, a brand of elegant men and women in black suits and briefcases were perpetually on the move, moving purposefully, between home and office, conference and meeting, hotel and business vacation. Movement was the lure of the lifestyle. In view of their routines, social exchange and the reality of daily events never mattered. Only a continuous barrage of signals and new records formed effective communication within culture.[7]

Was this then merely a period of transition, when a culture of events and spectacles imposed itself on society? Or was it a final form of transformation where the earth's crust was cooling after the volcanic eruption, and no one knew what would emerge? Did people believe that living from event to event was itself the only form

site to pick a partner for them for life? The causes of disruption are as much innovation as mistrust in the system. In the US, graduate education in formal universities is on the decline, many preferring to get a degree online. Forty percent of Americans also get their news from social media. Is this anything but an affirmation of people's growing faith in alternative sources? With every second person on Facebook, the chat rooms are filled with ideas about institutions failing, democracy on the decline, rigged polls, falsification of news and racist rants. Other than the odd MP surfing the net for pornography, Indian cyberspace as yet is safely nondescript and without excessive opinion. But not for long. The argumentative Indian has enough prejudices that he or she would like to air in public.

4. Perhaps it has something to do with the changed order of personal lives. The past and future are of little consequence to a society intent on living life instantly: instant rewards, instant culture, and instant affluence. The groundswell of opposition to anything that may delay the gratification appears in day-to-day encounters of disorderly incivility: the urge to overtake and break rules on the road, be the first off a plane, the encroachments.... Discordant notes of hostility are no longer even noticeable. The snarl, the scowl, the despondent leer in public dealings, the passing brush against schoolgirls in a social situation of stress and overpopulation—all of it now passes as acceptable.

5. Social media platforms perhaps allow the world to be more connected, but much of it comprises an unhealthy competition for more followers, more likes, and other shows of self-adulation. With more photos sent, more selfies taken, every life event recorded, the self-obsession passes down the line as a caring, if somewhat insincere, engagement. The reason for seeking connection is a desperation to gain approval from strangers. Consequently, in the narcissistic culture of today, mediocrity easily passes off as greatness. Small things are misread as big ambitions. Private actions when placed in the public sphere are then everyone's bid for immortality.

6. In the 1960s, the *Encyclopedia Britannica* was the single-most valuable compendium of relevant information gathered into 10 alphabetical volumes. It served student, institution and private researcher alike for basic information. Its entries were the work of scholars and specialists whose credentials were impeccable and duly recorded in the book. Wikipedia, on the other hand, allows anyone to propose information related to its growing archive, however inaccurate, all in the hope that the open format will itself act as an editorial corrective, and eventually the input of many will inform and embellish each sketch into coherence. Is this any way to work a legitimate entry into the world's most informed network encyclopedia?

7. Belief in records had grown into an industry. Just as 93-year old Mark Demott was climbing Mount McKinley in the US, to become the oldest man to scale the peak, a 15-year-old Australian schoolboy was on a boat to become the youngest to sail around the world. The utter absurdity of such heroism pales into existence when pitted against the fact that there are no more mountains left to climb. But then, no one has swum the Atlantic Ocean nude. No one has cycled up Mt Everest. No one has eaten 10 kilos of cow shit in less than two minutes. There are some who set a record for the sake of setting a record. The Guinness Book of World Records is manifestly the work of people incapable of enjoying the fruits of other people's labour. Govindan Reddy from Andhra Pradesh has the longest fingernails in the world. He began to grow them at the age of seven, with the hope that if he lived to the ripe old age

of expression in material life? Were arts like architecture and sculpture merely the apologetic buttresses for the event of the spectacle?

If so, the chances of a period of cultural gestation where ideas form, conform and liberate were remote. For architecture to be finally framed and accepted, history's judgements had to form a corrective wash or be liberated by a cataclysmic destruction. Without the turbulence, architecture remained a mere representation, a sign, an object of material life. Such architecture repressed the real in order to preserve appearances. It obscured and contaminated ordinary life with excess, promoting the infantile illusion that consumption was the only resolution of commodity. And the old assumption, that the more you have the more you want, was worked into a frenzy whose only outcome was a pathological sense of dispossession. Even outside the socialist perspective, the building and its promotion of its own technical facilities were as much a reminder of the spectacle as a real threat to social cohesion.[8]

Architecture had wholeheartedly submitted to the vision industry, to be manipulated by electronic means and resold to the viewer in new forms. Video, animation, photoshop, film and installation were all part of the factory production of seeing, the transmission of visual perception held captive in a variety of seductive mediums. Did then this industrialization of vision lead to overexposure? Was there a difference between the object seen with the eye, and the same manipulated by media or art? Did representation of objects indeed destroy their reality? Could techniques and mediums ever substitute for an eyewitness to reality in the flesh? In the city environment, the use of such devices only contributed to a perceptual misreading that was not only devious but unethical.[9] The act of simultaneous intervention through electronic or mechanical means had removed the space-time interval that let the resident tune his own domestic space. The room was now high-wired in close circuitry, truly a machine for living in.

In the past there were clearly visible differences between the inside and outside, and front and back of buildings; the up and down was often, without elevators and escalators, an arduous journey. Summer houses were restfully coated in a cooling dark, while the outside lay in blinding heat and light. The resultant sameness highlighted the importance of the interval in architecture, and the variable of time to enhance any building operation. The touch, the feel, the bodily movements, the slow motions, the aches and pains of physical action was a major player in setting up any environment for use. The effort to exert the change was always physical; people moved, extended, gestured, pulled, yanked in actions that extended themselves into a territorial hold of space. But the insidious force of Artificial Intelligence is now appearing as the new saviour.[10]

of 90, he would be able to break his own record. At 63, he stays away from manicurists, even getting his family to feed him. The man with the longest uncut hair is also Indian. As a country we are proud of their achievements.

8. Whether this evolving super-intelligence may pose a threat to the static human brain, only the future will tell, but in India, its prospect is harder to predict. The public use of computer data analysis, the most basic form of artificial intelligence, is in endless statistical correlations in sport. The automated third umpire in a cricket match has the final say in an important decision that cannot be made by two umpires. Will it soon replace the two men standing in the field? A line judge in tennis is overruled by a multi-dimensional camera better than the human eye. Will there soon come a time when a Supreme Court decision will be overruled by a machine better equipped to make constitutional interpretations? Will the future replacement of the reserve bank head by an artificially intelligent governor allow currency devaluations to take place automatically, along with timely interest rate hikes?

9. A well-known doctor in Bihar was announced dead on WhatsApp after an income tax raid at his house declared vast hoards of illegal currency. It took a press conference for him to pronounce both, his innocence and existence. Earlier, the absence of social media allowed such incendiary private opinion to die before it left the walls of your home. Now, every private utterance has the possibility of making it big in public space. You can make claims and arguments without facts; you can raise outright lies to the level of conspiracies. Fake news is a sort of Photoshop for words and ideas. When you can put together a convincing picture of Sachin Tendulkar's head on the body of Vidya Balan and pass it off as real, it isn't unusual to conjure up the sudden appearance of Jayalalitha's daughter in some remote corner of the US as fact. Factors of believability lie in the medium itself. A photo of Narendra Modi sweeping the floor at an RSS rally was circulated in 2015. The RSS denial of its legitimacy was accompanied with the pre-photoshopped picture of the actual sweeper.

10. Without our knowing it, 'artificial intelligence' has sprung up around us, performing tasks we as humans are incapable of. At present however, far too many people think that it is only a passing fad promoted by Western scientists with little to do. But whatever the eventual outcome, artificial intelligence is here to stay for the long term. Economists in the West are closely watching and anticipating its future outcome on ordinary life. Will it cause large-scale disruptive unemployment, or open up opportunities in new types of scientific exploration? A survey by the Bank of America estimates that in the US, Artificial Intelligence could have an impact on daily life commensurate with 300 times the transformation wrought by the industrial revolution. The biggest fear relates to what scientists call Deep Intelligence: a hitherto new phenomenon where computers can be self-programmed to perform emotional tasks. Its recent outcome in Japan is a domestic robot that absorbs home attitudes, smiles and bows when it greets the owner and even intervenes in household exchange.

With the transmission revolution and remote control, the architectonics of space was out of human control and collapsing. You no longer climbed a flight of stairs, you stood on a step and let the flight of stairs carry you upwards; in an enclosed room, the only reminder of moving upwards was the chronic hiss of the machine; on the flight, the induced darkness numbed the senses and carried you across time zones, entombed in a steel casket. Even natural light was now available through fibre optic cables implanted on the roofs of apartment blocks, imparting a celestial glow to interiors, like the synthesizer for sound. In this wired environment, architecture lost its relevance, and the occupier of remote space, remote in hand, and remote to the world, was happy in his sedentary exclusion. Unable to distinguish inside from outside, up from down, here from there, the space of the body from the space of the town, his primary displacement was temporal rather than spatial. The room inside the space within the building was always secondary to the desperate immediacy of time and its instancy.

The new resident of the estates also lived in a material gullibility. A spectator in his own home, a man sitting before a screen to experience the promised joys of domesticity. The success of the commodity was in his enhanced view of himself on the screen, and the perennial fear that stalked his subconscious that the screen may just be a hallucinatory delusion, and machines would take over one day. What would happen then?[11] Windows wouldn't open, the microwave might not operate, he could die. Architecture and all its attachments had to operate seamlessly in a state of induced somnolence and a deep fear that no-one is in control.[12] In the waking state, the awareness would be too despairing, too difficult to bear.

Everything was LIVE and tinged with the welcome of a computer download.[13] Data on the internet, people on long-haul flights, deliveries by courier, wire transfer of funds, everything occurred in the instantaneous perspective of real time. Only death, destruction, and the interval for grief kept the body in tune with reality.

The new community in highrise flats, in glass offices and bubbled and domed clubs, invariably hoped someday for connections to each other. The long-term aspirations for a happy connected life were fostered through a sharing of commodities, joint families, people sharing a meal.[14] It was hard to find common ground in the day-to-day processes of apartment living, no longer any need to borrow sugar from the neighbour, so other means were sought. People come together to share a pool, a golf course, a lift, a corridor, a roof-top barbeque.

Consumption became defined by lifestyle, lifestyle by income. The self-consciousness of the branded life extended into every aspect of daily living. The type of home,

335

11. Will the next Prime Minister of India be a robot? A BJP robot or a Congress robot, it is entirely likely that a few decades hence, the country's most important political position may be occupied by a machine. When for so long, the cult of personality and party affiliations has dominated government, many argue that artificial intelligence would serve India better than the current crop of bureaucrats and politicians. The latter's erratic behaviour and impulsive decision-making would be best replaced by machines, machines that analyse relevant data thoroughly, weigh the odds, and then come up with the best solution.

12. Will India survive as a ruling anarchy the way it has for generations, or will it fall prey to the sinister forces of democracy? Will the caste system continue to flourish the way it presently does, or will some do-gooder erode its balanced definitions with a hollow appeal for equality? Indeed, will the Constitution of India, used by lawyers to prop up the bed, retain its lustre as the country's greatest work of fiction, awaiting a Booker, or will some errant judge promote it as a working manual? The future remains riddled with as much uncertainty as the next India-Pakistan match.

13. Newspapers reported facts; opinions were reserved for the few whose long-term experience of those facts gave due credibility to their voice. Rejected articles and manuscripts, unsold art, unrecognized films, unfunded projects spoke as much about the quality of material allowed into the public sphere, as about the permanence of public space itself. The complicated and expensive nature of publishing ensured that only those who valued and practised the craft of thinking, writing, editing, those whose art would make a serious contribution, would see the light of day. The defined strata of unforgettable original writing, art, film would remain in public memory and as visible artefact; the mediocre rest would disappear like Snapchat. Permanence was itself a critical guarantee of quality.

14. A culture where eating is primarily a sexual activity is the French. To them food is like sex, to be lingered over, thought about, left soaking under the tongue. It tells a great deal about cultures, how they treat food. When the Americans stand and eat at Burger King, the idea is to devour it quickly, so that you can then spend a quiet evening slowly dispensing it in the toilet. The Chinese eat quickly too but in such small bites and flicks of the chopstick, that something of the taste remains. Sometimes the chopstick also gets caught between the teeth, but its quietly ingested without fuss, and its price tabulated on the bill. But the French are different. They don't much care for quantity. And at times an extravagant six-course meal may only serve up just a little bread, some wine and if you're lucky, a little cheese. The whole show is based on time and if you have a train to catch, it's best to avoid French meals. For a long while nothing is served. Guests arrive, they take their places, they discuss the weather and their suspicions about the English. Talk moves on to Mitterrand, even de Gaulle. The really hungry talk about Jacques Cousteau. Some hints are made about hunger. A lady brings up the recent starvation deaths in Somalia, the shipment of Canadian wheat to India. Some guests eat their plates, some nibble on their place names. Then grudgingly, very grudgingly, the hostess signals the servant, who heads into the kitchen and is heard opening and closing drawers. Another half hour passes, by which time some guests have already

the make of car, the choice of school for children, the width of the TV screen,[15] the number of servants, the employ of a security guard, a driver, the number of air miles, the seating capacity of the dining table, the upgrade of home appliances, the make of the mobile and laptop… an endless tyranny of labels and measures. The sheer weight of the social values of architecture and all its minor appendages, carried class consciousness to new levels of grotesqueness and satire.[16] In a growing economy with increasing numbers of middle-class aspirants, the prejudices of excessive choice which were once limited to a miniscule elite, had spread in a shamelessly brazen way. Everyone must not just consume. Everyone must not just appear to do so. Everyone must gloat in the power of greed. Everyone must indulge in a daily statement of their differences.[17]

Consequently, the connection with space had been effectively eroded, a come-down in experiential terms, a loss indeed of a tactile way of life. Today light is controlled, like food is packaged. It softens and disappears or becomes more crystalline and harsh. Are these then opening up newer experiences of architecture, another level of mental engagement rather than a physical one? Perhaps a gain in some form, technology and architecture had eradicated the differences between places; the office was like the home, the home like an office, the office similar to a club.

The literal facsimile of technology had begun to produce a web of lies that affect everything: home, transport, entertainment, politics.[18] In architecture it produces internal spaces with little or no differentiation. In highrise after highrise, the honeycombed cubes of saleable rooms were strewn with the familiarity of recognizable items, to draw in the buyers. Sofas and beds said it was a residence; table tops of computers said office; a rack of shoes on a wall meant a store. Unfortunately, the desire to continually differentiate was too deep a human condition to ever accept sameness as a permanent state. Perhaps because building environments were enlarging into whole communities under central control, architecture scales were shifting to urban design, while the interior took control of the building.

It has been demonstrated throughout history and across cultures that increasing wealth decreases people's participation in public life. Shared spaces for recreation, neighbourhood meeting points, squares for discourse or commerce, have been the hallmarks of traditional towns where the home was merely a focus of domesticity. Unable to afford land for their private leisure, most families sought out chowks and streets and maidans in the evenings. The organic inclusion of public open space in residential neighbourhoods was the natural condition of dense city living. But with increased private resources few felt the need to venture out. If at one time the

eaten their handbags, some are hungrily looking at other guests. The kitchen door opens, and the haughty-looking server walks in holding something in the air, looking much like Picasso carrying Guernica into Franco's house. He places a crusty stale looking loaf before the hostess who displays no interest in the new table addition, continuing to chatter away about Francois Truffaut. Her reluctance to pass the damn thing around is evident to everyone but the French guests, they continue to talk on in excited tones about the Foreign Legion and the upcoming Bastille Day Sale at the Gallerie Lafayatte. Some German guests faint with exhaustion, and are wheeled away by the bored servants, the Mexican Ambassador tries to suck some moisture out of the empty wine glass, hoping the glass blower rinsed it but forgot to wipe. After an hour or more, the server enters again, this time with a selection of cork screws. An animated discussion ensues and the hostess selects the wooden one over two others, the more modern steel and chromium kind. 'It will take longer to open the bottle,' she adds excitedly, and passes the cork screw around to the guests for their approval. Everyone approves of its vintage, the fine woody quality of the main handle, the springy sprightly, almost mischievous appeal of the screw. A bottle of wine finally appears near the hostess, appropriately dusted with dirt so it looks like it has just emerged from a musty cellar. But everyone knows that all French kitchens are equipped with a dust maker, an electric gadget that can spray a range of dust from different periods of French history, and make the newest wine bottle look like it's been handpicked by Napolean or Marie Antoinette or Marie Stopes or Marie Curie. By this time most foreign guests have either died or are being treated for malnourishment and dehydration in the elite ward of the city hospital. Only the French guests remain. The hostess applauds impulsively and shouts 'Voila'. The meal can now begin.

15. For many years I have tried to wean myself off alcohol and cigarettes by hoping to become a television addict. You won't believe how hard I tried to like television, but the quality of programming returned me very quickly to alcohol. For a while I tried the news channels, but almost all of them were trying to outdo each other in Breaking News. If one reported the death of 800 tourists in a flash flood, the other followed it with round-the-clock coverage of a Delhi autorickshaw driver overcharging a visitor from Agra. No news was good news, but all news was breaking news.

16. Satire in fact makes daily tragedy tolerable, applying distance and perspective to an observation or occurrence that may seem too dire close up. All too often, the tragic is so extreme and catastrophic it is already tinged with satire. When a killer earthquake hit Gujarat some years ago, and people lay dying under the weight of illegally conceived highrises, a German relief supply plane waited nine hours at the airport for customs clearance; at railway stations, a tout encourages you to limp so as to take advantage of the ticket quota for the handicapped. In newspapers and television, on roads and routine sightings around the city, are similar reminders of a system driven by greed, depravity and barbarism. Stories oscillate between reality and make-believe, tragedy and farce, and leave satirists wondering how to make an unwittingly funny situation funnier. When suitcases of notes are displayed in Parliament, microphones tossed, and knives brandished, it is hard to enact satire more effective than reality. The 2001 terrorist attack on Parliament House pales against the insider

cinema drew people out, the home theatre pulled them back. If people sought out the public cricket maidan for exercise and social banter, the private tennis court, treadmill and swimming pool now kept them home.[19] The house was everything at once: home, movie hall, theatre, playground, club, and with the office online, also, workplace.

In the private house, access to facility was at the expense of the community. There was no need to share a pool with strangers, when a similar blue container could be dug in the garden. Why engage with others in sport when there was enough room for a tennis court in the backyard? In fact, why depend on the family room for entertainment when the television could be mounted in the bedroom, above the refrigerator.

There were continuously shifting scales of value in architecture, but little time to define them. Time spans were limited; attention was continually shifting from screen to screen. Constant contraptional change. The compaction of time was itself changing relationships to the home, ideas of recreation, even the nature of commerce. You bought shoes on the net without trying them on for size; you chose a beach house in Brazil in a summer exchange for your home in Lucknow. Instant accessibility was the only message of the new life.

attacks that now occur with surprising regularity. If MPs are ready to kill each other in Parliament, Lashkar terrorists could reason, why even make an attempt from outside.

17. Even the false ambitions of the young, the verbal fluency of the intellectuals, and the oscillating conviction of the politicians leave little but a gnawing incompleteness, as if the scale of ordinary life can only be viewed in a flash of personal viewpoints. It is the rhetoric of mindless populism, where everything hinges on the economy, material output, rising aspiration, leaving a maladjusted social system, and a people unlinked to any collective desire for change. In the bleached atmosphere of the new century, it is hard to tell apart the ridiculous from the sublime, falsehood from utter falsehood. When the believers are themselves on sale, the equation hardly matters.

18. 'Every village must have a drive-in cinema, 70 mm; one vegetarian and one non-vegetarian revolving restaurant.' In the flakiest of rural hamlets the minister is seen extolling the advantages of a democratic government. 'I want everyone to have a share in law making,' he says with fiery nationalist fervour. He hasn't a clue what his speechwriter has written. He doesn't need to. Politics requires only physical presence. And he has plenty of that. He never stops to wonder how he can care so little for people and yet be utterly dependent on them for his self-respect, how he can use their universal poverty to heap up riches for himself. He does stop, however to slug down a Coke. Then he continues with complete conviction. 'Because the rich man is rich, he can make the law. But remember…' then another slug of Coke, 'because he is rich he can break it.' He stops to bask in the applause. Then before he resumes, he farts. This way everyone knows he is a man of the people, with gout and amebiasis. An ordinary man just like one of them. 'My promise to you, Friends is not safe drinking water, or live entertainment or safe sex, or free food or education, Rice subsidies or Dal subsidies,' he sneers to let the audience know this is a reference to his opponent, 'but a more wholesome, tangible and immediate gratification. I am so happy that you have all come today leaving all your household chores, cutting your time lying on the charpai. I know what it means to sacrifice the things you love. For this I am truly grateful.' Reaching down past the Gandhi charkha and the green and saffron stripes unfurling around his thigh, he picks up five or six wads of 100 rupee notes, all sealed by nationalized banks, and throws them into the startled audience. His voice booms into the medley of microphones. 'After the election, every registered voter will be given 1,00,000 in cash. Free of charge. Every year. As long as I am Chief Minister.'

19. Sports historian, Adrian Winetraub, writing in the 19th century, described sport as an expression of the six Ss: Strength, Skill, Stamina, Speed, Sweat and Spirit. 'Dost thou useth thine attributes to maketh and measureth sport', he wrote in Latin, making it sound like Olde Englishe. With these six measures, the point he made rang true for all sports, though I would not defend the presence of spirit on that list. Winetraub also made clear those activities that require skill or produce sweat, 'doth not sport' necessarily be, thereby excluding cooking, and baking from the list. And even casting suspicions on gardening. By the same token, how does rifle shooting qualify as sport? Certainly, it takes great courage to work with a weapon as deadly as a rifle, as opposed to a racquet or a bat. But to stand in one place, unmoving and emotionless, and aiming at something immovable, is the antithesis of all other forms of sporting activity. As Maharaja Jasvinder Singh Rathore of Bikaner put it, 'it's like shooting a sleeping tiger from a Machaan.'

24. Architecture as Idea

Perhaps in the information age, the celebration of architecture as a technological device is too simplistic a view. If buildings are used merely to express the sensibilities of technology and the marketplace, architecture would itself remain only a product like any other. The connections between art, the practice and the related discoveries of the commercial context, and the median would be crucial to expression. Moreover, an understanding of the psychology that motivates all the participants—the architect, the building, the buyer, the user—comes into play, producing the discordant variations that make architecture worthwhile.

With all the niggling oppositions and possibilities, the office-studio-drafting room view of art and architecture stands forever changed. That something of immense social value will evolve on a private canvas, without the intrinsic forces of the culture coming into play is difficult to anticipate. For too long, professional smugness has relied on a formula for self-appeasement: start with a few easy exercises in geometry and apply them to a set of requisite functions, enlarge the scope into a vocabulary of architecture, then apply the correctives of style and proportion that expose the building to public judgement and scrutiny. The recipe deadens the senses, but never fails to please. Without the public's place in it, architecture launched as a pitched battle between form, shape and style is an awkward configuration. The critical inquiry and its eventual statement falls outside the language of construction; the obsession with the object is but a view of the self. The self and the need to state an ideal position perhaps may be a starting point for architecture.[1]

At its peak performance, architecture speaks to everyone. Its many layers of information depict many strands of experience. At the centre of its potential is the ability to touch everyone and engage in a way that may in fact alter your conventional view of what buildings are, how they work, what they do. The originality of the experience depends on the building's ability to carry you outside of the conventional reference in memory.

The obliteration of conventional memory is a bitter pill; for though memory stands at the encyclopaedic forefront of experiences that facilitate design, it is also a grotesque impediment to imagination. My attempt to draw, redraw, exaggerate an architectural condition or a reference to buildings into altogether different perspective is in effect to deny the reality of architecture as it exists today. The greening of India Gate is not a design position that endorses the cultivation of grass on the monument. Nor indeed is the insertion of an escalator on the Humayun's Tomb a

1. Today the erasure and demolition of buildings that are out of sync with government policy is a quick antidote to lengthy democratic processes that all too often yields only a stalemate. Yet demolitions raise larger questions on not just the future of architectural heritage but what constitutes heritage itself. For too long, architecture has been the victim of political decisions. Nehru brought a French architect to design an Indian state capital; 70 years later the Andhra government chose a Japanese architect for Amravati; Delhi has awarded the design of the new conference complex at Pragati Maidan to a Singapore firm. Every decision has been backed by a political ill wind, fanned by megalomaniacal pretentions. The confusion is additionally compounded by forsaken responsibility. It took a judge, and not an environmentalist, to decide on the pollution benchmarks for Delhi; in the case of the BRT similarly, the court, and not a transport planner made the decision. A judge also takes the call on matters of heritage. When civic decisions are left to the judiciary, architectural conservation can easily fall prey to private prejudices and inconsistencies. Besides, since major monuments all have historic associations, it falls on the political party in power to decide the relevance of that association. Will someone in government propose the demolition of Chandigarh because it was built under Congress rule; as a viceroy's house, could not Rashtrapati Bhawan one day succumb to the rage of an irate nationalist? Till civic life remains enmeshed in political process, the future is uncertain.

plea for a modernization of the heritage site. Ideas are implemented by changing perceptions.[2] The formal subversion of known landmarks is merely a cause of disturbance to the picture book clarity of places in living memory. The visible erosion of the perfect place is a vital endorsement of keeping it, well, undisturbed, and a perfect place.

The grass on India Gate is there to deceive the eye. The insertion of an element like the escalator, found in shopping malls, into the forbidden sanctum of a world heritage monument like the Humayun's Tomb may be blasphemy. But the intention to confuse and juxtapose opposing refrains cannot be taken too literally. It is merely a device to reformulate and refocus perceptions of the various building types that exist around us. Is the wall of grass on a colonial building really bad; is Humayun's Tomb that good? The reversal and inversion of iconic images is done neither for reasons of confusion nor parody. The initial shock of the change is perhaps an easy way to say that even the most potent symbols of architecture, heritage and culture, now no longer communicate, concern or convince us of their presence.

It is difficult at times to account for the fear of design rejection that convulses and contracts the architect's mind. Perhaps it is too obvious an outcome of a profession that is smack in the public eye. Whose very physical presence on a street, in the city, demands a reaction. The visibility of architecture is in fact its most defeating, deadening component. Buildings can't hide or withdraw. The architect stands exposed along with his buildings. A hunted animal to be laughed at, spat upon, urinated against.

Among the more serious disabilities of the profession is the architect's own rejection of any work that falls outside a predetermined set of professional references. Unlike the liberating strains of art, architecture lives within the chosen confinement of structure, design, within a set logic of places made and occupied. To an extent, every work of architecture is also an unselfconscious description of formula. The practical applications of style, historicism, elevations, façade treatments, the defined parameters of inside and outside, the front and back, entrance and enclosure, the conventions of structure and utilities, all limit the expression into a rigid and strait-jacketed classification. Any and all ideas that do not fall within the comfort zone are rejected outright. New expanded definitions, inventions and untested applications and altered lifestyles, are viewed with suspicion in a profession defined by time-worn beliefs. Every architect begins and ends his work within a prescribed language of architecture. Like an accountant wholly familiar with the success rate of his monetary dealings, the limits of buildings are set firmly within the prescription

2. 16th-century Italy had no explicit need for a flying machine, yet Leonardo da Vinci's drawings for his model came from his own mental mappings. Similarly, a glass dome over New York City was one of Buckminster Fuller's many farfetched ideas. In it was a suggestion of the ecological problems he foresaw in the place. Both were ahead of their time. Having achieved some notoriety in official circles for their inventiveness, and a social label that varied from genius to crank, both enjoyed immunity from the conventions of the time.

344

of design exploration. A rigid mechanism of professional self-defence that cloaks the lack of imaginative thought with a precise controlling vocabulary.

For too long the practice of architecture has relied on such falsification and pretence to project an appropriately synchronized image in the public arena. Merely serving the function of physical accommodation or allowing life to be lived with a kind of natural ease and grace was not enough. That was just a minor requirement. It was always more important for people to use architecture as a convenient medium to convey some culturally acceptable but personal message. Building medieval palaces and English country houses on small city plots, or attempting to recreate ethnically correct allusions to the past, even proposing minimal and modernist assemblies, were all suggestive of a country uncomfortable with the present, uncertain of heritage, and without a clue to the future. In the midst of this terrifying uncertainty, the architect's position was open-ended, without definition or scope. And given the present state of the profession, the current despair of city life, and the lack of interest in building and environmental concerns, he was little more than a service provider. Like a repairman, remembered only when the drains backed up. Or the roof needed fixing.

Part of my own problem had been to think of architecture as a hybrid, a mix of different but related sensibilities that attracted each other, often confused, but invariably adding another dimension to the act of building. Art, sculpture, design architecture, the thrust of an idea always worked as an amalgamation. Often it became difficult to cite the source of the inspiration. Was a drawing on architecture, first a drawing, then architecture? Was the placement of a building within a defined grove of trees a product of landscape, or architecture? Was the underground a necessary condition of basement living? Architecture survives on the border of a whole host of related disciplines: film, painting, stage-set, graphics, sculpture and drawing. When reflected within the frame of architecture, they together produce a richer network of communication and a less stylized form of art. The wish to be inclusive of these influences, rather than selective, allowed for a wider reach of expression. And expressive indeed of more genuine forms of place and identity. Building that is architecture, drama, film, sculpture, literature, philosophy is far more gratifying than one that has too scrupulously complied with established professional codes, the serious monochrome only understood by architects as architecture.

The unfortunate malady of today's practice leaches away the potential for arts influencing each other and creating a more unifying expression. The serious flaws in reading the place of art and architecture in the city is the despairing divisions

between the disciplines. The curriculum is so clearly marked in categories that any collaboration between artists or architects looks like the work of people who have not spoken to each other. The professional disdain for the multidisciplinary work is cultivated so early in career that the artist or architect is forced to define the canvas of his influence. Closed in mind, cramped in style, and claustrophobic in expression, the potential of the work is narrowed and bordered to such an extent that the purity of the work must be retained at all costs. Hence, the small artwork against an empty building wall, the selected sculpture on a city roundabout, the contoured architecture concealed by high walls. The broader brush with the more malignant and terrifying forces of the city is not a safe bet for art or architecture.[3]

How does a developed and evolved work of architecture shed the differences between itself and landscape? When everything is considered in the making of the composition, the earth, texture, vegetation, light and sky, then numerous changing conditions come into play: soft shadows, earth textures, reflective surprises, all bridge the difference between reason and sentiment, between landscape and nature, building and architecture. Considering the whole as an accumulation of sensation rather than a distillation may become the more reasoned value for an industrial environment that is being continually degraded and made more industrial and dehumanized. Could this then become a more inclusive programme where art, ecology environment and architecture can be addressed?

In the last few years I realized that Indian architecture's failure was primarily linked to its lack of engagement with the cityscape. Architects had themselves narrowed the scope of their influence to small parcels of land bounded by walls so high that their capacity to integrate with anything else had been ruthlessly denied. Architecture had become much like Indian art, an object in a sealed gallery.

The inability to think and react outside the framework of requirement set by the building had stifled the work into a straitjacket. The seemingly chaotic external vibrancy of Indian urbanity found no expression in building. Much like Nero building his home while Rome burnt. Unfettered by these conditions, today's architecture is a hollow profession, enforcing conditions of sterility where none exist. In the hope of practising architecture as a pure art, it is once and for all, shorn of the real conditions of India. To be, so to say, a global profession, with a global reading of design, it can only emerge in a controlled vacuum.

The parasitic feeding of international images for Indian buildings only strengthens the resolve for a complete break where cultural integrity is cast to the wind, in

3. Of course most projects are so outrageous that many of them remain only on paper. Drawings in private collection show nuclear reactors converted into hospitals, suicide bridges on the Hudson river, fast food restaurants in the shape of a burger, French architect Bouelle's detailed plans for a penis-shaped brothel, and SITE Architects version of the garden city as a skyscraper.

preference to an international imagery. More and more, the dissatisfaction with the built environment produces a desire for urban work that is outside the usual confines of architecture. To resist any influence of formalized design and move in the direction of content that is socially relevant, indeed with expression drawn from public life is anathema.

In a world of virtual, and constantly changing, reality, the old truths about architecture don't hold anymore. No longer static, no longer controlled by comfort and familiarity, or illuminated and defined by light, its pressing need is one of performance. Its qualities of place-making, and associative memories can hardly be deployed in the shallow time frames within which buildings exist. An indication perhaps of the urban disorder and the heterogenous pluralism that now makes all things possible in architecture: construction, scenography, graphics, colour, language, and of course virtual projection. To recast Robert Venturi's prophetic phrase: Everything is almost all right.

If popular, rather than elitist, opinion was anything to go by, it would only reinforce the perception that architecture had done little but create anonymous backdrops in the city. And little of it contributed to any form of goodwill or human welfare. Recognition by peers was enough for architecture. Sadly, much of the recent work of the younger generation has also fallen prey to the stifling tyranny of formal design. By making every building an expression of geometry in service of real estate objectives the original purpose of architecture as an integration of the arts was lost.

Why had architecture aligned itself to formalist design, when it belonged so clearly in the realm of informed day-to-day art, to forms derived from ordinary urban situations? Instincts embedded deep in local psyche, when combined with circumstances and situations of architecture were the more potent and essential forces for today's symbolism. Assigning meaning to such situations by giving them formal structure could doubtless make for more compelling expressions of buildings, instead of merely contributing to the trite and trivial assemblies of formal design. Enlarging the scope of architecture by drawing on people, situations and urban circumstances was a necessary antidote to the dreary cityscape.

If the built environment's central premise was visual communication, the city lacked any cohesive imagery; any form of identifiable symbols that would contribute to a local community spirit or connection.[4] There was little understanding or indeed expression of current urban sources of content. Nothing that stated a spirit of contentment with the current conditions of the city, or any hope to alter its

4. In the surge to make new India accountable, the character of old India will doubtless play a major obstructive role. At the heart of Modi's Swachh Bharat, Smart City, and Make in India campaigns lies the indomitable problem of public attitude, one that through rigorous training, or denial, or hope is unlikely to simply go away. Unfortunately, the intrinsic nature of each of these three transnational exercises relies on a change of attitude: an outlook that encompasses a wider public dimension. For too long the Indian mind has mistaken Modernism for Modernity. The mere transposition of style, the making of fancy structures, glass malls and six-lane highways, has been seen by most as the shining India of the 21st century. Yet the glitter and shining steel may form a technological replacement for the old brick and plaster walls, but as symbols of the rising affluence they can hardly rescue a culture from its provincial mindset. Certainly, a corrosive and relentless expunging may create artificial pockets of international efficiency and design, a highway here, an airport there, an industrial township somewhere else, but the persistent belief in the second rate continues to mark the country as a stagnant third world backwater. If private enterprise flourishes it does so in a public garbage heap.

future. Architecture's grandiose agendas confused the architect with unnecessary ambition whose primary inspiration was disconnection and a complete severing of all prevailing urban imagery and associations. Architects and architecture survived unfortunately in a state of fearful execution. Nothing extended the limited scope of construction into new untested waters.[5] City governments were unwilling to alter building regulations despite extraordinarily difficult situations of density, infrastructure, transport, and land and building speculation.

It is a strange irony that in a world glutted with information and almost paranoid in its necessity to remain connected and communicative, architecture has grown into absurdly insular and derivative assemblies of arbitration. Its compositions do nothing but restate the architect's undying faith in technology. Obviously practical reasons for architecture invariably overshadow the psychology of communicative devices, but that can hardly be seen as a limitation. The self-imposed enslavement to abstraction is a painless choice the architect has made for himself. The safety of practice from a closet full of rules and a narrow scope for expression is just a method of convenience. By making technology and abstraction a virtue, the architect can easily avoid the looming threat of ideas and expression. Like the earlier styles that took inspiration from the industrial revolution, or machine age imagery, the present allegiance to abstraction is simply another style.[6]

Yet, for architecture, symbolism and the subconscious still remain a potent source for inspiration—unintended ideas at the edge of art, communication, social life, information, oscillating between the visible and unseeing, between fact and fiction, elusive and unbridgeable, without self-conscious associations or obvious links. An unapproachable new way of building, capable of establishing a starting point, a discourse, and an intended entry into the profession.

5. Our urban sensibilities have developed out of the state of permanence that links owner-ship rights to land and property, with the immortality of ancestral, and succeeding, families in continuous and permanent occupation. The house, like its owner, would live forever. The 99-year lease was not enough when many new generations would pass through the same piece of land.

6. Even now, despite an open globalized economy, the more relevant research and invention comes from abroad. In a small town in northern Sweden, Lars Lundgren, a mechanical engi-neer has invented a dust vacuum. A 30-inch high noiseless conical device that absorbs the dust in a room; small, battery operated, it requires no movement, just a place on the floor. Surrounded by snow for a good part of the year, Lundgren's invention was inspired by the few years he spent in Algeria, where high dust levels would make such a device useful and necessary. In Japan, only recently the Kuchofuku Company has designed an air-conditioned jacket. A bulky enclosing overcoat that draws air through a set of fans inserted along the side, and keeps the wearer cool for up to 11 hours on a single battery charge. A few succes-sive heat waves in Japan were enough to get Hiroshi Ishigawa to produce the device that does away with the expensive conventional cooling of whole buildings. 'Air conditioning people is a whole lot cheaper,' he said. Likewise, other ideas prevail. Germany, despite high levels of cloud cover, relies heavily on solar power for its energy needs. The vast acreage of solar farms is visible from the air all across the German landscape. All three devices, the dust collector, the air-conditioned jacket and solar power, are essential to Indian needs. Yet all these inventions are from the West (Japan is so far east that it is as good as West). In the search for solutions that are radical and far-reaching, the Indian mind is mired in the belief of a second-rate culture, unable to produce anything on par, or better, than others.

25. Art as Idea

Of the many real threats to urban life nothing is more visceral and despotic than the threat of daily living without spontaneity, imagination and the unfamiliar. A mere consciousness of daily routines is a limited and indeed limiting experience. The role of rational thought and the processes it entails is overrated as a measure of people's awareness of their surroundings. A life of automated skills, and all the forces of dulling habit, merely exercise the notion of economy, the quickest way to get to a goal—the passage down the street, the wait for the No. 17 bus, the stop for a coffee—every aim to be recalled in the mind and tackled in the most logical manner possible, completely unaware that reactions are passive and mechanical, in a daily game whose rules are all too familiar.

The establishment of a serious requirement for art as a meaningful representation of urban life is as critical a cultural need as physical infrastructure is a physical one. Moral codes, manners and social behaviour may be a daily experience for a city dweller, but its direct and visible reflection in art is an equally valid requirement. Art, unlike the sciences, or the physical needs of a city, however, has no real measure of progress. Periods of stagnation are obviously linked to art's indifference to ordinary life and reality. But in a world known to continually repeat tried and tested models, art helps to break moulds and realign the visual links to life in the city.

But much of the assessment of art can only be conjectural, since most artists do not, like scientists or writers or researchers, write or convey anything of their realization. Artists, unlike practitioners from other fields, are not subjected to the ordinary rules of the game. They do not require the laws of physics or scales of economy, or professional codes or regulations, to justify their work. The singular aim to all art, especially that which reflects a civic reality, is to make the spectator a serious accomplice in the creation. With bloodsoaked hands and a decoded understanding that says that the artist and viewer share a secret.

It is then hard to think that any artistic work is governed by rules, yet at a subconscious level there are doubtless codes that lend coherence to the work. Individual though it may be, it makes up its own visual codes in defiance of conventional rules. The fluid nature of the codes is itself enough reason for other artists to follow or flout the work. The discovery and imitation of the predecessor in artistic terms does not amount to plagiarism, but merely becomes an inspiration.

Is an artist's role one of creating accessories of architecture—a sculpture in the lobby, a painting on the façade, a fabricator of logos for corporate offices? The secondary

nature of such art trivializes both, the artwork and the artist. Architects who leave space for art in their building often produce as ordinary an architecture as the art they accommodate.

Instead, like architecture, the place-making aspect of public art is crucial to the setting. So loyal are sculptors and other artists to the form of their work, that they often miss its interactive quality with the environment. Much of contemporary urban art smacks of trite and unhealthy elitism, where appreciation is sought from a select few. Placed out in the open is enough reason for a common, more public appreciation of the work. Not as a gallery without walls, with wine- and cheese-tasting, but a decoded trampled transient place, with all the malignant urges of despair, greed, confusion and contamination that infest ordinary city space. The urge to mix with the surroundings, the people inhabiting the area, the urge in fact, to become the surrounding.

Architects and artist are too often dismissive of such criticism and are quick to cite the transitory nature of the new work, and its inherent inability to make any lasting contribution to city life. Perhaps the discord lies in the architect's reluctance to alter the prevailing definitions of architecture itself. To see outside the narrow field of space, and the parochial views of architecture as an abstract expression of technology. And that is all. Such a tendency limits the potential of cross-fertilization between art and architecture, between art and landscape, indeed between urban life and architecture, in a way that also promotes conventional distinctions between popular and high culture, between people's art and gallery art. Only a serious and informed rebellion against the predefined understanding of the arts can eliminate the distinction and offer untied urban possibilities for new explorations. Unless public architecture and urban art are together affected by this resolve, no purpose would have been served.

Art as a form of construction, or art that participates in architecture, or one that connects building to its surroundings adds inherent value to the environment. The staging of art in a gallery merely exaggerates the continuing isolation of artists from public life. To produce controversial objects and images within enclosed walls is a strange and smug form of personal indulgence in India. Especially so when the streets, the parks, the metro rail roads and public places of movement offer such a rich and radical source of inspiration and participation. In the absence of public discourse, public life, and indeed the public's lack of urban participation, civic art can act as a desirable catalyst to erase people's indifference to city life. The opposite of the controlled gallery, the heavily peopled commonplace urban areas are the

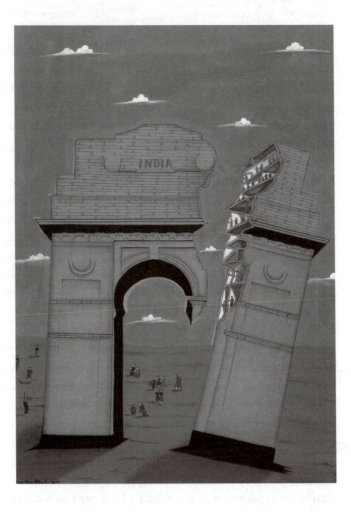

canvas for developing artistic ideas. The spaceless sidewalks of Chandni Chowk in Delhi, the messy street life around Mumbai's Gateway of India, or the Sabarmati riverbed crossings between the old and new cities of Ahmedabad pose formidable possibilities. The potential for public art is at its highest in places where peoples' presence can give it weight and impact. An isolated sculpture on top of Delhi's India Gate has as much impact as a seminar on water harvesting during a severe drought.

Public art's most serious intent is also to rile and provoke. To create conditions of mismatch and serious misunderstanding between the observed and the observer. The situation of visual discomfort can come from art's ironic juxtaposition of the ordinary in an extraordinary setting. Humour is a critical tool to create a thaw. To introduce an idea and to elicit a reaction. So encapsulated in a routine is the public in the movement around the city that little distracts from its daily sight path. Art offers the sudden change in visual plan. Humour marks it as an instantaneous initiation.

The reading of the urban Indian landscape as inherently ugly makes artists withdraw into a closed door confinement. As if any expression in public space will only render the art object impure. Yet the many impure forces of urbanity—sign boards, roads, buildings, language, popular media, advertising—can all be used to enrich the engagement with art and can themselves become interactive forms as potential sources for inspiration.

The current search for art that is appropriate to a public place lacks both the conviction to experiment at a public scale as well as a comprehension of the artistic challenges available in the city. This stems in part from the confusion of what constitutes public space itself and partly from the inherent inability to understand the relationship between art, architecture and landscape. The conventional view of art as a curatorial commission of works in a gallery, and open to select private viewing, has denied the city the truly environmental impact of art. In a few cases, in Delhi and Mumbai, public art has merely come to mean a large object open to appreciation on the street.

In urban art perhaps some of the old codes of composition, relief, organization and perfection today rarely apply. Judgement rarely takes such archaic positions. The seemingly critical aspect lies in an innate connection with the viewer itself. However original it may be, art's success can only be gauged when the piece becomes common property, when the engagement with the public amounts to a prideful possession of the public work.

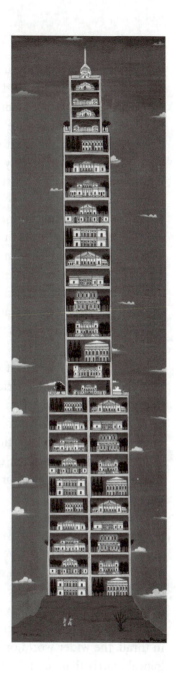

All across the way, the attractions of art are coated in visual pitfalls. The visible is a complex and personal field, which works through vague intimations, blurring in part, focused in another, issuing reminders through a twilight of memory and experience. The viewer is at once scanning an outer landscape as he is testing it through a mental one deciding what is relevant, what indeed can be dismissed. The entire view is patterned differently for different observers. The trance of a dreamer, the vivid imagination of an artist, the fantasy of the day dreamer.

Some years ago, I started looking at the possibilities of integrating art within the existing structure of Indian urban life. The proposals acted as an interface between architecture and the city, landscape and the city. Because so much of contemporary architecture was without culture and contextual reference it was critical for the projects to introduce a direct and visible relationship between people and their city. Without the overstretched and much maligned principles of modernist design, it was possible to make places that had a more visible impact on ordinary lives.

In a maze you lower yourself slowly, as if immersing your body in a river whose currents are invisible on the surface. The visible pattern of the maze invites exploration that is part mathematical and part visual, part even memory and recall. Each step is a process towards a centre; a journey that marks many moves and many reversals in plan. Paradoxically, the reasoning is an unconscious method, and excessive thought or analysis is often detrimental to the movement and progression within the maze. Successful random moves are possible when the thought process is no longer a guide.

By the same token, the artwork's visibility in the urban maze requires a relaxation of the social codes that govern behaviour on the street. Its true success as a work of art depends on its denial of logic and common sense, and instead an unfolding of some other unconscious resource. When the connection to art flows in freely drifting so to speak by its own gravity, in reverie, there is a discarding of all conventional sources of reference and associations. For that short spell when you are held in thrall, the wider world opens, and draws you away from the mean-spirited and logical matrix that you inhabit most of the time. The experience of art destroys the links and meanings of the surroundings and leaves you open to a new experience. At its best, art or architecture acquiesces to the observer's extreme gullibility.

Many of the proposals suggest a hollowing out of the ground, an underground game, which is perhaps a way of seeking a position outside of ordinary urban surface; heading into the air or down below into a substratum. As if in seeking solace

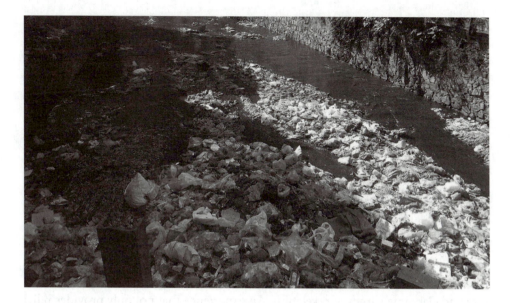

and haven, the mind too drops below, to some prehistoric archaeological place, buried below the city. And relief can only be sought from the hurried, blemished surface by dropping below, into a forbidden and uneasy excavation. All those people denied their daily dose of dreams, their inarticulate and sudden impulses, would find relief in the tomb below. Outside the daily frame of habit, the underground and its mystery becomes a psychic dose, essential to a life deliberated by automotion, and controlled by routine. The city's necessity to give visibility to its mysterious underground in sporadic moments of urbanity, will provide a 'useless' undetected tissue, to the obviously 'useful' city structure above.

The difference between the two layers reflects the body's own juxtaposition of the conscious and the subconscious. Outside the realm of awareness, the underground reveals no instant patterns or messages, no evident plan, position or orientation. Instead it remains embedded in a personal flight, an experience that unfolds in rare and elaborate surges of revelation. An experience that not only provides relief from surface tensions but requires a whole different set of observational skills and maneuvres to master the new matrix. If ever a wholeness is felt in the experience, it comes only after a conscious relinquishing of conventional codes and behaviour. Away from the waste, the deliberations and weariness of the city.

At the heart of the exercise lies the hope that the temporal experience of the substratum will at some point block the experience of the surface, and the logic operating above in the waking state will be defeated and lost. Its real success can obviously be measured only in the parallel states of two completely incompatible urban contexts. The quiet underground secret garden in the tumult of Chandni Chowk; a water maze within the parched summer ground around India Gate; or a glass structure housing Mughal antiquities in the centre of Humayun's Tomb.

Free-wheeling and outside conventional thought, the final prize in fact is not an isolation of the original score, but an engagement of two opposites, working in tandem and ultimately producing a combination with a singular multi-dimensional purpose. In time the two begin to be seen as one. In even greater time when the whole becomes saturated with rational purpose, a third intervention may be called for. The forever changing layers of city, surface, air, and substrata keeps the viewers in a permanent haze, always intermediate and in-between acts, part conscious, always between dream and action, between change and permanence.

The image of the maze is not meant to deliver confusion, but as a piece of mathematical art, its delivery is always obscured by movement and the occupant's inability

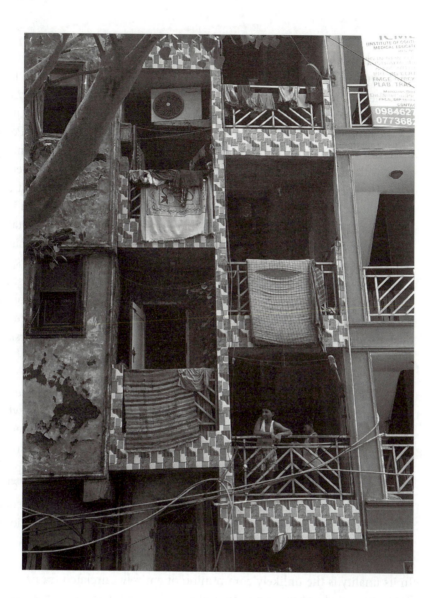

362

to view it in a completeness. Its precise and unstructured movement is its greatest asset. And the viewer feels his way around a structure of increasing possibilities. That there is no one single answer, leaves the viewer feeling his way, trying to imagine a pathway, in his mind's eye, even completing the journey. The frustrations of travel through the maze are conditioned in positive environments. People move, turn, move again, only to find their movement blocked by an internal garden, a space with a halt in the journey, a water course with a bench, a shade tree in an open path. The successful discovery of the centre may be the final prize, but the journey itself is staked in a series of smaller prizes. In such a place the human imagination is not tested, but merely descends to a more primitive, more archaic, state. As if the boundary between the body and the mind are fluid and interchangeable. Your own self is diffused within the intricacies of changing fluid and an uncertain space forever on the move. Alone within the maze, the mind's surface agitations are stilled and an empathy with the surrounding occurs, when boundaries are not visible, front and back undefined, and even movement is not a final commitment. The enveloping mistrust of architecture induces the occupant into an ancient catharsis—an utter calm or an involuntary fear of the underground.

Inside the maze, drawn into the work of art, the mind suspends the preconceptions and prejudices, and the tyranny of its own overuse, and for a short while at least becomes liberated. It unlearns and resorts to a hope-filled forgetfulness, losing its bearings, relieved of the order necessary to maintain its discipline in society. For most, such moments are merely a form of relief; for the artist perhaps they serve to recall a creative impulse and fresh insight oscillating between the old world of habit and the new one of surprise and discovery, residual places, structured and juxtaposed as opposites, recalling the subconscious within the conscious, and the impulsive, illogical and creative streams to the surface.

In its finality is the unlikely communion of entirely unrelated frames of reference. They are united not in a resolution of an urban problem, but a hope of exacting a more resonant fluency and exchange with city space, a sort of artistic liberation that is not possible in the day-to-day ordinary structures of city life. The work of urban art conforms therefore to a dream sequence. A space devoid of urban etiquette, the rules of behaviour, and all the social niceties that coat the daily play on the surface. Instead the dream turns the work into a visual riddle for the mathematically inclined, a twilight passage for travellers, and a spot of shade for those seeking rest. A different purpose, a different memory of reminder to each player. In the end leaving only a tangential record of the experience, merely a speculative pointer to time spent, time lost and regained.

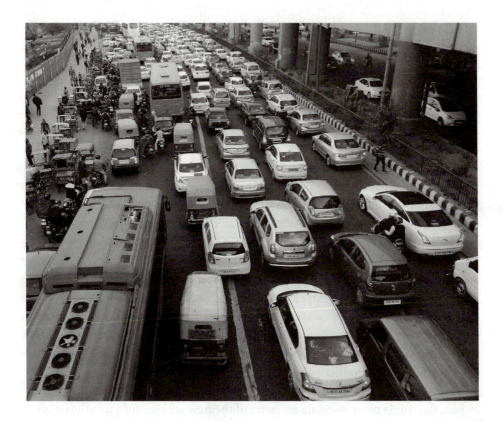

A Future Imagined

For so long I had approached architecture as a problem to be solved, much like a surgeon treating a cancer patient. Indeed much in the way a politician perceives India, a place of problems. It took some undoing to understand that such an approach was not only flawed but filled with a ready dose of perennial defeat. As a result, whenever I built, I felt a desperate need to rub in a point, to force my building beyond the boundary of mere acceptability. This is in part the outcome of a culture that exists beyond subtlety and nuance, where exaggeration and extravagance are legitimate ways to make a point; the obsessive Indian needs to create melodrama in order to be heard, to shout louder than the rest and rescue the message from noisy oblivion. The Indian architect, me included, had established himself through over-design, and ensured visibility by clearly stating in the façade that a professional had been at work. Such an attitude is often expressed in the need to perpetually complicate the simplest of expressions, or conversely, to simplify to a minimalist caricature something naturally rich and complex. The idea was to needlessly corrupt and hinder communication. When the hyperactivity of marketing had overtaken the minutest task, it left the final product as just another product on display.

In fact, the single most palpable measure of the new architecture was the delight in its own impermanence, in its demise. Where decay was no longer the accepted outcome of ageing and passage, but of decline. The highway was potholed out of incompetence and negligence, but architecture was decadent by design. It endured only during the short period of its waking state at night, but in the sunshine, it looked sad and forlorn, reduced to obsolescence and irrelevance. I stood many times in fancy glass malls and rundown small-town hotels called Maharaja Regency or some equally unironic aristocratic name, and wondered if these were the true representations of 21st-century culture, my culture. Monuments to the new century's belief in intemperance and impermanence. To fill your sight quickly with city noise, and the belief of wealth, could hardly replace the loss of intimacy that accompanied the death of the old ways, and the mismatch of the new. The confusion of participation in architecture's foreign language, its techniques and semantics was the outcome of an elastic stretched identity. The young girl from Punjab wiped away her accent to answer the American phone complaint, in a building that had tossed itself into the global discourse. The resident and residence were now both one and the same.

At its core the experience of architecture had changed, from three-dimensional space to a planner image. More and more, buildings were being practised as stage sets. Part of the reality of a world where the day was merely an interval for the

movement of information and the steady deletion of junk. Architecture too was getting closer to time than to space. Its physics, and perceived tactility, belonged to another time. The corrosions may have altered perceptions, but at its core, it was not a serious loss; for the idea that any element—building, art, or landscape—marked a serious change in people's thinking was itself enough of a success. Within the public sphere, involved in the imparting of ideas, and the serious delivery of a message, the effectiveness of the public's participation was after all the final test of architecture. Besides, as a culture we liked our buildings to be insular and formed out of private inhibitions, not as expressions of collective ideas.

A more successful application of ideas was already visible in the landscape of other countries. China's experiments with alternative energy were already reaping benefits for its own rural North. Villages around Houxinqiu near Mongolia got their power from wind turbines mounted on the surrounding hills. At Abu Dhabi, known for too long as a playboy kingdom with a long tradition of imitating Las Vegas architecture, a sheikh had hired architect Norman Foster to work on the plans of an entirely new zero carbon, zero waste city. Foster's new form of town planning was a combination of the traditional and the technological, the earth surface treated as the obvious interface between humans and nature. At ground level all the attributes of the organic life were visible: low dwellings, closely packed, shaded walkways, cycle paths, meeting, sports, recreation and household amenities, all within easy walking distances. Below ground and above it, however, the architecture became an efficient machine, feeding the building its energy from the sky, and drawing on the insulating thermal qualities of the earth. At its very core, the design of houses, their relationship with each other, the nature of the neighbourhood, the scale of amenities and recreation, and the value of transport were thoroughly investigated, and realigned in unexpected partnerships. A form of innovation, extreme in scale and monumental in effort eventually produced a working blueprint that could influence lifestyle in future communities.

On an island near Shanghai, plans were also underway to house a million people in what would be China's first eco-city. Not a half-baked idea to reduce the carbon footprint, but an attempt to eliminate carbon altogether. Not an eco-friendly place because eco-friendly is the trend these days, but a radical search for a new form of urban life. A lifestyle without cars, without streets, without conventional houses, Dongtan, the largest single construction project, a future city never attempted in the developing world. The effort was an unprecedented mix of high finance and lofty ideals. However, in a country with rampant uncontrolled urbanization, and more than 90 cities of a million plus residents, it was an experiment worth trying.[1]

1. Large scale demolitions and upheaval is nothing new in a country where State ambitions—ideological and economic—override those of ordinary citizens. Whether the Three-Gorges Dam, a thousand mile highway between Lhasa and Beijing, or high-tech rail links between the cities along the East coast, the Chinese bulldozer devastates on a monumental scale. Without a whimper of protest. No voice of dissent, no public interest litigation. How can there be? When the images of change are so seductive, when the conversion of historic cities into global showpieces for Western architects is so easy, the long-term tragic consequences of globalization can barely be felt.

When complete, Dongtan would leap way beyond the environmental and technical thresholds set by Western experiments, and create its own benchmarks for future cities. In sheer scale and ambition it was meant to even out-Foster Foster.

In India, with apocalyptic demographics,[2] a daily population surge from the countryside, and unquenchable demands for energy and power, the search for new solutions for urban life, energy and transport should be a priority with all civic governments.[3] Yet most attempts are half-hearted and timid: low repetitive housing continues to be built on a suburban scale, a few solar panels are mounted on street lights, buildings are still designed on pre-independence technology, and an infrastructure of broken roads and bridges tries desperately to keep pace with changing demand. Beyond all the fancy glass shopping malls, laden with dust and pigeon droppings, the city remains a spiritless mass of broken plaster, smudged and monsoon-stained.

Without the radical reach of new ideas can the Indian city ever expect to cope with its rising population and material demands?[4] In three quarters of a century since independence, little has changed in Indian urbanism or architecture, or ways of thinking. No attempt has been made to define in a common language the kind of city we would like to live in. No one has initiated a perceptibly different idea for preserving the culture of historic quarters, or creating a fresh approach to the design of new towns. If the fortress towns of Jaisalmer and Jodhpur were battling modern problems of incorporating increased utilities and sewage disposal into a traditional city-structure, the new state capitals of Gandhinagar and Bhubaneshwar were repeating the urban mistakes of Chandigarh—vast, sprawling and characterless, they continue to straddle the uncomfortable mix of discarded planning ideals with Indian living patterns: the rich living in the selected sectors, the poor on the fringes, and commerce everywhere in between.[5]

Twentieth-century ideals of urbanism fall apart when applied to the numbers' game of migratory shifts. The character of the modern Indian city of the last half century is based not on planning and design, but on the uncharted forces of urbanization. The movement of people—as refugees, or village migrants—is largely an economic phenomenon that, unlike the Western ideal where movement from country to town is a search for a better way of life, is here governed purely by economic needs. The critical social dimension of concern for settlement is entirely missing. The city is

2. By 2025, the 300 megacities, each with populations of 10 million or more, will use only 2–3% of the earth's surface, but will be responsible for more than 80% of carbon emissions of the 5 billion strong urban population, of which a fifth is expected to be Indian cities. This requires both a realistic assessment of the land's natural capacity, and a quantum leap in planning. A recent report by McKinsey Global places India at the forefront of urban uncertainty with rapid urbanization; the country's towns will populate to dangerously high levels. In barely 10–12 years, 35 cities will grow into megacities. The conventional relationships with the land and the house as an independent entity on a plot is archaic and wasteful and requires a serious rethink of what constitutes a home in the 21st century. While Tokyo at 20 million remains the largest city, Mumbai is expected to climb from its present 6th place to 2nd place.

3. Today, the need to accommodate the rising numbers by extending the city into multiple corridors between metros may be the Indian government's way of taking the city to the village, but the seriousness of the attempt can only be gauged if there is a genuine desire to create appropriate space and livelihood along the corridor. The densification of villages into cities can be a success only if the social and cultural constraints of local lives are taken into account on the road to prosperity. Never having ever attempted even a modest alternative to the current city—or village—how can the mere fact of industry and manufacturing be used to reorder rural lives, or become the basis for new cities? It is in the nature of migration that it can neither be forced nor planned. This is as much a condition of democracy as it is of human nature itself. Certainly if given a chance, people will move into conditions of security and permanence. But the forced evacuation of large numbers from the rural areas and their eventual resettlement into the unfamiliar hardened landscape of a new town is often a catastrophic social nightmare. The Industrial Corridor's decision to bring the city to India's villages may seem like a novel idea, but its sociology seems misguided and simplistic. The intent, to lift Indian poverty into European abundance and make, once and for all, a complete erasure of rural memory, is as inhumane as it is implausible.

4. *Radioactive wastes from a joint-venture nuclear reactor had contaminated the sacred river, but the four Brahmins who lived in the village on the river bank didn't give a damn. Caste was still the only major political issue in their small town, and the only real measure of social standing. For the four, friendship was governed less by shared age or interest in cricket, and more by the inexplicable bond of birthright. They were Brahmins. They had grown up together, stoned Scheduled Caste children together, together they had burned a Muslim shrine, and together they had used the temple fund to invest in Reliance shares. They were truly men with an illustrious ancestry. Of the four, three of the Brahmins were well-versed in the sacred texts. They could deliver long-winded dissertations on pure, chaste living on crowded mass transit trains, or give convincing lectures on moral upliftment at the opening ceremony for a Nike shoe factory. When it came to religious scholasticism they were absolute pros. But in real life situations they had one problem: they were entirely lacking in common sense. The fourth Brahmin was precisely the reverse; he was completely ignorant of the Shastras, even the abridged paperback version, and he had no interest in reciting Sanskrit shlokas at weddings, even when he knew he was going to get a polyester silk lungi at the end of it. But he did have one enormous asset: he knew how to handle bureaucrats with political aspirations; he knew how to haggle and*

merely an agglomeration of private opportunity and temporary footholds that pro-
vides no valid reasons for a collective urban life.[6]

In its constantly transforming, beleaguered state, the city's engagement with its cit-
izens also stands changed. Unlike its medieval conception as a place bounded by
walls and gates, the new city is without physical boundaries; it stretches beyond
visibility, beyond physical comprehension; and it houses people, places, incidents
and ideals that may never intersect with each other. Its dimensions, consequently,
can only be vague—measured in mounting kilometres, and expanding statistics—
numbers of homes, numbers of homeless, etc. But within its vast agglomeration is
the existence of smaller cities, places with personal boundaries, prolonged and expe-
rienced over time, places that set the limits of engagement for each of its residents.
While the larger city is in constant flux of migration, construction, demolition or
other less easily measurable incidents—crime, marriage, rape, accident, political
protest, religious festival—the personal city remains constant and unchanging; its
sites are traversed daily, and still engage the senses like a traditional city in a phys-
ical way—in walks, drives to workplace or market, recreation and sport, domestic
activity....

However, the psychological dilemma of a spreading city unfortunately fuels
unreasonable sentiments: both, private aspiration and public apathy. In a city
where people are privately demanding and publicly indifferent, it is impossible
to create cohesive communities. They want more electricity, more water, more
entertainment, more shopping options, more and bigger cars, better schools,
better medical care, more servants, house pets, security guards. All life is built on
material expectations and the promise of their quick delivery. In contrast, public
life is steeped in abject squalor. The inability to share urban resources equita-
bly makes for lowering standards of city life. More pollution, uncollected gar-
bage, encroachments, stolen electricity, water wars, road rage, crime and sexual
assault.[7]

Bureaucrats and planners are too often dismissive of such conditions as the unfortu-
nate side-effects of an era of transition. But the amalgamation of the present, social
concerns, imaginative ideas, and the long-term hopes for the future always over-
ride the designer's private reality. What he built as an expression of his reality was
doubtless different from the larger collective that experienced his architecture. So
any personal call to self-expression eradicated and submerged the revelation of that
experience. The autobiography of building revealed much more about the architect

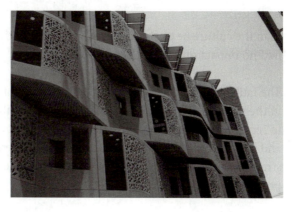

bring down the autorickshaw fare, even with a driver of a minority community. He knew who to bribe for a government house allotment, and with what amount. Though he did not possess the smooth oratory of his learned colleagues, he had a sort of earthiness that let him commune with every situation. He was, as you might have guessed, blessed with a great deal of common sense. One day, the four friends were sitting around the sacred fire after a marriage ceremony, discussing the Ecclesiastical Nature of Religious Inquiry.

'Religion is an important concept,' the eldest of the group said, passing around the ghee.

'Of course,' replied another.

'It's more important than physics and chemistry.'

'Certainly older, and more lasting.'

'It's God's way of bringing order to the world.'

'You might say religion is a way of life.'

'Yes, you could say that.'

The discussion proceeded from philosophy to poetics to dogma. As the flames of the havan shot higher and higher, the tone got harsher, more polemical. 'Can you imagine what would happen without religion?' the wisest of the four said.

'Gosh, that would be awful…. Housewives would have to convert their puja rooms back into closets.'

'Temples would be sold to some hotel chain, I guess,' said another.

'Life would become meaningless. People would wither away and die,' said the third.

'We'd lose our jobs,' This from the one with common sense.

As the four gazed at the room full of affluent businessmen, and the glow of the fire, resentment crept into their visages. They saw the businessmen's wives, all hennaed and lipsticked, their powdered chests burdened with entire jewellery shops, and they could not but feel the pain of economic injustice. It occurred to them, not for the first time, that the ascetic life left something to be desired.

5. Unfortunately when foreign ideals and designer townships become realities in the Indian city, few are interested in cross-examining its contents for ecology or equities in energy, transportation and lifestyle. Yet if ever there was a need to comprehensively examine the forces of Indian city living, it is now. With growing populations and nagging displacements, a yawning gap between the old settled and the newly arrived, and indeed between livable space and available space, the search for an alternative way of urban living is the single most glaring need for the city. Despite monumental problems and annual shortfalls, the incomplete approach to planning and design is part of a government psychology unable to take bold initiatives. Working within the limits of conventional understanding only when problems manifest themselves in health epidemics, housing shortage or food contamination does the government initiate action. An ₹8,000 house designed by an engineer 20 years ago was seen as great thrust towards a bold future. That the cement and bamboo structure would be hot and cold in the wrong season, had inadequate ventilation, and was entirely unsuited to local ideas, was overlooked by the seductively low cost. The house was a winner solely on the thrift of its construction.

than the culture he or she inhabited. Consequently, architecture's private expression had no impact on the collective feel of the city.

The fault lay in the disregarded imagination and the inability to lay claim to a place in the present. Other places and cultures had deliberately nurtured the imagination to recast ideas of architecture for themselves. But complacency had left us withered, and sown the mistaken seed that whatever happened in the disjointed chaotic daily stream around, architecture would itself provide us the much needed message of protection and resurrection.

We had come to understand the culture of cities in one-dimensional terms: the growth of a society from a piece of land, private ownership, a home and family, all growing independently and piece by piece, like an elaborate jigsaw filling ground space and gaining height, till land and air and sky became one, Delhi turning into Mumbai, Mumbai to Singapore, Singapore to New York. The rational logic of land and buildings remains moored in the self-conscious bits of self-made structures, which over time, began to coalesce into larger fragments, into neighbourhoods and communities. The incremental growth was rarely seized or overlayed by some other more potent architectural logic, certainly never tested by ideals that upturned a simplistic ancient resolution on its head.

In its present state no one had asked how the current enlargement of the city by migration could create better lives?[8] If home was a job, and all urban life was characterized by displacement, where did it position the value attached to human activities, to culture, social life, even the sustenance and growth of the spirit? On its own, migrant life could hardly be the aspiration for city living, when all it did was place survival at centre stage. Food and procreation, more food, movement and work, a family huddled over a few *rotis* on the sidewalk.

Certainly the historical view always pitted survival as the first basis for life. But why was there always a linear progression in establishing food and family security as the first basis of home and settlement, and only then to enlarge and encompass into community? If so, the reach of art and culture would be an altogether impossible aspiration for the new migrants—people who would form the primary population of Indian cities. Could then a reversal be enacted where urban life begins as an offshoot of culture, where art is itself used as a means to urban survival? Would then a rural imagination flower and give added value to the city?

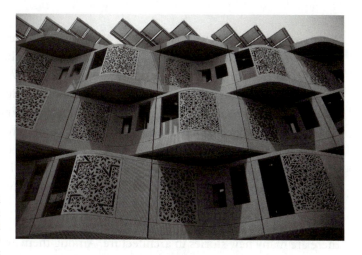

6. The city of the future will emerge out of migration numbers, and planning will be turned upon its head. No longer will the great symbolic spaces of Delhi or the state capitals hold relevance. For the new majority, the tradition of land ownership, home, civic participation will be drowned in their own reality: a shifting employment and home as temporary camp. Public professions of bureaucracy and planning will necessarily have to reorient their aims to migratory tasks rather than defining fixed structures and boundaries. Fluid, constantly transforming cities will become the norm; the architect and planner will be pushed into a corner, figuring out possible methods for their new, relentlessly mobile clients. Without building, how do you give definition to a city? Lacking ideas of its own the government has no choice but to accept the prototype of the Western model. But to simply allow the Indian city to fester into a half-baked imitation of European urbanism like China is shameful and callous. In the long term, the Indian city will become a recognizable original entity only if it gives cohesive structure to migration. The will to survive and prosper will only happen if urban life is clearly defined for the new majority. If anything, the older, settled middle-class residents must learn to live with change, and if necessary integrate, or move.

7. After my sister's death some years ago, I had carried her ashes for immersion in the Kosi river, an insignificant mountain tributary of the Ganga. I wanted an unsullied bit of water for a religious ceremony, and so chose a secluded stretch of the river in Uttarakhand near Ranikhet. But despite the remoteness, the water and its sand bed was littered with plastic, toothpaste tubes and instant noodle packets. And as the ceremony progressed, I noticed upstream from us a group of men defecating and chatting on the river rocks. It is no secret that India has the largest number of people defecating in the open, even when a toilet is available. Whether rivulets along sloped hillsides in pristine Himalayan valleys, rivers coursing through cities, or indeed along coastal beaches, water is as much an invitation to drink as it is to excrete.

8. The question is not whether a city should be governed as a business model, as a state, or as a municipality, but whether it can be governed at all. Take Tokyo, London or Singapore, for example. Despite radically different political and commercial enterprises and social attitudes, these cities have grown with remarkable similarities: they have encouraged diversity of population and culture, preserved historic neighbourhoods; their upgrades are formed out of local consensus. Their primary governance comes from citizens' groups with local civic priorities. Private philanthropy funded New York's theatre, parks and libraries a century ago; in Jerusalem a museum shows any proposed building additions to the city, allowing citizens to veto proposals they don't like; a Stockholm civic ordinance allows apartment dwellers without access to a park, to use the gardens of private houses. The essential nature of civic life abroad is formed out of a capacity to share. The government acts merely as facilitator, an enforcer of equality, while the real work rests on private initiatives.

Where would India be were it to resort to an imaginative resolution of its many problems? Would urban transport find a solution in more buses or designing communities where work and home are in the same place?[9] Would smaller cities like Bhopal and Nagpur with relatively lower electric consumption patterns benefit from solar farms? Or port cities like Kochi from wind farms? Could building by-laws in Rajasthan be changed to allow houses to be built underground to take advantage of the desert's ambient temperatures? Can bio-degradable cars be made of pulp or waste wood for the relatively low speeds of our towns?[10] Is there a non-polluting bukhari that can keep a homeless family warm without spewing the 30 tons of daily carbon in winter?

There are many new stories in architecture. Among them are the low-cost house in suburban Lucknow that is entirely powered by solar energy, the textile factory in Gujarat that uses desert wind to power its looms, the low-budget hotel in Rajasthan where guests sleep in underground courtyards. Even in the hills, the building of individual vacation cottages is now viewed as wasteful and uneconomical. Used as occasional summer retreats, an enterprising builder has created 'The Verandah House' where private apartments are built around a common verandah, used as a shared living room. Or a riverside retreat built with stone walls but with a tent as a roof, a light device rolls away on pleasant spring nights. Is it possible to redefine Indian lifestyle in the context of lower budgets and a recessive economy? To find that luxury exists not in excessive air-conditioning but lying in a courtyard looking at the stars. Or sharing a verandah with friends because there is no living room in your mountain house. The absence of conventional luxury is conveniently replaced by the attractions of design innovation and economy. Why does the low tree-lined landscape of Bangalore suffer the indignities of footbridge replicas of the Howrah Bridge in steel and concrete? Does mere state-of-the-art engineering make the new Jamuna Bridge in Delhi a landmark? Wouldn't a more comprehensive public art view of a river crossing by pedestrians, rickshaws, cars and other forms of local transport have generated a more thoughtful, possibly multi-level, structure? When architecture is seen as a problem, the building is itself one. A cultivation of innovation brings to the profession an outlook that coats the building with an unexpected future.

If I gauge the state of architecture in India, it begins in a rousing ground-swell of good intentions and ambition, then peters out into an erratic rudderless uncertainty. In the 30 years of my own practice little has changed in technique, material, construction and design. Little of the country's political moods, its national and international affiliations draw attention to any new logic or precise idea.

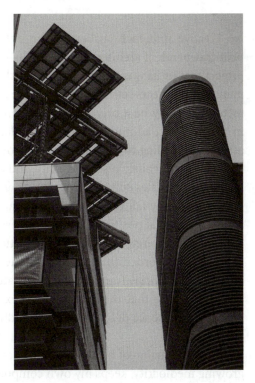

9. The best cities are in fact built entirely on undemo-cratic foundations. They are based as much upon the provision of opportunity to its citizens, as on enforc-ing a severe restrictive framework on their daily life. That London has some of the best natural parks in the world is the result of numerous ordinances that control the buildings around them, limit activities within, and, now with the imposition of a congestion tax, restrict inflow of vehicles into town. Could Delhi ever place similar restrictions on its city centre, or Lucknow on Hazratganj? The municipality in Copenhagen provides free cycles to its citi-zens. Pick up any cycle anywhere in the city, use it for however long you require, and drop it at any municipal cycle lot. Could Park Street in Kolkata, the old quarters in Ahmedabad or Hyderabad, benefit from a similar scheme? In New York City prohibitive rates for parking itself restricts the entry of private cars into Manhattan. People walk, bus or take the subway. Along the East coast of the US many new towns are designed only for pedestrians, parking lots banished to the periphery of the town. In our own country however, where a majority of the people own no vehicle at all, the sidewalk has disappeared altogether.

10. In the half a century it has taken western planners to realize the serious folly of their promotion of the automobile, most Indian and Chinese cities have only just begun their journey to affluence. In both places the car is idolized as one of the true benefits of cap-italist freedom. While cities like Copenhagen, Tokyo, and Louvain have put a premium on other forms of transport, private bicycles or public transport, those like Singapore and Hong Kong pose serious restrictions on car ownership. Hong Kong's raised corridors allow pedestrians to go from one building to the next without coming down to street level. When possible, cities around the world celebrate car-less days. Posing restrictions on cars may be seen as undemocratic by some, yet truly democratic governments work on imposing norms that emerge from a common set of urban values. That a pedestrian takes precedence over a vehicle and a cycle ride through parkland is more desirable than a ride on asphalt in a closed machine, are preferences that need to be clearly stated in city plans. More than ever, transport planners require a freer hand in determining a fresh mix of transport modes throughout the city. Combinations that allow a planned and ordered connection between home, street and neighbourhood that makes effective links between cycle rickshaws, metro, autorickshaws and buses. Indian cities need to take decisions out of municipal hands, to a fresh band of urban bodies capable of big imaginative leaps in reversing conventions and inventing new urban ideas. Henry Ford began the decline of urban life with his car; it may take a greater invention to eventually kill it.

No creative influence challenges the mild suppositions on which the country's post-independent architecture was built—the borrowed scaffold that allowed us to project that India was meant to be a free-thinking place of private depth and public magnitude. It bears rethinking that in the absence of an institutional culture, architecture can only be a private inconsequential activity. People build on whim, day in and day out, adding personal appendages of construction to new or previous assemblies, adding to the jumbled mix. Somewhere in time, the collective of bricks begins to erroneously resemble a city, and encourages the false belief that what has been built indicates cultural progress. As architects, we are never alert to such falsehoods and easily fall prey to any such magnified building seduction. The architect assumes a special position amid the gallery of city structures, determined by himself, for himself. Yet, unless there is a critical reaction and a sustained response to the growing disorder, things will continue to be accepted as reasonable, and mere evocations of social function and class attitudes. Like physicists, architects have come to believe that the world can be explained in mere material and technical terms. The presence of building, any building, is proof of architecture.

Within the squalor of a profession and career, the tendency to contribute to the growing mediocrity, keeps my own computer screen flickering and the drawing on perpetual standby. For some years now, I have begun to cast an oversized shadow on my own drawing board. I realized that the inclination towards design and building had become so natural and almost like second nature, that I accepted wholeheartedly whatever I drew and built. I had become a victim of my own fluency. Now, as I age, I realize it is time to step forward, not step back, and take an extreme position. That, I hope, also holds true for architecture.

About the Author

Gautam Bhatia graduated in Fine Arts and went on to get a Masters degree in Architecture. A Delhi-based architect, he has received several awards for his drawings and buildings and has also written extensively on architecture. Besides a biography on *Laurie Baker*, he is the author of *Punjabi Baroque*, *Silent Spaces* and *Malaria Dreams*—a trilogy that focuses on the cultural and social aspects of buildings. *Blueprint*, a collective of his architectural works will be published in 2018. Bhatia is currently working on *Future Building: Ideas for the Future City*.